The Visual Arts Companion

Larry Smolucha

The School of the Art Institute of Chicago

PRENTICE HALL, Englewood Cliffs, New Jersey 07632

Library of Congress Cataloging-in-Publication Data

Smolucha, Larry.
 The visual arts companion / Larry Smolucha.
 p. cm.
 Includes bibliographical references (p.) and index.
 ISBN 0-13-042987-2
 I. Art Appreciation. I. TITLE.
N7477.S57 1995
701/.1—DC2 94-31193
 CIP

Acquisitions Editor: Bud Therien
Project Manager: Robert C. Walters
Design Director: Paula Martin/Leslie Osher
Interior Design: Studioizbickas
Cover Design: Studioizbickas
Cover Artist: Anne Miranda
Photo Editor: Lorinda Morris-Nantz
Photo Researcher: Rhoda Sidney
Production Coordinator: Bob Anderson

© 1996 by Prentice-Hall, Inc.
A Simon & Schuster Company
Englewood Cliffs, New Jersey 07632

Printed in the United States of America
10 9 8 7 6 5 4 3 2

ISBN 0-13-042987-2

Prentice-Hall International (UK) Limited, London
Prentice-Hall of Australia Pty, Limited, Sydney
Prentice-Hall Canada, Inc., Toronto
Prentice-Hall Hispanoamericana, S.A., Mexico
Prentice-Hall of India Private Limited, New Delhi
Prentice-Hall of Japan, Inc., Tokyo
Simon & Schuster Asia Pte. Ltd., Singapore
Editora Prentice-Hall do Brasil, Ltda., Rio de Janeiro

Contents

Chapter 4
Principles of Composition 96

Chapter 5
A Survey History of Art in Synopsis Form 121

Preface

This is a guidebook to the realm of visual art. And like the famous *Baedeker's* line of travel guidebooks, it is best used in hand while exploring the actual territory it describes. This book has been specially designed to be easily portable and relatively inexpensive; thus, it will suit introductory students and casual readers especially well. It can also be enjoyed equally well from a favorite armchair.

The content of this book reflects recent multicultural trends in education; the art history survey includes sections on the major non-European cultures of Africa, China, and selected principal Native American tribes, as well as the art and cultures of the Ancient Near East. In addition, frequent textual references to non-Western aesthetic systems, often illustrated with examples, present readers with significant alternatives to the European tradition in visual art.

The organization of the text is as follows:

Chapter 1 introduces important basic concepts and explores the distinction between *art* and *aesthetics*.

Chapter 2 presents a survey of traditional art-making techniques, as well as information on more recent and innovative avant-garde art forms.

Chapter 3 discusses the *formal elements* of art, the most basic features common to all works of art.

Chapter 4 examines the essential compositional principles used in making art and shows how these principles operate through an in-depth analysis of a selected painting. This chapter may be regarded metaphorically as an introduction to the languages of the region.

Chapter 5 offers a brief and highly condensed historical synopsis of the major eras of Western and non-Western art and is suitable for use as a museum fact book, as a complement to classroom lectures, or as a quick reference guide for the neophyte student, museum or gallery visitor, or casual collector.

Students and more casual readers seeking a quick reference guide to the visual arts will appreciate the fact-filled glossary and pronunciation guide that appear at the end of the book. I have endeavored to pass along as much knowledge to the reader as possible in the *Visual Arts Companion* while, at the same time, preserving something of the mystery and fascination that the arts have held for me

over these past decades. The *Visual Arts Companion* is intended to serve as a complete introductory guidebook, whether one is pursuing a degree in the field, or simply seeking a deeper appreciation of the visual arts and their role in contemporary life.

Acknowledgments

The production of a book such as this involves, in addition to the author's contribution, the efforts of many talented people. I would like to thank, in particular, Bud Therien, whose editorial skills guided the development of the project; Bob Walters, who managed the varied phases of its editing and production; and Mary Kalscheur Choi of Prentice Hall, who not only helped steer this project through the early stages of the proposal process, but also fielded many abstruse questions with uncommon grace and diligence.

I am grateful to the staff of the Ryerson Library of the Art Institute of Chicago, to Ms. Pat Wilcoxen at the Regenstein Library at the University of Chicago, and to Rhoda Sidney, photo researcher, whose professional assistance greatly facilitated my research. I must also mention the extraordinary reference staff at the Downers Grove, Illinois Public Library, who either know the answer to any question or can find it for me in about half an hour.

I also acknowledge with thanks the distinguished critics Richard Shiff and the late Harold Rosenberg, with whom I had the privilege of studying while at the University of Chicago, and also my longtime friends and art colleagues, particularly Peter D. Feiberger (for the concept of the "E.Q."), James W. Meyer (for the anecdote concerning his first experience interpreting an abstract painting), and my graduate mentor, Kanani Bell, whose encyclopedic knowledge of poststructuralist linguistics, contemporary sculpture, and Native American cultures would be truly frightening if ever turned to evil purposes. I must also mention the kindness of Betsy and Wesley Teo, who provided me with free use of their private xerography facilities, and Professor Louann Tiernan, who graciously translated some obscure pages from several old German manuscripts.

I must thank my wife, "the good doctor," Francine Smolucha, whose appreciation for the deeper levels of meaning embodied in the arts has been a sustaining influence for much of my work, and finally, the authors and artists whose works appear throughout the body of this text. Any errors remain, of course, my own.

Larry Smolucha

The
Visual
Arts
Companion

Chapter 1

The Fine Arts in General Terms

ong ago in a distant land there lived two eminent wine tasters, each of whom believed himself to be the greatest connoisseur of vintage wines. As it often happens in such situations, a bitter rivalry developed between these two men. One night, they met unexpectedly at the home of a mutual friend, a nobleman, who invited each of them to sample some of his finest wine. The wine tasters agreed—each one hoping to embarrass his rival—and eagerly followed the nobleman down the winding stone steps into his wine cellar. There they came upon an enormous wooden cask.

"This wine is from the best vineyard in the country, *my own!*" declared the proud nobleman as he filled two glasses from the large, oaken cask and handed one to each of the men.

The first wine taster, whose father had been a humble village blacksmith, swirled the ruby-colored liquid in his glass, took a sip, and frowned. "It would be excellent …" he remarked coldly, staring into the drink, "… were it not for a subtle undertaste of iron."

The other wine taster, whose father had been a humble shoemaker, sniffed warily at his glass and took a sip. "I'm afraid you're wrong about the undertaste," he said with a supercilious grin. "There is an undertaste, of course, but I'm certain it's *leather*, not iron."

Their host, angered by the wine tasters' arrogant display, called for his servant. "Bring me an axe," the nobleman shouted, "I'll settle this business once and for all!" And when the servant returned, the nobleman seized the axe and smashed open the great wooden cask,

sending rivulets of fouled wine cascading across the stone floor. Then, seizing a lantern, he thrust it through the hole and peered inside. At the bottom of the smashed cask lay a rusty iron key with a leather cord tied around its end, evidently dropped in by a clumsy barrel maker many years ago.

This story, inspired by a passage in Miguel de Cervantes's epic satire *Don Quixote* (c. 1615), mixes together two different meanings of the word *taste*.[1] On the one hand, taste appears in the story in the literal sense as one of the modes of sensory perception. But taste also appears in its figurative sense meaning *good taste,* or *good judgment on aesthetic matters,* which in turn suggests intelligence and superiority.

By mixing together these two different meanings of the word *taste,* the story illustrates that taste is shaped by both one's native perceptual skills as well as one's life experiences. The blacksmith's son responds to the undertaste of iron in the wine, while the shoemaker's son is sensitive to the underflavor of tannin. In some respects this story is reminiscent of the old East Indian dervish tale of the blind men who encounter an elephant for the first time. Each man perceives only a part of the whole. The one who feels the elephant's foot believes the animal to be tall and cylindrical, like a tree trunk, while another man who feels its side thinks it to be broad and smooth, like a stucco wall, while the one who touches the tail believes it to be slender, like a snake. Only the reader is privileged to see the whole truth.

The story of the wine tasters also provides us with a model for understanding the development of the visual arts in human culture. Each cultural period, like each wine taster in the story, has its own standards of taste, its own ideas of what is beautiful or desirable, as well as what is not. Art history traces the development and expression of these ideas as they appear in each cultural epoch.

Aesthetics

Any serious discussion of visual art must also include some understanding of **aesthetics** (sometimes written as *esthetics*). Aesthetics, for our purposes, can be defined broadly as *the philosophical study of beauty and all that it involves.* Let us take this

[1]*From an anecdote told by Sancho Panza in Don Quixote (1615) by Miguel de Cervantes (Part 2, Chapter 13). The basic story, in abbreviated form, is also mentioned by Scottish philosopher David Hume in his essay "On the Standard of Taste" in Hume: Of the standard of taste and other essays, ed. John W. Lenz, (Indianapolis: The Bobbs Merrill Co., Inc., 1965), pp. 10–11.*

general and somewhat old-fashioned sounding definition as our starting point and qualify it further by examining its application in several specific instances.

First, aesthetics is a much broader category than art and includes not only art objects such as paintings, sculptures, drawings, and purely decorative *objets d`art* (like vases, snuffboxes, and other such bric-a-brac) but also can involve ideas and things usually associated with art as well. For example, the late English mathematician G. H. Hardy (1877–1947) writes in his insightful essay, "A Mathematician's Apology," on the concept of aesthetics in mathematics:

> *The mathematician's patterns, like the painter's or poet's must be beautiful; the ideas, like the colours [of the painter] or the words [of the poet], must fit together in a harmonious way. Beauty is the first test: there is no permanent place in the world for ugly mathematics.*[2]

Hardy's concept of the beautiful in mathematics is closely related to what scientists call *elegance* or *parsimony*, namely, the idea that all really great mathematical or scientific concepts are characterized by simplicity and economy of expression. For example, an equation that expresses a profound mathematical truth with just a few symbols is preferable to one which requires a long and rambling exposition running several pages in length. In a similar vein, one often hears in scientific research the expression **Occam's razor,** which means that when a scientist is confronted with two explanations for a given phenomenon, the simpler explanation is always preferred over the more complicated one. *Occam's razor* is named after the Franciscan philosopher William of Occam [Ockham] (died 1349), who used the concept extensively in his writings. It is called *razor* because it "cuts away" all that is superfluous.[3] Aesthetics in science involves such ideas as these.

In contrast to Hardy's notion of the beautiful in science, aesthetics appears in an entirely different form in the Japanese Tea Ceremony, called *Chado* (the Way of Tea), recognized as one of the

[2]*Godfrey Harold Hardy, A Mathematician's Apology, (London: Cambridge University Press, 1967). Also found in Newman James R. The World of Mathematics, vol. 4 (New York: Simon & Schuster, 1956), p. 2027.*
[3]*Entia non sunt multiplicanda præter necessitatem (Entities ought not to be multiplied except from necessity). These exact words do not actually occur in Occam's works but the principle expressed occurs in several other forms. From Brewers Dictionary of Phrase and Fable, ed. Ivor H. Evans (New York: Harper & Row, 1981), p. 801.*

traditional art forms of Japan. The tea ceremony is closely allied with the martial arts traditions of feudal Japan and is believed to have originated when one warrior, before engaging in a desperate and deadly battle, served to another warrior what was very likely to be his final cup of tea. Every detail of the tea's preparation and serving—from the number of times it is to be stirred, to the exact way the cup is to be held out to the recipient—is done in a certain prescribed way. In addition, every detail of the surroundings is likewise fixed by tradition, including the precise height of the planklike stepping stones at the entrance to the tearoom. All the sights and sounds associated with the ritual preparation of the tea, from the quietly boiling water to the quiet wiskings of the tea brush, are calculated to evoke an atmosphere of serene, contemplative tranquility amid the anxiety and confusion of everyday life. The atmosphere and state of mind evoked by the ritual are also considered a part of the overall aesthetic experience; consider the following description of a tea ceremony held one April morning, precisely at dawn:

> There was not even an oil lamp by the seats, and only the sound of the kettle bubbling was heard; all was exceptionally tranquil. After we had taken our places, the screen behind us slowly began to brighten ... [The tea master] Rikyu suddenly stood up and opened the screen. At that moment the daybreak moon setting in the west lit up the window [and Rikyu] looked at the hanging scroll and read by the moon's light the poem by Fujiwara Teika written there: "If you look towards the singing cuckoo, only the daybreak moon remains."[4]

Thus, we see that the kind of aesthetic experience sought by the Japanese Masters of the Tea Ceremony is more sensuous, though no less exacting, than the aesthetic experience described in G. H. Hardy's essay.

Aesthetics is recognized as one of the four major areas of inquiry in philosophy, along with *epistemology* (the study of how we come to know things), *ontology* (the study of the nature of reality), and *ethics* (the study of the moral good). Also included under the concept of aesthetics are the descriptions, discussions, and

[4]Kaisen Iguchi, *Tea Ceremony*, trans. John Clark (Osaka: Hoikusha Publishing Company, 1976), p. 22.

criticisms of aesthetic experiences. Philosophers have had an active interest in art and aesthetics for many centuries because in aesthetic judgments, it is believed, our ideas of perfection or truth lie closer to the surface than in other areas of human experience. On the other side of the coin, however, there are philosophers who believe that there is no absolute truth, only relative truths valid at certain places and at certain times. To these philosophers art and aesthetics are relatively trivial matters which may be of passing interest to students of culture or ethnography but are on the whole no more important than a game of chess. Which of these two viewpoints is the more accurate is still a matter of debate.

As one might well suspect, since every major philosophy has its own ideas concerning the nature of truth, the nature of reality, and exactly what is involved in the moral good, there are likewise many diverse and sometimes contradictory interpretations of exactly what the study of the beautiful actually means. Even philosophers within the same cultural period often have had differing ideas on the nature of beauty and the value of art. The classical Greek philosopher Plato (427–347 B.C.) excluded artists from his model of what the ideal state might be like. In *The Republic* Plato argues that the objects we see in the world are all illusions, shadowlike reflections of *ideal forms* that exist somewhere apart from the debased objects of the world in a realm of spiritual perfection. The pathway to truth for Plato involved striving to understand these ideal forms. But since the physical world is imperfect and corruptible (at least according to Plato), these ideal forms cannot be approached through the things of the world. Only through reason (i.e., logic), which Plato considered the highest mental faculty, can a person come to know real truth. Too much involvement with mere appearances, which is exactly what happens in art, serves only to detour us from the pathway to truth, wherein lies the essence of all things. Thus, Plato saw artists as forever chasing illusions, making copies of physical objects that are themselves only poor copies of the ideal forms.

Other classical Greek philosophers, however, did not share Plato's philosophical disdain for art. Plato's pupil Aristotle (384–322 B.C.) identified **mimesis** or imitation as the essential concept in art. Aristotle, furthermore, recognized that some artists portray people realistically, while others portray them as more than they actually are in idealized portraits, or as a good deal less than they actually are in caricatures. Each of these approaches has its own merit

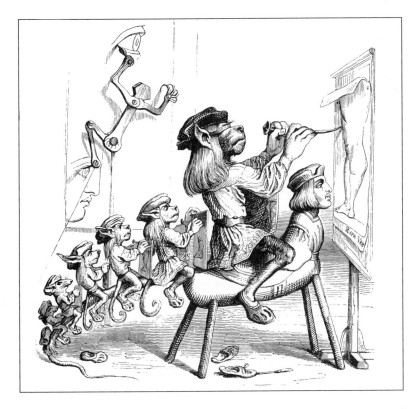

Figure 1.1 *An artist's commentary on other artists (Aristotle's concept of mimesis applied to social commentary). Caricature from the illustrated book Les Animaux by Ignace-Isidore Gérard called GRANDVILLE (1803–1847). An academic teacher of art and his pupils, mounted on a Raphael hobbyhorse, trace details from the Old Masters while a mechanical pantograph, a device for copying pictures, is similarly busy in the background. (Illustration: Dover Pictorial Archives)*

according to Aristotle. Caricature might be useful for purposes of moral instruction (to "correct behavior through laughter," *castigat ridendo mores,* as the Romans used to say), whereas idealized portraits might serve to uplift the spirit, and realism might admirably serve to provide realistic historical documents. In Aristotle's concept of aesthetics, art need not always be beautiful. (See Figure 1.1.) Social satire like political cartoons, for example, can be quite grotesque and still be inspired and successful artworks.

Interestingly enough, the Christians of the Middle Ages evolved an approach to art that echoed, at least in spirit, the writings of the pagan philosopher Plato. Early Christian artists avoided sensuous figures which might present an occasion for the sin of *idolatry,* the worship of graven images, and focused instead upon illustrating inspirational stories from the Bible. (See Figure 1.2.) The medieval Christian concept of the world as an inherently evil place prompted many artists to renounce drawing from live models. Christian artists relied instead upon images copied from preexisting **illuminated manuscripts.** These older images were called *prototypes.* It was not until the early Renaissance (beginning about A.D. 1350–1400) that artists began to take a renewed interest

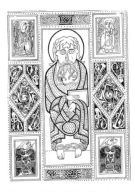

Figure 1.2 *Saint Mark Surrounded by Symbols of the Evangelists from the St. Gall Codex 51, (c. eighth century). Images such as these copied from other illustrations have more in common with the lines and curves of calligraphy than the musculature of the human body. The medieval copyist, unskilled at drawing subjects from life, used his talent for lettering to compose such figures. (Photo: Kunstgeschichte in Bildern II)*

in things of the world. Some Renaissance artists, notably Leonardo da Vinci and the sculptor Michelangelo (Michelagniolo Buonarroti), dissected human cadavers in order to improve their knowledge of human anatomy. As these few examples illustrate, a culture's **ideology,** its system of values and beliefs, strongly influences the kind of artworks produced within that culture.

But this is not meant to suggest that all artists are only slaves to cultural tradition. Individual artists often work according to their own system of aesthetics, which combines the influences of various thinkers, admirable works done by other artists, as well as the artist's own thoughts on aesthetic principles. Before Plato, the classical Greek sculptor Polykleitos (active c. 460–440 B.C.) believed that an artist could find perfection and, therefore, truth by using a set of mathematical rules, a **canon of proportions,** as a guide for producing ideal figures. By carefully adjusting the proportions of a figure until all its parts were in visual harmony with one another, Polykleitos believed he could arrive at perfect human figures suitable to represent the most perfect and immortal of all beings, the Greek gods. Polykleitos's canon of proportions involves not so much specific measurements for each body part but rather guidelines for various part-to-part relationships such as the length of the fingers in relation to the overall length of the arm, for instance, or the width of the shoulders in relation to the overall height. A careful observer will notice that the height of most classical Greek figures is between eight and eight-and-one-half heads high, which are believed to be the most heroic proportions. If the head were too small, the figure would appear lacking in intellect; if the head were too large, the result might appear dwarflike or brutish.

We can see from these examples that aesthetics involves much more than the simple discovery and cataloging of examples of physical beauty. Embedded in the various notions of beauty are other similarly complex ideas, such as the nature of truth, the concept of perfection, and the ever present human need to search for meaning among the seemingly random events of everyday experience. These concepts are all interconnected, nested like those tiny egg-shaped Russian lacquer dolls that each contain miniature versions of themselves, so that by examining one, we wind up encountering them all. The investigation of these interrelated concepts of beauty, truth, perfection, and meaning has become the basis for a large part of contemporary aesthetic theory and has, likewise, inspired much of the visual art of the last century.

The concept of style in art

Not all artists were in agreement with Polykleitos's ideas on what constituted ideal proportions so the works from each sculptor's studio, based as they were upon each artist's differing canon of proportions, took on a subtle yet distinctive flavor which became as easy to recognize as their individual styles of handwriting. (See Figure 1.3.) The uniquely personal quality that an artist imparts to his or her work is called *style*. Some commentators have gone so far as to claim that the word style springs from the Latin word for a pointed writing implement, a stylus, but careful entymological research reveals that this word origin is highly doubtful. Nevertheless, the comparison between the uniquely personal element in an artist's work and the distinctiveness of one's handwriting remains a poetic, if somewhat etymologically inaccurate, metaphor for style.

An artwork is said to be **stylized** when the artist allows his or her own personal expression free reign, even when that indulgence causes the image to slew away from an absolutely accurate representation. Generally speaking, *the more realistic* a painting is, the *less stylized* it appears to be. Even in the most realistic works,

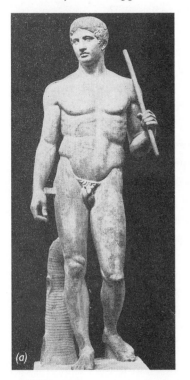
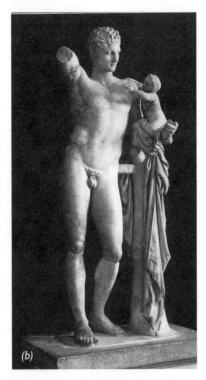

Figure 1.3 *Which of these represents the ideal human figure? Compare Polykleitos's vision of the ideal figure (a) with that of the later sculptor Praxiteles (b). Both attempted to arrive at perfection by using a canon of proportions.*
(a) Spearbearer (Doryphoros) by Polykleitos. Roman copy of a Greek bronze (height 6 ft 6 in.). (Photo: Kunstgeschichte in Bildern I)
(b) Hermes with the Infant Dionysus (c. 340 B.C.) by Praxiteles. Possibly original, rather than a Roman copy; height 7 ft. (Photo: Almari Art Resource, NY.)

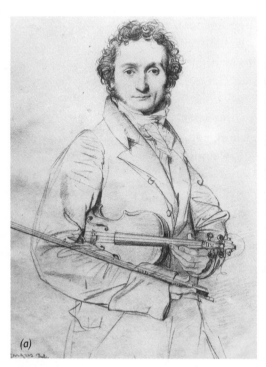

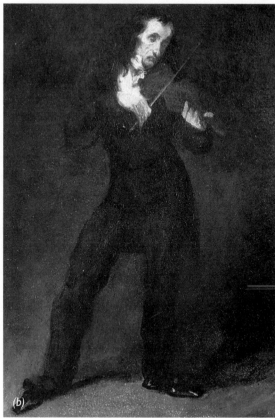

Figure 1.4 (a) Paganini (1819) by Jean-Auguste Dominique Ingres. Size 12" X 8" (Louvre, Paris) (Photo: Giraudon Art Resource)

Figure 1.5 (b) Paganini (c. 1832) by Eugène Delacroix. Oil on cardboard, Size 17" X 11" (Phillips Collection, Washington, D.C.)

however, an artist's style is still recognizable in subtle ways, from the artist's characteristic arrangement of lights and shadows within the painting, to the artist's choice of subject matter, color preferences, and even the sort of brushstrokes used to apply the paint to the canvas.

As a case in point, consider these two realistic portraits of the flamboyant nineteenth-century violinist Niccoló Paganini, both of which were done in the early 1830s. As seen in Figure 1.4, by the French painter Jean-Auguste Dominique Ingres (1780–1867), this pencil drawing portrays Paganini in a cool, intellectual light. The details are rendered with meticulous precision, suggesting the great refinement and dignity of the musician.

In contrast, the more stylized portrait in Figure 1.5 by the French painter Eugène Delacroix (1798–1863) focuses upon the emotion-charged performance of Paganini, whose musical presence was so entrancing that it was rumored he had been possessed by the devil. Delacroix attempts to give us a taste of Paganini's distinctive performance style by cloaking the violinist in moody shadows and

delineating his contours with swift, bold brushstrokes that echo the frenzied strokes of the violist's bow.

The radically different styles of Ingres and Delacroix led them to become not only artistic rivals but bitter personal enemies as well. Their enmity toward one another was well known, as a popular print from that era demonstrates (see Figure 1.6). The two artists are shown jousting in the forecourt of the French Académie des Beaux Arts (Academy of Fine Arts), the institution that acted as the official "tastemaker" during that period. Delacroix, who was almost 20 years younger than Ingres, is depicted as a scruffy young bohemian. Ingres, in stark contrast, appears as the venerable, if somewhat pompous, old master. The humorous legend on Delacroix's paint pot and horse reads, "Line is a Color. Only at night are all cats grey!" whereas Ingres's shield proclaims "Color is a [false] Utopia. Long Live Line!"[6]

Today, most art historians regard Ingres and Delacroix as equally great, but in the final analysis Delacroix appears to have been more gifted with romantic imagination, whereas Ingres appears to have been the more precise draftsman.

There is another difference worth noting in the work of these

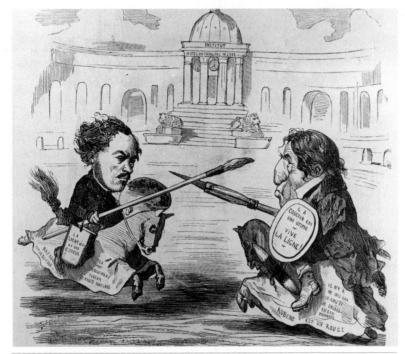

Figure 1.6 *The rival painters Delacroix (left) and Ingres (right) jousting in the forecourt of the French Academy. (Illustration: from* Time-Life Encyclopedia of Art: The World of Delacroix *by Tom Prideaux and the Editors of Time-Life Books. Copy photograph by Jean Marquis. ©1966 Time-Life Books Inc.)*

[6]From Time-Life Encyclopedia of Art: *The World of Delacroix by Tom Prideaux and the Editors of Time-Life Books. Copy photograph by Jean Marquis ©1966 Time-Life Books Inc., The World of Delacroix (New York: Time-Life Books), p. 128.*

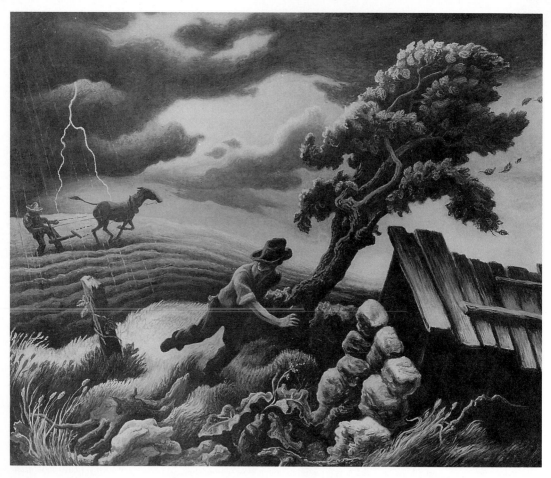

Figure 1.7 The
Hailstorm *(1940) by*
Thomas Hart Benton. Oil
and tempera on canvas,
Size 33" X 40" (Joslyn Art
Museum, Omaha,
Nebraska. Gift of the James
A. Douglas Memorial
Foundation.)

two artists. In Ingres's drawing, one senses a cool perfection of technique and a distant, almost austere intellectual spirit that has come to be called **classical** (after the Greek sculptures of the fourth and fifth centuries B.C. which epitomize this style). In contrast, Delacroix's spirit-charged interpretation, in which precision takes a back seat to emotional expression, represents an approach that has come to be called **Romantic** (after the eighteenth-century movement that believed emotional expression to be the highest purpose in art). Many critics, historians, and commentators regard the tension between the classical and romantic styles as one of the essential driving forces in art and culture. It sometimes appears as if cultural and artistic periods oscillate back and forth like an immense pendulum between these two extremes of classicism (intellect) and romanticism (emotion), the emphasis shifting from one to the other with each successive generation.

As aesthetic standards change over time, artistic styles change

along with them. Consider the two works illustrated on the facing page, one by American master Thomas Hart Benton (Figure 1.7), and the other by his most well-known student, and a master in his own right, Jackson Pollock (Figure 1.8). Pollock began painting, as most students do, by emulating the stylized realism of his teacher. Eventually, however, Pollock became dissatisfied with simply copying Benton's style and struck out in a completely new direction, developing an unusual style of nonrepresentational painting in which the pigments were dropped onto a horizontal, unstretched canvas.

Pollock's style later came to be called **action painting** because it emphasised the physical gestures made by the artist as he moved across the canvas, dropping the paint onto its surface with a brush or a stick. It is ironic that although Pollock's approach differs from Benton's in nearly every respect, something of Benton's style, particularly his emphasis on curved contours, seems to haunt Pollock's work. It is almost as if Pollock, in reacting against Benton, actually managed to distill or **abstract** the essence of Benton's style. This recalls our earlier observation that an artist's style is partly the product of personal thoughts and skills, and partly the sum of the significant influences acting upon the artist at key points in his or her career.

In the same way that personal artistic styles differ, cultural expectations of exactly what art involves also undergo considerable

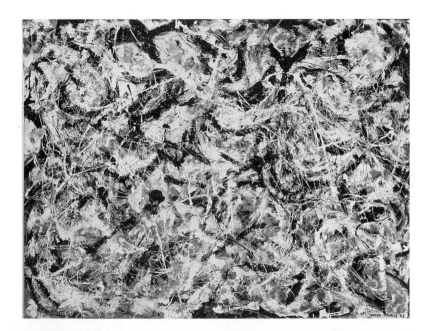

Figure 1.8 Greyed Rainbow (1953) by Jackson Pollock. Oil on canvas 72" X 96". (Photo: The Art Institute of Chicago. Gift of the Society for Contemporary American Art.)

change. For example, in our own era the uniqueness of a work, its originality, is considered by most people to be an important aspect of a work of art. But in France during the reign of Louis XIV from 1661 to 1750, calling an artist's work "original" was one of the most damning criticisms one could make. Artistic virtue then meant upholding venerable and long-standing traditions in painting by copying and emulating the great works of revered masters, not indulging in personal flights of fancy.

Within our own culture a distinction is often made between **popular art,** which is aimed at pleasing the general public, and **fine art** which is ostensibly aimed at pleasing an elite group of refined *aesthetes*. Popular art has long been stigmatized as an inferior form of art which panders to unsophisticated tastes. Popular art often takes the form of **kitsch** meaning bad or debased art (from the German word for "something thrown together"). Kitsch appears in many guises, ranging from badly made plastic replicas of "high art" masterpieces like Rodin's sculpture, *The Kiss,* depicting two nudes in an ardent embrace, to the overly sentimentalized paintings of illustrators such as Maxfield Parrish and Norman Rockwell, which critics often deride as presenting a superficial and falsely idealized vision of the world. Works of so-called high art, on the other hand, are often criticized by followers of kitsch as equally shallow and sensationalistic, serving only to inflate the egos of the pretentious few who can afford to finance its production by artists who often seem more like expensive pets of the gallery owner than true cultural visionaries. There is a little bit of truth embedded in each of these extreme viewpoints.

Perhaps the strongest attack against the spiritual vapidness of so-called high art was mounted by Russian novelist Leo Tolstoy in his book, *What Is Art.* Unfortunately, the criterion Tolstoy adopts for determining what constitutes good art (that is, works that evoke feelings of genuine human brotherhood) is interpreted so narrowly by Tolstoy that Beethoven, Michelangelo, and even much of Tolstoy's own work winds up falling beneath his critical axe. Most critics today would argue that while Tolstoy's modest book does not provide the definitive answer to the problem of which art is best, it nevertheless succeeds in illustrating the complex interrelationship between moral and aesthetic judgments.

When faced with seemingly irreconcilable dilemmas, such as those posed by the tensions between popular and high art, it is always useful to recall what was said at the outset of this chapter;

that is, all artistic judgments are made from within a larger social, historical, and cultural context that dictates what is good, what is bad, and what is even possible for an artist to do at any given time in history, as well as what an artist's proper role in relation to the rest of society ought to be. History teaches us, if nothing else, that eventually our own perspective on art will appear as quaint and incomplete as that of any culture that has preceded it.

We can further understand the close interrelationship between individual artistic styles and their larger cultural ecology by borrowing a metaphor from the writings of the great nineteenth-century biologist Charles Darwin. The following excerpt is from the very last paragraph of *The Origin of Species,* the now famous "rumination on a tangled riverbank":

> *It is interesting to contemplate a tangled bank, clothed with many plants of many kinds, with birds singing on the bushes, with various insects flitting about, and with worms crawling through the damp earth, and to reflect that these elaborately constructed forms, so different from each other, and dependent upon each other in so complex a manner, have all been produced by laws acting around us.*[7]

If we consider the history of art in metaphorical terms as also representing a kind of tangled riverbank, we can understand that artistic styles, like their biological counterparts in Darwin's illustration, are continually engaged in a struggle for survival and dominance. Newly emergent styles called the **avant-garde** (the "advance guard") struggle against older, outmoded styles called the **decadents** (meaning "fallen" or "fallen away"). Some of the avant-garde styles will disappear without ever firmly establishing themselves, while others may establish a tenuous foothold and, if conditions are favorable, may even overshadow their older, outmoded predecessors. But all the while, the development of these myriad artistic forms is continually shaped by the larger cultural ecology of enduring ideological principles and values. To put it briefly, when we look at art and culture we see as we do in nature not static forms, but rather dynamic systems undergoing continual processes of change.

It is true that in certain cultures little or no change occurs

[7]*Charles Darwin, The Origin of Species. (New York: Literary Classics, Inc., no date), p. 356.*

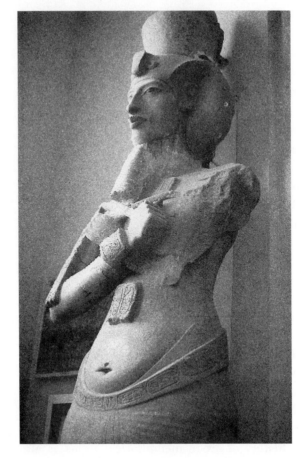

Figure 1.9 *The Pharaoh Akhenaton, a great reformer of Egyptian art, depicted in a pillar statue from Tell el-Amarna (c. 1357 B.C.). Carved sandstone (height approximately 13 ft). (Photo: Foto Marburg Art Resource, NY.)*

over long spans of time. We see examples of this in the cultures of ancient Mesopotamia (the region between the Tigris and Euphrates rivers, corresponding roughly to present-day Iraq) and also in the art of ancient Egypt. In these cultures, changes of artistic style happened very slowly, if at all, and then only over many centuries. In fact, the later part of their existence is often marked by extended periods of virtual stagnation. Once in a while a reformer appeared, such as the Egyptian pharoah Amenhotep IV (c. 1350 B.C.) who called himself Akhenaten but such individuals are rare. (See Figure 1.9.) Akhenaten created a cultural revolution by instituting a more realistic, relaxed artistic style in place of the stiff, idealized figures favored by his predecessors. Although Akhenaten made many changes during his lifetime like introducing the belief in one god, named *Aten* (*Akhen-aten* means "pleasing to Aten"), styles soon reverted to the older ways after Akhenaten's passing.

Because of their stubborn resistance to change, such apparently static cultures often manage to exist for thousands of

years within dauntingly hostile environments. By clinging to time-tested ways, these cultures remain always within the safe boundaries of their established survival niche in contrast to the more dynamic and relatively shorter-lived cultures, such as our own, which seem to exist in a state of perpetual flux.

A note on the idea of cultural evolution

When we observe the development of any animal organism, we see it pass through a series of developmental stages. The human embryo in the womb appears to reenact in miniature the entire sequence of evolution beginning with the most primitive one-celled forms of life and continuing, through the various stages of development, to its culmination in a complete human being. In the sciences this concept is stated as *ontogeny recapitulates phylogeny*. Simply put, the stages of individual development (ontogeny) echo the evolutionary stages of the entire species taken as a whole (phylogeny).

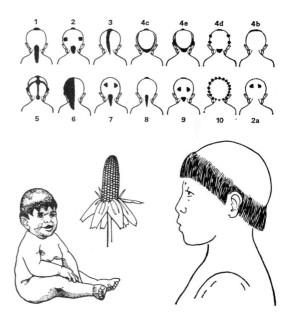

There is a temptation to assume that the converse of this statement—*phylogeny recapitulates ontogeny*—is also true, namely, that all earlier cultures must, therefore, be childlike, while our own culture must represent a more advanced or mature stage of evolution. This is definitely *not* the case. Anthropological research informs us that so-called "primitive cultures" exhibit a high degree of intellectual and cultural development which, in certain respects, may rival or even surpass the sophistication of our own culture.

One example of the marvelous ingenuity of a primitive culture is seen in the use of haircuts as clan membership symbols by Omaha and Osage Indians. In the illustrations in Figure 1.10, compiled from the field notes of the early twentieth-century ethnographer Francis La Flesche, we see that each clan haircut has a special association to its totem image. The haircut at the extreme lower right, for instance, represents the clan "Rock with algae

Figure 1.10 Omaha and Osage Indian Haircuts According to Clan, *after LaFlesche. From Claude Levi-Strauss,* The Savage Mind *(Chicago: University of Chicago Press, 1966),* © 1962 by Librairie Plon, 8, rue Garancière, Paris-6e; English translation © 1966 George Weidenfeld and Nicolson, Ltd., London. All rights reserved. Reprinted with permission of the University of Chicago Press.*

[9]*Claude Levi-Strauss,* The savage mind, *trans. John Weightman and Doreen Weightman (Chicago: University of Chicago Press, 1966), p. 171.*

floating around it," while the scalloped edges of the boy's hair opposite clearly identify him with the clan "Petals of the cone flower."[8]

Rather than being caught up in unproductive questions about which artistic style or cultural period is the more advanced, observers of the arts would do well to consider each period and style on its own terms as representing a legitimate response to the larger forces surrounding it. We must bear in mind that cultures and artistic styles are conceptual constructs embedded within and dependent upon other more complex constructs for their very identity and existence.

The artist and the critic

During the Paleolithic era, near the very dawn of human history (c. 15,000 B.C.), animal images painted on cave walls played an important part in magical rituals associated with the success of the hunt. Thus, the first artists may have been **shamans** (sorcerers or medicine men) believed to be capable of controlling supernatural forces. Throughout the Middle Ages and during the Renaissance, an artist's training became more skill oriented and typically began while the artist was still a young boy serving as an **apprentice** in the workshop of a **master.** At first, the young apprentice performed menial duties, such as mixing paint, sharpening carving tools, or cleaning paintbrushes, until he was old enough to learn the master's style. Later, the apprentice might assist the master more directly by working on the less important parts of a painting (such as the background scenery) or perhaps varnishing the finished works, thus freeing the master to concentrate upon more important parts of the work. Female painters often studied under the direction of their artist fathers (many of whom were minor talents) since women were, before the mid-seventeenth century, more or less excluded from the field of art.

It was not at all unusual for master painters, particularly the more successful ones, to employ an entire staff of apprentices as well as other more advanced assistants, each of whom specialized in a particular type of painting, such as landscapes or animals. The seventeenth-century Flemish painter Peter Paul Rubens maintained a veritable art factory, which efficiently turned out many masterworks to meet the great commercial demand for Rubens's paintings. We can see the involvement of Rubens's apprentices in

these excerpts from an annotated price list which Rubens sent to Sir Dudley Carleton, ambassador to England's King Charles I.

> *500 florins. A Prometheus bound on Mount Caucasus, with an Eagle which pecks at his liver. Original, by my hand, and the Eagle done by Snyders.*
>
> ...
>
> *600 florins. Leopards taken from the life, with Satyrs and Nymphs. Original, by my hand, except a most beautiful Landscape, done by the hand of a master skilful in that department.*
>
> ...
>
> *1200 florins. A Last Judgement, begun by one of my scholars, after one which I did in a much larger form for the most serene Prince of Neuberg ... but this, not being finished, would be entirely retouched by my own hand, and by this means will pass as original.*
>
> ...
>
> *600 florins. A picture of an Achilles clothed as a woman, done by the best of my scholars, and the whole retouched by my hand, a most brilliant picture full of many beautiful young Girls.*[9]

After having served the full term of his apprenticeship, the young **journeyman** (now around 20 years of age) became fully qualified to practice his craft as a member of the painters' **guild,** a lodgelike group formed to safeguard the profession and standardize its practices. After years of devoted application to his craft, the journeyman might complete a work of considerable size and complexity, a **masterpiece,** after which he would be recognized as a master in his own right. The new master would then seek a patron for his works and eventually might take on an apprentice or two, thus beginning the cycle all over again.

In our own era a person who wishes to become an artist passes through an educational curriculum much like that of the other professions, yet some of the trappings of the old apprenticeship system remain in place. Students are often taken under the wing of a faculty member who, like the masters of old, functions as the

[9]Elizabeth Gilmore Holt, ed., Literary Sources of Art History (Princeton: Princeton University Press, 1947), p. 419.

student's mentor. Most fine art degree programs still require a student to complete a series of works that demonstrates mastery of basic principles and techniques. These required works are, for all purposes and intents, the student's **journeyman's pieces.** It should not come as too great a surprise that our universities, which are the living ancestors of the medieval cathedral schools, should operate in accordance with these time-honored traditions.

Few new fine arts graduates realize, however, that many years of training still lay ahead *even after one has graduated from an advanced degree program.* It is more or less standard practice for young art graduates to find employment in commercial art agencies or, perhaps, as teachers in college art departments, where they hone their skills for ten years or more and build up a body of work before striking out in earnest to make a reputation for themselves among the commercial galleries. There are, to be sure, certain talented (and very lucky) individuals who seem to "connect" early on in their careers, but such sudden rises to fame are rare and often meteoric—brilliant, but short-lived. Many artists work diligently for years perfecting a personal style only to find that, in the meanwhile, new stylistic developments have made their work less interesting to collectors than it once was. Success in the art world truly depends not only upon talent, intelligence, and perseverence, but also on a number of factors which lie entirely outside any individual's control. Because of this, many artists eventually eschew notions of fame or immortality as part of their youthful delusions and work only for themselves or for a small circle of friends. I am reminded of the great classical musician Johann Sebastian Bach who composed his greatest works while serving as an obscure choirmaster largely ignored by the prominent musicians of his own time.

The idea of criticizing an artist's work is perhaps as old as the idea of art itself, but the concept of the critic as a professional **aesthete,** a person presumed to possess extraordinary taste and great insight in artistic matters, is believed to have originated among the ancient Greeks. Even the Greek historian Thucydides (about 471–400 B.C.), for example, felt compelled to voice his opinions on the relative merits of the artists of his time. It was not until the Italian Renaissance (roughly from 1400 to 1600) that art criticism became an integral part of artistic life and a profession in its own right.

Approaches to art criticism have varied almost as much as the artistic styles that make up their stock in trade. One eighteenth-century art historian and theoretician Roger de Piles (1635–1709),

who served as a diplomat in the court of Louis XIV of France, went so far as to rank each well-known artist on a "scale of merit" according to his relative level of skill in the basic areas of composition, drawing, color, and expression. A score of 20 on de Piles's scale would indicate "sovereign perfection" (a theoretical ideal that has never been achieved, and probably never will be). A short sampling from Roger de Piles's scale appears in the following table.

A Catalog of the Names of the most noted Painters, and their Degrees of Perfection, in the Four principal Parts of Painting; supposing absolute Perfection to be divided into twenty Degrees or Parts.

Artist	Composition	Drawing	Colour	Expression
Albrecht Dürer	8	10	10	8
Le Brun	16	16	8	16
Giorgione	8	9	18	4
Holbein	9	10	16	13
Leonardo da Vinci	15	16	4	14
Michelangelo	8	17	4	8
Merisi (Caravaggio)	6	6	16	0
Poussin	15	17	6	15
Rembrandt	15	6	17	12
Rubens	18	13	17	17
Raphael Sanzio	17	18	12	18
Titian	12	15	18	6

Adapted from Holt, E.G., ed., Literary Sources of Art History ©1947 by Princeton University Press. Reprinted/reproduced by permission of Princeton University Press.

While a score of 20 represents perfection, 18 is the highest score de Piles ever awarded—to Rubens (for his compositional skill), to Giorgione (for his color skill), and to Raphael Sanzio (for his drawing skill and expression). Even a quick glance at the list, however, reveals that de Piles was more than a little biased toward his own countrymen. Charles Le Brun, for example, a competent though arguably minor French painter who collaborated with Louis LeVau on the design for the Louvre's facade, receives a whalloping 16 points in three of the four categories, while the great Renaissance master Albrecht Dürer (perhaps the greatest of all German Renaissance printmakers) limps away with mediocre scores of 8 and 10 on de Piles's scale. (To say nothing of poor Caravaggio!)

The most notable feature of such "report card" rankings is the utter presumption that these judgments could ever be made with such an exaggerated degree of accuracy. This perhaps reveals more about the person who would attempt such a thing, and the culture in which he or she lives, than it does about the artists being evaluated.

The role of the critic has changed in recent years, moving away from the concept of the critic as an exacting judge, and moving toward the idea of the critic as a guide or interpreter of the visual arts. Serious critics examine an artist's work within the larger cultural context in which it occurs, and in relation to the artist's other significant works in order to clarify the artist's intentions in making the work. Thus, a good critic guides and educates rather than gives a simple thumbs-up or thumbs-down, like one of the spectators at an ancient Roman gladiatorial contest.

Auteur criticism

One approach to criticism, practiced widely in film criticism, and also to an extent in literary and visual art domains, is *auteur criticism* (author-focused criticism). Auteur criticism takes a single film director's entire *corpus,* or body of work, and examines those aspects of his or her style that make it unique in comparison to all other directors. A critic practicing this approach would take all the films directed by, say, Stanley Kubrick, and would look for patterns that have emerged throughout the development of that director's career. These patterns might be purely formal, such as Kubrick's characteristic technique of having an actor walk directly toward the camera while the camera backs continuously away. Or they may be patterns associated with the director's choice of subjects, such as Kubrick's apparent fascination with individuals forced by circumstances beyond their rational limits. All historians practice auteur criticism, in some sense, when they examine the features of an artist's work that make him or her unique among all other artists from a particular era.

Iconography

Another approach to the study of art involves a close examination of the conventions of pictorial representation used in various times and places, usually by tracing the expression of a single artistic theme as

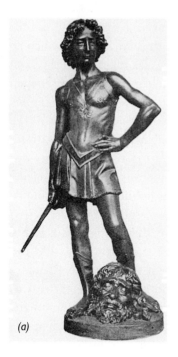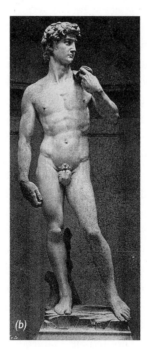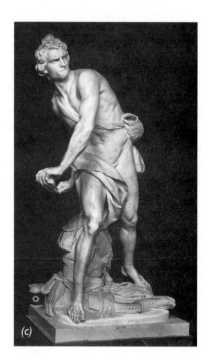

(a) (b) (c)

it appears in several different cultures or in several different eras. This approach, called **iconography**, can be illustrated best by example. Consider the following three sculptures shown in Figure 1.11, each of which takes as its subject the Old Testament story of the shepherd boy, David, who fought the Philistine giant, Goliath (I Samuel 17:4–49). Even a casual inspection of the three works reveals that each artist has approached the theme in a slightly different manner.

The earliest version by Andrea del Verrocchio depicts David after his victory over Goliath. David (shown life-size for an adolescent) stands alone, dressed in the unpretentious garb of a shepherd, the large severed head of Goliath at his feet. The figure's stance recalls the weight shift of classical Greek sculpture. While Verrocchio's sculpture communicates the principal moral of the biblical story—the meek shall inherit the earth—there is little drama in this after-the-fact representation. Although this is a bronze sculpture of the early Italian Renaissance (1465) and demonstrates the technical expertise and anatomical sophistication of that period, this work has the same unemotional stillness found in medieval mosaics, which served mainly as teaching images rather than as sensuous objects.

Michelangelo's *David,* in contrast to Verrocchio's more modest

Figure 1.11 *Variations on a Theme: The Biblical Hero David, from the fifteenth, sixteenth, and seventeenth centuries.*
(a) David (c. 1465) by Andrea Verrocchio. Bronze, approximate height 4 ft. (Photo: Kunstgeschichte in Bildern III)
(b) David (1501–1504) by Michelangelo. Marble, height 13 ft 5 in. (Photo: Kunstgeschichte in Bildern III)
(c) David (1623) by Gianlorenzo Bernini. Marble, life-size. (Photo: Almari Art Resource, NY.)

version, is a monumental marble carving over 13 feet tall. Michelangelo has depicted David at the critical moment in which he decides to accept the Philistine challenge. He takes the sling down from his shoulder while thoughtfully cradling the stone with which he will slay the giant in his right hand. The expressive facial features communicate something of David's inner tension and hint at the drama which is about to unfold. Michelangelo's image of David, which depicts the shepherd boy as a giant (in the literal as well as figurative sense), goes well beyond the biblical story. Michelangelo's *David* stands as a metaphor for human nobility and indomitable spirit. This is a work of the late Italian Renaissance (1501).

In contrast to the other two versions, Bernini depicts David at the moment of combat, winding up for the throw. This life-size marble carving tells us that the artists of the Baroque Era were keenly interested in portraying dramatic action as well as demonstrating their mastery over materials. This is the era of the virtuoso craftsman, such as Bernini, who can tease us into believing that a brittle, nontensile material like marble can be twisted like a coiled watch spring. (Before he was 20 years old Bernini completed a statue of Saint Lawrence which depicts the martyred saint chained to a gridiron among *flames carved in marble!*)

An iconographic study focuses upon the subtle differences in the way a subject or a theme is treated at different times or in different cultures with an eye toward the distinctive representational conventions used during those eras. Through such iconographic comparisons, historians gain insights into the subtle and pervasive cultural forces that effect the expression of artists' ideas.

Be aware that **iconography** is often confused with two similar terms: *iconology,* which involves the study and analysis of pictorial symbols, especially those used in religious devotional images called *icons,* and *iconolatry* which like **idolatry** is the worship of graven images.

I n t e n t i o n - r e f e r e n c e d c r i t i c i s m

Even the most nonjudgmental approaches to criticism, such as those outlined previously, still have something of an evaluative tone. The basic choices which a critic makes to ignore some works and write about others amount, as one of my colleagues used to say, to an "argument by exclusion." It seems, from this perspective, that value judgments are inescapable. If this is so, then how should

we deal with the problem of judging the success or failure of a work of art?

When judging whether or not a work of art is successful, it is not always possible (or desirable) to evaluate it simply on the basis of its **verisimilitude,** that is, the degree to which the work appears real or true to life. If that were the case **trompe l'oeil painting,** which is so realistic it literally "fools the eye," would be the highest form of art. During the 1970s and early 1980s muralists delighted in painting illusory windows and other architectural ornaments on the blank walls of buildings. From a distance these highly realistic trompe l'oeil effects are quite convincing, but are such technical tricks really the highest form of art?

One might well ask the question: If realism isn't the issue, then what other basis for judgment is there? One widely held approach focuses upon whether a finished work actually communicates the artist's stated intentions for that work. Such **intention-referenced criticism** considers the artwork as a communication event that occurs between the artist and the viewer, a sort of nonverbal utterance. This form of criticism borrows concepts from fields such as linguistics and **semiology** (the study of symbols and their interpretation).

The intention-referenced method of criticism has gained wide acceptance in art schools and in the larger art community because it encourages artists to clarify and verbalize their intentions during *critique* sessions, and because it provides an analytic pathway for tracking down what went wrong when a work fails. The intention-referenced approach, however, has definite limitations; it seems to encourage the idea that all works of art must have a didactic message, rather like a punch line that must be "gotten" in order for the work to be considered successful. This is, obviously, not always true.

One occasionally encounters a strange work or an enigmatic artist who chooses not to make his or her intentions clear. One such artist is Jasper Johns, who is regarded as one of the most influential American artists of the post-World War II period. Johns's early works are bewildering—painted targets with plaster faces arranged in a row across the top, painted sequences of numbers, painted maps of the United States, and enigmatic variations on the American flag—objects so absolutely mundane that they seem to contain no meaning at all beyond the mute fact of their sheer physical presence. Yet, Johns's paintings convey an elusive, mysterious

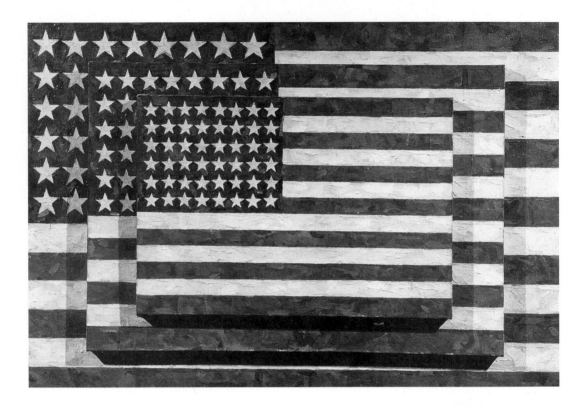

Figure 1.12 3 Flags (1958) by Jasper Johns. Encaustic on canvas, 31" X 45" X 5". A collector once asked Johns if he had actually bothered to paint the covered parts of the flags. Johns's Zen-like reply was that he had indeed painted them, but in a shade of grey. (Whitney Museum of American Art)

quality suggesting a conundrum that can never be solved. Johns's flag, target, and number paintings (Figure 1.12) appear to be a reflection on the nature of symbols, or about how we have come to regard symbols, which have no real existence in and of themselves, as real presences in our world. Or is it, perhaps, the other way around … that the substantive objects of our experience constitute merely another kind of symbol? Johns's paintings are interesting precisely because their meanings are *not* manifestly evident to the casual observer.

Formalism and Nonformalism

All artworks can be categorized generally as either formalist or nonformalist in intention. Works that attempt to address issues that lie outside of art such as political, religious, or philosophic issues are referred to as **nonformalist paintings** because they stress the importance of their subject matter rather than the formal elements of design (line, shape, and color for their own sake). On the opposite side of the coin, a painting that is intended purely as an aesthetic statement, which has no discernible subject matter other

than its own colors, textures, and shapes, is called a **formalist painting** since the artist is concerned exclusively with the *formal elements* of design.

Bear in mind that these broad categories are somewhat artificial; most artists fall somewhere in between these two extremes of pure concern for design and pure concern for subject matter. Some degree of technical skill is almost always necessary in art, even if only in the barest, most minimal sense in order for the work to actually get made. Likewise, the formalist's attempt to deny all meaning only serves to locate the work within a narrow category of painting where visual design itself is treated as meaning.

The critic Lucy R. Lippard's writings on art stress the concept that when something looks good, that is good design; art should involve more than good design. This is an example of a nonformalist approach to art. In contrast, the painter Frank Stella flatly denied that his geometric paintings contained any subject matter at all— what you see is what you see. Stella's frankly tautological approach is typical of formalist art, which tends to ignore everything but the work's pure visual design. (See Figure 1.13.)

Generally speaking, formalist approaches to art criticism consider artworks as statements of visual design and, therefore, concern themselves almost exclusively with how well the design

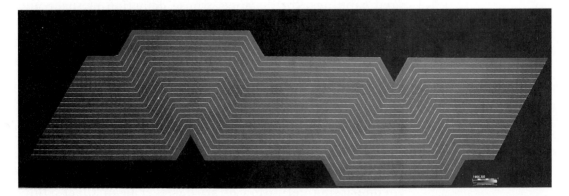

elements in a work have been handled by the artist; indeed, in a purely formalist work of art there is usually little else to consider beyond pure design. The degree to which any artwork can be judged successful in the technical sense usually depends not only upon whether the artist has met his or her stated intentions for the piece, but also upon the *degree of technical skill* evidenced by the artist in manipulating the work's physical properties, as well as the work's *richness of conception* and its *expressive power.*

Figure 1.13 De la Nada Vida a la Nada Muerte (1965) by Frank Stella. Metallic paint on canvas, 6'7"X 24'5". The formalist approach to painting–what you see is what you see. (The Art Institute of Chicago, Ada S. Garrett Prize Fund)

A painting in which the illusion of three-dimensional space has been developed to its fullest extent by contrasting regions of deep space with foreground details that seem nearer to the picture plane will probably be judged as representing a higher *degree of technical skill* than a work which consists entirely of a flat profile image. Similarly, a statue which exploits the full range of possibilities inherent in its sculptural material will probably be regarded as *richer in conception* than one in which such sensitivity to materials is less evident.

Critical judgments of an artwork, however, seldom rest exclusively upon the artist's technical proficiency; the expressive content of the work is also an important consideration. One frequently encounters works which are technically correct in all their particulars and yet appear vapid and uninspired. Many of the amateur painters one encounters at local Main Street art fairs are actually fairly accomplished technicians who misapply their painting skills to the most insipid subject matter. The idea of a work's *richness of conception* applies not only to the material parts of the work but to its intellectual and emotional content as well.

Of course, there are exceptions to these general principles, which serve to remind us that criticism is itself an art form rather than an exacting science. I can think of some perspectiveless Navajo sand paintings, for instance, whose depiction of space and illustration of narrative event is so complex that they rival some of the most sophisticated twentieth-century abstractions. Similarly, there are examples of ancient Egyptian sculpture such as small bronze votive statues, essentially throw-away objects, left for devotional purposes in the temple of a long-forgotten god, that have more expressive power and modeling sensitivity than some statues from our own era. Works of art, like people, are best addressed as individuals, on a one-to-one basis.

Because of the many diverse approaches to art, no single all-encompassing definition of art has ever been successfully formulated. But while no single definition has been shown to be applicable to all art at all times and in all places, some of art's more enduring features can nevertheless be identified. In the chapters that follow, we will turn our attention to some of these features, namely, the forms and techniques of visual art, the formal elements of design and composition, and the enduring themes of art history.

Art Forms and Techniques

An exhaustive catalog of all the various art forms and techniques used throughout the centuries could easily fill a volume this size many times over, and yet many of these almost innumerable techniques are really variations on a few basic approaches to making art. This section surveys most of the basic two- and three-dimensional techniques, as well as some of the more recent avant-garde forms.

Drawing techniques

Drawing is the most basic of all art forms. At its essence drawing involves nothing more than a piece of paper, the stub of a pencil, and an intelligent, sensitive eye. In spite of its apparent simplicity, however, drawing is one of the most difficult techniques to fully master. An artist's true level of skill (or lack of it) will be immediately laid bare in his or her drawings—especially those of the human figure, the most unforgiving of all subjects.

The most frequently used drawing surface or **ground** is paper, the earliest form of which was made from dried *papyrus* found along the banks of the Nile. Papers are available in various grades of quality, ranging from **newsprint** (the cheapest, lowest-quality paper, made from treated wood pulp) to the highest-quality **100-percent rag papers** (made from shredded cloth fibers or old rags to which a sizing has been added). There are also **handmade papers,** usually of very high quality, which may contain exotic inclusions, such as

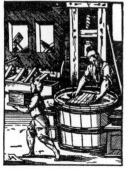

Der Papyrer.

Figure 2.1 Medieval paper making. Pulp is skimmed from the vat onto a wire screen, then pressed between squares of felt and set aside to dry (German woodcut). (Illustration: Dover Pictorial Archives)

butterfly wings or bits of gold leaf. **Parchment** (lambskin) and **vellum** (vealskin) are also used. (See Figure 2.1.)

Rag papers, unlike papers made from wood pulp, are resistant to discoloration and have a life span of many centuries. In contrast, newsprint left unprotected might last only a decade or two. Under a microscope, the apparently flat surface of high-rag content paper is revealed to be a webwork of ropey fibers. When making a pencil drawing, the microscopic bits of graphite lodge in and among these weblike fibers, producing the image we see on the paper. Erasers, among the best of which is a wadded-up piece of white bread (try it, but first trim off the crust), combine with these particles and carry them away as the eraser crumbles.

The wide variety of drawing media can be divided into two basic categories: **dry media** and **wet media.** The dry media are by far the most popular and the oldest media for drawing. (Drawings in charcoal done on cave walls have been found dating from the Upper Paleolithic Period, c. 15,000 B.C.) Before the invention of the familiar wooden pencil in the early 1800s, graphite sticks or charcoal (carbonized wood) pressed into stick form were widely used. The softer metals such as lead and silver have also been used in drawing implements. **Silverpoint,** a technique which produces lines of great refinement and delicacy, uses a length of silver wire inserted into a pencil-like holder. The ground upon which a silverpoint drawing will be made must be prepared, that is, roughened by the addition of a thin coating of *gesso* or Chinese white (a thick watercolor paint hightened with chalk) in order for the silver particles to adhere properly. Soon after the silverpoint image has been drawn, atmospheric moisture causes the silver to tarnish, changing it to a shade of rich, velvety black.

Most line drawings are improved by the addition of shadows, surface values (shades of grey representing an object's colors), and surface textures, all of which can be represented in several different ways. The most common method, **shading,** uses the side of the pencil lead. Transitions from light to darker shaded areas can be smoothed by rubbing with the fingertips or with a paper *blending stick.* **Hatched lines** (closely drawn parallel lines) are used frequently in pen drawings to suggest shadows or shades of grey. (See Figure 2.2.) Hatched lines that follow the apparent surface contours of an object are called **cross contours.**

Figure 2.2 The drawing technique of Hatched Line. Archeologist's field drawing of an Etruscan winged lion with ram's horns from the sixth century b.c. (Illustration: Dover Pictorial Archives)

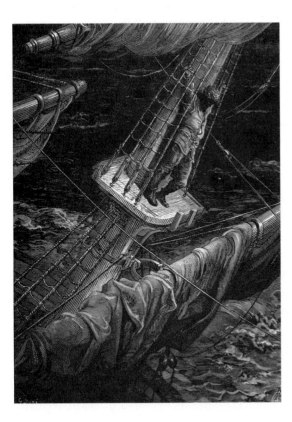

Figure 2.3 The technique of Cross Contour. One of Gustav Doré's illustrations (engraving) for Coleridge's poem Rime of the Ancient Mariner. (Illustration: Dover Pictorial Archives)

(See Figure 2.3.) In the technique of **crosshatching,** darker values are generated by adding additional layers of hatched line, usually at oblique angles to the first layer. **Stippling** produces values by the controlled application of dot patterns of varied density made with the tip of a pen or pencil, or by flicking ink onto the paper with a stiff-bristled brush. (See Figure 2.4.)

Figure 2.4 The drawing technique of STRIPPLING. Archeologist's field drawing of an Etruscan roof ornament from the fifth-century B.C. (Illustration: Dover Pictorial Archives)

 Scratchboard (or **scraperboard**), a nineteenth-century drawing technique, involved coating a cardboard panel with a thick layer of white gesso, then painting it with India ink. White lines were then created by scraping this inked surface away with a needle or knife blade to uncover the white gesso layer beneath. Scratchboard requires an artist to mentally reverse his or her drawing technique by drawing the *light* areas of the image rather than the dark areas.

 The **wet media** include all manner of inks and the various implements for applying these inks to paper. Historically speaking, inks were simultaneously invented in Egypt and China sometime around the third millenium B.C. Traditional Chinese and Japanese inks come in small, rectangular blocks that must be hand ground

with water on a smooth slab of slate—an essential part of the drawing ceremony—then applied with a horsehair calligraphy brush. The popular India ink is made from carbon particles, like candle soot, suspended in a liquid binder (the permanent variety uses shellac). Inks have been made from vegetal dyes, the galls of gnarled oak trees, and even from the natural inks found in the ink sacs of squids and octopodes.

In the Middle Ages, goose quills, carved at the tip into a penlike **nib,** were a common instrument for writing and drawing. Quills made from feathers with a "left-handed" curve (which pointed annoyingly at your face while you scribbled) were cheaper than the preferred "right-handed" feathers that turned gracefully over your shoulder. During the industrial revolution in the early nineteenth century, metal nibs of various widths were manufactured to be inserted into an inexpensive wooden handle. This type of pen is still in use for fine calligraphy. The ubiquitous ballpoint pen is generally not well suited for fine drawing due to its heavy, irregular line and smeary ink. The **rapidograph,** a penlike instrument with a hollow, mosquito-nose tip, is a better choice for linear work which demands a fine ink line of constant width. Rapidographs are widely used by engineering draftsmen as a precision drawing instrument.

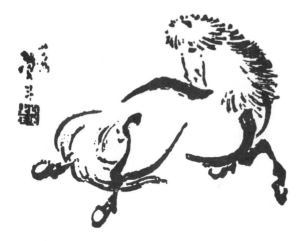

Figure 2.5 *Japanese brush-and-ink drawing (sumi-e) by Kakunen. Sumi-e paintings emphasize impressionistic images drawn with a few dynamic brushstrokes. The horse (uma) is a traditional Japanese symbol of fertility and agricultural prosperity. (Illustration: Dover Pictorial Archives)*

Horsehair brushes of the type used in Japanese calligraphy allow a draftsman to capture bold yet subtly expressive gestures on paper, the very soul of Oriental drawing techniques—as shown in Figure 2.5. A thin **wash** of ink diluted with water is sometimes used to lightly tint portions of a drawing, but the traditional Japanese drawing style of *sumi-e* favors monochromatic washes for it is believed that color is too often used by lesser draftsmen to compensate for weakness in their drawing. In stark contrast to the works of this highly traditional, even austere *sumi-e* style, many commercial illustrators and graphic designers prefer to use felt-tip markers (with high-quality tips and refillable ink reservoirs) to enhance their compositions with bold color, which has a way of commanding a viewer's attention.

Commercial artists and illustrators often employ mechanical aids to reduce the time and labor involved in copying drawings. **Opaque projectors** allow a drawing to be projected directly onto paper for tracing. The **pantograph,** a mechanical copying instrument consisting of several wooden rods joined in such a way that tracing over an image at one end produces a copy of the image at the device's other end, is a tool which has been in use for centuries. The size of the copy can be altered by adjusting the relative length of the wooden rods or the position of the tracing stylus. Similar devices exist for copying sculptures in three dimensions.

Sculpture techniques

Sculpture involves the carving, chiseling, casting, modeling, or assembly of some material in order to create a three-dimensional figure or art object. Unlike painting, the popularity of sculpture as an art form seems to wax and wane with the times. A certain well-known painter once disparagingly defined sculpture as "something you trip over when you step back to look at a painting." More perceptive artists, however, have found that sculpture offers a rich domain of aesthetic and expressive possibility.

Historically, sculpture has taken a variety of different forms. **Freestanding sculpture,** or figures carved or modeled in the round (visible from all sides) are the most common type. **Portrait busts** that include a subject's head, shoulders, and upper chest were popular among the ancient Romans who worshiped their ancestors as household gods called *lars* (See vignettes.). Portrait busts of the god Hermes, affixed to a rectangular pillar of stone, were used by the Romans as roadside milestones. Ancient travelers often patted these **herms** (male) or **hermas** (female) for good luck when they passed them along the roadside. The **equestrian statue,** an ancient type of military portrait which depicts its subject on horseback, is rarely encountered today outside of quaint town squares and old-fashioned parks. Mounted warriors were typically shown directing their forces in battle or riding forward with great dignity, as if to claim a hard-won victory. Traditionally, a charger rearing up on its hind legs symbolizes that its rider fell in battle.

Partial figures attached to a flat background slab are called **relief sculpture,** or simply **reliefs.** Those modeled in the low or flat style, with figures that barely protrude from the background slab,

Sculpture in the round. (Illustration: The Complete Encyclopedia of Illustration)

Portrait bust. (Illustration: The Complete Encyclopedia of Illustration)

are called **bas** (low) **reliefs;** those done in a somewhat more rounded style are called **mezzo** (middle) **reliefs,** while the most fully developed figures, projecting well forward of the background slab, are called **alto** (high) **reliefs.** Reliefs, like freestanding sculpture, were occasionally painted but more commonly left in their native finish. Coins typically bear an image in bas relief on both their **obverse** (front) and **reverse** (back) surfaces.

Any technique for producing object-oriented sculpture can be broadly categorized as either an **additive** or a **subtractive technique.** Modeling, which involves building up a sculpture from some *plastic* (meaning shapeable) material such as clay or wax, is perhaps the most common additive technique, while carving is the most basic subtractive technique. The famous Renaissance sculptor Michelangelo (Michelagniolo Buonarroti) claimed he was able to visualize his gigantic sculpted figures as if resting fully formed within the raw marble blocks at Carrara; his carving tools simply released the figures from the imprisoning stone.

Virtually every fabrication technique known has, at one time or other, been used in the production of sculpture. The modeling of clay into images or vessels is among the oldest of sculptural techniques. Several nonhardening varieties of sculpture clay are available under the generic name of plasticine. The traditional modeling clays, however, are a mixture of **kaolin** (a fine white clay used in making porcelin) and fine sand, and range in color from white or ash grey, to an iron oxide-rich reddish-brown variety known as **terracotta** (Italian for "baked earth"). Smaller-scale *terracotta* figures can be hollowed out to uniform thickness and fired to stonelike hardness in a high-temperature kiln. Larger clay figures require an internal skeleton called an **armature** of wood or pipe to support the weight of the moist clay while it is being worked. In the traditional bronze-casting process, the finished clay model is cast in plaster of paris (a natural gypsum compound) or a quick-setting dental plaster to produce a plaster model, which is then taken to a foundry to be cast in metal by specially skilled craftsmen.

In the **lost-wax method** of bronze casting, also called *cire perdu* (*Sear* pear dew), a piecemold of the plaster model is made (usually with a gelatin or rubber compound) and from this piecemold a wax copy of the model is cast. After the wax copy has been separated from the piecemold and retouched by the artist, wax rods which will become the gates, channels, and vents for the molten bronze are attached to the wax figure. This entire assembly

is then jacketed in a clay-plaster mixture called the **investment** and heated until the wax softens and runs out, leaving behind a negative impression in the hardened investment mold. A sand core is added (to reduce the wall thickness of the sculpture) and the entire mold is packed in an insulating layer of foundry sand. Molten bronze, which is an alloy of copper and tin, is poured in through the gates and channels left by the melted wax rods. When the bronze has cooled, the figure is released from the mold and the sand core is purged from the statue's interior. The gates, channels, and vents are trimmed, along with any seam lines left from the piecemold (a process called **chasing**) and the cleaned bronze sculpture, bright as a newly-minted penny, is either polished or heated with a blowtorch and brushed with acids to give the surface a colored **patina** ranging from velvety black to blue-green or warm brown.

A variation on this technique called *sand casting* works directly from the plaster model, thus eliminating the intermediate wax copy. Sand casting is a cruder technique used in industrial applications where fine surface finishes are not an issue. Both of these casting techniques can be used to produce multiple copies of the sculptor's original plaster model; in fact, multiple castings are almost required to justify the expense involved in making the mold.

Carving techniques are usually associated with stone or wood, although any relatively soft, yet durable material such as ivory or bone is suitable for carving. The softer varieties of marble are

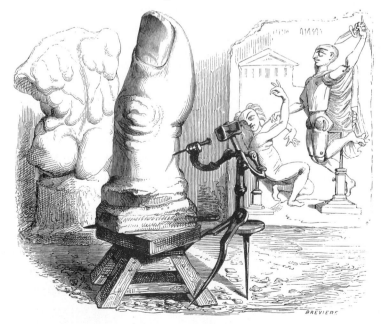

Figure 2.6 The Sculptor's Studio *by Grandville. An illustration from his book Un Autre Monde. (Illustration: Dover Pictorial Archives)*

generally preferred for stone carving and are graded according to their color, veining, texture, and ease of working. Some varieties of marble are almost legendary. One of the best carving stones, the snowy white Italian marble from the Carrara region, was often used by the Renaissance sculptor Michelangelo. The fabled honey-colored Pentelic marble (from Mt. Pentelicus) favored by the sculptors of classical Greece is no longer available. **Lapis lazuli,** a semiprecious stone with an arresting deep blue color used widely by artisans in ancient Mesopotamia, is still a favorite material for decorative inlay work, miniature carvings, and jewelry.

Ironically, many of the oldest stone monuments around the world have been damaged or destroyed by acid rain, a corrosive byproduct of industrial pollution. The University of Chicago's Department of Egyptology is engaged in the long-term project of documenting the deteriorating wall decorations on the ancient Egyptian temples at Karnak. It is estimated that, given the current rates of decay, the incised painted reliefs on the temple walls will be completely obliterated within two hundred years, at which time the highly detailed drawings and photographs preserved in the volumes of the *Chicago Epigraphic Survey* will be all that remains of these great artworks from the past.

Carving even a small figure in stone is a very time-consuming, labor-intensive activity, even with the use of such contemporary innovations as pneumatic power tools and carbide-tipped saws and drill bits. First, the overall form of the composition must be blocked out in three dimensions, using saws and rough cutting tools. Usually the artist has already prepared a number of sketches and perhaps a **maquette,** which is a small model of the finished work, to guide him or her at this early stage. Work proceeds with chisels, files, and rasps. All the while the sculptor continually makes adjustments to the composition by increasing or decreasing the size of an element, shifting its position, or eliminating it entirely in order to preserve the integrity of the composition as it is translated from the working drawings or small maquette into the actual marble. Fine surface details are cut with finishing or riffler files, whose thin ends are curved like a knife blade. Finally, the sculpture's surface may be polished with various grades of carborundum, an industrial abrasive of nearly diamondlike hardness, available in powdered form or in sheets (usable wet or dry) that resemble black sandpaper. The finest grit sizes (#600 and higher) are used for polishing the stone to a glasslike smoothness.

Figure 2.7 *The traditional stonecutter's tools: chisels, maul, and riffler file for detailed work.*

Wood-carving techniques are, for the most part, analogous to those employed in stone carving. First, the basic form is roughed out with a saw. (Many sculptors prefer a small chainsaw for larger compositions.) Then, razor-sharp wood chisels and gouges, hammered with a traditional wooden *lignum vitae* mallet, are applied to refine the details. The carving progresses through finer and finer hand chisels, rasps, and riffler files. (See Figure 2.8.) In the last stages the wood is sanded and preserved with a coating of buffed beeswax, or it may be painted, varnished, or left with its pristine natural surface.

Wood for carving must be seasoned or cured for several months before carving to allow the moisture content and grain structure of the wood to stabilize, otherwise cracks may develop due to uneven shrinkage. Rather than harvest their own wood stock, many sculptors prefer to purchase precut and seasoned wood blocks, planks, or log sections, sometimes with the core wood removed to reduce expansion and subsequent cracking.

The best choice for small carvings is basswood from linden trees, an inexpensive, honey-colored wood of medium softness and tight-grain structure. Walnut is another popular choice, though much more expensive. Generally speaking, softer woods, such as cherry and the other fruitwoods, are preferred by carvers over the harder woods like oak and those with less interesting grain structure, like maple or birch. Lignum vitae and black African ebony are among the hardest imported woods and, consequently, are extremely difficult to carve. Cork and balsa, the softest and lightest woods, are generally more suitable for craft projects than for serious carving.

Direct-metal sculpture has become a widely practiced sculptural form largely due to the development of industrial metal-working techniques such as oxy-acetylene welding (invented around 1910). Unlike bronze casting, which requires many intermediate steps that must be handled by specialists, welding allows for a more spontaneous, immediate approach to making art.

In **oxy-acetylene welding,** two flammable gases, oxygen (in a green cylinder) and acetylene (in a red cylinder), are mixed together at controlled pressures and ignited. The welder holds the torch in one hand, keeping its cone of blue flame licking at the steel, while the other hand feeds a thin metal welding rod into the molten joint to fill it. Special *metal-cutting heads* for the welding torch are used to burn through thin sheet steel. While welding is not an inherently

Figure 2.8 *The traditional wood-carver's mallet made of lignum vitae, a wood of stonelike hardness.*

dangerous technique, care must be taken when working around the pressure regulators, hoses, and most particularly the gas cylinders which, if dropped or badly damaged, can take off like an errant torpedo.

Sheet steel is the most widely used metal for welding. **Corten steel,** which forms a protective outer surface layer from its own rust, is a favorite of sculptors who work on a large scale. Direct-metal sculptors have used all manner of cast-off items, including automobile fenders and bumpers, old machine parts, scrap iron, and lengths of lead and copper pipe as sculptural raw materials. Dissimilar metals like aluminum and steel, for example, cannot be welded securely (although a welder with a steady hand can ``fake it'' by swirling them together). It is usually simpler to join dissimilar metals mechanically with bolts or rivets. *Hot-rolled mild steel,* a relatively soft steel with low-carbon content used widely in industry, can be manipulated with the aid of large pneumatic devices that can slice, bend, roll, or fold even thick steel plate into surprisingly complex shapes. Mild steel purchased as sheet or plate from a mill comes surface-treated with a greyish oxide inhibitor called *mill scale.*

The process of welding exceptionally thick metals on the order of I-beams or thick steel plates requires concentrated high temperatures such as those produced by an arc of electricity. In the process of **arc welding** (developed during the 1930s) one electrode is attached to the metal surface and the other electrode is held by the welder. An alloy-welding rod, which fits into the tip of the welder's electrode, melts and fills the weld as it generates the electrical arc. Arc-welding techniques are only mastered after many long and often frustrating hours of practice. If the electrode is allowed to linger too long in one spot, its hot end may fuse to the metal; if it is held too far away, the arc will be broken. In *heli-arc welding* the electrical arc is bathed in a flow of inert gas (helium) to reduce oxidation of the molten metal, allowing delicate metals like aluminum to be welded.

Assemblage, a form of sculpture produced from **found objects** reassembled in unexpected ways, often consists of wood or metal junk remnants bolted, welded, or simply nailed together with a hammer. (One of the most elegant examples is a small bull's head fashioned by Picasso from a bicycle seat and handlebars.) Painted wood assemblages harken back to the ancient technique of painted reliefs but are also most clearly a sculptural variant on the technique of **collage** (ko *lahz*) pioneered by Pablo Picasso and

Georges Braque in the early twentieth century. Collage in its simplest form involves attaching flat objects, such as corrugated cardboard or pieces of rope, to the surface of a painting. (See Figure 2.9.) A collage made exclusively from flat scraps of paper such as theater tickets, torn newspapers, and so forth is sometimes identified by the specialized term *papier collé.*

Both collage and assemblage techniques are prized for their immediacy and qualities of playfulness which allow the artist free range to explore the accidental wonders observable in certain common objects, like the "faces" we sometimes glimpse in a pattern of wood grain, for example. Or the artist may explore the textural qualities of contrasting materials juxtaposed against one another like the separate contrapuntal voices in a fugue. In some respects, collage and assemblage techniques seem almost poetic ruminations on the nature of the creative act itself, in which the artist comes to see the scraps and remnants of his or her everyday experience recombined in new and unexpected ways.

Figure 2.9 *Collage. Minotaure (1933) by Pablo Picasso. 19"X 16". Pencil on paper, cardboard, silver foil, ribbon, wallpaper, doily, burnt linen, leaves, and charcoal on wood. (Museum of Modern Art, New York)*

Kinetic sculptures, which emphasize motion, have been powered by electric motors, wind currents, magnetic fields, programmed electronics, and even small explosive charges. One well-known kinetic work, a self-destructing "machine" titled *Homage to New York* (1960), was so marvelously inefficient that when exhibited in the courtyard at the Museum of Modern Art its creator, Jean Tinguely, had to assist in its demise with a baseball bat.

Alexander Calder (1898–1976) anticipated the development of kinetic sculpture with his **mobiles,** (*mo* beels) arrays of flat sculptural forms hung from wires that revolve slowly in the breeze. Since their introduction in the 1930s, Calder's mobiles have quickly found their way into popular culture. Their static form called **stabiles** are typically large abstract compositions assembled from welded or riveted steel, often painted in bright, artificial hues like orange or high-intensity blue to emphasize their nature as manufactured objects. Both mobiles and stabiles owe much to the earlier works of the cubists and also Russian constructivists, like Vladamir Tatlin (1885–1953), who applied their artistic sensibilities to the production of sculptural constructions which were built and/or assembled like machines or architecture, rather than modeled and/or carved in the traditional ways.

Mixed-media works share many of the same qualities found

Figure 2.10 ASSEMBLAGE Monogram *by Robert Rauschenberg. Stuffed Angora goat, tire, and mixed media. It is believed this combine painting is a tongue-in-cheek allusion to Jackson Pollock's method of action painting.*

in assemblage techniques and thus are grouped among the forms of sculpture. Robert Rauschenberg's poetic combine paintings of the 1950s in which junk objects are attached to the surface of the canvas are notable examples, as shown in Figure 2.10. **Multimedia works,** however, are an entirely different art form combining film, video, recorded sound, and projected images, often along with live actions performed by the artist(s).

Performance art is closely related to both primitive rituals and the avant-garde productions of underground or guerilla theater. Unlike true theater, however, performance art does not require the *willing suspension of disbelief,* the imaginary shift of time, place, and action, that is demanded by a dramatic presentation. In a work of performance art, the artists portray only themselves doing real actions in real time. The acts they perform are not acting per se but usually have a metaphorical meaning. As part of a complexly structured performance event, for instance, an artist might remove an article of clothing, turn it inside out, and put it back on while reciting a passage from a psychology text about how we sometimes project our own feelings and motives onto the actions of others (another kind of "turning the inside out").

Performance art began, like Alan Kaprow's **happenings** of the 1960s, as an ideologically-conscious attempt to subvert the entire "gallery business" and its cycle of production–exhibition–collection, which seems to reduce the artwork to nothing more than a debased consumer commodity. Performance artists rely heavily upon significant or loaded gestures, which make an ideological or political statement, like a riot caused by tossing dollar bills from the balcony of the New York Stock Exchange, or alternately convey a highly personal or absurd meaning. The young nineteenth-century French novelist Isadore Ducasse (penname Comte de Lautrémont) perhaps captured the essence of performance art when the hero of his novel *Maldoror,* finding he no longer is able to smile at the world's atrocities, carves a perverse artificial smile into his face with a knife blade. In fact, a highly controversial and predictably short-lived group of performance artists actually engaged in similar body mutilations during the 1970s. In one of Chris Burden's bodyworks, the artist had himself nailed in a crucifixion pose to the top of a

Volkswagen Beetle, then had the car backed into traffic on a busy New York street. After several minutes in traffic, the Volkswagen pulled into a nearby garage and the garage door was dropped—like a theater curtain—to end the piece. It is rumored that the nails used in this work were later acquired by the eminent painter Jasper Johns for his private collection.

The eighteenth-century Japanese painter-printmaker Katsushika Hokusai, who was doubly gifted in wit as well as drawing skill, once produced a drawing after the fashion of performance art for the amusement of his patron by inking the feet of a barnyard hen and letting it scamper across a sheet of paper. Hokusai titled the resulting image *Maple Leaves Floating Down the Stream.*

Although performance art is still regarded as a vital and continuing phenomenon in some quarters of the art community, many of the gestures, statements, and street theater-like events which were used to such great shock effect in the 1960s and early 1970s seem to have lost much of their novelty over the years and now seem, at times, even a little pretentious and passé.

Installations and **earthworks** are, like conceptual or performance artworks, essentially uncollectable art forms which convert an entire site into an artwork. Installations are, almost as a rule, removed after a certain specified date at which time the artwork, like all other things in the universe, comes to an end. Since the early 1960s, Bulgarian-born American artist Christo Javacheff, known simply as Christo (born 1935), has produced several large-scale wrapping projects done in situ (on site). (See Figure 2.11.) He

Figure 2.11 *INSTALLATION.* Wrapped Coast, one million square feet of mesh fabric wrapping the Australian coastline (1969) on-site installation at Little Bay, Australia by Christo. (© Christo 1969, photographer Harry Shunk)

Figure 2.12 EARTHWORK. Spiral Jetty (1970) by Robert Smithson in Great Salt Lake, Utah. 1500 ft long, 15 ft wide. (Photo: Smithson John Webber Gallery, New York)

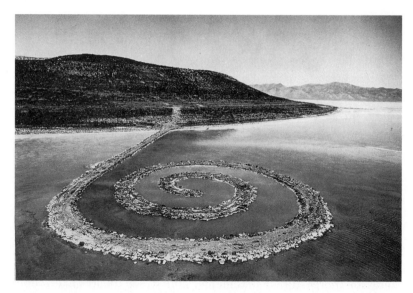

has wrapped, among other things, a portion of Australia's coastline (in one million square feet of white fabric), surrounded several islands with fabric in Miami's Biscayne Bay, wrapped Chicago's Museum of Contemporary Art, and hung a curtain across Rifle Gap in Colorado, as well as wrapped several famous European buildings and landmarks. All of Christo's monumental wrappings were temporary installations which no longer exist, although some of his smaller wrapped-object works can be found in museums and private collections. The financial backing for Christo's projects is generated entirely from the sale of his project-related graphic works.

Permanent in situ constructions called **earthworks,** such as Robert Smithson's quarter-mile-long *Spiral Jetty* in Great Salt Lake, Utah (Figure 2.12) use the raw elemental landscape itself as a sculptural material, much as the ancient mound builders did centuries ago. **Conceptual art,** a highly controversial art form whose popularity probably reached its peak during the 1960s and 1970s, sought to replace art objects with statements, performed gestures, and other nonobjects, all of which emphasize the idea that the aesthetic experience resides in the concepts embodied in the work of art, rather than in the physical aspects of its presence such as its color, materials, shape, and so forth. In Robert Morris's conceptualist sculpture *Box with the sound of its own making* (1961), a tapeloop of the sounds recorded during the box's construction (a 9-inch-square walnut cube) is continually played back inside the completed box reminding us that physical objects are extended events in space and time, having a definite beginning

and an end. The architect R. Buckminster Fuller, who invented the **geodesic dome,** seems to have anticipated this idea with his famous phrase, "I seem to be a verb," supposedly the first statement he uttered after not speaking for an entire year.

More recently, conceptual artists have found acceptance and occasional employment as creative consultants in the film industry. As an art movement, conceptualists have been often compared with the antiartists of the **Dada** movement (circa 1916–1922) who sought to overthrow the corrupt bourgeois culture which they held philosophically responsible for bringing about the wide-scale destruction of the First World War. A typical Dada gesture involved announcing a great one-night Dada exhibition, then bolting the gallery doors shut on the day of the scheduled exhibition. It is a wonderful irony indeed that the philosophical descendents of the Dada movement have found a home in one of the great icons of "Western bourgeois culture," the Hollywood film industry.

Ceramics

The word *ceramics* usually evokes an image of handmade clay vessels intended to be both functional as well as aesthetic. In reality ceramists produce all manner of objects, from practical clay pots to nonrepresentational sculpture. The ceramist's instruction in clay-handling techniques begins with crude pinch-pots and progresses to more complicated constructions made from clay slabs or coils, and finally to **thrown vessels,** made by handworking a moist lump of clay on a revolving potter's wheel. (See Figure 2.13.)

Ceramics techniques are deceptively complex. Before the ceramic clay can be modeled, it must be **wedged** by slamming it down repeatedly onto a hard surface in order to remove any trapped

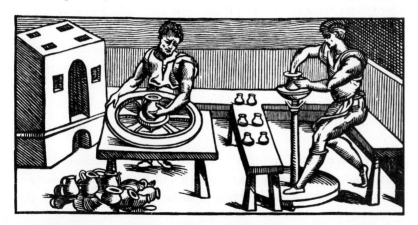

Figure 2.13 Medieval woodcut of a potter's shop. The figure at left, working on an improvised lazy Susan, applies handles to the vessels while the potter "throws" a pot on the wheel. The oven or kiln appears at extreme left. (Illustration: Dover Pictorial Archives)

air pockets that might explode during firing. After the modeling of the vessel has been completed, the clay vessel is dried to a leathery hardness (called **greenware**), then fired at very high temperatures (**bisque firing**) in an oven called a **kiln.** When the vessel has cooled, a watery **glaze** is applied to the hardened vessel (now called **stoneware**), and the vessel is fired a second time (**glaze firing**) to melt and crystallize the glaze upon the vessel's surface, thus transforming the muddy glaze into lusterous hues of glasslike hardness. Any glazed earthenware is called **faïence** (*fay* ahnz), although the term most properly is used to refer to a particular kind of metallic glaze. Translucent porcelain is made from a fine white clay called **kaolin** (Chinese for "high hill"), after the location where it was found.

Ceramic techniques demand a sculptor's skill in handling form, a painter's eye for color, and a chemist's skill in handling and blending the glaze compounds. Premixed glazes are available commercially in ready-to-use packets, although dedicated ceramists constantly experiment with their own arcane formulas for achieving particularly brilliant hues or unusual surface effects.

The ancient Japanese *raku* masters produced glazes of astonishing character and elegance from the humblest of materials, and often combined religious ritual with the firing of their pieces. I have heard marvelous tales of how, after attending to their kilns for many long hours, the raku masters plucked the hot ceramic cups from the kiln with iron tongs and flung them through the air into great heaps of ox dung and sawdust, where they acquired a magnificent surface patina. Then, while the cup was still smoking, it was immediately filled with tea leaves and water. This ritual drink—warmed by the heat still trapped within the very heart of the cup—was drunk down in one mighty draught by the master, whose thirsty spirit drew from it new inspiration for his work. Stories such as these, however apocryphal they may be, nevertheless communicate something of the unspoiled, earthy vigor of this unpretentious art form. It is no wonder that some raku masters have been designated as "living treasures" by the Japanese Ministry of Culture.

Painting

Painting techniques are usually identified by the **vehicle** or **binder** employed to get the colored particles of **pigment** to stick to a surface, or alternately by the type of surface or **ground** to which the

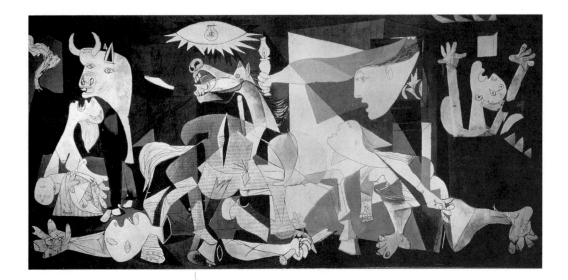

paint is applied. A painting done exclusively in shades of grey, to simulate the look of relief sculpture, is called a **grisaille.** (See Figure 2.14.)

Oil painting on stretched canvas is a relatively recent development in the history of art. Oil paints were known long before the 1400s but not widely used, and stretched canvas did not come into use as a painting ground until nearly a century later. In previous eras, the preferred painting media were either watercolor or *egg tempera* in which pigments are mixed with egg yolk (*not* the white of the egg) and applied to prepared wood panels. The ancient Egyptians used a form of watercolor similar to **gouache,** watercolor thickened with chalk, as did the Romans and the many anonymous masters of medieval manuscript illumination.

The usual vehicle or binder in oil paint is treated linseed oil. Less commonly used oils include poppy and walnut, either alone or in combination with linseed oil. For the painting ground a piece of raw cotton canvas called *cotton duck* is used. The raw canvas is stretched over a wooden framework built with mitered corners and, preferably, tongue-and-groove joints. This assembled wooden frame, over which the canvas is stretched, is technically known as the *chassis* or *stretcher.*

The finest grades of canvas, known as *Belgian linen,* are noticeably dark in color—nearly brown—and exhibit a characteristically bold weave that persists even through layers of thick paint. Belgian linen, sold in rolls or by the yard, is about

Figure 2.14 Guernica (1937) by Pablo Picasso. Approximately 12'X 26'. (Mueso del Prado, Madrid). Picasso painted this grisaille, a painting done entirely in shades of grey, as a protest against the merciless incendiary bombing of a small Basque town on the eve of World War II. The shades of grey, suggestive of a newspaper photo, capture the stark, unreal horror of the event. (Photo: Giraudon Art Resource, NY.)

five to ten times more expensive than standard cotton duck canvas.

After stretching, the raw canvas is coated with glue sizing and covered with a smooth layer of **gesso** (a chalk-white acrylic paint) or white lead. The oil paints can then be applied thinned, in transparent layers, building up the image slowly and gradually one layer at a time, or they can be applied all at once, *alla prima.* Carefully controlled layering techniques produce a smooth glasslike surface, while alla prima techniques result in thick *impasto* surface textures. The alla prima method is favored for *plein-aire* **paintings** done outdoors, while the more exacting layering techniques are clearly more suited to indoor studio work. In the eighteenth century it was common practice for artists to paint figures in several layered stages, beginning with the skeleton, then adding the musculature, the surface anatomy, and finally the clothing. The transparency of oil paints allows the layers of underpainting to bleed through to the surface (a phenomenon called *pentimento*) which was exploited to achieve subtle effects of modeling unattainable by alla prima methods.

Acrylic paints, whose vehicle is water-soluble acrylic plastic, combine some of the characteristics of oil paints with the advantages of drying times measured in minutes rather than in the weeks required for oils. Acrylic paints also allow the convenience of using water rather than noxious solvents for thinning and cleanup. Purists claim these new synthetic emulsions have not yet proven their longevity, but this argument is countered by pointing out that the newer synthetic paints were developed specifically for use in painting, unlike the natural materials that were pressed into service more haphazardly. Acrylic paints can be mixed with gel extenders for increased transparency, or retarders to slow the paint's drying time, allowing for many of the subtle blending effects usually associated with oils. The brilliance of oil colors, however, has yet to be fully matched by the new acrylic paints.

The compositions of most commonly used paints are included in the following list.

Name	Composition
Watercolor	Binder is water-soluble gum arabic. Brilliant, transparent colors of great delicacy. A spontaneous medium particularly suited to rapid execution (formerly called *aquarelle*).
Tempera	Egg yolks, thinned with water. Quick drying;

colors have a matte finish; difficult or impossible to blend colors or work in layers.

Oil Paint — Linseed oil, or less commonly, poppy, walnut, and other vegetal oils; the traditional technique of master painters allowing for a wide range of flexibility.

Gouache (goo *osh*) — Tempera paint whitened with chalk; colors are brilliant, but somewhat impermanent. Used in advertising and photography where color permanence is not essential.

Gesso — White paint to which plaster of paris or chalk has been added. Used mainly to provide an undercoat on wood or canvas grounds.

Fresco — A favored technique for wall murals *Buon* (true) *fresco* is done on plaster while it is still wet, so only a small portion of the wall is done at a time. *Fresco secco,* considered an inferior form, is applied over dry plaster.

Encaustic — Beeswax, heated before application to the ground; a surprisingly permanent medium, encaustic portraits on wood panels have survived intact from the second century A.D. difficult to master, encaustic is rarely used today.

Casein (Kay *seen*) — Animal protein (often milk or cheese) or a synthetic glue with similar properties. Most tempera paints sold for children's use are actually casein. Casein paints are too brittle for application on canvas and thus are limited to rigid backings such as wood. They are similar to goache, though somewhat less elegant.

Acrylics — Water-soluble acrylic plastic. Shares some of the characteristics of oil paints but dries more quickly. Colors are somewhat duller than oils but probably as permanent.

Mosaics — A method of "dry" painting in which chips of colored stone called **tesserae** (*Tessa* ray) are set into an adhesive grout. The ancient Romans admired both the durability and fussy craftsmanship of this medium.

Sand Painting — A Native American form of ritual painting which involves carefully trickling colored sand onto a flat surface. In genuine ritual paintings, the images are erased (in reverse order) at the conclusion of the ritual.

The **air brush** a precision spray-painting tool formerly used to correct defects in photographs has come into wider usage among fine artists in recent years. Its characteristic slick surface finishes and subtle color transitions easily reproduce complex effects like reflections on curved chrome surfaces. Flexible palette knives with dull blades, intended for mixing paint or are sometimes used like trowels when a thick **impasto** surface texture is desired. Rembrandt occasionally worked his portraits with the butt end of his wooden

Figure 2.15 PHOTOREALISM. Michigan Avenue with view of the Art Institute of Chicago (1984) by Richard Estes. Oil paint on canvas, 36" X 48". (Art Institute of Chicago, Gift of the Capital Campaign Fund)

Figure 2.16 PAINTERLY ABSTRACTION. The Dance (1909) by Henri Matisse. Highly stylized nudes portrayed in an abstracted natural setting. (Museum of Modern Art, NY. Gift of Nelson A. Rockefeller in honor of Alfred H. Barr, Jr.)

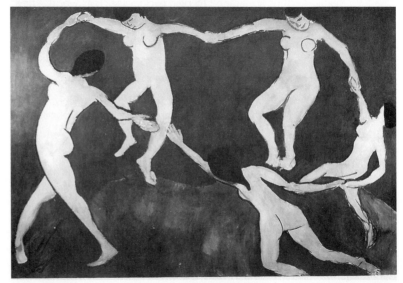

paintbrush, scraping the painted surface to produce *graffito* (scratch) effects.

In addition to the preceding categories, paintings are also grouped according to their subject matter and style of painting. *Photorealist painting,* a **representational style,** aims at producing a nearly photographic likeness of its subject. (See Figure 2.15.) *Color field painting,* a type of **abstraction,** focuses upon broad, flat expanses of color. *Hard-edge abstractions* have the cool, slick look of architectural geometry, whereas *painterly abstractions* have a manifestly handmade or **maniform** look to them. (See Figure 2.16.) Additional background information on subjects and styles of painting is presented in Chapter 5, "Outline History of Art."

Printmaking techniques

Printmaking techniques are sometimes also referred to as **graphics** or the **graphic arts,** not to be confused with *graphic design,* which involves the production of layouts and designs for the advertising industry. (Remember: the graphic *arts* are fine *arts.*)

In most types of printmaking, the image is transferred onto a smooth surface called a **matrix** (a wood block, metal plate, or limestone slab) in such a way that it can be inked and printed in large but limited quantities called **editions.** During the eighteenth and nineteenth centuries, inexpensive etchings, engravings, and lithographs became a sort of everyman's art form. Even persons of modest income, who might never be able to afford an original painting or sculpture, could afford to own a print produced by the hand of a master. This is still true today.

Prints are signed and dated by the artist, and numbered using a fraction-like system which specifies both the number of that particular print (upper number) and the total number of prints in the edition (lower number). *Artist's proofs* are trial runs made prior to the start of the edition. Since the image quality breaks down slightly with every print, lower-numbered prints are valued more highly than the higher-numbered ones. At the conclusion of the edition, the image is canceled with cross-out lines by the artist to prevent later unauthorized restriking of prints. A typical edition pulled from a single copper plate may number as many as 500 or more, although smaller editions of 250 are just as common. Sometimes an artist will rework a plate after running a short edition of 50 or so to produce a *second state* of the print. States other than

the first are always specified as such in the title of the print. Third, fourth, fifth, and even higher states are quite possible, though rarely encountered.

Printmaking can be subdivided into four basic processes: **relief, intaglio,** (in *tah* lee oh), **lithography,** and **serigraphy.** (Photographic reproduction processes are dealt with in a separate section.) It should be noted at the outset that, unlike drawing inks, most printing inks are stiff, heavy, semisolids more akin to tar or axle grease than water. Lithographic and relief printing inks are available in tubes in a limited range of colors; other varieties come in metal tins. This latter kind is handled with a flexible spatula, paint scraper, or putty knife.

The most primitive way to copy a relief image is by placing a piece of paper over a raised surface and rubbing the paper's backside with a pencil or a piece of colored chalk. In the resulting image, called a **rubbing,** the raised surfaces are darkened while the recessed surfaces remain untouched. Max Ernst (1891–1976) used a variation on this technique, called *frottage,* to capture the latent images present in wood grain and other rough surfaces, which he then combined into images of fanciful beasts in his print series *Histoire Naturelle.* (See Figure 2.17.)

In the relief printing technique called woodcut, the matrix is the flat side of a wooden plank. In a **wood engraving,** the endgrain of wood planks glued together is used as the printing surface. The wood is cut away with gouges (a **burin** or **graver** is used in a wood engraving) leaving raised areas for the dark parts of the image. The block is then inked with a roller, which resembles a small rubber

Figure 2.17 FROTTAGE. Stallion and Bride of the Wind, #33 *from* Histoire Naturelle (1926) by Max Ernst. (Photo: Museum of Modern Art)

Figure 2.18 WOODCUT. Death Claims the Peddler (1523–26), by Hans Holbein. Between 1347 and 1350 one third of the population of Europe succumbed to the Black Death (bubonic plague). Illustrations such as this, often showing skeletons and people dancing together in the streets, were common. The small lion accompanying the traveler symbolizes courage and alludes to the resurrection of the dead. (Illustration: Dover Pictorial Archives)

paint roller, and a sheet of paper is laid face down upon the inked block. The back surface of the paper is then rubbed (a large spoon works well) in order to transfer the ink to the paper. The print is peeled off, and the block is wiped clean and reinked for the next print. (See Figure 2.18.)

Woodcuts are among the oldest forms of printmaking. Their image quality can range widely, from a rugged primitive look when the grain structure is very pronounced to precise images of great character and subtlety. Multiple-color woodcuts require multiple printing blocks, one for each separate color. The blocks must be keyed with reference marks to ensure that the successive printings line up or register properly. All woodcuts and wood engravings reverse the image drawn upon their block. This reversed image, produced by all true fine art graphic techniques, is called an **autographic replica.**

Another simple relief technique involves cutting into a soft lineoleum block that has been bonded to a wooden backing. These **lineoleum cuts,** although easier to make than woodcuts, are suitable only for rough, high contrast images. Because of the severe limitations on image quality and edition size imposed by their material, lino cuts are held in lower esteem than woodcuts and used primarily as an introductory demonstration technique for students.

Lithography (from the Greek word *lithos,* meaning "stone") is, as its name implies, a method of printing an image from a thick slab of grayish Bavarian limestone or slate. It is called a **planographic process** because the printing surface remains a flat plane, in contrast to the **relief** (raised), **intaglio** (incised), and stencil-like **serigraphic** processes of printmaking. Lithography has been used as a fine art medium as well as a commercial printing method since its accidental invention in the last years of the eighteenth century by a German playwright, Aloys Senefelder, who was searching for an inexpensive way to duplicate his writings. The hand-colored lithographs produced by the now defunct printing firm of Currier

Figure 2.19 LITHOGRAPH. Siren Coming Out of the Waves Clothed in Flames *(1883) by Odilon Redon. Lithograph (plate IV from* Les Origines, Mellerio 48 *1883). (Art Institute of Chicago, Charles Stickney Collection)*

and Ives during the mid to late 1800s (advertisements of the time erroneously call them "colored engravings") cover a wide range of subject matter and are still popular as illustrations on Christmas cards. The Currier and Ives prints included reproductions of popular paintings, political cartoons, and original American genre scenes all at prices ranging from a few cents to no more than three dollars. Lithographs have a distinctive, slightly grainy appearance that resembles a shaded pencil drawing on medium-rough paper. (See Figure 2.19.)

The technique of lithography is fairly simple. Briefly, an image is drawn directly upon a prepared limestone slab with a grease crayon, then treated with a fixative solution of nitric acid and gum arabic to prevent accidental smearing. The stone's surface is then moistened with water; the marks of the grease crayon repel the

water, causing them to remain dry. Then, an oily lithography ink is rolled onto the stone with a large leather roller (which looks very much like a chef's rolling pin). The oily ink adheres to the greasy areas (the drawn image) and is repelled by the water-soaked areas (the empty spaces). A sheet of paper is laid over the inked stone, and both are handcranked through a mechanical press which transfers the image, in reverse, onto the paper. (In **photolithography,** a sensitized metal plate is substituted for the litho stone.) At the end of the edition, the drawing is then erased from the stone by hand grinding the stone's surface with fine sand, a process called *graining,* which returns the stone to a velvety smoothness. The litho stone's printing surface must never be touched with the fingers since even "clean" fingerprints deposit oils that can mar the surface and show up in the printed image.

Because the lithographic process is, aside from the original drawing, a strictly mechanical one, many artists hire professional lithographers to carry out the more laborious aspects of the process once a successful specimen print, called an *artist's proof,* has been "pulled." Many artists choose to preserve the spirit of the process by printing on colored paper that duplicates the greyish-tan hue of the lithography stone.

A simpler planographic process called **monotype** is basically a one-print edition—a one-shot deal—in which an image is painted onto a copper or zinc plate in ink, or made by selectively removing ink from a coated printing plate to produce the white portions of the image. When a sheet of paper is laid upon the inked plate and run through a press, the image is transferred to the paper. Surprisingly delicate effects can be generated by wiping away the ink with the fingertips, the point of a pencil, or by laying shreds of cheesecloth, thread, or other materials upon the plate prior to printing. Another well-known monotype technique involves sliding an image to be copied under a sheet of glass, then tracing the image upon the glass in printer's ink. A sheet of paper, hinged to the glass with tape, is then lowered onto the inked surface and rubbed with a spoon to transfer the image. In either case the ink image is not permanently fixed to the printing matrix and, therefore, is transferred completely to the paper during the act of printing, leaving no reusable traces behind on the surface of the matrix.

A **monoprint** (not to be confused with the *monotype*) is also a one-of-a-kind print which has been made unique by the application of handcoloring, or some other alterations or additions to the image

after it was pulled from a prepared matrix. In a monoprint, the basic image remains preserved in the matrix after printing as a simple etching, engraving, and so forth. (As a little memory aid to help keep the two straight, think of this: mono*types*, like *typos*, are always erased.)

The **intaglio processes** (a technical advancement over the less refined process of relief printing) all involve cutting or incising an image into a metal plate, usually 1/16 inch to 1/32 inch in thickness. Copper is the traditional choice for the intaglio matrix because it is easy to cut and holds up well through large editions, but zinc (a soft silver-white metal) is often substituted when economy is a consideration. The edges of the plate must be filed smooth (a large radius added) so that the thick felt blankets which cover the plate when it is run through the press will not be damaged by any sharp edges. In principle, all intaglio processes are the same. Ink is forced down into the lines or tiny cavities cut, either directly or through the etching action of acids, into the surface of a metal plate. When a moistened piece of paper is set on top of the plate and run through the press, the pressure forces the paper fibers down into the incised lines or cavities where they pick up the ink, causing the image to be transferred to the paper.

The principal intaglio processes are: **drypoint, engraving, etching, aquatint, soft-ground etching,** and **sugar-lift** (or **lift-ground**) **etching.**

An **engraving** is produced using a sharp metal instrument called a graver or burin whose blade, seen in cross section, is diamond-shaped. (See Figure 2.20.) The burin's steel blade is held between the thumb and fingers, close to the pont, while the mushroom-shaped wooden handle rests against the heel of the hand. The engraver must glide the burin across the surface of the plate with a light touch to avoid gouging the point into the soft metal. As the burin cuts, it raises a curly metal burr which is removed by rubbing the plate with a scraper's sharp three-sided blade. Ink is then applied to the plate with a cylindrical dauber made of thick, tightly rolled fabric. The bottom part of the dauber is charged with ink; then the dauber, held in the fist, inked side down, is slowly mashed down onto the plate with a twisting motion so that the ink is forced down into the engraved lines. Excess ink is wiped from the surface of the plate, which is then set onto the press bed, covered with a sheet of moistened paper (and sometimes a second sheet to protect the felt blankets from ink spotting), then cranked

Figure 2.20 *Engraving tools: (from top) gravers or burins, correct grip, resin bag, etching needle, scraper. (Heck)*

through the hand-operated press. The intaglio processes all emphasize line. Values are added to the image using **hatched lines** or **crosshatching,** as in the images engraved on dollar bills.

The technique of **drypoint** is very similar to that of engraving except the tool is an etching needle, which looks like a sharpened steel pencil. The etching needle, wielded like a drawing pen, raises a slight burr along one edge of the incised line as it cuts into the metal. Because of this raised edge, drypoint lines print with a characteristic slight blur that imparts a kind of softness (like soft-focus photography) to the image in contrast to the crisp, sharp lines typical of an engraving. The soft, delicate drypoint line, however, cannot be preserved through large editions due to the fact that the burr eventually breaks down under the mechanical stress of repeated printings. It can then be removed with a scraper, after which the print will, alas, resemble just another engraving. Graphic artists frequently combine etching and drypoint techniques on the same plate.

The **mezzotint** (a variation on the drypoint technique) allows for subtle and painterly transitions of value. In the days before the invention of photography, the best black-and-white reproductions of famous paintings were handmade mezzotint copies, the best of which are virtually indistinguishable from black-and-white photos.

Roulette

To produce a mezzotint, the entire plate surface is first uniformly pitted using a spiked-wheel called a *roulette* or a tool with a curved surface called a *rocker.* A **burnishing tool** is then used to smooth out the pits for the lighter areas of the image; the more they are smoothed, the brighter they will print. As you might suspect from this brief description, the mezzotint process is a tedious and labor-intensive one; consequently, it is seldom practiced today. Mezzotint images are, nevertheless, unrivaled for their subtle value effects and moody sense of atmosphere.

Rocker

Etching is a refinement of the engraving technique. Instead of cutting directly into the plate, as in an engraving, the plate is first coated with a thin layer of melted wax or resin, sometimes blackened with a candle flame. To produce the image in the plate, the printmaker draws upon this prepared surface, lightly scraping away the protective coating with the tip of an etching needle. The entire plate is then submerged in a shallow pan of dilute acid solution called **mordant** (four parts nitric to six parts water). The acid eats away at the unprotected areas of the plate, etching lines into the surface of the copper or zinc. The longer the plate is left in

the acid bath, the deeper the lines become; and the deeper they become, the darker they will print. After several minutes the plate is removed and fixed in a clean water bath to halt the etching process. The plate is then cleaned with solvents, inked, and printed.

Etchings allow the artist a wide range of freedom and control. Lines can be drawn more lightly and easily in etching than in most other techniques, and their depth and boldness can be regulated by the amount of time the plate is left submerged in the mordant bath. The delicacy of certain specific lines can even be preserved by brushing an acid-proof resist over them (to prevent further etching), then reimmersing the plate in the mordant bath to deepen the unprotected lines. Experience is the only reliable guide for such sophisticated plate techniques. Many artists make a small trial plate as a reference before attempting a large, complex composition.

Soft-ground etching is a process that allows an artist to easily transfer a drawing onto a printing plate. The surface of the plate is first covered with a ground mixture containing *tallow,* a fatty waxlike substance formerly used in candle making. The drawing (on paper) is then laid directly on top of this ground and the image traced over with a sharp pencil or ballpoint pen. When the tracing is lifted, the soft tallow ground sticks to the paper where the lines have been

Figure 2.21 A *FLAT-BED ETCHING PRESS* of the wheel-and-spindle variety. The roller is about 18 inches wide. (Illustration: Dover Pictorial Archives)

traced, leaving those areas of the plate exposed. The plate is then etched in a mordant bath, cleaned, inked, and printed. The resulting lines have a soft crayonlike appearance well suited to landscapes and figural compositions.

Aquatint allows the printmaker to reproduce smooth gradations of value in the printed image. Unlike the values in an etching, which must be generated using linear techniques like hatching and crosshatching, the values in an aquatint more closely resemble the drawing technique of fine **stippling** (see Chapter 3). To produce this effect, a small cloth bag of powdered resin is shaken over the plate until the plate's metallic sheen is just covered by a layer of the yellowish resin dust. The particles of resin dust are then melted, fixing them into place, by setting the plate directly onto a hotplate for a few seconds. As soon as the resin turns a carmel color indicating it has liquified, the copper plate is removed from the heat and allowed to cool. At this point the metal surface of the matrix would appear under magnification to be evenly covered with tiny spots of resin. If the plate were now submerged in the dilute acid solution for a short time, an even grey tone would be produced over the entire matrix. Areas which the artist wishes to leave white are to be brushed with an acid resist before the plate is placed into the mordant bath. The areas not covered by the resist are pitted by exposure to the acid and print as darker values. A graduated value scale can be produced easily by periodically "stopping out" the lighter value areas with an acid resist, and allowing the darker areas to receive successively longer exposure to the etching action of the acid.

The technique of **sugar-lift etching,** which is similar to aquatint, duplicates the effect of a brush-and-ink drawing. First, the image is brushed onto the surface of a resin-dusted metal plate using a thick sugar-water ink. After the sugar-water image has dried, the entire surface of the plate is coated with a liquid hard ground. The plate is then immersed in warm water, causing the sugar-painted areas to dissolve, thus lifting off the protective ground at those points. The exposed plate surface is then etched in a mordant bath, inked, and printed.

An unusual inkless print, which produces a bas-relief effect on the surface of the paper, can be made by running an inkless metal or stiff board matrix through the printing press. This technique called **embossed printing** (or **gauffrage** by purists) is technically a variation on the intaglio print.

Serigraphic prints or **silkscreen prints** are basically stencils printed through a fine-mesh sieve. First, a piece of fine-mesh silk is stretched over a wooden frame and the image to be printed is traced upon this screen. The areas in the drawing that are to remain white in the final print are painted with lacquer, shellac, or a similar resist. A thin, synthetic film, available in dry sheets, is often substituted for liquid resist. To print an image, the silkscreen stencil is placed on top of a piece of paper or fabric, and a quantity of semiliquid ink is forced through the uncoated areas of silk mesh with a wide, rubber-edged squeegee. Several variations on the basic process have been developed since the introduction of silkscreen printing at the New York World's Fair in 1939. It remains one of the most widely used commercial printing processes, since it works equally well on paper, wood, fabric, or metal. The term *serigraph* is used to discriminate the fine art application of this technique, while *silkscreen* refers to its use as a commercial printing process.

Although computer graphics probably enjoy their greatest popularity in the areas of technical illustration and commercial art, they nevertheless deserve mention as an emerging technique/art form unique to the last decades of the twentieth century. In general, computer-generated images are either of the analog type (produced by manipulating a keyboard mouse, or by drawing with an electronic pen directly on the CRT screen) or of the digital type (produced by entering equations which specify an image's mathematical parameters into an image-generating software program).

Computer graphics have found acceptance in the motion-picture and television industry where they are often employed for special-effects shots in place of the older pencil-and-brush animation techniques. Further innovations in computing hardware and software will no doubt result in higher-quality computer images, but the success of any artistic enterprise, it should be remembered, is ultimately dependent not only upon the sophistication of the tools, but upon the insight, creativity, and technical skills of the artists who wield them.

Concerning reproductions

Mass-produced photographic copies of artwork called **reproductions** are considered a separate category from true art prints. In the case of reproductions the artist is seldom, if ever, consulted at any point during the process. The most frequently

encountered color reproductions occur as plates in art books, as posters, or as art prints sold in museum shops.

When selecting art books, examine the reproductions closely. Higher-quality color reproductions are printed separately on quality papers, then pasted onto blank pages in the text. Fine reproductions, like fine wines, carry a high price tag; there is simply no way to cut cost without sacrificing quality. Even in the best reproductions, however, the discerning eye may detect some slight variation in hues between two reproductions of the same original. The ideal solution would be to compare several of these reproductions against the original work, then select the best copy from among them. When this is not possible, one can memorize a particular passage—an especially striking area—in the original painting, then compare it with the same area in the reproduction. The reproduction's quality, or lack of it, will be immediately apparent.

A *catalogue raisonné* is a book, usually illustrated with reproductions, devoted exclusively to a single artist's lifework. The true *catalogue raisonné* lists every work completed by the artist (if made posthumously), along with a detailed physical description of each piece and, perhaps, a commentary on the more important works. Such catalogs are essential tools for the serious art collector, historian, and appraiser, and are usually only found in specialized museum libraries or private collections.

Photography, film making, and videotape techniques

Perhaps no art forms have had more impact on popular culture than photography and its offspring, the motion picture. Long before the development of photography in the early nineteenth century, it was known that certain chemical emulsions such as silver nitrate and some cyanide compounds react by changing color when exposed to light. Similarly, the idea of using a lens to project an image upon a darkened screen, which is the principle behind the *camera obscura* (literally "darkened room"), dates back to at least the seventeenth century. It was not until 1829, however, that two Frenchmen, Louis J. M. Daguerre (a former landscape painter) and Joseph-Nicéphore Niepce, working separately on the same idea, combined these two concepts to produce the first practical photographic technique.

These earliest photographs were made on highly polished

metal or glass plates and required extremely long exposure times—
sometimes as long as several hours. Moreover, the chemicals used
in **developing** and **fixing** these fleeting images were poisonous
compounds of lead, silver, and mercury, which made early
photography one of the more hazardous professions of the 1800s.
Despite these drawbacks, photography attracted the attention of
visual artists to such a degree that some painters feared that
Daguerre's new invention would eventually render the craft of
painting obsolete. (See Figure 2.22.)

Figure 2.22
*DAGUERREOTYPE. The Artist's
Studio (c. 1837) by L. J. M.
Daguerre. Early photo
processes required long
exposure times to capture
an image, making still life
a popular choice of subject
matter. (Granger Photo
Archives)*

Because of the very long exposure times required, the earliest
photographs were generally static images: still lifes, interior scenes,
and images of architecture. In 1839, William Henry Fox Talbot, an
English chemist, developed the photographic negative, which
allowed multiple images to be produced from a single original glass
plate. The **calotype,** a photographic print on paper and the
forerunner of our own snapshots, followed soon afterward. Prior to
Fox Talbot's invention, the **daguerreotype** process produced only a
single photographic impression, a tarnishlike image on a shiny silver
plate. A later development called **rotogravure,** widely used by

newspapers at the end of the nineteenth century, involved printing copies of a photographic image from a curved copper cylinder mounted on a rotary press.

Contemporary photographic techniques take full advantage of the long history of technical developments in film emulsions, optics, and electronics. The basic principle, however, remains the same: An image is projected by a lens upon a photosensitive film emulsion which is then developed and fixed. The speed of the photographic film, expressed as its ISO number (formerly known as its ASA rating), is a measure of the film's sensitivity to light. The faster a film "grabs" an image, the higher its ISO number. Kodachrome 64, still a popular film for outdoor slide photography, has an ISO of 64 (relatively slow). In contrast, *TriX Pan,* a black-and-white film once widely used by news photographers and photojournalists, has an ISO rating of 400 (fast), making it sensitive enough to use at night without a flash or with extremely short exposure times. Some commercial films have speeds as high as ISO 1200, sensitive enough to shoot a scene lit by dim candlelight. Unfortunately, the faster film stocks tend to have a coarser, grainy-looking emulsion which some photographers find aesthetically objectionable. It is, therefore, considered a rule of thumb to use the slowest film available for your particular shooting conditions. Special ungraded ultrafast film stocks have also been produced for military and scientific use, such as astronomical photographs shot from the prime focus of a large telescope.

Almost all serious photographers develop and print their own film. In fact, most professional photographers print only a small percentage of the negatives they actually shoot. The standard practice is to cut the developed negatives into strips five or six images long, then lay these cut negative strips side by side on a sheet of photographic paper and expose them to light. The resulting **contact sheet** catalogs in miniature all the images taken on a roll of film, which can then be examined and compared by the photographer with a magnifying lens. The best images are selected for printing on an enlarger, an optical device that projects the negative image down onto a sheet of photosensitive paper. Most serious photographers amass considerable personal libraries of their unused negatives over the years.

Printing negatives is usually a fairly uncomplicated process but sometimes special steps must be taken in the darkroom to achieve a good, balanced print. Overexposed areas can be improved by

dodging, which involves blocking out some of the light during the enlargement process with a tool that looks something like a flat, black spoon. Similarly, underexposed areas can be improved by **burning,** allowing more light to reach a certain part of the image by letting it shine through a hole in a cardboard or plastic mask. Special processing can be used to push film beyond its usual limits in order to save an important but badly miscalculated exposure. Printing photos has become its own specialized craft. Some photographers have been known to purposely scatter a few specks of dust or a few tiny hairs upon their prints, or stop-out a corner to make it look bent, in order to keep their images from looking too perfect, too precious. As you can see from even this short description, most of the photographer's work occurs *after* the camera shot has been taken.

The versatility of the photographic image has allowed it to function in a variety of art contexts, such as elements in sculptural montages, as "documents" of actions or gestures, as images juxtaposed with the objects they represent in conceptual works, or simply as objects and images manipulated in their own right. Photographs, however, always seem somehow to appear to their best advantage when collected in books, rather than hung on gallery walls. And this may be due, in part, to the implicit journalistic quality of the photographic image, and in part, due to the simple cultural conditioning of seeing them appear so frequently within the context of illustration. Postmodern photographers, like British painter/photographer David Hockney, have challenged this aspect of the photographic image by assembling photographs shot in time sequence, then cut apart and reassembled (somewhat like a cubist collage). In this manner arrangements are produced which are simultaneously intriguing as objects in themselves and also as conceptual ruminations on the process of how one's attention is focused during the act of seeing. Such works which force photographic images out of their usual context as simple aesthetic or journalistic documents offer promise of further developments.

Film making, also called **motion-picture cinematography,** is undoubtedly the most popular art form of the twentieth century. (The term *movies* is a colloquialism seldom used among professional film makers, who prefer the word *film.*) Early experiments with images projected on a screen in rapid sequence were performed as far back as the 1870s. Eadweard Muybridge, an early master of sequence photography, used multiple cameras triggered in sequence

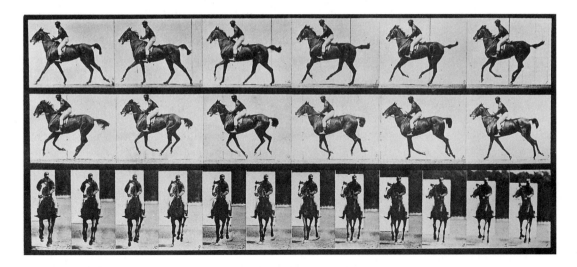

to capture fleeting movements too quick for the naked eye. (See Figure 2.23.) But while Muybridge's *zoogyroscope* device provided interesting demonstrations of animal and human motion, it did little to suggest the narrative possibilities inherent in the new medium of motion-picture film. In 1894, the American inventive genius Thomas A. Edison recorded his chief research assistant Fred Ott on motion-picture film in the act of sneezing. Titled simply *The Sneeze,* Edison's little movie was the forerunner of many such short-subject films, usually one or two reels in length, depicting common or not-so-common actions suddenly transformed into marvels by the motion-picture camera.

Figure 2.23 Animal Locomotion (1887) *photographic sequence by Eadweard Muybridge. Muybridge was once called upon to settle a bet as to whether racehorses ever had all four hoofs off the ground at the same time. With his array of sequential cameras, Muybridge proved that they did. (Courtesy Amon Carter Museum, Fort Worth, Texas)*

Although all early films were shot in black and white, particularly dramatic scenes were sometimes projected through a colored gelatin filter (red, blue, or gold) to heighten their emotional effect. Before the invention of sound recording, projected films were typically accompanied by a solitary piano player, although the director D. W. Griffith once hired the entire Los Angeles Philharmonic orchestra to serve as accompaniment for one of his big screen epics. These early movie houses, called nickelodeons (nickel admission), were considered rather low-brow places—not much better than burlesque houses—and lacked the amenities of today's movie theaters.

The first narrative motion pictures were essentially stage plays enacted in front of a static camera that sat like a mesmerized spectator at front row, center. Later "set pictures," shot mainly indoors on sound stages furnished with props and painted backdrops, provided a transitional phase between the early stage-play

films and those shot entirely on location. D. W. Griffith's *Birth of a Nation* (1915), a controversial silent epic that chronicles life in the South during the periods immediately before and after the Civil War, used cameras mounted on moving vehicles to capture the panoramic sweep and intensity of the film's carefully staged battle scene. Griffith reportedly spent $50,000 (equivalent to nearly half a million dollars today) on the staging of that battle, whose action had to be directed by waving colored flags since a megaphone could not be heard over the din of the mock fighting. Multiple simultaneous cameras, whose different perspectives were later recombined in the editing room (called narrative editing), provided the conceptual basis for the three-camera technique of filming still used in most commercial films and television programs.

Later technical innovations included a **sound track** synchronized with the film's action (first presented commercially in the Warner Bros. film *Don Juan* (1926) with John Barrymore), and in the 1930s the first full-length color motion pictures.

Almost all popular commercial films are produced at one of the three film capitals (Hollywood, New York, or London). The production of a commercial film involves an enormous expenditure of labor-hours as well as staggering amounts of money—the average cost is currently over $15 million. Production usually starts with a screenplay (often derived from a preexisting novel or short story) which includes not only the actors' dialog lines, but general stage directions and instructions for camera movement as well. An illustrated storyboard, which resembles a comic strip, is drawn to enable the director to visualize the shots and the sequence in which they will occur. Once filming has begun, progress on the set is reviewed each morning with a screening of the **dailies** (the previous day's shooting). After all the scenes have been filmed—they are seldom shot in narrative sequence—the raw takes are then edited together and music, titles, and special effects are dubbed in during the **postproduction** phase. A typical Hollywood film may be shot in a few months (sometimes a few weeks) but the postproduction, wherein the edited film actually comes together, takes much longer. In fact, a year or more is not unusual.

Most directors regard editing as the single most important aspect of good film making. One visually engaging technique of film editing, introduced by Sergei Eisenstein in his film *Potemkin* (1925), was inspired by the cubist technique of combining several different viewpoints in the same image. In one memorable scene

of Eisenstein's *Potemkin,* whose plot involves a mutiny on board a Russian warship on the eve of the Soviet Revolution, Eisenstein shows us a disgusted sailor smashing a ship's dinner plate simultaneously seen from two different camera angles. Eisenstein's technique of rapidly combining views from different cameras gives viewers an "instant replay" of the film's most salient actions, thus underscoring their visual power and significance. Eisenstein's so-called Russian style of editing is still widely used today.

While the **director** is in charge of the film as a captain is in charge of the ship, much of the actual production work is delegated to technicians; in fact, it is said that during his entire directing career Alfred Hitchcock never once looked through the viewfinder of a camera. He simply told his cinematographer (the person responsible for setting up the camera shots) exactly what he wanted, then supervised the actors' performances from the vantage point of his director's chair; a small army of highly skilled technicians and assistants took care of the rest. Thus, we see that filmmaking, unlike most traditional artforms, is essentially a collaborative endeavor. This collaborative aspect sometimes presents problems, particularly when the involvement of untalented producers and coproducers in the decision-making process results in a kind of "aesthetics by committee" which undercuts the director's artistic authority. It is perhaps no accident that the most successful directors have also been extremely forceful personalities who either managed to charm their producers into submission, or simply did as they pleased regardless of what the studio's board of directors told them. Film making, in spite of its problems, remains the most vital art form. The often brilliant Orson Welles (director of *Citizen Kane*) once compared directing a film to playing with "the biggest electric train set ever made."

The immediacy and verisimilitude of motion pictures have been greatly enhanced through various special projection techniques, such as the wide-screen Cinemascope® projection system (which uses three overlapping projectors), and the more recent Omnimax® (dome projection) and Imax® (ultralarge screen) systems. Both of these systems employ a special high-resolution film stock, where each individual frame is the size of a standard postcard. The associated hardware of such systems is complex and often ingenious. Anamorphic lenses, which compress an image in one dimension, allow wide-screen images to be squeezed onto standard 35-mm film. The compressed image is then unsqueezed by

another anamorphic lens during projection onto a viewing screen. (This uncorrected anamorphic effect is sometimes visible when films intended for wide-screen distribution are shown on television or projected with regular spherical lenses. During the opening credits you may notice actors and scenery suddenly becoming elongated, like figures in an El Greco painting, as the titles and credits roll by.)

Unfortunately motion-picture films are always cropped somewhat when shown on television because the TV screen's aspect ratio (i.e., screen proportions) is narrower than the projected film image. Since the introduction of wide-screen TV systems, many films are now available on videotape in letterbox format (full size with black masks at the top and bottom, like looking through a letterbox) which preserves their true proportions.

Videotape, the most immediate and cost-effective medium for the recording and playback of sight/sound images, was first developed by the Ampex Corporation in 1955. Videotape recording is in principle identical to the process of recording sound on tape. In videotape, the tape is a thin, polyester film (about 1/50-mm thick) which has been coated with a layer of ferric oxide particles suspended in a binder, much like the pigments in paint. The alignment of the needle-shaped iron oxide particles on the tape can be changed by passing them through an electromagnetic field, which encodes a signal onto the tape. In the playback phase, a separate playback head reads these signals from the ferric oxide particles and reconstitutes the images they represent by aiming streams of electrons at a phosphor-coated television screen. In recording and playback, the drum-shaped head sweeps across the surface of the videotape at an angle, rather than straight across, to increase the amount of data storage space available for each encoding line.

There are six sizes of videotape in use today, although most persons are familiar with only two or three of these. The oldest type called Quadruplex (or simply Quad), uses 2-inch-wide tape on an open reel. Though it served as the broadcast industry standard for many years, Quadruplex is rapidly being replaced by 1-inch (25-mm) cassette-loaded videotape, which is used by most commercial television broadcasters. The 3/4-inch format, also called U-matic (manufactured by Sony) is an oversized cassette used in semiprofessional applications such as community-based cable television programs, high-fidelity documentation in medicine and

industry, and educational programs. The ubiquitous minicams employed by TV news reporters also use 3/4-inch tape. The most well-known videotape format is the 1/2-inch width used by two incompatible systems, both designed for home use: VHS developed by the Matsushita Corporation, and Beta developed by Sony. Although the picture quality of the original Beta systems were superior to their VHS counterparts, the less expensive VHS system has become so popular that it has all but driven the Beta machines and tapes into extinction. Even Sony now manufactures 1/2-inch VHS cassettes for use on its competitor's machines. Further technical advances in tape fabrication and encoding have made palm-sized cameras which use 8-mm videocassettes (the smallest size now commercially available) popular for personal documentation use.

In addition to these differences in tape width and cassette size, there are also three different broadcast standards for the color television signal, each of which is incompatible with the other two. In the United States, NTSC (National Television Standards Committee) is the system used. The PAL system, which uses a different subcarrier frequency, is the standard in Britain and throughout much of Europe, while SECAM is used in France. Tourists who purchase prerecorded videocassettes while on holiday in a foreign country often find them unplayable on their home VCRs due to these different broadcast standards. Programs produced by the BBC in London must be electronically translated to NTSC standard before they can be broadcast on American television, and vice versa.

Unlike film editing, videotape editing is done entirely with electronics. The typical editing suite combines two or more videotape machines linked in a master-slave configuration along with a color processor (which adjusts color settings) and an image enhancer (which sharpens contours and textures). The French word *montage*, suggesting a heaping up of images, is television's counterpart of the collage technique. Television news and sports programs often feature a montage of images in their opening titles.

While the content of commercial television programs has been rightly criticized upon occasion, television has proven itself to be a powerful communications tool and an effective means of transmitting cultural ideas and values. Both film and television are likely to remain major cultural and aesthetic forces throughout the years to come.

Architecture

Architecture has a twofold nature as both a means of aesthetic expression and a noble craft which produces structures of immediate practical value. As such, architecture is often regarded as one of the *practical* or *applied arts,* as distinguished from the *fine arts,* whose aims and purposes remain purely aesthetic and nonutilitarian. To hold too rigorously to this distinction, however, would unfairly undercut the significance of architecture as a recognized realm of aesthetic discourse and would also overlook the sometimes subtle and profound influences that architecture has exerted upon painting and sculptural styles.

The history of architecture closely parallels the history of art, so closely in fact that architecture can be studied as another material expression of the same stylistic and aesthetic principles embodied in the paintings and sculpture of virtually any era. The fifteenth century's reawakened interest in the ancient cultures of Greece and Rome, for example, is as plainly evident in the spurious Greek columns and pediments with which Italian Renaissance architects adorned their palaces and banking houses, as it is in the sculptures and paintings of that time which borrowed their themes and subjects from salient episodes of Greek and Roman mythology. Similarly, the seventeenth-century taste for dramatic, action-filled compositions finds its analog in the rippling curtainlike Baroque facades where concave and convex surfaces meet and interact with such great dynamic complexity. In fact, throughout history many painters and sculptors like the Renaissance masters Brunelleschi, Michelangelo, and Leonardo da Vinci, to name only three, enjoyed considerable reknown in not only the fine arts of painting or sculpture, but in the realm of architectural design as well. Brunelleschi, who was originally trained as a goldsmith, even abandoned his sculptural work in midcareer to devote himself entirely to the pursuit of architecture.

But architecture is also a preeminently practical art; the architect must be as concerned with the soundness of the structure's engineering as well as the aesthetic integrity and "livability" of its overall design. Viewed from this perspective, the history of architecture can also be considered as a series of technical innovations and elegant solutions to specific technical or engineering problems. Sometimes these solutions are tied directly to the introduction of stronger, lighter, or more cost-effective building

materials, like the prefabricated glass and iron units from which Joseph Paxton erected his greenhouse-like Crystal Palace for the London Exhibition of 1851. In other instances, these solutions are prompted by the creative use of existing materials or techniques in new and more efficient ways, such as the ancient Romans' extensive use of the round arch—an ancient device also known to the ancient Egyptians, Etruscans, and Mycenaeans—as the modular basis for their domes, barrel vaults, and groin vaults.

From its very beginning, the history of architecture presents a history of forms developed around building techniques which are elaborated further during each successive era. Primitive tectonic forms, believed to be simple roofs erected upon standing poles, appear in the Paleolithic cave paintings at Lascaux (c. 15,000 B.C.) and may represent the earliest timber constructions. In later periods, we witness how the basic **post-and-lintel** systems used by the Egyptians and Greeks consisting of two upright members joined by a spanning lintel were gradually modified by the introduction of bricks. These modifications led to the development of the round **Roman arch** and the pointed **Gothic arch,** both of which allowed builders to widen spans by replacing the horizontal lintel with an array of curved bricks held in place by channeling their outward thrust into downward compression. More recently, we see how the introduction of new mass-produced materials of greater tensile and compression strength, such as modern steel I-beams and prestressed concrete, have allowed architects to create structures which **cantilever** (jut out while anchored at one end, like a diving board) in ways that few Renaissance architects could have envisioned.

If the history of architecture were nothing more than a string of technical innovations, it could be represented as an uncomplicated developmental sequence which, of course, it is not. Interests and styles shift suddenly, sometimes unexpectedly, backward and forward along the historical continuum. An excellent case in point is post-modernism's revival of the art deco styles of the 1920s and 1930s. This all serves to remind us that the history of architecture, like the history of art itself, does not move along a simple developmental vector from basic to more complex forms, but rather moves in response to the complex and varied cultural demands of each dynamic and ever-changing era.

The brief history of art presented in synopsis form in Chapter 5 strikes a balance between these two aspects of architecture—its

material and its immaterial forms—by focusing upon the principal architectural achievements which have also played a significant role in cultural life. An example of this is in the tomb styles of the ancient Egyptians, who seem to have lived their entire earthly lives with their gazes fixed upon eternity. The historical synopsis also includes, however, a discussion of some important technical innovations, such as the pinched Gothic arch and flying buttress. When used together, these building techniques allowed medieval architects to increase the height, width, and stability of their spanning vaults and simultaneously reduce the thickness of the stone walls, thereby evolving the grand stained-glass cathedrals which served as the focus for nearly all aspects of later medieval life.

Beyond meeting one of the most basic human needs, that of providing shelter from the elements, architecture has distinguished itself as a subtle and complex field of human endeavor that provides us with an opportunity to examine our notions of what is considered good design from a variety of perspectives. This is possible often with a purity of insight unobtainable through the allusive, illusive, and often elusive statements of painters and sculptors. The writings of the twentieth-century Swiss architect and designer called Le Corbusier (Charles Édouard Jeanneret-Gris), for instance, provide us with a treatise on fitting the living space to the dimensions and physical form of the human body. Le Corbusier's writings stand among the great pioneering works in the field of ergonomics and allow us to peer into the conceptual foundations of the Bauhaus school of design and associated art movements like De Stijl in much the same way that Clausewitz's *The Art of War* allows us to peer into the subtleties of thought underlying Napoleon's brilliant military campaigns.

More than a decade ago, I had occasion to present a paper at a conference in Cardiff, Wales on issues jointly related to art and science. I recall during one of the presentation sessions hearing a marvelous joint paper describing subjects' psychological responses to old and new architecture. The authors noted that their test subjects responded most favorably to buildings which blended traditional aspects with innovative features, but responded less favorably to structures which were either all traditional (which subjects perceived as too boring) or all avant-garde (which subjects perceived as too strange and threatening). Since then, that jewel-like observation has epitomized, for me, the role of the architect as artist, an individual who must straddle the boundary between the

familiar and the unfamiliar, while at the same time joining them in a physical dialectic which preserves the best aspects of each. After hearing this it should come as no surprise to learn that Frank Lloyd Wright, the veritable dean of American architecture during the early part of the twentieth century, was as successful at designing private homes—such as the Kaufmann House ("Falling Water") at Bear Run, Pennsylvania (1960)—as he was at carrying out his larger corporate commissions, such as the Guggenheim Museum of Art in New York (1959).

Architects have occasionally indulged their talents by producing models or sketches of projects which lie beyond the realm of feasibility. Such speculative projects as Wright's grandiose Mile-High Towers, designed to be erected upon the flat prairieland where they might cast a suitably long shadow, belong as much to the realm of conceptual art as the field of architecture. This fact has not gone unnoticed by sculptors. Charles Simond's (born 1945) miniature primitive villages of the 1970s and 1980s and Alice Aycock's (born 1946) full-scale architectonic structures are essentially forms of architecture reinterpreted purely as sculpture rather than as practical living spaces.

In such imaginary projects, as well as in architect's writings, are found perhaps the purest and most essential expressions of the idea of architect-as-artist, presented with all the mystic intensity of an ecstatic vision abstracted into their characteristically terse, pithy aphorisms: "Form follows function," "Less is more," and "God is in the details."

Chapter 3

The Formal Elements of Art and Design

Images as texts

To understand how works of art convey meaning, let us borrow a concept from anthropology, the idea of objects as cultural texts.[1] To an anthropologist, any handmade object can be read much like a book or document, providing that the reader knows how to interpret it. By looking at art objects as texts, we gain not only an understanding of the object's nature and purpose, but also learn something about the culture that produced it as well.

Ritual sand paintings produced by Navajo shamans as part of traditional healing ceremonies, for example, can be understood not only as aesthetically pleasing objects, but also as *cultural texts*. The colors and images of the sand paintings have predetermined symbolic meanings and must be drawn in a certain prescribed way in order for their healing magic to take effect. For the native participants in these rituals, who are already familiar with these symbols, the meaning of the paintings is evident. For an outside observer who knows nothing of their elaborate symbolism, the

[1]The idea of cultural artifacts as texts was first developed in the writings of the noted ethnologist *Clifford Geeretz.*

paintings may be misinterpreted merely as interesting designs which mingle strangely stylized figures and cryptic symbols. An observer who considers the sand paintings in this way will probably miss the subtle and implicit messages they convey about the tribe's respect for religious tradition (suggested by the strictly observed rules governing their creation), the tribe's belief in homeopathic magic (suggested by the intended magical use of the paintings), and the tribe's highly developed system of religious symbols (suggested by the representational content of the painting). All these implicit messages are contained within the text of the painting, if one considers all aspects of the work as equally important.

To illustrate my point further, let us consider the text of this rather cryptic illustration, found on the opening pages of a German manuscript from 1648. (See Figure 3.1.) What does this image mean? What is it supposed to represent?

Figure 3.1 *"My Glass Empties Quickly" (printer's motto from a German manuscript, 1648). (Illustration: Dover Pictorial Archives)*

To begin with, the skull and crossbones, perhaps one of the oldest symbols known to human culture, is readily identified as a symbol of death; it is sometimes referred to as a *memento mori* (literally, "Remember, death awaits"). The winged hourglass, a visual pun on the idea of time flying, probably alludes to the idea of how swiftly our days pass. The struggling tortoise upon which the hourglass rests, a strange symbol, may suggest how little ground can be covered in a lifetime, a restatement in visual form of the old adage "Life is short; art is long." The inscription on the plinth (translated) means "My glass empties quickly." Taken together, all these elements appear to present an admonition or gentle warning for us to get on with our business for there is little time remaining for us. By careful observation, it is possible to unravel the bizarre symbolic elements in this image and make some sense of them.

Thinking of artworks in this way, as texts which can be read, can be particularly useful when confronting unfamiliar or experimental art forms whose meaning is not always immediately clear. We also know, however, that not all paintings are intended to tell a story. Some artworks aim at a more **formalist** conception of aesthetics; that is, they are simply statements of good visual design. A friend of mine (now an accomplished painter) once told me that while he was a young student on a museum field trip, he attempted to unravel the hidden meaning in a nonrepresentational painting by considering the symbolic meaning of each individual color used by

the artist—red meaning violence, black meaning despair, white meaning purity, and so forth. Later, when he sought help from the instructor in formulating his interpretation, which had become an unintelligible jumble, the instructor patiently informed him that the painting was a design statement never intended to be taken so symbolically.

When we are confronted by difficult or perplexing artworks, the idea of regarding the work as a readable text can still be useful but must be applied on a subtler level. For instance, the lack of a definite up or down in Jackson Pollock's paintings is an evident, readable feature of its text. So is the painter's unusual technique, which emphasizes an acceptance of accidents as they spontaneously occur, making the artist seem more like a spectator who helps bring the work into being than a creator who exercises absolute control over his images. These insights, taken together, tell us something about Pollock and the era in which he worked, even though there is no story as such to be found in his abstract paintings. That is what is meant when people speak of the cultural text implicit in a work of art.

The formal elements defined

If we were to ask a chemist to show us a portrait of the universe as a scientist sees it, the chemist would probably present us with the following array of letters and numbers, which you might recognize as the Periodic Table of the Elements. (See Figure 3.2.) The chemist's portrait of the universe represented by the periodic table is

Figure 3.2 *The Periodic Table of Elements.*

THE PERIODIC TABLE OF ELEMENTS

1 H																	2 He
3 Li	4 Be											5 B	6 C	7 N	8 O	9 F	10 Ne
11 Na	12 Mg											13 Al	14 Si	15 P	16 S	17 Cl	18 Ar
19 K	20 Ca	21 Sc	22 Ti	23 V	24 Cr	25 Mn	26 Fe	27 Co	28 Ni	29 Cu	30 Zn	31 Ga	32 Ge	33 As	34 Se	35 Br	36 Kr
37 Rb	38 Sr	39 Y	40 Zr	41 Nb	42 Mo	43 Tc	44 Ru	45 Rh	46 Pd	47 Ag	48 Cd	49 In	50 Sn	51 Sb	52 Te	53 I	54 Xe
55 Cs	56 Ba	57 La	72 Hf	73 Ta	74 W	75 Re	76 Os	77 Ir	78 Pt	79 Au	80 Hg	81 Ti	82 Pb	83 Bi	84 Po	85 At	86 Rn
87 Fr	88 Ra	89 Ac	104 Unq	105 Unp	106 Unh	107 Ung	108 Smo	109 Lu	110 Cha	111	112	113	114	115	116	117	118

58 Ce	59 Pr	60 Nd	61 Pm	62 Sm	63 Eu	64 Gd	65 Tb	66 Dy	67 Ho	68 Er	69 Tm	70 Yb	71 Lu
90 Th	91 Pa	92 U	93 Np	94 Pu	95 Am	96 Cm	97 Bk	98 Cf	99 Es	100 Fm	101 Md	102 No	103 Lr

a highly **abstract** one reduced to its absolute, bare essentials. Yet, this portrait reveals in schematic form (like a simplified diagram) the essential chemical elements from which all other compounds are derived. It is, as far as we know, a complete and accurate representation of the known universe at the molecular level.

If we were to ask an artist to show us a representation of the essential elements of visual art, the result might look something like Figure 3.3.

The eight **formal elements** are the basic physical features that make up most works of art. And like the chemical elements of nature, the formal elements of art are interrelated in complex and subtle ways. Let us examine these basic formal elements in detail.

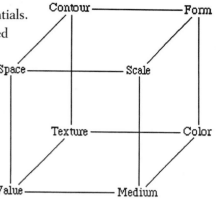

Figure 3.3 *The Formal Elements of Visual art.*

Form and medium

Form usually refers to the actual physical manifestation of the artwork, that is, whether it exists as a sculpture, a painting, a drawing, a gallery installation, an earthwork, a performance, a film, or a proposal for a structure that for practical reasons cannot be built. The term *form* can also refer, more specifically, to a shape represented within an artwork. **Biomorphic forms,** for instance, are abstract shapes inspired by plants or simple animal life (such as seed pods, sand dollars, or horseshoe crabs), whereas geometric forms are usually suggestive of precision handmade objects or the pristine abstractions of mathematics.

Medium refers to the specific material out of which an artwork is made. The various painting media, for example, are identified by the vehicle or binder used in each instance (such as *oil* paints or *acrylic* paints), or by the ground to which the paint is applied (*fresco,* for example, is paint applied to fresh plaster). Sculpture, drawing, and graphic processes are identified, as we have seen, by the materials and techniques involved, such as a *marble* carving, a *silverpoint* drawing, or a *copper plate* engraving.

Every medium has its own unique and distinctive character which it imparts to its subject. A former student of mine once explained that he preferred graphite pencils when sketching city scenes because graphite is dirty and smeary—just like the city. Watercolors, in contrast, have an informal, spontaneous feeling to them; marble carvings suggest enduring permanence and grandeur.

Strange, uncanny effects can be achieved by representing a subject in an unusual medium, for example, ocean waves carved in granite, or clouds made of hammered steel. Such juxtapositions, however, can also appear ludicrous if they are not handled with care, as when a well-meaning sculptor carves a subject's eyeglasses, lenses and all, in opaque stone.

Space

The term *space* can refer to either actual space (such as the masses and voids in an abstract sculpture) or to illusory space (the imaginary scene represented in a landscape painting or in a perspective drawing). In theater, actors speak of the imaginary wall between themselves and the audience as the "fourth wall." The analogous concept in painting is the **picture plane,** which separates actual space from illusory space. In painting, the stretched canvas is the picture plane; in drawing it is the surface of the paper.

Landscapes typically portray deep space; interior space is shallow but well defined by the limits of the room. Some commentators associate a painting's use of space with either the classical or romantic sensibility. Landscapes represent **romantic space** since the Romantics reveled in the sublime expanse of nature, whereas interior spaces with their clearly defined boundaries suggestive of precision and clarity are thought to represent **classical space.**

A series of psychological experiments performed by Bernard Aaronson at Princeton University in the 1960s suggests that our experience of space is closely linked to our emotional responses. When Aaronson's hypnotized subjects were given the suggestion that the space around them would appear more three-dimensional, the subjects spontaneously reported feelings of great euphoria mingled with insights of almost religious intensity. But when the same subjects were given the hypnotic suggestion that they would perceive no depth in the space around them, the subjects became anxious and withdrawn, some even exhibited mildly schizoid or catatonic behaviors along with disturbances of gait, movement, and posture.[2] It is perhaps no accident that the Viennese psychoanalyst Sigmund Freud described feelings of deep religious insight as "Oceanic."

[2]*Bernard Aaronson, "Hypnotic alterations of space and time" in Proceedings of an international conference on hypnosis, drugs, dreams, and psi held at Le Piol, St. Paul De Vence, France, June 9–12, 1967 (New York: Parapsychology Foundation, Inc., 1967), p. 43.*

Scale

The term *scale* refers to the size of an artwork. Figures portrayed larger than life-size, such as Michelangelo's *David,* are called monumental or colossal. Large figures evoke a sense of majesty befitting the heroic figures of myth and legend. Even a relatively small **maquette,** however, produced as a preliminary three-dimensional sketch for a larger sculpture may sometimes appear monumental due to the brave stance of the figure or the sheer grandeur of its concept.

Increasing the scale of a human figure makes it appear more grand, but enlarging a common object to monumental proportions, such as a clothespin or typewriter eraser, makes it appear at the same time captivating and absurd. The sculptures of American pop artist Claes Oldenburg (born 1929) take full advantage of the uncanny effects produced by changes in scale. Oldenburg's notebooks are full of sketches for enormous sculptures, such as a mountain tunnel in the shape of an immense nose. (Cars presumably drive in through one nostril and out through the other). Oldenburg's outlandish proposals seem to be tongue-in-cheek commentaries on the absurdity of monuments in an age where nothing seems worth memorializing.

Line and contour

A line is the simplest means of representation and also one of the most versatile. Lines are present everywhere in nature, from the delicate tracery patterns in a spider's web to the trail of a meteor as it streaks across the late summer sky. A line is sometimes defined as the path described by a moving point or, in Euclidian geometry, as the shortest distance between two points.[3] When a line indicates the surface boundary of an object, as in a silhouette, the line becomes a **contour.** (See Figure 3.4.)

Lines are known to have some measure of expressive character according to whether they are straight or loopy, of constant or varied width, or are lightly or firmly drawn. Horizontal lines are thought to suggest stability; vertical lines indicate strength. Diagonal lines may elicit a feeling of rhythm, movement, or instability depending upon

Figure 3.4 *Contour Drawing of an Egyptian ba, a ghostly shadow-self analogous to the Western idea of the soul. (Illustration: Dover Pictorial Archives)*

[3]*Post-Euclidian geometries have proven that since all space is actually curved, a straight line is no longer the shortest distance between two points. For our purposes, however, we will ignore the curvature of space and confine ourselves to the virtual plane of the paper.*

Figure 3.5 *The technique of SFUMATO ("smoky contours") is used to suggest background distance in* Mona Lisa *by Leonardo da Vinci (1503–1505). Sfumato simulates the blurring of distant objects by atmospheric haze. (Photo: Foto Marburg Art Resource, NY.)*

other factors present in the composition. In any case, keep in mind that the attributes of the lines listed previously are generalized tendencies rather than invariant rules.

The illusion of distance can be rather simply produced by lightening or blurring the contours of distant objects. This technique is called **sfumato** (Italian for "smoke"), since it imparts a smoky or hazy appearance to the image. (See Figure 3.5.) Sfumato was widely used in the paintings of Renaissance masters such as Leonardo da Vinci and Correggio.

An even more compelling illusion of depth can be achieved through the apparent recession of parallel lines (or **orthogonals**, lines perpendicular to the picture plane) to a **vanishing point** along the horizon. This concept is the basis for **linear perspective,** a system for creating the projection of three-dimensional space on a two-dimensional surface. The laws of perspective were first formulated in a comprehensive and systematic manner by the great Italian Renaissance sculptor-turned-architect, Filippo Brunelleschi, during the early fifteenth century.

In standard linear perspective, the vanishing point is always in the background, usually somewhere along the horizon line (which represents the viewer's eye level). A cube with its front surface exactly parallel to the picture plane appears in one-point perspective. A cube seen "edge on" has two vanishing points and, thus, appears in two-point perspective (See Figure 3.6.). Tall buildings when seen edge-on from ground level, require three vanishing points, one for height, one for width, and one for depth, or three-point perspective. The laws of perspective, which seem so intuitively obvious to us due to our familiarity with them as conventions of seeing, entirely eluded the ancient Greeks, Romans, early Christian artists, and even the great fourteenth-century painters of the early Renaissance period. Before the development of perspective, artists relied upon simple depth cues (such as *size differences* or *overlapping contours*) to indicate the relative depth of figures in pictorial space.

Before the laws of perspective were formulated, artists frequently combined several different vantage points haphazardly in the same image. Medieval illustrations present many examples of this sort of **simultaneous perspective.** Consider the following details in *Christ Raising Lazarus from the Dead,* a wall mosaic from the Byzantine chapel of St. Apollinare Nuovo at Ravenna. (See Figure 3.7.) Notice how the sepulcher of Lazarus is composed of an

vanishing point

horizon line

One face of cube
is parallel to the
picture plane

A cube drawn in
1-point perspective

Figure 3.6 *Linear
Perspective (illustrating
situations involving one, two,
and three vanishing points).*

vanishing point 1 horizon line vanishing point 2

A cube drawn in
2-point perspective

Front edge is
parallel to the
picture plane

to vanishing point 3

A tower drawn in
3-point perspective

horizon line

vanishing point 1

vanishing point 2

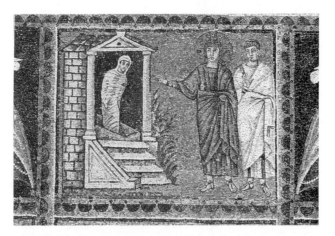

Figure 3.7 Christ Raising
Lazarus from the Dead,
*detail of a Byzantine wall
mosaic (c. A.D. 500) from
the Nave of St. Apollinare
Nuovo. (Photo: Ravenna Art
Resource, NY.)*

Figure 3.8 Portrait of Sylvette David *(1954) by Pablo Picasso. This cubist painting combines frontal and profile views in the same image. Oil on canvas 51"X 38". (Art Institute of Chicago, Gift of Mr. and Mrs. Leigh Block)*

odd arrangement of views, all seen from different vantage points. The roof appears to be drawn in three-quarter view, while the columns and pediment of the entrance are shown in frontal view. The riser of the steps, however, is seen in profile, while the steps themselves look as if we are gazing down on them from above.

Interestingly enough, the painters Pablo Picasso (1881–1973) and Georges Braque (1882–1963) used a similar approach but in a more controlled way to suggest the idea that our knowledge of objects results from our experience of seeing them from many different viewpoints over an extended period of time, rather than from one static position as implied by a photograph. (See Figure 3.8.) Picasso's and Braque's highly conceptual style of painting, developed in 1907, came to be called **Cubism.**

As we have seen, some styles of representation deliberately ignore standard linear perspective in order to show us another way of looking at things. Objects in mechanical drawings, for example,

A cube in isometric projection
(iso = equal, metric = measure).
All edges are equal in length.

A cube drawn in 2-point perspective
(edge length varies with position)

Figure 3.9 *Comparison of isometric projection and two-point perspective. A cube in* **isometric projection** *(iso = equal, metric = measure); all edges are equal in length. A cube drawn in* **two-point perspective,** *edge length varies with position.*

are often shown in **isometric projection,** in which the dimensions of objects appear in their true measurements undistorted by perspective. (See Figure 3.9.)

Artists sometimes intentionally deviate from strictly correct perspective in order to elicit a startling or uncanny effect. Georgio De Chirico's metaphysical landscapes derive their bizarre, dreamlike quality in large measure from the painter's deliberate exaggeration of linear perspective, produced by placing the vanishing points unnaturally close together. (See Figure 3.10.)

Although drawing, specifically pencil or ink drawing, is the medium most often associated with line, successful linear

Figure 3.10 Mystery and Melancholy of a Street (1914) by Giorgio De Chirico. Oil on canvas, 34" X 28" (DeChirico Acqua Vella Galleries, Inc.)

Figure 3.11 Hudson River Landscape *(1951) by David Smith. (Smith/Whitney Museum of American Art)*

compositions have been produced in a variety of media, including sculpture. David Smith's *Hudson River Landscape* is a sculptural object as well as an abstract drawing in welded steel. (See Figure 3.11.)

Value and texture

The greater the amount of light reflected from a surface, the brighter that surface appears to be; the more light absorbed by a surface, the darker the surface appears to be. The representation of these shades of light or dark in an image is called *value.*

Careful examination of the lights and shadows of any object reveals several distinct regions: the darkest areas (the umbra of the shadow), partially lighted areas (the penumbra of the shadow), regions where the object's actual surface value appears more or less as it actually is, highlights (the brightest areas of the object), reflected light (from the surface upon which the objects sets), and backlight (the value of the ground immediately behind the object or figure).

The modulation of values to create the illusion of a modeled surface in a drawing or painting is called *chiaroscuro.* (See Figure 3.12.) Areas of uniform value tend to appear smooth and flat; areas in which values change abruptly appear roughly textured. Regions of smoothly modulated values may appear as concave (hollowed out, like a *cave*) or convex (protruding, like a *vex*ing blister) depending upon the apparent position of the light source.

Figure 3.12 *A scene improved through the addition of* **chiaroscuro.** *(Illustration: Complete Encyclopedia of Source Illustrations)*

It is interesting to note that when a photograph of any concave or cratered surface is turned upside down (so that the light appears to come from below rather than above), the crater is suddenly transformed into a moundlike protrusion. (See Figure 3.13.) This compelling illusion occurs because we have been conditioned to expect a **drop shadow** generated by an overhead light source, that is, the sun shining in the sky. As this illusion neatly demonstrates, the act of seeing is not the raw, unmeditated act we usually take it to be. Visual clues such as the drop-shadow effect, which help us to interpret what we see, make the act of perceiving more like a series of higher-level conceptual inferences than a simple beholding of the naked truth.

Value contrasts have long been used to create expressive and dramatic effects in painting and drawing. One recognized master of such effects was the sixteenth-century Baroque painter,

Figure 3.13 DROP-SHADOW EFFECT *The Barringer Meteorite Crater. When viewed upside down (as shown), this photo resembles a mesa or butte rather than a crater; this illusion is caused by the* **drop-shadow effect.** *(Yerkes Observatory Photograph)*

Figure 3.14 (a) Conversion of St. Paul *(1601) by Michelangelo Merisi (called Caravaggio.) (Photo: Almari Art Resource, NY.)*

Figure 3.15 (b) Judith and Maidservant with the Head of Holofernes *(c. 1625) by Artemisia Gentileschi. The painting depicts the biblical tale of Judith of Israel who slew the enemy general who had forced himself upon her by beheading him while he slept. (Detroit Institute of Arts, Gift of Leslie H. Green. Photo: Detroit Institute of Arts/Gentileschi)*

Michelangelo Merisi, called Caravaggio (1571–1610). Caravaggio's style of painting exaggerated the usual chiaroscuro effects by highlighting the principal subject and leaving the background cloaked in a mysterious darkness. (See Figure 3.14.) This technique called *tenebroso* or **tenebrism** (meaning the "dark manner") was so distinctive a style that artists who adopted the *tenebroso* manner of painting, like the seventeenth-century female painter Artemesia Gentileschi, were called **Caravaggisti,** disciples of Caravaggio (See Figure 3.15). The famous portraitist Rembrandt Van Rijn (1606–1669) likewise recognized the expressive possibilities of tenebrism and used it throughout his career as a portraitist.

The eye is particularly sensitive to sudden changes in relative value. In other words, in a dark painting the lighter passages will command our attention, and vice versa. This phenomenon is often exploited by artists in order to lure a viewer's attention to the most important passages of the painting.

In addition to its expressive characteristics, value can be used to suggest pictorial depth when no other depth cues (such as converging parallels) are present to contradict the interpretation. The well-known depth cue of **atmospheric perspective,** in which distant objects are made to appear hazy and indistinct in proportion

Figure 3.16 Atmospheric Perspective: View of Rheinstein Castle by an anonymous nineteenth-century engraver. Distance is suggested by the dramatic shift in values between the foreground, midground, and background, simulating the effect of atmospheric haze. (Illustration: The Complete Encyclopedia of Illustration)

to their distance from the viewer, is basically an abrupt value shift between the foreground and background.

The apparent texture of a surface can also be used to suggest pictorial depth. A roughly textured surface, such as a pebble-strewn beach, appears to become smoother and more uniform as it recedes from the viewer. This gradual change in texture (from coarse to fine) is called a texture gradient and is often suggested in drawing by a smoothly graduated value scale. (See Figure 3.16.)

An interesting **simultaneous-contrast** illusion can be produced by setting any figure of uniform value against a light and a dark background. In Figure 3.17, the actual values of the T-shaped bars (and their bases) are identical. This can be verified easily by covering the upper figures with a sheet of paper. And yet, the bar on the left appears noticeably darker than the bar on the right. This phenomenon demonstrates that values are always perceived in relation to one another and that our perceptions of apparent value are decidedly subjective. A grey cat sleeping on a black stair might appear almost white under certain conditions, but later that same cat may appear almost black when seen against a white wall. A similar phenomenon affects our perception of color, as we shall see in the next section.

Figure 3.17 Simultaneous Contrast. Both T-shaped bars are exactly the same shade of grey, and so are their bases. Cover the upper part of the figures with a sheet of paper to compare them. Yet the T-shape at right looks noticably lighter due to the effect of **simultaneous contrast.** (Author's illustration)

Color

Few aspects of visual art are more complex and yet seemingly more immediate than our perception of color. Any good painter knows how challenging it can be to wrestle the colors of a painting under control while, at the same time, preserving a sense of freshness and

immediacy in the work. The basic laws of color interaction have been formalized, however, and provide us with a good starting point.

To begin with, the word *hue* refers to a color's name or, more precisely, its position within the visible spectrum. White light, as Sir Issac Newton demonstrated with a glass prism, is actually composed of seven distinct hues, each corresponding to a different wavelength of electromagnetic energy. The seven hues of the **visual spectrum** can easily be remembered with the aid of an old acronym *Roy G. Biv.* This stands for the hues as they appear in the spectrum arranged from the longest wavelength to the shortest: red, orange, yellow, green, blue, indigo, violet.

The hues of the spectrum can be divided into the cool colors (green, blue, violet) and the warm colors (red, orange, yellow). Cool colors appear to recede slightly from the picture plane, while warm colors appear to come forward. This **push-pull effect** can be quite striking, especially when bold regions of high-intensity color are placed alongside one another as in certain hard-edge abstractions. The blues actually appear to drop back like holes in a flat red or yellow wall. Most painters plan their compositions to take full advantage of the push-pull effects of warm and cool colors.

Hermann Helmholtz, one of the early pioneers of perceptual psychology (called *psychophysics* in the nineteenth century), developed a captivating device for demonstrating the true spectral nature of white light, thereby reassembling what Issac Newton had split apart with his prism. Helmholtz took a disk of white cardboard and divided it, like a pie, into seven equal sections. He then painted each slice with one hue of the spectrum. When Helmholtz mounted his color disk on a motorized spindle and spun it around, the colors suddenly vanished, their separate hues recombined into white light. The French impressionist painters of the late nineteenth century were very impressed by Helmholtz's demonstrations and utilized optical blending as the basis for their painting style. The Impressionists found that a small brushstroke of yellow placed close beside a small brushstroke of blue appeared, to a viewer's eye, as a brilliant green more vibrant than the hue produced through the standard technique of mixing pigments. The postimpressionist Georges Seurat carried this approach to its logical conclusion in his *pointillist* paintings which consist entirely of tiny color dots optically blended into recognizable images (see page 193). We can understand this phenomenon more clearly by examining the nature of light and color.

When white light strikes a colored surface, a portion of its energy is absorbed by that surface. The unabsorbed wavelengths that are reflected back at us is what our eyes perceive as color. A red rose, for example, absorbs all the wavelengths of the visual spectrum *except* red. A white rose reflects all wavelengths. A black rose absorbs all wavelengths, reflecting back none.[4]

Because color in painting is the result of light being reflected from the painted surface, it is called **subtractive color** since the color we see is what is left over after all the other wavelengths have been subtracted (absorbed) by the painted surface. Three of the hues, magenta, yellow, and cyan, are called the **primary subtractive hues** (popularly known as the three primary colors) since they are the basic colors from which all other hues of the spectrum can be derived. (Mixing cyan and yellow produces green; mixing magenta and cyan produces violet, and so forth.) Mixing the three primaries together produces, at least in theory, a neutral grey. In practice the result is a bit muddied by impurities in the pigment or by slight inequalities in the admixture.

In addition to the subtractive colors there are also **additive colors** produced by shining white light through a gelatin filter which blocks all but one pure hue of light. Additive colors are used primarily in theatrical lighting and in motion-picture photography, but they are also the basic principle behind the color television screen. Unlike the subtractive primaries, the **primary additive hues** are red, blue, and green. When the lights from three spotlights, each of which has been fitted with a gelatin filter of red, green, and blue, are superimposed on a screen, the three colors blend together to produce pure white light—a quite unexpected thing, the first time it is seen. Look closely at a color television screen and you will see that all its colors are generated from varied combinations of tiny red, blue, and green phosphor dots energized by the scanning raster's stream of electrons.

Any color can be described in terms of three dimensions or attributes: its hue (position in the spectrum), value (degree of lightness or darkness), and intensity (purity or brilliance) sometimes also called *chroma* or *saturation*. The close interrelationship between these three attributes of color is illustrated in the following chart.

[4]*When the first atomic bomb was dropped on Hiroshima, many of the survivors received heat-flash burns which corresponded to the black patterns on their kimonos, while the skin beneath the white fabric which reflected rather than absorbed the flash was virtually untouched. Samuel Glasstone, ed.,* The Effects of Nuclear Weapons *(Washington, DC: U.S. Dept. of Defense/U.S. Atomic Energy Commission, 1962), p. 568.*

To Change	Add	Example
Hue	another hue	red + yellow = orange

(Red's position in the spectrum has been shifted by the addition of yellow.)

To Change	Add	Example
Value	white, black	red + white = pink

(Red is now a lighter shade [pink] due to the addition of white.)

To Change	Add	Examples
Intensity	an equivalent grey	red + grey = dull red
	or the complementary hue	red + green = dull red

(Adding a small amount of a hue's complementary color will partially cancel out that hue, making it duller without altering its value. Mixing complementaries together produces grey.)

These few principles are illustrated further by the following descriptive statements. Read each one carefully and consider the color dynamics involved in each case.

> To change *hue,* mix any color with another different color.
> (Example: Mix red with blue for a *violet* hue.)

> To change *Value,* add a neutral shade (white or black) or add a lighter or darker hue.
> (Examples: Mixing black with blue changes *value*, not hue
> … it's still blue, only a darker shade; but mixing yellow
> with blue changes *value* and *hue* because now it's a lighter
> shade of green.)
> But,
> Mix a hue with its equivalent shade of grey and you will
> lower the hue's overall intensity (its purity or brilliance),
> but you will not alter its value.
> (Example: Mix light grey with yellow, get the same value
> yellow, only duller.)

> To change *intensity* (purity or brilliance) add white, black,
> grey, or a lower-intensity hue.
> (Example: Adding dark grey to red kills intensity dead.)

Thus, the entire spectrum can be generated by mixing the three primary hues together in varying quantities. This fact is often

illustrated using a diagram which places the primary hues equidistant from one another. Positioned in this way, the three primary colors illustrate the primary triad of cyan (vivid blue), magenta (vivid red), and yellow.

<div align="center">

Red Orange Violet

Yellow Blue Green

Hues of the primary triad Hues of the secondary triad

</div>

Mixing each of these primaries with its adjacent hue results in the secondary triad: orange, green, and violet. The individual colors of the primary and secondary triads can be combined further to yield all the intermediate hues of the spectrum, which occupy the spaces between the primary and secondary hues in this 12-color wheel.

<div align="center">

Red

Red-Orange Red-Violet

Orange *Violet*

Yellow-Orange Blue-Violet

Yellow **Blue**

Yellow-Green Blue-Green

Green

</div>

The 12-color wheel, illustrating the primary, secondary, and intermediate color triads

In the preceding configuration, the colors opposite each other on the color wheel are called **complementary colors.** Complementary hues, such as red and green, cancel each other out when mixed together, resulting in an *achromatic* (colorless) grey.

Our perception of an object's apparent color is subjective and context-dependent. A small grey square appears slightly green when placed in the center of a large red area, but if you take the same grey square and place it in the center of a blue field, the grey will suddenly appear slightly orange. This perceptual phenomenon is called **chromatic simultaneous contrast.** Any color can be enhanced by placing it alongside its complement. Any red appears more intense when seen against or alongside a green background. (Food stores exploit this effect when they set their sliced meats on display surrounded by a decorative green border.)

The color pairs red-green, orange-blue, and yellow-violet have

the greatest degree of contrast because they involve the high-intensity colors of the primary and secondary triads. Pairs of complementary colors formed from the intermediate hues are of necessarily weaker contrast, since the purity of their hues has already been diluted by the intermixture of other hues. **Split complementary colors,** formed from a hue and the color on either side of its complement are likewise weaker in contrast than true complementary pairs. The weakest contrast occurs between hues that lie next to one another on the color wheel because they each share a common hue; such colors are called **analogous hues.**

<div align="center">

Red

Red-Orange Red-Violet

Orange Violet

Yellow-Orange Blue-Violet

Yellow Blue

Yellow-Green Blue-Green

Green

</div>

The split complementary colors of red (yellow-green and blue-green). Split complementary hues are weaker in contrast than true complements, but stronger in contrast than analogous hues, which lie next to one another on the color wheel.

Early in the twentieth century, American artist Albert Munsell developed one of the most comprehensive systems for exact color identification based upon the three dimensions of color: hue, value, and intensity. The **Munsell system** assigns each color a specific position on a three-axis sphere (the north pole of which is white, the south pole black, and the equator the pure hues of the spectrum). This system allows any color to be identified with a very high degree of precision. The elegant simplicity of Munsell's color atlas has made it the standard reference used by industry's American Society for Testing and Materials (ASTM).

A different system of color specification is used in photography where subtle variations in tint of photoflood lamps must be identified with great accuracy. The light from photographic bulbs is measured in terms of the **Kelvin scale** that tells us to exactly what temperature a pure carbon rod (called a *black-body radiator*) would need to be heated in order to give off light of that particular hue. Thus, the light from a photoflood bulb rated 1700 K would have a slightly orange tint, while one rated 4800 K would

have a distinctly bluish cast. For convenience in notation, these color temperatures are expressed in degrees Kelvin, which fixes the zero point at −273 Centigrade (absolute zero).

If a movie director wanted to artificially duplicate the exact quality of light on an average summer day at noon, he would choose photofloods rated according to the value presented in the following table, which gives the Kelvin scale values for common light sources and atmospheric conditions.

Table 3.1 Kelvin Color Temperature Scale (of black-body emission)*

Light Source	Temperature
Matchflame	1700 K
Candleflame	1850 K
Sunlight at sunrise or sunset	2000 K
Sunlight 1 hour after sunrise	3500 K
Early morning sunlight	4300 K
Late afternoon sunlight	4300 K
White flame carbon arc lamp	5000 K
Average summer sunlight, noon (Washington, D.C.)	5400 K
Direct midsummer sunlight	5800 K
Overcast sky	6000 K
Average summer shade	8100 K
Partly cloudy sky	8000–10,000 K

*Table courtesy of American Society of Cinematographers. Charles G. Clark, ed., American Cinematographer Manual, 5th ed. (Hollywood: A.C.S. Holding Corporation, 1980), p. 310.

Painters are customarily divided into two general categories: draftsmen, whose main interest is linear design, and **colorists,** whose main interest is exploring color. Perhaps the most famous of all colorists is the nineteenth-century French impressionist Claude Monet (1840–1926). Ironically, Monet was often criticized in his day because his intense interest in color led him to produce works insufficiently rooted in the academic tradition which, in Monet's time, demanded that an artist demonstrate his scholarly acumen by producing paintings of obscure historical subjects, figures from mythology, or abstruse intellectual allegories. Monet focused instead upon the subtle effects of light and atmosphere found in such *plein-air* subjects as haystacks, train stations, church facades, and views of the French countryside. Not surprisingly, Monet's preoccupation with these effects led one of his detractors (the painter Cezanne, of

all people) to remark of him, "Monet—he's only an eye … but, My God, *what an eye!*"

The later expressionist painters Paul Gauguin (1848–1903) and Vincent Van Gogh (1853–1890) adopted a more inward-looking approach to color, treating it as a means of symbolic and emotional expression. Gauguin once advised a student to always use the most intense color possible—if a shadow looks a little bluish, it must be painted with the most vibrant blue on your palette, nothing less. Gauguin also took the bold step of representing figures in unnatural hues for expressive effect. He once painted a crucifixion with a yellow Christ because only yellow, he felt, conveyed the appropriate mood of pathos and hopelessness. Van Gogh likewise experimented with bold color juxtapositions to the extent that a certain "family resemblance" is noticeable between his work and his friend Gauguin's work. Actually such cross influences of style are not uncommon among painters who work closely together.

Many artists and researchers have tried to compile a definitive list of the emotional responses linked to specific colors. The great German poet and dramatist Goethe (1749–1832) devoted part of a long and involved treatise on color to that very topic. While it is possible to see patterns in viewers' emotional responses to certain colors, we now recognize that such associations are highly subjective and influenced strongly by one's cultural background. (The Chinese and some Native American tribes, for instance, regard white as associated with death and mourning having the same associations that Europeans and Americans make to black.) The following chart summarizes some of the most frequent color associations among contemporary Americans.

Musicians of ancient Greece believed that certain musical tones had the ability to influence a listener's mood and behavior. For example, certain tones played upon the harplike lyre were conducive to the development of an even-tempered mental clarity, while certain tonal patterns played upon the trumpetlike aulos were believed to rouse the passions. Classical Greek orators put so much faith in this idea called the *doctrine of ethos* that they often spoke to the accompaniment of a musician whose tones helped rouse or soothe the passions of the listeners, as the occasion dictated. In visual art, the parallel to this doctrine of ethos is the idea that certain hues have the ability to influence a viewer's affective state and his or her behavioral responses. Research on visual perception has demonstrated, for example, that certain shades of pink act to

Table 3.2 Modern American Color Associations

Color	General appearance	Mental associations	Direct associations	Objective impressions	Subjective impressions
Red	Brilliant, intense, opaque, dry	Hot, fire, heat, blood	Danger, Christmas, Fourth of July, St. Valentine's, Mother's Day, flag	Passionate, exciting, fervid active	Intensity, rage, rapacity, fierceness
Orange	Bright, luminous, glowing	Warm, metallic, autumnal	Halloween, Thanksgiving	Jovial, lively, energetic, forceful	Hilarity, exuberance, satiety
Yellow	Sunny, incandescent, radiant	Sunlight	Caution	Cheerful, inspiring, vital, celestial	High spirit, health
Green	Clear, moist	Cool, nature, water	Clear, St. Patrick's Day	Quieting, refreshing, peaceful, nascent	Ghastliness, disease, terror guilt
Blue	Transparent, wet	Cold, sky, water, ice	Service, flag	Subduing, melancholy, contemplative, sober	Gloom, fearfulness, furtiveness
Purple	Deep, soft, atmospheric	Cool, mist, darkness, shadow	Mourning, Easter	Dignified, pompous, mournful, mystic	Loneliness, desperation
White	Spatial—light	Cool, snow	Cleanliness, Mother's Day, flag	Pure, clean, frank, youthful	Brightness of spirit, normality
Black	Spatial—darkness	Neutral, night, emptiness	Mourning	Funereal, ominous, deadly, depressing	Negation of spirit, death

From Faber Birren, Color Psychology and Color Therapy *(Secaucus, NJ, Citadel Press, 1961), p. 143.*

pacify feelings of hostility. This is why the walls in prison common rooms and mental hospital wards are often painted pink. It should be remembered, however, that emotional responses to color are always mediated by cultural factors, both on the microcultural or personal-experiential level, and on the macrocultural or broader social level as well.

S u b j e c t m a t t e r

In the center of our little diagram of the formal elements we would find what is perhaps the most important formal element of all, the *subject matter* of the artwork,—that is, its very reason for existence. In traditional representational painting, subject matter tends to follow the three well-known general categories of *persons* (portrait), *places* (landscape), and *things* (still life), or some combination of these. Abstract artworks often take one or more of these traditional categories as their initial point of departure, then focus exclusively upon a narrower concept, or set of related concepts, embedded in them. For example, the futurist painter Umberto Boccioni once produced a series of paintings on the various "states of mind." While ostensibly abstracted landscape paintings (his work *The Farewells* features a highly abstracted train departing from a station), these paintings are also images of the deeper, more intangible feelings they evoke. In other words, Boccioni's paintings are not really about places in the strict representational sense, but rather the emotional responses that certain places evoke for a viewer under certain circumstances. In this sense, abstract paintings can be regarded as adding a fourth general category of subject matter, namely *concepts,* to the three already mentioned. In frankly formalist paintings, where the pure formal elements of design become the work's subject matter, our cube-shaped diagram of the formal elements turns in upon itself (rather like the mathematicians' Moebius strip or Kline bottle), thus creating a tiny replica of itself (i.e., color, shape, value, and so on) at the very center of the cube. Formalist painting is *self-referential* (that is, painting about painting) rather than concerned with traditional subjects in the usual sense of the term.

Within the traditional category of subject matter are certain time-honored themes that have captured artists' imagination throughout history. War, in both its glorious and ignominious aspects, is one such theme; it has served as the impetus for many military portraits, battle paintings (landscapes combined with group portraiture), and still life/genre scenes depicting the soldier's martial accoutrements and way of life, not to mention uncountable images of fighting ships, equestrian statues of mounted officers, and other variations too numerous to fully catalog here. Practically every lasting human concern has represented, at one time or another, a theme in art. Stories from mythology, inspirational religious figures, and tales of the cruel and tender vicissitudes of love are three well-

known themes common in Western art, to which may be added yet more abstract notions, such as the struggle of a hero to achieve some good after a test of courage.

Readers encountering stories from different world mythologies for the first time are frequently surprised to find that virtually the same story often appears in the myths of different cultures, though often subtly changed and represented by a different cast of characters. The story of the Germanic god Odin, who glimpsed the rune symbols while lashed to the world tree Ygdrassil, for instance, bears uncanny parallels to the story of Christ's crucifixion. It is a belief commonly held among structuralist philosophers that all the world's great myths and legends are actually innumerable variations on a small handful of tales which constitute, in their primal essence, the very core of human experience.

Summary: Portrait of the artist as a *bricoleur*

As the anthropologist Claude Levi-Strauss has pointed out, the primitive artist and myth maker have a good deal in common with what the French call a *bricoleur,* a handyman or jack-of-all-trades who improvises his tools on the spot, combining cast-off objects into devices intended to be used only once, then thrown away.[5] In a similar fashion, the artist culls what he or she needs from the reservoir provided by the culture, borrowing inspiration from other artists, picture books, travel posters, catalogs, and the world-at-large.

Artists modify all these things, transforming and combining them through a sort of visual language that they did not invent and may not, in some cases, even fully comprehend. But from these odds and ends the artists manage to produce a New Thing that is partly their own creation and partly a product of all the inherited cultural material that has been left to them by posterity. In order to understand how this process of creation occurs, how these formal elements are combined into something that is more than the sum of its individual parts, we must take a close look at the *principles of composition,* the basic organizational tools of the visual arts. In the next chapter we will examine how the various formal elements are orchestrated into finished artworks.

[5]*Claude Levi-Strauss, The Savage Mind, trans. George Weidenfeld and Nicolson Ltd. (Chicago: The University of Chicago Press, 1968), see especially pp. 17–18.*

Chapter 4

Principles of Composition

Art is not really a strict imitation of life, but rather an attempt at grasping the essence of a subject and representing that essence in a convincing way using the basic formal elements of line, shape, color, and space.

Figure 4.1 A Satire on False Perspective *after William Hogarth (1697–1764). This humorous engraving from a drawing manual for architects contains over a dozen errors; how many can you identify? From Dr. Brook Taylor's Method of Perspective, British Museum, London. (Photo: Hogarth/ The Granger Collection)*

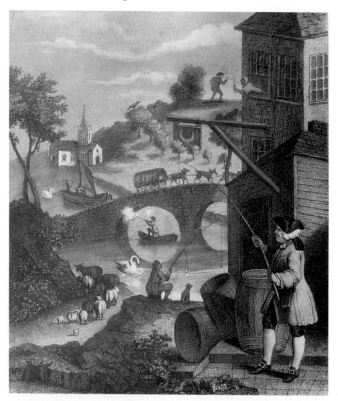

The principles of composition are the structural relationships used to bring an artwork's formal elements together into a well-made, integrated whole or composition. Although somewhat less tangible than the formal elements of line, color, shape, and space, these structural relationships nevertheless constitute an important feature of every drawing, painting, and sculpture. In this chapter we will examine these compositional principles in detail, beginning with a look at how our concept of composition springs from some of the most basic laws of visual perception. (See Figure 4.1.)

Perception and composition

Visual perception involves a complex interplay of both inborn and learned responses to visual stimuli. In the 1930s and 1940s, psychologists of the Gestalt school (in German *gestalt* means "form" or "whole") formulated several basic laws of perception all revolving around the idea that *there is an inborn tendency for human beings to perceive wholes rather than disconnected, unrelated parts.* The **Gestalt laws of perception** summarize tendencies that appear to be innate or inherent in our biological heritage and which undoubtedly serve as the basis for our concept of composition in visual art. These basic laws are briefly summarized below. (See Figure 4.2.)

1. **Similarity facilitates grouping.** Objects which resemble one another tend to be seen as belonging together. (Example: Four identical triangles tend to look more like an interrupted square than four dissimilar triangles.)

2. **Proximity facilitates grouping.** Objects placed close together tend to form a figure. (Example: The Big Dipper is one of the easiest asterisms to identify because its individual stars are bright and relatively close together.)

3. **Tendency toward closure.** Missing visual information is filled in by the brain. (Example: If a star is drawn with gaps in its sides, there is a tendency to still see the star rather than a group of unrelated angles. The eye closes the open parts of the figure because it wants to see a whole rather than a collection of unrelated parts.)

4. **Tendency toward continuity.** An interrupted linear figure is similarly filled in by the brain. (Example: When we look at a partly submerged sea serpent, we see the animal as a continuous whole rather than as separate unrelated pieces.)

Figure 4.2 *The Gestalt laws of perception. (a) Similarity facilitates grouping. (b) Proximity facilitates grouping (The "Big Dipper" in Ursa Major). (c) Closure. (d) Continuity. (e) Tendency to perceive figure/ground.*

1. Similarity facilitates grouping

a. *b.*

2. Proximity facilitates grouping
 (The "Big Dipper" in Ursa Major)

3. Closure

4. Continuity

5. Tendency toward figure/ground

5. Tendency toward figure-ground. There is a tendency to interpret visual data as objects against a background, or more precisely, *figures* against a *ground*. (Example: The drawing appears to be a three-dimensional notch or bulge, rather than simply a flat arrangement of straight lines and curves.)

Not all principles of composition, however, arise from inborn tendencies. In earlier times it was generally believed that the feelings of tension or relaxation experienced while looking at a work of art were caused by the subtle movements of the viewer's eye muscles as he or she scanned the composition. Gracefully curved lines produced a feeling of calmness or relaxation since the eye muscles, it was believed, tracked smoothly across the curves. Similarly, it was thought that jagged lines with slashing, acute angles caused the eyes to dart back and forth, which in turn conveyed a sense of uneasiness to the brain. This rather naive explanation, however convincing it may at first appear, is not entirely accurate.

Experiments have since demonstrated that the eyes do *not* track smoothly when they observe curved lines, but rather skip like a stone from point to point in short, jerky movements that are nearly identical to those recorded when subjects observe jagged, irregular lines. This surprising fact leads us to conclude that the emotional responses to certain types of lines are determined not by a physiological response of our eye muscles, but rather by more conceptual considerations. In other words, our culture has *taught us* to associate curves with relaxation and jagged lines with tension.

Similarly, what looks good or satisfying in a visual design, as opposed to what looks bad or awkward, is also a matter of culturally determined values. Some commentators have gone so far as to refer to the principles of composition and other related aspects of visual perception as constituting a kind of "grammar" or "language" learned as part of each individual's enculturation process. (The use of red at a Chinese wedding as an expression of joy, for instance, is one instance of a "chromatic utterance" which would not translate well into our own culture.) Linguists have argued that describing art as a kind of visual language stretches the idea of language beyond reasonable limits. Yet, however imprecise the concept may be, it serves to communicate something of the close relationship that exists between culture and perception, a relationship which has profound implications for our understanding of artworks from cultures other than our own.

The idea that our culture can have such a strong influence upon our perceptions may appear strange. Most people are used to thinking of visual perception as a very immediate, unmeditated experience; we simply open our eyes and the things of the world yield themselves up to our inquiring glance seemingly without any conscious effort on our part. Yet, this naive assumption—that what we see is simply what is there—breaks down when we confront optical illusions. For example, parallel lines appear to converge in the distance, yet we know this cannot happen; the moon swells in size when it looms just above the horizon, then shrinks noticeably as it arcs across the sky, yet we *know* its size must be constant. These familiar phenomena remind us that the act of perceiving things is as much a cognitive experience—an exercise in thinking—as it is a sensory one. The eyes may be, as the ancient scriptures tell us, "windows unto the soul," but the brain is the true organ of perception.

I bring all of this up to illustrate the idea that when we look at a work of art we are observing more than just lines, shapes, values, and colors; we are also seeing, though sometimes quite unconsciously, important principles of organization that help transform the linear scribbles and patches of color before our eyes into something more than the sum of those individual parts. The way these principles of composition are applied in any given work can also tell us something about the attitudes of the artist and the cultural period in which he or she lived.

As we examine the basic principles of composition, we must also bear in mind that an artist may sometimes deliberately violate one or more of these organizational principles in order to "make a statement." Moreover, we would do well to remember that different cultures perceive the world in very different ways. We must be alert to unusual and provocative features—sometimes subtle, sometimes obvious—that appear in artworks from other cultures and other eras.

Repetition and contrast

Repetition is perhaps the most fundamental principle of organization. I have heard it humorously observed that whereas one eccentric artist constitutes a nuisance, five eccentric artists constitute an art movement. An analogy is also found in visual design when a single element is repeated over and over; it gains a kind of authority, a degree of visual interest that the same element

alone does not possess. The early silkscreen works of Andy Warhol
(1930–1987) capitalize on this very idea, turning the ultramundane
images of 1960s' popular culture into bold design statements, a new
twist on the old and venerable genre of still-life painting. (See
Figure 4.3.)

Warhol's fascination with popular mass media, especially
motion pictures, led him to experiment with film making as a fine
art technique. His epic *Empire,* an outrageous foray into what
Warhol described as the "aesthetics of boredom," consists of an
eight-hour movie of the Empire State Building shot from the

vantage point of a single fixed camera. I have seen *Empire* discussed
as an abstruse comment on the metaphysics of time perception
(written by a critic who presumably sat through the entire film).
Other less intellectualistic commentators have dismissed it as an
elaborate practical joke, a tongue-in-cheek parody of artsy,
pretentious fine art films. Whichever it may be, *Empire* certainly
stands as an object-lesson in how an artist can intentionally stretch
a basic compositional premise to absurd limits in order to make an
aesthetic (or antiaesthetic) statement. As a film that most people
will never see, and which few indeed would ever wish to see, *Empire*
also crosses over into the category of **conceptual art,** that is, a work
whose meaning lies not in the physical beauty of the work itself, but
in the ideas underlying its creation. In fact, if all surviving copies
of *Empire* were to be somehow lost, perhaps no significant feature
of this work would really be violated. Ironically, it might even
be strengthened.

While repetition can add visual interest to a work, unrelieved
repetition (as we have seen) is an invitation to monotony. *Most
successful compositions, therefore, aim at achieving a balance
between repetition and contrast.* One way to achieve this balance is
to structure the composition so that the repetitions and contrasts
are both subtle and unexpected. The artist may arrange a group of
soldiers marching in the foreground so that their shapes are echoed
by the craggy outlines of the distant mountains, or paint fleecy
clouds that repeat the contours of a flock of sheep grazing placidly
in the meadow below. Such juxtapositions have an inherent
metaphorical quality to them and have provided some of the most
poetic passages in painting.

By repeating certain key contours throughout the composition
and juxtaposing them with contrasting elements (smooth surfaces
against rough, dark against light, and so forth), the artist weaves
these various pictorial elements into something more than a random
collection of images. The deceptive simplicity of this idea can only
be fully appreciated when one attempts to put it into practice at the
easel or drawing board. Students and amateur painters often sense
that their painting "just doesn't look right" but are at a loss to
explain why. Often it is because there are no repeated or contrasting
passages in the painting to link the unrelated elements together.

As an illustration of how repetition and contrast can function
in the hands of a master, consider the complex arrangement of
figures in the *Rape of the Daughters of Leucippus* (1617) by the

Figure 4.4 Rape of the Daughters of Leucippus (1617) by Peter Paul Rubens. Subtle repetitions of shape and contour unify the forms within this painting. (Photo: Scala Art Resource, NY.)

Flemish painter Peter Paul Rubens (1577–1640). (See Figure 4.4.) By way of a brief introduction, let me say that this painting depicts an obscure episode from ancient Greek mythology. The twins Castor and Pollux (who incidentally were hatched from eggs laid by their mother Leda, a beautiful mortal with whom Zeus had once enjoyed a romantic liason while disguised as a swan) are shown sweeping the daughters of King Leucippus quite literally off their feet.

First, the composition is organized around several implied geometric figures which function as a kind of supporting armature for the entire painting. (Most artists use some variation on this strategy.) If you look carefully at the arrangement of figures, you will notice that there is a diagonal line that sweeps across the composition (beginning near the drapery at the lower left, continuing up along the kneeling woman's body, and through the other woman's raised arm). This virtual line, subtly described by the contours of the figures, lends a feeling of movement to the

composition; diagonals generally suggest motion, whereas verticals and horizontals suggest stability or repose. This diagonal is balanced by an opposing vector that moves from the horse's head at upper left, downward along the mounted figure's arm, along the woman's thigh, and finally, through the shoulders of the kneeling woman and the rear leg of the standing hero. In addition, Rubens has suggested a sense of sweeping motion by placing the various faces, arms, and legs around the circumference of an implied circle. All these elements combine to give the work a feeling of desperate, swirling action.

Of no less importance are the many rotations, inversions, and repetitions of contour which Rubens has used to bring a sense of order to what might otherwise have been a chaotic jumble of details. Notice, for example, how the horse's leg with the white fetlock (at lower left) repeats almost exactly the shape and position of the standing hero's front leg. Likewise, the flowing silk in the center foreground, added for textural contrast, is mirrored in the mounted hero's billowing cape. A careful study of this image reveals many other repetitions, reflections, and inversions which you may wish to identify as an exercise on your own. Most paintings can be analyzed in this same manner.

Contrast is the opposite of repetition. By deliberately bringing together contrasting elements, an artist can set one detail against another to produce a kind of extended dialog between them. For example, a certain architect used rough-hewn (*rusticated*) stone slabs to cover a building's exterior wall but specified that smooth, narrow grooves be cut in the slabs at regular intervals to provide visual relief from the roughness of the stone. As one approaches the wall, the smooth grooves in the stone invite us to glide our fingers down their length, while the rougher stone that surrounds them simultaneously warns us away. Taken together they produce a tension that makes both elements seem more interesting than either feature would have been if it had been used alone.

Similarly, we have noted in our discussion of basic color theory (Chapter 3) that the strongest contrasts are produced by juxtaposing hues that lie opposite one another on the color wheel. The colors of the strongly complementary pair red-green, for example, look especially striking when placed close together; the red seems redder and the green seems greener. So do warm colors seem enhanced when seen against cool colors, or light hues seen against dark hues. The French impressionist painters (c. 1870) were masters at

Figure 4.5 Nymph and Satyr (c. 1775) by Clodion. Terracotta, approximately 23 inches tall. The satyr's muscular body, ungainly animal limbs, and coarse features provide a strong contrast to the nymph's smooth, voluptuous contours. (Clodion/Metropolitan Museum of Art, New York).

orchestrating these complex color harmonies, all based upon principles of repetition and contrast. (Interestingly enough, the French composer Claude Debussy regarded himself as an impressionist, since he often juxtaposed the high-pitched strings against the contrasting lower-toned horns in his musical compositions, much like his colleagues contrasted the hues in their paintings.)

In traditional bronze or stone sculpture, where color harmonies are usually not an issue, textural contrasts play a greater role in the success of the composition. A sculptor working in stone, for example, might decide to portray a nude figure partially concealed beneath a rough cloak, thus emphasizing both the roughness of the cloak and the smoothness of the skin. In eighteenth-century France, when courtly flirtation was the fashion, sculptures often portrayed nymphs in the amorous embrace of a shaggy old satyr whose decrepit beastliness made the figure of the young woman appear all the more sensuous by comparison. (See Figure 4.5.)

Symmetry and asymmetry

Symmetry involves a sameness between figures or parts of a figure. Symmetries can be formed in several ways: (1) by reflection of one part across an implied mirror axis (as in the symmetric halves of a human face), (2) by rotation of one part around a center point (as in a swastika design formed from a rotated "L"), or (3) by translation (as in wallpaper patterns where a single design element is shifted and/or staggered to fill the space). Images in which the left half closely resembles the right half, much like a folded inkblot, are considered highly symmetric. Images in which there is no evident mirror axis or center of rotation are considered asymmetric.

During certain historical eras highly symmetric compositions were preferred over asymmetric arrangements, particularly during those eras which believed in the rational order of all things. At the height of the Italian Renaissance, for example, compositions typically displayed a high degree of bilateral or mirror symmetry. In Raphael Sanzio's *School of Athens* (1510–1511), an immense wall fresco depicting the greatest thinkers of the classical age, the right and left sides of the painting are almost as identical as an inkblot. (See Figure 4.6.) Raphael purposely used this symmetric composition, wherein each part finds its equal and opposite

counterpart, to compare and contrast the great thinkers of antiquity in much the same way that the historian Plutarch (c. A.D. 46–120?) compared and contrasted the accomplishments of distinguished Greek and Roman statesmen in the volumes of his *Parallel Lives*.

In the center of Raphael's composition Aristotle, the worldly philosopher, is balanced against Plato, the mystic, who gestures upward toward the realm of the ideal forms. Similarly, a statue of the god Apollo (patron of poets) presides over the left half of the assembly, while a statue of Athena (goddess of wisdom) reigns over the right half. By emphasizing this clear idea of balance throughout the composition, Raphael provides us with a sort of object-lesson in the very essense of rational thought itself, namely, a balanced ordering of opposites.

Another favorite Renaissance compositional ploy involved arranging figures in a triangular or pyramidal grouping. This strategy yielded a highly symmetric image that appears visually very stable, suggesting the enduring timelessness of the Greco-Roman classics which the artists and scholars of the Renaissance found so appealing. (See Figure 4.7.)

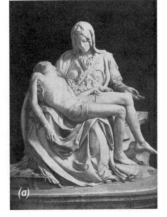
(a)

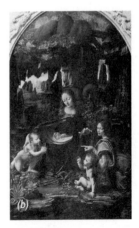
(b)

Figure 4.7 A sense of timelessness and stability communicated through the triangle. (a) Michelangelo's Pietá (1501–1504) and (b) Leonardo da Vinci's Madonna of the Rocks (c. 1485). (Photos: Kunstgeschichte in Bildern III, Alinari Art Resource, NY)

During the Baroque Era (1600–1715) following the Renaissance, this taste for understated elegance and reserved, highly symmetric compositions gave way to an interest in more theatrical arrangements emphasizing dynamic force and movement. (You may recall our comparison of Lorenzo Bernini's version of *David* winding up for the throw, with Michelangelo's quietly resolute version in Chapter 1). The Baroque masters, instead of organizing their compositions in stable, triangular arrangements as their Renaissance forebearers had done, preferred the feeling of movement suggested by strong diagonal vectors within their compositions. Rubens's *Rape of the Daughters of Leucippus,* analyzed earlier, is one example of this sort of configuration.

If all the elements of visual design each possessed exactly the same degree of visual interest, achieving harmony among them would be an easy, even simple-minded task; but this, of course, is not the case. In painting one quickly learns that even a small amount of red on the canvas carries a great deal of visual authority and can be effectively used to counterbalance a much larger area of black—much like a small brick of lead balancing an entire box of feathers. This phenomenon, in which a design element is felt to be balanced against another element of greater apparent visual power is called *asymmetric balance* or sometimes *occult balance,* the term *occult* here meaning "mysterious."

Artists sometimes deliberately skew a composition into asymmetry to thrust a single element directly into the viewer's center of attention. French painters of the nineteenth-century Romantic era, who reveled in the soul-stirring power of storms and other natural cataclysms, often composed their landscape paintings so that a tiny group of people observing, say, the eruption of a volcano was dwarfed into insignificance—literally as well as figuratively—by the titanic forces of nature.

A subtler example of compositional asymmetry is found in Jacque Louis David's portrait of Jean Paul Marat, one of the famous martyred leaders of the French Revolution. Marat, a prolific writer of political pamphlets, met his death at the hand of Charlotte Corday, a loyalist to the crown, who stabbed him while he sat helpless in the medicinal bath which he used to control a chronic skin affliction. David balances the figure of Marat, pathetic in his nakedness, against a blank expanse of dark canvas that hangs like a funerary pall over the absurd bathtub-desk that, in David's hands, has become transformed into a lidless coffin. The stark emptiness

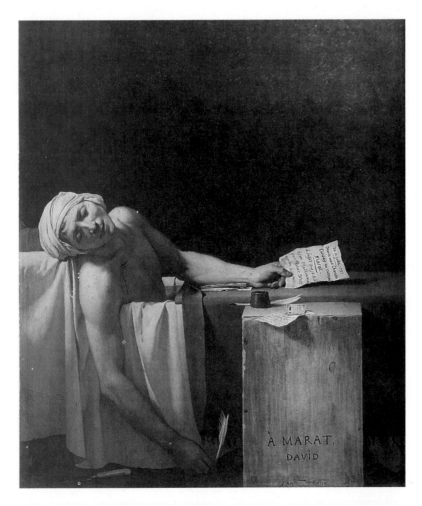

Figure 4.8 The Death of Marat *(1793) by Jacques Louis David. Oil on canvas, approx. 60"X 50". (Musées Royaux des Beaux-Arts de Belgique, Brussels) (Photo: Giraudon Art Resource, NY.)*

of the upper half of the composition forces upon the scene below a strange kind of gravity that gives even the awkwardness of Marat's slumping pose, so reminiscent of the dead Christ in Michelangelo's Pietá, an aura of sublime grandeur. (See Figure 4.8.)

Positive and negative space

In addition to orchestrating the objects within a composition, the artist, as we have seen, must also control the surrounding *ground* or *negative space* against which the objects or, more properly, *figures* will be seen. In sculpture, for example, the holes or **negative spaces** are as important as the positive volumes and must be carefully considered as part of the composition. In painting the ground surrounding the figures must visually compliment the figures and yet, at the same time, not detract from their significance.

Figure 4.9 Reclining Figure (UNESCO, Paris) (1957) by Henry Moore. Bronze, approximately 8 ft long; one of six casts. (Art Institute of Chicago, Gift of Mr. and Mrs. Arnold H. Maremont. Photo: Thomas Cinoman).

Vase/Face Illusion

The monumental abstractions of British sculptor Henry Moore (1898–1986) reveal a particular sensitivity to the visual power and concreteness of negative space. His abstract figures in bronze, wood, and stone use empty spaces as a contrasting counterpoint to the massiveness of their solid forms. The voids in Moore's monumental reclining figures recall images of fossilized skulls and natural stone arches—allusions which lend an earthy, primal power to his figures. (See Figure 4.9.)

When the relationship between figure and ground is unclear, an optical illusion often results. One example of this phenomenon is the well-known vase/face illusion which illustrates a condition of *reversible figure-ground*. (See vignette.) In the hands of a master, ambiguous figure-ground effects can be quite provocative, as in Salvador Dali's *Slave Market with a Disappearing Bust of Voltaire*. (See Figure 4.10.) This painting, one of Dali's "hand-painted dream photographs" as he called them, cunningly arranges the various objects in the composition so that they can be read in two different ways. The broken pedestal and two women standing in the archway combine to make a portrait bust of the philosopher-playwright Voltaire, who appears suddenly, like an apparition at a seance, in the center of the composition. The presence of Voltaire, one of the leading figures from the ultrarational Age of Enlightenment, in such a bizarre image as this can only be interpreted as ironic in the extreme.

Less inspired, but no less humorous figure-ground errors are relatively common in amateur photographs; lampposts seem to

Figure 4.10 Slave Market with the Disappearing Bust of Voltaire (1940) by Salvador Dali. (Salvador Dali Museum) Ambiguous figure-ground effects are manipulated by the painter to produce ghostly secondary images. The bust of Voltaire in the foreground is formed from the figures standing in the archway. (Dali/Salvadore Dali Museum, St. Petersburg, Florida).

sprout from the head of a person standing in the foreground, or tree branches will seem to enter their one ear and come out the other.

Closed versus open compositions

Most representational paintings present us with a scene viewed through a timeless window. Some of these scenes look as if they were staged solely for our benefit where every figure is carefully posed within a clearly delineated space, rather like actors posing self-consciously upon a stage. In these **closed compositions,** the entire image seems to exist solely for the benefit of the viewer; there are no visual loose ends. The composition is considered closed, like a sealed box, because all the pictorial elements are completely contained within a clearly delineated space, usually an interior, or a courtyard. Often there is one principal subject in a closed composition, toward whom all of the action is directed. (Compare this idea with the concept of *classical space,* page 78.) *Closed compositions convey the feeling that their subjects stand apart from the world of mundane events.*

An **open composition,** in contrast, reminds us that we are seeing only one small portion of a larger whole. In contrast to the closed composition's aura of artificial timelessness, an open composition conveys an informal immediacy, like a spontaneous, casual snapshot. The world itself, a small part of it at least, becomes the subject in such a painting and, consequently, pictorial boundaries in an open composition are not so rigidly fixed. Figures at the edges may appear to be stepping into (or out of) the limits of the painting, like disinterested passersby caught in a photograph, or their attention may be directed toward something that obviously lies outside the composition. In an open composition the artist draws our attention to a scene but reminds us that a larger part remains unseen, beyond the limits of the canvas. (Compare this idea with the concept of Romantic space, page 78.) *Open compositions convey the feeling that their subjects are very much a part of the world, rather than separate from it.*

Such distinctions as these, which may at first seem overly refined, become important when an artist must decide how to portray a particular subject or theme. An open composition might be eminently suitable for a moody painting of Parisian nightlife, for example, whereas a closed composition might be the better choice for a more solemn work depicting, say, the martyrdom of a saint.

Proportion

Proportion may be defined, for our purposes, as the relative sizes of elements in a composition. Among the early civilizations of Mesopotamia and Egypt, size was equated with greatness. Kings were represented as "giants among men" in the literal as well as the figurative sense. Later, Greek artists of the classical period devised canons of proportion through which they hoped to achieve a perfect, and therefore godlike, human figure. The ancient Greek mathematician Euclid (c. 300 B.C.) formalized a geometric principle known as the **golden section,** for dividing a line or rectangle into two or more harmonious parts. Even well into the Renaissance, artists and philosophers attributed almost magical properties to Euclid's golden section and frequently used it as the underlying principle in their compositions. (See Figure 4.11.)

Artists in our own time are more inclined to rely upon their own aesthetic judgment rather than upon some presumed formula for perfection, however illustrious its history may be.

The proportional problems faced in sculpture are subtly different from those encountered in painting. Sculptures produced in bronze or marble must compensate for their lack of realistic color with increases in the proportional size of some details. For example, when a face is carved in an essentially colorless white material like plaster or alabaster (a statuary marble), the result is often unconvincing. The portrait sculptor does not produce a strict likeness of his or her subject in the sense that we usually think of an exact copy, like that produced by a three-dimensional pantograph machine. Instead the sculptor must be sensitive to all the distinguishing features that give a face its uniqueness: the subtle flush or palor of the face, the color and intensity of the eyes, and so forth. To compensate for the lack of contrast in the sculptural material, the sculptor must exaggerate the size of features such as strikingly red lips or deeply colored eyes. The end result is often a subtle caricature of the subject rather than a strict point-for-point likeness. The same adjustments must be made, though to a lesser degree, in a portrait sketch done exclusively in black pencil or charcoal on a white ground.

When working on a sculpture for eventual casting in bronze, a novice sculptor will frequently be astonished (and sometimes dismayed) to see how different the finished sculpture looks when it has been transformed from the weightless white of the plaster

Figure 4.11 THE GOLDEN SECTION. *A line is divided in such a way that the ratio of the smaller part to the larger part is the same as the ratio of the larger part to the whole (as AB is to BE, so BC is to AC). The golden section is discussed in detail in Euclid's Elements, ii, 11.*

model to the heavier-looking finished bronze. The same forms that looked so elegant and etherial in the pristine whiteness of plaster may suddenly appear heavy and awkward when translated into metal. Consequently, many sculptors paint their plaster models to simulate the surface finish of the final bronze cast to catch potential problems at a stage when they can still be corrected.

The strangeness of the *Parthenon*

Proportion plays a similarly important role in architecture in such subtle and complex ways that some structures seem more like sophisticated large-scale sculptures than dwellings. The Parthenon of ancient Greece (completed 438 B.C.), perhaps the most paradoxical structure ever made and certainly one of the most studied buildings of all time, provides an excellent case in point. Designed as a temple-monument dedicated to Athena, goddess of wisdom, the Parthenon's architectural program is a virtual essay on perception and illusion. But before we examine the Parthenon in detail, let us first review briefly the events leading up to its creation.

In the years before the Parthenon was constructed, Athens won a series of decisive battles against the Persian Empire, its longtime military rival, by routing the invading Persian forces under Xerxes at the battle of Marathon (490 B.C.) and later in an epic naval engagement just off Salamis (480 B.C.). Reconstruction of the old Greek temples was ordered by Pericles in 449 B.C. in commemoration of these decisive victories. The Parthenon was among these new structures rebuilt upon the foundations of the older destroyed temples. (See Figure 4.12.)

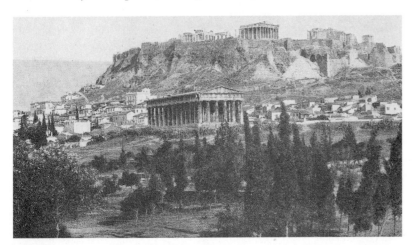

Figure 4.12 *View of the Acropolis in Athens as it appeared about 1900. The Parthenon, partially reconstructed, is visible at the top of the hill. (Photo: Kunstgeschichte in Bildern I)*

Figure 4.13 The Parthenon, partially reconstructed. View from the northwest. (Photo: Kunstgeschichte in Bildern I)

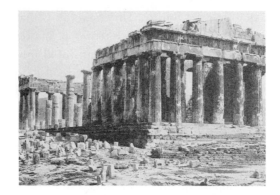

Figure 4.14 An analytic section through the PARTHENON's facade, revealing its underlying structural details. (Illustration: Weltgeschichte der Kunst)

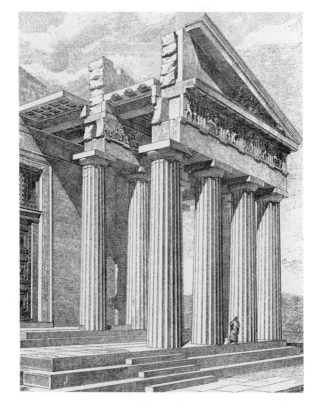

The Parthenon is situated atop the large, mesalike hill called the *acropolis* (*acro* = hill + *polis* = city), a sacred site within the city of Athens. The architect Iktinos (a nickname meaning "the Kitebird") was entrusted with the architectural program. All sculptural decoration was under the supervision of the eminent sculptor Phidias. The ancient historian Herodotus mentions another architect, Callicrates, as having had a hand in the design, though current scholarship on this point is less certain. The architect of the Parthenon had two aims in mind, one religious, one

practical: provide a temple-monument to the goddess Athena in thanks for her presumed help in defeating the Persians, and provide a treasury building for the confederation of Greek city-states united against potential aggressors.

Strangely enough, although its plan appears straightforward, like a typical rectangular temple of the early Doric type, the Parthenon's overall design incorporates some very unusual features. The platformlike steps upon which the outer columns rest curve downward slightly toward the corners, an intentional deviation designed to offset the illusion of sagging in the middle that occurs whenever a long, low structure is viewed from a distance. Tour guides illustrate this curvature and, at the same time, indulge in a bit of showmanship by placing at one corner of the building a woman's glove or some other small object which, of course, disappears when viewed from the other end. The actual curvature of the upper step or *stylobate* amounts to only a few inches over all, but it is enough to produce this illusion and, more importantly, to prevent the building from appearing to sag unaesthetically at its middle.

The columns, carved from stacked drums of honey-colored marble quarried from Mount Pentelicus, are fit together with dowels and carved so as to bulge slightly at their lower ends as if compressing under the load of the spanning stone lintels. This bulge, called *entasis,* emphasizes the mass of the lintel and counters the illusion of the roof appearing to sag, which would have been intensified had straight-edged columns been used. (See vignette.) While the diameters of the columns and the spaces between them appear to be constant, in fact, they are not. The corner columns are thicker and spaced more closely together to compensate for being seen against the open expanse of sky, the contrast effect of which tends to distort perceptions of relative size and distance. Moreover, the columns are all tipped very slightly inward so as to eliminate the leaning-wall illusion that occurs when one looks straight up at a looming facade. It has been estimated that if the vertical axis of each column were extended into space, they would all intersect roughly a mile above the structure.

Subtler deviations from precise geometric regularity are also evident in the small, decorative reliefs consisting of three vertical bars called a *triglyph,* which are thought to refer back to the days when temples were roofed by laying timbers across the spanning lintels. The triglyphs, which symbolize the ends of those spanning

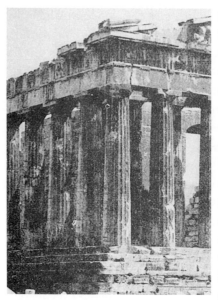

Figure 4.15 *Corner detail of the Parthenon showing placement of the triglyphs. (Photo: Kunstgeschichte in Bildern I)*

roof timbers, are spaced so that there is a triglyph centered exactly above each column and a triglyph set exactly between each pair of columns except at the corners, where this system of spacing breaks down. (See Figure 4.15.) Rather than attempt to bend the triglyph around the corner (an awkward solution at best) or center the triglyph over the corner column and leave a blank space dangling at the edge (also an unsatisfying solution), Iktinos let this strange little error stand as if in a gesture toward the ultimate imperfectability of gross matter.

A philospher friend of mine once remarked that the ancient Greek philosophers did not distinguish between things that were perfect and things that only appeared to be perfect. To their way of thinking, a thing's degree of perfection had to be directly related to its physical beauty. There could be no ugly perfect thing because ugliness is an imperfection. By the same token it was thought that every beautiful thing had to be closer to perfection; an imperfect thing could not masquerade as something higher than itself. In other words, it was not enough for something to be perfect, it also had to *look perfect,* too.

The Parthenon achieves its compositional perfection, oddly enough, through a strange set of paradoxes: Surfaces are curved in order to make them appear straight, columns are widened in order to make them appear the same size as all the others, or are tipped in order to keep them from appearing to tip. These unusual adjustments demonstrate not only the design skill of the Parthenon's builders, but also the pervasiveness of philosophical thought in every aspect of ancient Greek art and life.

It should be noted that the Parthenon as we know it today differs considerably from the original appearance of the structure. The gabled roof was once tiled with white marble and most of its architectural details, as well as the relief panels, were painted. Decorative bronze accoutrements (such as reins for the horses)

were attached to the stone reliefs. The building's fragmentary condition is partly due to the fact that during the seventeenth century it was used by the Turks as a storehouse for cannon ammunition and was nearly destroyed when it took a direct hit during a Venetian artillery bombardment. At present, even in its incompletely reconstructed state, the Parthenon's compositional details reveal to us many significant aspects of ancient Greek thought and culture, thus demonstrating the ability of artworks to function as cultural texts—essential repositories of cultural knowledge.

A formal analysis of David's *Oath of the Horatii*

Thus far we have examined the various formal elements and principles of composition used to create works of art. Let us now examine how these elements and principles interact in a finished painting. An analysis of this type, which focuses on the formal elements of a work and how they have been brought together, is known as a *formal analysis*. Some aficionados resent the postmortem tone of such analyses, as if talking about how the art was made somehow makes all the magic go away. On the contrary, a good analysis can reveal unexpected dimensions of complexity and meaning within a work, thereby broadening rather than diminishing our knowledge and appreciation of it.

Most published formal analyses are highly detailed, exhaustively documented treatises written by art historians expressly for other art historians. But if we strip away all the abstruse jargon and the intellectualistic digressions, we are left with one simple idea: *Take a very close look at a painting and tell others what you've noticed about it.* The section which follows is a formal analysis of Jacque Louis David's painting *Oath of the Horatii.* It is offered as one useful model, though certainly not the only one, of how to approach an analysis of this type.

Let us begin our analysis with a close look at the work in question. Take a few moments to look carefully at all its details. Art instructors often go to great lengths to get students to appreciate the necessity of *seeing,* a term artists utter in tones of great reverence. We have all experienced, at one time or other in our lives, the phenomenon of cognitive dissonance when we've looked directly at something but didn't see it because we didn't want to see it. Perhaps it was the dental appointment you had written on your calendar yet never noticed, even though you must have glanced at it a dozen times a day. For some individuals, cognitive dissonance develops into a more generalized resistance to seeing what is before their eyes; they see only what they want to see or expect to see and mentally dismiss anything unusual or unexpected. It sometimes takes quite a lot to jolt such complacent personalities from their state of visual inertia. That is why drawing instructors sometimes insist that a scene be drawn upside down, or in its mirror image, in order to force students to see the scene before them more completely. Similarly, many painters find it helpful to check their work in a mirror or view it through a reversing lens, either of which causes unnoticed mistakes to become immediately apparent.

As an exercise in seeing, let your eyes wander for a few moments through David's *Oath of the Horatii.* (See Figure 4.17.) Examine the painting as if you were describing it to a friend who has never seen it. Begin with basic concrete facts: What is the subject? What sort of materials have been used? How are the figures arranged? Is this an open or closed composition? Is the style realistic or stylized? Try to unravel the mechanics of the piece as well, that is, how the artist has organized the image using concepts such as repetition and contrast, implied lines to structure the composition, and so forth. In a formal analysis *you are essentially reconstructing the decisions made by the artist during each step in the process of the work's creation.* By stepping into the role of the artist,

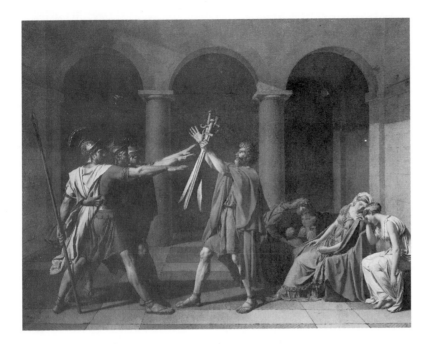

Figure 4.17 Oath of the Horatii (1784) by Jacques Louis David. Oil on canvas, approximately 11' X 14'. (Louvre Museum, Paris) (Photo: Erich Lessing Art Resource, NY.)

we are able to come to a more complete understanding of the work than would be possible merely through casual observation alone.

It is important to bear in mind that all works of art are the products of individuals working within a cultural system whose values and beliefs might not necessarily be the same as our own. Any good analysis is sensitive to the possibility of misreading a painting's text because of these cultural differences; therefore, it is always desirable to locate the artwork under analysis within a specific historical frame of reference. We know, for instance, that Jacques Louis David lived during one of the most turbulent eras in European history (1748–1825), the period of the French Revolution. During his early career he did commissioned works for King Louis XVI of France, then later switched his allegiance to the revolutionaries. By midlife, David's social status was important enough to gain him membership in the Republican Convention, the new provisional governing body of France, where in 1793 he voted for his former patron's execution! Later, during his tenure as "First Painter of the Empire" under Napoleon Bonaparte, David established a stern and scholarly academic style whose influence lasted well into the nineteenth century.

We know that *Oath of the Horatii* was painted in 1784 (five years before the French Revolution) and that social conditions during that period in France were particularly harsh. These few

facts already shed light upon the stoic simplicity of the painting, which probably was intended to inspire in its viewers the same stern dedication to their patriotic cause—whatever the cost—that also inspired the ancient Romans.

David's early studies in Rome left him with a strong neoclassical orientation. Never content to produce simply decorative paintings, many of David's works of the 1780s are monumental epic paintings that speak in manifestolike tones of the importance of self-sacrifice for a higher patriotic cause. One of David's principal influences was the great neoclassical painter Nicholas Poussin, who believed that true artists choose only grand themes for their art. (It is no small irony that David was the great nephew of Françoise Boucher, a well-known rococo painter who specialized in light, dreamy little paintings whose themes revolved around the vicissitudes of courtly love.)

History tells us also that David's *Oath of the Horatii* was inspired by a scene from one of Pierre Corneille's plays concerning a famous episode from Roman history. In this episode two warring clans, the **Horatii** of Rome and the **Curiatii** of Alba, agreed to settle a conflict by sending three sons from each family to duel to the death—winners take all. David alludes to the source of his inspiration by arranging the pictorial space like a shallow theatrical stage or *proscenium*, immediately giving us a context in which to frame the events we see enacted there. The scene before our eyes, David tells us, is a noble legend: Three Horatii sons swear to fight to the death for their family honor and the survival of the state. The father Horatius Proclus blesses their swords while one of the Horatii sisters, whose fiancé happens to be one of the three enemy Curiatii brothers, swoons in misery, her hand pressed to her forehead in a pantomimic gesture of woe. While the painting ostensibly represents an episode from Roman history, it also portrays through that distant metaphorical mirror the actual conditions in prerevolutionary France where people were called upon to face analogous situations in their day-to-day lives. To the people of nineteenth-century France, David's painting offered courage by telling them, in essence, that what they were living through was the stuff of which great legends are made.

Now that we have established a basic historical frame of reference for this artwork, let us examine its formal features. First, and most obviously, some viewers may be put off by the fact that *Oath of the Horatii* is not a particularly pretty painting. Its sparse

composition and subdued colors—mostly elemental, muted primaries and neutral shades of brown and grey—echo the somber mood of its theme and convey a sense of what the Romans called *gravitas,* the feeling of being in the presence of humbling greatness. David's painting invites us to witness a great moment in human history.

The painting is, like its theme, monumental in scale (almost 11 feet high by 14 feet long), its figures slightly larger than life. Like all David's works, this painting has an immaculate surface finish— smooth as velvet—one of David's trademarks. This smooth surface allows the actual painted canvas (or *picture plane*) to go unnoticed, thus strengthening the illusion of space presented by the realistic composition. The pictorial space is organized in straightforward one-point perspective (evident in the floor orthogonals), which lends a sense of bold, classic simplicity to the composition.

The figures are arranged in a kind of slashing diagonal pattern that cuts across the entire foreground. Notice how the straight blade of the sword is continued in the lines of the floor immediately below its tip, and how the father's upraised arm creates a mirror-image complement to this angle which is, again, picked up by the pattern of the floor tiles, thus creating a virtual triangle in the center of the composition. This triangle is repeated in the stance of the three brothers and echoed in the angular space between the sons and their father. Another angular shape appears in the pyramidal arrangement of the two daughters who lean toward one another exhausted by grief. The stark, somewhat brittle sunlight emphasizes the figures in the foreground, much like a theatrical spotlight, while a shadowy figure—perhaps a premonition of death—gathers two children into the protective folds of her blue mantle (only one of the Horatii sons will survive the contest). The older child prys away the cloaked figure's shielding hand, as if in defiance of her admonition to look away.

The visual tension of the foreground diagonals is relieved by the curved regularity of the stone arches, whose quiet presence in the background suggests a transcendent order which will endure amidst all this chaotic human activity. The three arches divide the painting into three neat compartments, each of which contains a primary element of the drama about to unfold: the resolute sons raise the old Roman salute, their arms outstretched like the three heads of the mythological Cerberus, guardian at the gates of Hades; the father, wearing the scarlet cloak of the Roman patrician class,

stands as the embodiment of the call to patriotic duty; while the daughters function as allegorical figures of pain, loss, and mourning. Everywhere forms echo other forms: The sons' helmet crests repeat the curves of the arches; the sons' foreshortened hands and arms echo the sword blades; the limp swath of gown beside the woman in white repeats the limpness of her arm. These repetitions weave the pictorial elements together and help sustain our visual interest.

We notice that David uses a basic value contrast of light versus dark to draw our eyes to the bright foreground figures (this effect is particularly obvious in black and white photos of the painting) which causes the figures to stand apart from the darker background like the rounded figures in a relief carving. The relatively pure hue of the father's red cloak, contrasted with the cooler neutral shades of the background, thrusts him into visual prominence. Similarly, the white gown of the grieving daughter and the white cape of the foremost son balance one another, like the pans on a balance scale, and draw our attention secondarily to these two figures.

Every feature of the painting is handled with great precision and economy; even the arrangement of the shadows is used to further the overall composition. Lay a ruler or straightedge along any of the prominent lines and you will see it echoes the stance of a nearby figure, completes an implied line, or leads back to the centerpoint (i.e, the vanishing point) of the composition where the father holds the joined swords, establishing the painting's theme of conflict. While not all artworks, of course, are this tightly organized or rigorously developed, *Oath of the Horatii* stands as one example of how carefully the individual elements in a painting can be controlled and their subtle characteristics harnessed to express the meaning of the work.

We have seen how artists use the various principles of composition to give order and intelligibility to the raw materials of their craft. The following section will survey some of the most well-known and historically important works of art, demonstrating the almost infinite diversity of these forms of expression.

Chapter 5

A Survey History of Art in Synopsis Form

Preliminary comments

In a simplified version of the history of nations there is, during any given era, one political state that enjoys *hegemony*—that rare combination of dominance and leadership—over all the rest of the world. England enjoyed such a period of hegemony during the days of the wooden sailing ships when its conquests were so far-flung that "the sun never set upon the British Empire." The history of art, however, does not always coincide with the history of nations; sometimes the same artistic trends can be discerned among rival nations, or the art of a conquered people might live on in unexpected ways to influence the artistic style of their conquerers.

Like the history of nations, however, the history of art also presents a roll call of artistic styles that have enjoyed some degree of *cultural hegemony* over all the rest. It is important to remember that such a view of history is always incomplete; while medieval stonemasons were carving the gargoyles on the cornices of their cathedrals, samurai swordsmiths on the other side of the world were hammering out an entirely different cultural tradition.

It should be remembered, therefore, that when we look at works from the past or from other cultures, we view them though the distorting lens of our own cultural ideology. Ethnographer Gary Witherspoon presents a good example of this phenomenon in his book *Language and Art in the Navajo Universe*, where he points out that in Navajo culture nature is conceived of as an animistic heirarchy in which even wind, water, and stones are endowed with an elemental life

force. In the Navajo universe it is impossible for a lower form of life to act meaningfully upon a higher form. Thus, the English phrase "the horse kicked the man" has no literal equivalent in Navajo because it suggests the impossibility of a lower form (the horse) acting upon a higher form (the man)—a clear violation of their basic worldview. The Navajo translation of the phrase would convey the sense that the man *allowed himself* to be kicked by the horse, or perhaps even that he *wanted himself to be kicked* and used the horse as the instrument through which he accomplished *his* action.[1] This is a surprising departure from our "standard" Western-European interpretation of reality. When examining material artifacts from other cultures we must likewise be sensitive to analogous problems of translation.

A note on format

The survey presented here traces the most significant high-water marks in the Western and selected non-Western cultural traditions (i.e., those most often mentioned by historians) presenting them in a factual, rather than interpretive manner.

The dates given for each civilization are the most reliable estimates available based upon current published scholarship. The reader is advised, however, that the dates of earlier civilizations are always somewhat tentative. The **radiocarbon-14 dating** technique, which involves measuring the amount of undecayed radioactive carbon-14 present in organic remains, has been shown to involve a rather large degree of uncertainty that increases in proportion to the age of the artifact. Future research methods will no doubt provide a greater degree of precision. **Dendrochronology**, which dates wooden objects through a close examination of the seasonal variations in the wood's annular rings (indicating drought/wet periods), is one recently developed precision method of dating ancient artifacts.

It is common practice among archaeologists and historians to divide a civilization's life span into old, middle, and late periods roughly corresponding to that culture's emergence, maturity, and decline. I have adopted this standard in instances where such information might prove useful to a casual observer. In most other instances, however, the dates simply reflect the culture's period of peak attainment, its artistic "golden age."

[1] *Gary Witherspoon, Language and Art in the Navajo Universe (Ann Arbor: University of Michigan Press, 1977). See especially Chapter 3, pp. 67–68.*

I. The Stone Age
(c. 15,000 B.C. to 1300 B.C.)

PALEOLITHIC ART (*paleo* = old + *lithos* = stone; the "old stone tool age") is the art of seminomadic CRO-MAGNON HUNTERS (c. 15,000 B.C. to 10,000 B.C.). Its subject matter is closely linked to the struggle for survival in a harsh and unforgiving environment.

Cave drawings of the late Paleolithic period predate written language. The artists may have been medicine men or **shamans** within their tribal groups. The lives of these primitive men were, as Thomas Hobbes so succinctly observed in *Leviathan,* "... nasty, brutish, and short," which makes their accomplishments seem all the more remarkable.

Cave drawings and paintings are believed to have been associated with rituals ensuring the success of the hunt through HOMEOPATHIC MAGIC, the idea that "slaying" an animal by defacing its image would magically insure success in the hunt. Images are rendered with remarkable sensitivity yet, paradoxically, newer drawings frequently overlay older ones in a haphazard manner. The isolated locations of the drawings and the fact that most images depict only prey animals suggest that these images served a religious purpose, rather than being merely instances of visual storytelling or decoration for its own sake. (See Figure 5.1.)

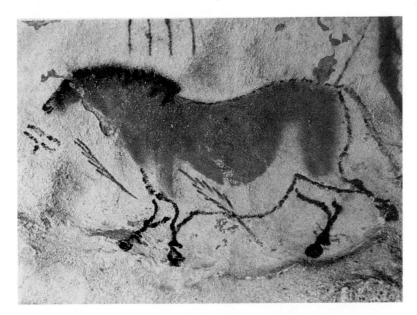

Figure 5.1 PALEOLITHIC. The Chinese Horse, *Lascaux (c. 15,000 B.C.)* (Hans Hinz, Basel, Switzerland. Photo: Art Resource, NY.)

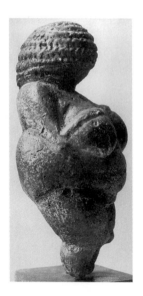

Figure 5.2 PALEOLITHIC. The Venus of Willendorf (c. 25,000 B.C.). Cast of original; palm-size. (Photo: Foto Marburg Art Resource, NY)

Contour drawings (with raw charcoal, lead, or manganese) on cave walls tend toward simple profile illustrations but feature instances of *conceptual perspective* (i.e., showing both antlers of a deer seen in profile when strictly speaking only one would be visible, or depicting known-but-unseen details, such as the skeleton beneath an animal's hide). Drawings were colored with iron-oxide ores in mainly red, brown, and ochre hues, using blowpipes or simple daubers. Highly abstracted FETISH statuettes, carved in the round or in relief, exaggerate anatomical features associated with fertility (enlarged breasts, hips, and sexual organs) presumably to evoke homeopathic fertility in the tribe or bearer. Most artifacts tend to be small, easily portable objects suited to Cro-Magnon's seminomadic existence. Fist-sized stone or bone objects or statuettes are typical. Small implements and tools (stone scrapers, hand-axe heads, and so on) and rock carvings are found throughout Europe, southern England, and North Africa. (See Figure 5.2.)

Principal locations of cave complexes dating from c. 15,000 B.C. are in the Dordogne region of France at **Lascaux** (discovered 1879) and in Spain at **Altamira** (discovered 1940) as well as at other sites scattered throughout Europe. During the Paleolithic era, marshes and landbridges connected Britain, continental Europe, and Africa allowing African savannah animals to migrate northward into continental Europe.

MESOLITHIC ART (c. 10,000 B.C. to 8000 B.C.) comprises a transitional stage between the nomadic hunting groups of the Paleolithic era and the more permanent agricultural settlements of the later Neolithic era.

Rock paintings, drawings, and **petroglyphs,** images incised into rock, are found on exposed cliff surfaces and on sheltering rocky overhangs. Most Mesolithic images are reminiscent of earlier cave drawings, tending toward simple contour illustrations shown in profile aspect, but are distinguished from earlier works by their storytelling intent.

NEOLITHIC ART (c. 8000 B.C. to 1300 B.C.) is associated with the development of permanent agricultural settlements at scattered sites throughout the Near East, Britain, Europe, and the Americas.

In Europe: Colossal stone monuments called **megaliths** (*mega* = great + *lithos* = stone) stand as evidence of humankind's transition from a nomadic hunter-gatherer mode of existence to a

way of life based more firmly upon permanent agricultural settlements. Megaliths were often erected in alignment with rising or setting positions of the sun on astronomically significant days, such as the vernal or autumnal equinox marking the beginning of the seasons of spring and fall. These complex alignments attest to the rising importance of agriculture and fertility rituals associated with the crop cycles. Two of the most famous are those at **Stonehenge** (England) (see Figure 5.3) and **Carnac** (France).

In the Near East: Fortifications at **Jericho** at the southern end of the Jordan River Valley (c. 8000–7000 B.C.) include a 5-foot thick brick wall over 12 feet high and a circular tower 30 feet tall with a 30-foot diameter. Excavations at **Hacilar** and **Çatal Hüyük** in Anatolia (c. 6000 B.C.) reveal a Neolithic culture spanning 800 years. There were no streets at Çatal Hüyük; the modulelike mudbrick buildings, with simple rectangular rooms, were all interconnected by common walls for easy defense. Simple landscape murals and numerous ritual shrines (to an unknown bull deity) are found within.

Clay statuettes from Çatal Hüyük resembling the ample-figured VENUS OF WILLENDORF (p. 126) probably depict a fertility goddess. Wall Murals, depicting groups of hunters, resemble Mesolithic rock-shelter paintings. Decorated human skulls found at Jericho called **spirit traps** (vessels for the souls of departed ancestors) suggest cults of ancestor worship. Decorative **petroglyphs,** incised images on stone, often cover an entire surface leaving no spot untouched, a style typical of primitive decoration called **horror vacui** (i.e, abhorrence of the void).

Figure 5.3 *NEOLITHIC. Stonehenge, near Salisbury, England. (about 100 feet in diameter) (Photo: Pronm Art Resource, NY.)*

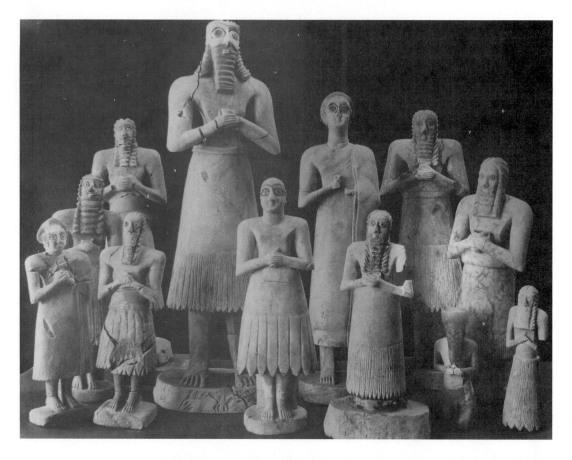

Figure 5.4 SUMERIAN. *Votive Figures. (c. 2700 B.C.). Marble, from Tell Asmar. Arms are folded in attitude of prayer; note characteristic eyes and frontal stance. (Photo: Courtesy of the Oriental Institute, of University of Chicago)*

II. Principal Civilizations of Mesopotamia (c. 3000 B.C.–300 B.C.)

MESOPOTAMIA means, in Greek, "between the rivers" (Tigris and Euphrates). The ancient kingdoms of Mesopotamia encompassed the riverbed plain north of the Persian Gulf, corresponding roughly to contemporary Iraq (see map, inside front back cover). The periods spanned by the Mesopotamian civilizations are often subdivided into the **Bronze Age** (c. 3500–800 B.C.) and the **Iron Age** (c. 800–300 B.C.).

Several civilizations rose to prominence in this semiarid region during this period, including those of Sumer, Akkad, Babylon, and Persia. The culture of **Sumer,** in particular, served as the model or paradigm from which most later Mesopotamian cultures derived. The Sumerian representational style, especially its use of SIMULTANEOUS PERSPECTIVE (also called SIMULTANEOUS PROFILE)

which combines profile and frontal views of the figure, was widely emulated throughout the region. The bull, due to its sheer physical power and virility, appears frequently as a cult symbol in most ancient cultures.

SUMER (c. 3200–2300 B.C.) [pronounced *"soo* -mare", although *"shoe* -mare" is perhaps more authentic] comprises a loose grouping of cities in the region where the rivers Tigris and Euphrates converge. Principal city sites have been discovered at Ur (="doorpost"), Lagash (="treasury"), Eridu, and Uruk (now called Warka).

The Sumerians are the first of the great Mesopotamian civilizations and roughly coincide with the ancient Egyptian culture. The Sumerians are credited with several significant cultural inventions including (1) the invention of written language [**cuneiform**], (2) the concept of the city-state, (3) an organized religion based upon the propitiation of powerful gods (such as MARDUK, creator of humankind and king of the gods), (4) the introduction of the hand-turned potter's wheel, and (5) further improvements in observational astronomy.

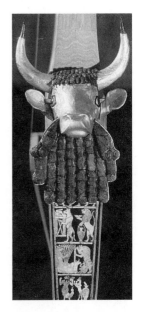

Figure 5.5 SUMERIAN. *Harp with inlay soundbox (c. 2600 B.C.). Wood, lapis lazuli, gold leaf. (The Granger Collection)*

Sumerian art, like all Mesopotamian art, exists in service of religion and the absolute ruler-king. Carved and painted VOTIVE FIGURES (i.e., prayer statues) are easily identified by their rigid, frontal stance, hands folded across chest in an attitude of solemn prayer. (See Figure 5.4.) Eyes are exaggerated, wide and staring, and outlined in black. The BEARDED BULL, perhaps representing a legendary god-hero, is a frequent design motif, and often appears humanized with a coil beard. Decorative Inlay work in shell and/or semiprecious stone (such as deep blue lapis lazuli) adorns objects with images of legendary and mythic characters. (See Figure 5.5.)

Relief figures are depicted in SIMULTANEOUS PERSPECTIVE which combines frontal and profile views. Some reliefs depict a sequential narrative, somewhat like a comic strip, a pictorial innovation certainly inspired by the development of written language.

Sumerian representational styles are highly formalized, exhibiting little variation from one piece to another, even during more naturalistic periods. Most later Mesopotamian civilizations borrowed freely and heavily from the distinctive Sumerian style, making it a prototype for artworks of this region.

Among the significant architectural works of this region, now

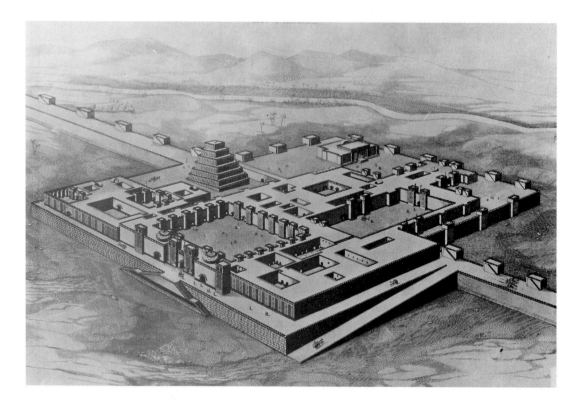

Figure 5.6
MESOPOTAMIAN. A ziggurat. Originating from Sumerian temple designs, ruins of ziggurats are found throughout ancient Mesopotamia. This example (from Khorsabad) has a spiral ramp leading to the top; other designs featured long, ramplike stairways. (Illustration: Denkmäler der Kunst)

lost, is the fabled **Tower of Babel** (see Figure 5.6), a mudbrick ZIGGURAT (step-pyramid) at Babylon dedicated to the god MARDUK, creator of humankind and head of the Babylonian pantheon. The Greek historian Herodotus (c. 484–424 B.C.) mentions an enormous golden couch at the top of the Tower of Babel upon which, it was said, the god Marduk often passed the night after consuming food provided by temple priests. (Herodotus, however, was also quick to point out that he himself did not believe this.) The **Hanging Gardens of Babylon,** a terraced garden cited as one of the SEVEN WONDERS OF THE ANCIENT WORLD by Herodotus, was also of this period.

III. Ancient Egypt (c. 3100 B.C.–300 B.C.)

MEDITERRANEAN SEA

UPPER EGYPT GIZA
MEMPHIS SINAI

LOWER EGYPT

ABYDOS
THEBES KARNAK

ASWAN
(1st cataract) RED SEA

NUBIA

ANCIENT EGYPT
(*circa* 3100 B.C.)

The civilization of ancient Egypt arose in the fertile river valleys bordering on the River Nile. (*Egypt* = "gift of the Nile," from the ancient Greek historian Herodotus). Before 3100 B.C., Egypt was divided into a **Lower Kingdom** which included the Nile delta, and an **Upper Kingdom** which extended south of Memphis. These two kingdoms were first united into one land by King NARMER (MENES in Greek) (c. 3100 B.C.) who established his new capital at Memphis. Important archaeological tomb sites include the Old Kingdom **pyramids** and **necropolis** at Giza, and the Middle Kingdom tombs in **The Valley of the Kings** at Thebes.

Egyptian art is concerned mainly with the ruling pharaoh (*pharaoh* = king) and his preparations for the afterlife, which was envisioned by the Ancient Egyptians as a lush vineyard. The body was preserved through *mummification* to provide a dwelling place for the vitalizing force or **ka** (not to be confused, as Yves Bonnefoy points out, with the **ba,** a ghostlike entity represented as a man-headed bird, associated with the shadow of the deceased[2]). The process of mummification traditionally included removal and separate preservation of most internal organs. The brain was removed with a long, fishhook-shaped instrument inserted through one of the nostrils. The body cavities were then washed, filled with batting and natron (a mineral salt preservative), and sutured closed. Finally, the body was wrapped in cloth bandages and placed in a **sarcophagus.**

Sculptural **ka portraits,** usually idealized, served a purpose similar to SPIRIT TRAPS. Spare body parts, like *reserve heads,* were usually provided for the deceased pharaoh's convenience, as well as carved or modeled figures of servants called **ushabti** for the pharaoh to command. Generally speaking, persons of lesser prestige and animals are represented in a more realistic manner, while those persons of greater prestige are idealized. (See Figures 5.7, 5.8.)

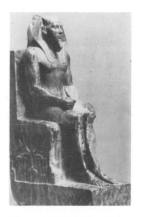

Figure 5.7 *Egyptian, Old Kingdom. Khafre (c. 2500 B.C.). Life-size, black diorite. The benevolent god Horus, pharaoh's spiritual double and protector, shields pharoah with outstretched wings (behind Khafre's head). Entwined lotus and papyrus plants, carved in relief on the side of Khafre's throne allude to the unification of the two kingdoms of Upper and Lower Egypt. (Photo: The Book of the Ancient World, p. 28)*

Figure 5.8 *Egyptian, Old Kingdom. Sheikh el Beled (c. 2400 B.C.). Wood covered with painted plaster. Persons of lesser prestige are represented in a more realistic manner (and in less expensive materials). (Photo: Weltgeschichte der Kunst, p. 30)*

[2] *Compiled by Yves Bonnefoy, Mythologies, trans. Wendy Doniger (Chicago: The University of Chicago Press, 1991.), see especially vol. 1, pp. 97if98ii.*

Figure 5.9 *OLD KINGDOM.*
Step pyramid of King
Zoser, designed by the
genius Imhotep (c. 2600
B.C.). The step pyramid was
developed from stacked
mastabas, *low tombs with*
battered (sloped) sides.
(Photo: Weltgeschichte
der Kunst)

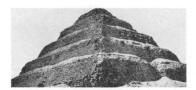

Figure 5.10 *OLD KINGDOM.*
The necropolis at Giza
(c. 2500 B.C.). The Sphinx
(center) is carved from a
spur of sandstone, 65 feet
high, 240 feet long;
pyramid of Menkure is in
the background. (Photo: A
History of Art, p. 39)

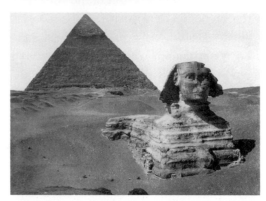

Figure 5.11 *MIDDLE*
KINGDOM. Temple of
Ramses II at Abu Simbel
(c. 1250 B.C.). Carved
sandstone, each fig. 60' hi.
During the 1960s the
entire temple was
disassembled and moved
to higher ground to rescue
it from inundation by the
Aswan High Dam project.
(Photo: Weltgeschichte
der Kunst)

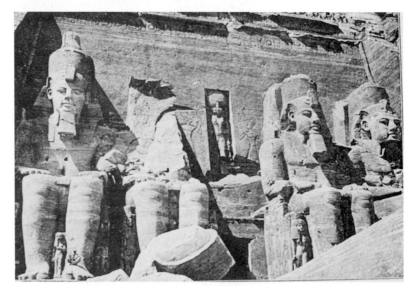

Figure 5.12 *NEW KINGDOM.*
Mortuary Temple of Queen
Hatshepsut,
(c. 1450 B.C.). The temple's
barren terraces were once
lavish gardens. (Photo:
Giraudon Art Resource, NY.)

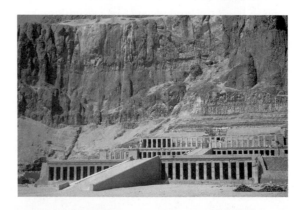

Tomb styles vary according to era.

Old Kingdom Tombs (before c. 2100 B.C.) follow an evolution from **mastabas** (low boxlike structures with sloped sides), to **step pyramids** (resembling stacked mastabas), to the massive **pyramids at Giza** (modeled after the *ben-ben*, a prism linked with the sun god Amen-Ra). An Egyptian **necropolis** or City of the Dead often included pyramid tombs, temples, as well as guardian statues of composite monsters such as the fabulous SPHINX (See Figures 5.9 and 5.10.)

Middle Kingdom Tombs (c. 2000–1500 B.C.) were essentially horizontal shafts cut directly into the rocky hillsides to confound the tomb robbers who had so easily plundered the treasure caches of the Great Pyramids. A **post-and-lintel** entrance facade was often erected at the mouth of the rock-cut tomb, along with one or more monumental carvings of the deceased. (See Figure 5.11.)

New Kingdom Tombs (after c. 1500 B.C.) consist of elaborate **mortuary temples** placed at some distance from the actual burial site. (See Figure 5.12.) The **sarcophagi** (burial boxes) often bear a sculptural or painted image of the person contained within; those of the pharaohs were often fashioned of gold and other precious materials. The EYE OF HORUS painted on the exterior of a burial box allowed the deceased to see out with spiritual vision.

The Egyptian figural style of **simultaneous perspective** (frontal eye and torso, profile face and legs) is more elegant than the earlier Sumerian style and derives from the Palette of Narmer reliefs which set the standard for all later figural work. (See Figure 5.13.) Egyptian art is highly formalized, carved in accordance with mathematical **canons of proportion** presumed to yield an ideal figure.

Eye of Horus

Ankh, a symbol of eternal life

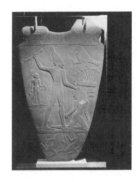

Figure 5.13 Palette of Narmer (c. 3000 B.C.). Intended for mixing eye makeup, its reliefs established the Egyptian representational style of simultaneous profile. Slate relief, about 2 feet high, shows Narmer overcoming foes to unite the Upper and Lower Kingdoms in 3100 B.C. (Photo: Art Resource)

Figure 5.14 Psychostasis painting (The deceased's heart weighed against the feather of truth). Old Kingdom Papyrus, about 30 inches high. (Photo: Geschichte der Bildenden Künste)

Tomb frescoes often depict the rites of passage into the afterlife. Typical among these is the so-called PSYCHOSTASIS (soul-balancing) PAINTINGS in which the deceased's heart is weighed against the **feather of truth** while a hybrid crocodile-demon looks on, ready to devour the unjust. (See Figure 5.14.) The Egyptian

Principle Gods of Ancient Egypt

Name	Representation	Role
(a) AMEN-RA	Bearded man with double crown	King of the gods, lord of heaven and earth
(b) OSIRIS	Green human mummy with bottle-shaped crown of Upper Egypt	Lord of the netherworld
(c) ISIS	Woman with vulture headdress (also appears winged, or with bull horns)	Wife of Osiris and mother of Horus
(d) HORUS	Falcon-headed man	Sky god, pharaoh's spiritual double and protector
(e) ANUBIS	Jackal-headed man	Guardian of underworld, taught secrets of mummification to man
(f) THOTH	Ibex-headed man	Scribe of the gods
(g) HATHOR	Black-haired woman	Goddess of beauty, divine avenger
(h) SEKHMET	Lion-headed woman	Goddess of fire and war
(i) NUT	Arched female body covered in stars	Great mother, sky goddess
(j) MA'AT	Woman with staff and *ankh*	Goddess of truth, order, moral law

pantheon includes over 1,000 gods, many of whom appear in several different aspects or guises. The most commonly represented are depicted in Figure 5.15 along with their respective roles.

Ancient Egyptian history is divided into *dynasties* that correspond to the life span of a royal line of rulers; the last dynasty (XXXI) ended with the conquest of Egypt by ALEXANDER THE GREAT about 330 B.C.

Other significant pharaohs include:

Rameses II (Old Kingdom, 1317–1250 B.C.) Great statesman and builder of the famous temple at ABU SIMBEL.

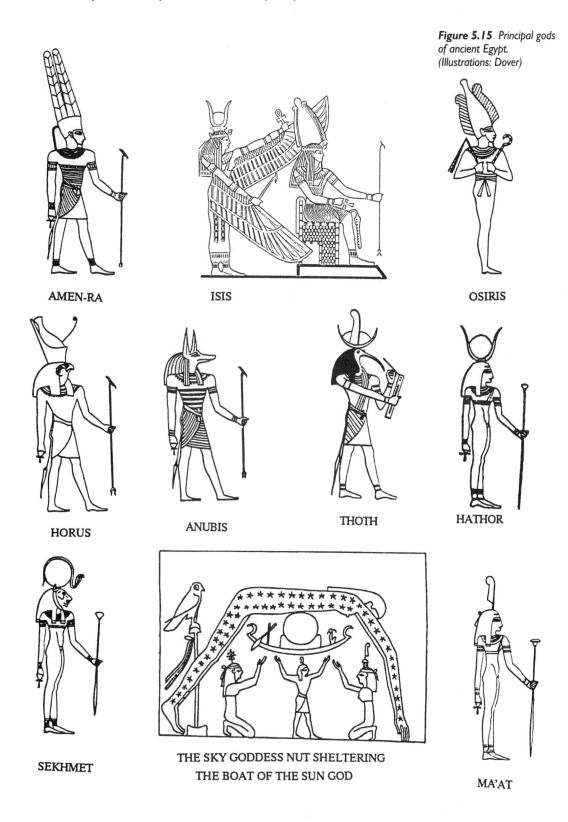

Figure 5.15 *Principal gods of ancient Egypt.*
(Illustrations: Dover)

AMEN-RA

ISIS

OSIRIS

HORUS

ANUBIS

THOTH

HATHOR

SEKHMET

THE SKY GODDESS NUT SHELTERING
THE BOAT OF THE SUN GOD

MA'AT

Figure 5.16(a) NEW KINGDOM. King Smenkhkare (and Meritaten?) (c. 1350 B.C.). *Compare the relaxed style of this work (from the era of Akhenaton) with the formal rigidity evident in the portrait of Seti I. (Staatliche Museen, Berlin)*

Figure 5.17(b) NEW KINGDOM. Seti I *(father of Rameses II) bearing a devotional statue of the god Ma'at (c. 1300 B.C.). Painted limestone relief from Abydos. This work, produced a few decades after Akhenaton's death, demonstrates how quickly artists reverted to the older representational style. (Photo: A History of Art)*

Khufu (Greek, Cheops), **Khafre** (Greek, Chefren), and **Menkure** (Greek, Mycerinus) all of the IV Dynasty, Old Kingdom, who built the three GREAT PYRAMIDS at Giza. (See Figure 5.7.)

Akhenaton (New Kingdom, fourteenth century B.C.) Pharaoh who introduced belief in one god called Aton. *Akhenaton* means "He is Pleasing to Aton." The relaxed and fluid **Amarna style** in Egyptian art is associated with his court. (Akhenaton is also known as Amenhotep IV.)

Tutankhamen called "Tut" (New Kingdom, 1361–1352 B.C.) A relatively minor "boy king" of the late Amarna period whose tomb was discovered remarkably intact in 1922.

Queen Hatshepsut (New Kingdom, fifteenth century B.C.) called "the first great woman of history"; writings of her period boast of how she made the Two Lands labor "with bowed back" in her name.

Relatively few stylistic changes occur in Egyptian art until the AMARNA PERIOD, associated with AKHENATON'S court at Tel el-Amarna, which introduced figures in relaxed, naturalistic poses, a startling contrast to the stiff and conventionalized figures of the earlier dynasties. Soon after Akhenaton's passing, however, artistic styles reverted to the old established ways. (See Figures 5.16 and 5.17.)

The first artist known to historians by name is the Egyptian artist IMHOTEP (c. 2600 B.C.), a figure of universal genius also referred to in writings of his period as the "father of medicine." Imhotep served as principal advisor to Old Kingdom ruler ZOSER and also as architect of Zoser's step-pyramid tomb at Saqqara.

Each year in July, when Sirius the Dog Star first reappears over the horizon, the River Nile overflows it banks and deposits rich silt upon the land. This cycle of rebirth may have inspired the Egyptian belief in an afterlife. The Egyptian *Book of the Dead* details all prayers, rites, and warnings associated with entry into the afterlife and served as the pharaoh's spiritual guidebook to the netherworld. A copy was buried with the pharaoh (an English translation is available by E. A. Wallis Budge). Common people also believed in an afterlife, but thought it merely a pale reflection of this one. Slaves and common laborers were buried facing west, knees bent in a fetal position in small pit-graves along with a few personal artifacts and vessels filled with food.

The ruined colossal statue of Rameses II at Thebes inspired the nineteenth-century poet Percy Shelley's poignant sonnet, "Ozymandias"[3]:

> I met a traveler from an antique land
> Who said: Two vast and trunkless legs of stone
> Stand in the desart...
> And on the pedestal these words appear:
> "My name is Ozymandias, king of kings:
> Look on my works, ye Mighty and despair!"
> Nothing beside remains. Round the decay
> of that colossal wreck, boundless and bare
> The lone and level sands stretch far away.

[3] *Harry Buxton Forman, Shelley's Poetical Works, Volume 1 (London: Reeves and Turner/Ballantyne, Hanson, and Co., 1882) p. 250.*

IV. Classical Greece
(fourth and fifth centuries B.C.)

The art of classical Greece existed in service of philosophical ideals expressed through reasoned aesthetic principles. Images of the Greek gods evoke the concept of humanity raised to a level of immortal physical perfection (although the myths themselves often involve all too human tales of envy, pettiness, and jealousy).

The city-state of **Athens,** named for the goddess **Athena,** became the cultural epicenter of the classical age. (The semilegendary city of **Troy,** (sacked c. 1200 B.C., also figures prominently in the Homeric myths, the *Iliad* and *Odyssey.*) Athens was finally vanquished by **Sparta,** a rival city-state of distinctly militaristic character, during the Peloponnesian Wars (431 B.C. to 404 B.C.), so named because they involved the entire southern Greek peninsula or Peloponnesus. The later cultural period under **Alexander the Great** of Macedonia (356–323 B.C.) is called the **Hellenistic era** (meaning "Greeklike"); it is regarded by some commentators as a decadent period.

The development of Greek art can be traced through several well-studied evolutionary phases and substyles, the most significant of which are outlined here.

In **ceramics** the stylistic evolution follows a progression from simple patterns to increasingly complex representational images. (1) **The geometric phase** (tenth to seventh century B.C.) featured bold geometric designs, later combined with simple black silhouette figures depicting funerary rites. (2) In the **archaic phase** (c. sixth century B.C.), Eastern influences are evident in the flowing designs and figures. The **amphora** bearing an image of Odysseus blinding the Cyclops is of this era. (See Figure 5.18.) (3) **The Black Figure style** (early fifth century B.C.) is characterized by black silhouette figures, detailed in red, against a natural clay-red ground. Linear details were drawn with a syringelike instrument. No colored glaze is used, instead a *slip* of thinned clay was applied which oxidized during firing. One artist usually fashioned the vessel, and another artist decorated it. (See Figure 5.19.) (4) **The Red Figure style** (late fifth century B.C.) depicts clay-red figures against a velvety black ground, the negative of the Black Figure style. (See Figure 5.20.) Sophisticated compositions sometimes appear in reverse, in Red

Figure 5.18
GEOMETRIC/ARCHAIC. An
AMPHORA (storage jar)
depicting Odysseus and his
men blinding the one-eyed
giant Polyphemus (seated)
by driving a sharpened
wooden stave into his eye (c.
650 B.C.). (Photo: Giraudon
Art Resource, NY.)

Figure 5.19 *BLACK FIGURE
STYLE.* Hector and Achilles
(at a game of checkers)
*(c. fifth century B.C.). (Photo:
Kunstgeschichte in Bildern I)*

Figure 5.20 *RED FIGURE
STYLE.* Odysseus and His
Companions *(late fifth
century B.C.). Athena,
Odysseus's protector,
appears as the helmeted
figure (at left) wearing a
full-length peplos.
(Photo: Einsubrung in
die Kunstgeschichte)*

Figure 5.21 *ARCHAIC. Kouros figure (c. 530 B.C.). The influence of other cultures on early Greek art is particularly evident in this work, which incorporates the distinctive "Egyptian stride" (left foot advanced, arms held rigidly at the sides). Later figures appear increasingly more naturalistic. (Compare Spearbearer by Polykleitos) (Staatliche Antikensammlungen, Munich; Photo: Weltgeschichte der Kunst)*

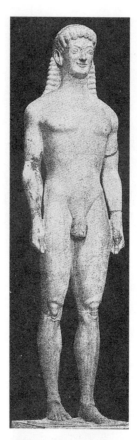

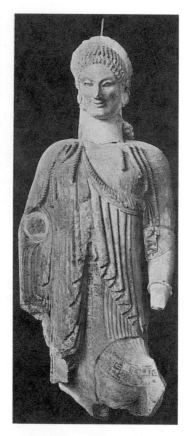

Figure 5.23 *CLASSICAL. Charioteer of Delphi (c. 470 B.C.). Bronze, cast in separate sections and riveted together. The garment folds mimic the fluting of the classical columns, against which this work was intended to be seen. This figure was originally part of a sculptural group which included a full-size chariot and horses. (Photo: Alinari/Art Resource, NY)*

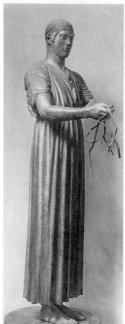

Figure 5.22 *ARCHAIC. Kore figure (sixth century B.C.). Note the "archaic smile" typical of works from this period. (Photo: Kunstgeschichte in Bildern I)*

Figure 5.24 *CLASSICAL. The Three Fates (c. 410 B.C.) from the Parthenon (east pediment); workshop of Phidias. Marble, over life-size. The drapery folds are exaggerated so as to be easily visible from ground level. (Photo: Kunstgeschichte in Bildern I)*

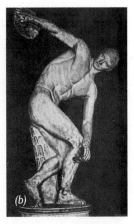

Figure 5.25(a) CLASSICAL. Dionysus (with winecup) (c. 440 B.C.) from the Parthenon (east pediment); Workshop of Phidias. Marble, over life-size. (Photo: Kunstgeschichte in Bildern I)

Figure 5.26(b) CLASSICAL. Myron. Discobolos (discus thrower) (c. 450 B.C.). This idealized composite pose is physically impossible to duplicate in real life. (Roman copy of a lost Greek original.) (Photo: Kunstgeschichte in Bildern I)

Figure style on one side of the vessel and Black Figure style on the other. Vases filled with olive oil were awarded as prizes in athletic competitions, as the olive is a sacred emblem of the goddess Athena.

Sculpture, the favored art form of the Greeks, is generally divided into an early or **archaic** phase and a later **classical** phase. The earliest figures are small, solid-cast bronze warriors which resemble the crude silhouette figures found on geometric era vases. Also typical are life-size 6-foot marble votive statues of nude male **kouros** figures (formerly thought to be Apollos) and draped female **kore** figures in poses reminiscent of the "Egyptian stride" (left leg advanced, right leg rigid, hips and shoulders level). (See Figures 5.21 and 5.22.). Anatomy in these early figures is heavily stylized and tentative. Faces tend toward a generic sameness stamped with the distinctive "archaic smile."

Later CLASSICAL SCULPTURE (c. fifth century B.C.) in contrast is quite naturalistic; figures exhibit a **weight shift** (one load-bearing leg, one relaxed; shoulders tilted in opposition to hips). Subjects include gods and heroes sculpted in marble or bronze according to the prevailing **canons of proportion,** thought to represent a presumed ideal figural type. Most Greek sculpture was painted, especially the facial details and drapery, to enhance verisimilitude. Most surviving "Greek" statues are actually Roman marble copies of lost bronze originals. Few specimens of Greek painting survive, mainly frescoes which stylistically resemble Minoan murals. Curiously enough, ancient Greek painting never seems to have reached the degree of perfection manifested in sculpture and architecture. (See Figures 5.23, 5.24, 5.25, 5.26.)

In the later HELLENISTIC PERIOD of Greek art (meaning "Greek-

Figure 5.27 *HELLENISTIC.* The Laocoön Group *(first century* B.C.*). Marble, 8 feet high. When the Trojan priest Laocoön discovered the ruse of the Trojan horse, the gods sent a serpent to devour him and his sons. (Photo: Kunstgeschichte in Bildern I)*

Figure 5.28 *HELLENISTIC.* Winged Victory of Samothrace *(c. 190* B.C.*). Original included a full-size ship with Victory alighting upon its prow (an allusion to the Battle of Salamis). (Photo: Kunstgeschichte in Bildern I)*

like"), sculpture emphasizes motion, greater realism, and more grandiose themes, sometimes badly overdone. While most Hellenistic works are regarded as inferior to those of the classical era, a few works, such as the *Winged Victory of Samothrace,* are admired for their vigor and realism. (See Figures 5.27 and 5.28.)

Greek architecture utilizes the **post-and-lintel** system of construction resulting in rectangular temples surrounded (or fronted) by one or two rows of supporting columns beneath a gabled roof. Three *classical orders,* or substyles, are easily identified by their distinctive column capitals: **Doric** (with simple "cushion" capitals), **Ionic** (with scroll-shaped volutes on the capitals), and **Corinthian** (with bundled acanthus leaf capitals). (See Figures 5.29 through 5.32.) Principal structures of the Athenian **Acropolis** (*Acra-* = hill + *polis* = city), built in gratitude to Athena for victory over the Persians at the Battle of Salamis (480 B.C.), include the following principal structures: (See Figure 5.33.)

PARTHENON (Architect: **Iktinos,** in collaboration with **Callicrates.** Sculptor: **Phidias**). A Doric temple dedicated to the goddess Athena, the Parthenon originally housed Phidias's colossal gold and ivory statue of the goddess (now lost) as well as a treasury. Most of the building's relief carvings and pediment statues were salvaged by Lord Elgin in the early nineteenth century and are now in the British Museum. (The Parthenon is discussed in detail at the conclusion of Chapter 4).

ERECTHEUM (Architect: **Mnesicles**). Ionic structure built to commemorate the contest between Athena and Poseidon (sea god) for protectorship of the city of Athens. Religious cult objects within

Figure 5.29 DORIC ORDER.
(Photo: A History of Art)

Figure 5.30 IONIC ORDER.
(Photo: A History of Art)

Figure 5.31 CORINTHIAN ORDER.
(Photo: A History of Art)

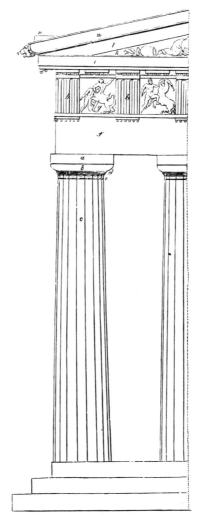

Figure 5.32 Structural
elements of Greek temple
architecture. (Illustration:
Charakterbilder aus der
Kunstgeschichte)
(m) raking cornice
(k) pediment (i) cornice
(h) triglyphs (g) metope
entablature (f) architrave
(a) abacus (b) echinus
(d) capital (a and b combined)
(e) necking
(c) column (top platform)
stylobate (lower platforms)
stereobate

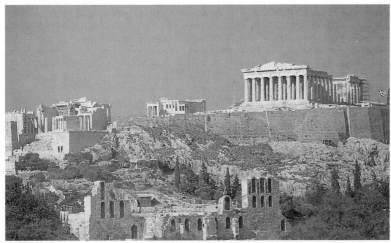

Figure 5.33 THE ATHENIAN
ACROPOLIS. The Parthenon, a
large Doric temple
dedicated to Athena, is
visible at top right, directly
behind the Propylaea
(gateway building). The
asymmetric Erectheum is
visible at left. (Photo:
Einsbrung in die
Kunstgeschichte)

Figure 5.34 CLASSICAL GREEK ARCHITECTURE. The Erectheum (completed 405 B.C.) by the architect Mnesicles. A rambling Ionic temple built on two levels to house important cult items. The famous PORCH OF MAIDENS appears at far right. (Photo: Weltgeschichte der Kunst)

Figure 5.35 CLASSICAL GREEK ARCHITECTURE. A caryatid (female column figure) from the Erectheum's PORCH OF MAIDENS. (Photo: Kunstgeschichte in Bildern I)

its precincts include an olive grove (the olive being sacred to Athena), a stone bearing the mark of Poseidon's trident spear, a saltwater spring, and the legendary tomb of the semimythical hero Erectheus. The Erectheum is unusually asymmetric and built on two different levels. The south *Porch of Maidens* is famous for its **caryatids** which are female figures used as supporting roof columns. (See Figures 5.34 and 5.35.)

PROPYLAEA (Architect: **Mnesicles**). A Doric gateway structure and resting place for visitors to the Acropolis. The Propylaea also contained an art gallerylike exhibition room.

Greek philosophy stresses the concept of perfection as an ideal attainable through reason, a notion reflected in much of Greek art. Perfection of form was thought to go hand in hand with perfection of concept. The white, pristine sterility of classical sculpture and architecture is entirely an accident of history; much of Greek architecture and sculpture was originally painted and, ironically, their bold color harmonies might even strike contemporary eyes as a bit jarring.

Many humanities and art history survey texts begin their history of art with the classical Greeks, a bold-faced bit of Western ethnocentrism which nevertheless underscores the profound influence this era has had on subsequent Western cultural development.

V. The Roman Empire
(first and second centuries A.D.)

In the two centuries following the birth of Christ, the Roman republic expanded from a small Etruscan settlement on the Italian peninsula to completely encircle the Mediterranean region, extending at its peak well into Britain, northern Africa, and Asia Minor—in short, the entire known world. Following the defeat of Carthage in the *Punic Wars* (264 B.C. to 146 B.C.) and the subjugation of France and Belgium in the *Gallic Wars* (89 B.C. to 51 B.C.), the Roman world enjoyed an unprecedented epoch of peace known as the Pax Romana (Roman peace), also referred to as the Silver Age of Rome. This period is also regarded as a continuation of the CLASSICAL AGE.

To their credit, the Romans did not exterminate newly conquered people but rather allowed their subjects to continue old ways of life under Roman law. Because of this, it has often been said that the Romans were, in the end, conquered by their own subjects. The Romans particularly admired Greek culture and often emulated it, employing Greek slaves as artisans and educators. The fall of Rome in A.D. 410 to Germanic tribes migrating southward (the so-called "barbarians") signaled the beginning of the decline of Roman power and the end of the Greco-Roman CLASSICAL AGE. (See vignette)

Roman bust of a "barbarian". (Photo: Kunstgeschichte in Bildern I)

Figure 5.36 MURAL PAINTING. *Detail from wall fresco, from the Villa of the Mysteries near Pompeii (c. 50 B.C.). Figures about 5 feet high. Much of our knowledge of Roman culture comes from the well-preserved sites at Pompeii and nearby Herculaneum, which were buried beneath a thick layer of volcanic dust and ash during the eruption of Mt. Vesuvius in A.D. 79. The volcanic debris virtually "froze" these cities at the moment of their destruction. The fresco shown here (one wall section of a decorated room) depicts a religious ritual or cult initiation involving flagellation with a whip. (Photo: Alinaril Art Resource, NY.)*

THE MODULAR BASIS OF ROMAN ARCHITECTURE

Parts of a ROMAN ARCH

i - intrados s - springing
K - keystone v - voussoirs

BARREL or
TUNNEL VAULT

GROIN VAULT formed from
intersecting BARREL VAULTS

DOME formed by
rotation of an ARCH

Figure 5.37 *The modular basis of Roman architecture (a) Parts of a* ROMAN ARCH: *i = intrados, s = springing, K = keystone, v = voussoirs (b)* BARREL *or* TUNNEL VAULT *(c)* GROIN VAULT *formed from intersecting* BARREL VAULTS *(d)* DOME *formed by rotation of an arch Roman composite order column (Illustration: Charakterbilder aus der Kunstgeschichte)*

Roman Composite Column

The Romans excelled at public art and architecture. Most Roman structures are constructed of modular elements derived from the characteristic round or **Roman arch,** which was used extensively but *not* invented by the Romans. An arch extended through space forms a **barrel vault,** two intersecting barrel vaults form a **cross** or **groin vault,** and an arch rotated around its vertical axis forms a dome. (See Figure 5.37.) Each of these arch-derived modules finds its application in Roman architecture and, used in combination with elements borrowed from classical Greek post-and-lintel temples, formed the basis for most examples of Roman architecture. Many Roman buildings were constructed of **cast concrete** poured over stone rubble then faced with slabs of **marble veneer.** The PANTHEON of Rome, dedicated to the principal planetary gods, [*pan-* = all + *theos* = gods] incorporates most of the distinctive Roman architectural elements (dome, marble veneer walls over concrete, Greek columns and pediment, and so on). (See Figure 5.38.)

Roman architectural columns often blend elements of the Ionic and Corinthian orders into a distinctive **Roman composite order,** identified by the Ionic scrolls set above the bundled Corinthian acanthus leaves. (See vignette.) The wooden **basilica,** a civic meeting hall consisting of a main central aisle flanked by two narrower side aisles, became the model for most later Christian churches. (The **early Christian style** itself is closely tied to the art of Imperial Rome.)

The **Roman baths** or "peoples' palaces" featured pools of warm, hot, and cold water [hence their Latin name *thermae* = hot springs] and also featured shops, restaurants, and theaters—much like our own shopping malls. Lavishly decorated with marble statues and reliefs, the baths provided the average Roman citizen with a taste of imperial splendor, such as the famous baths in the city of Bath (in southwestern England). An elaborate system of sloped watercourses called **aqueducts,** some over 20 miles long, were constructed to bring water from the distant mountain streams into the cities. (See Figures 5.39 and 5.40.)

During the later decades of the empire, gladiatorial contests

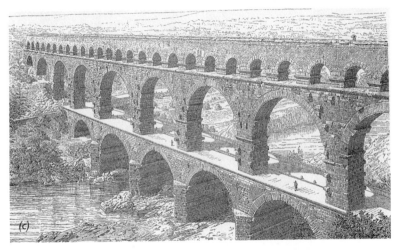

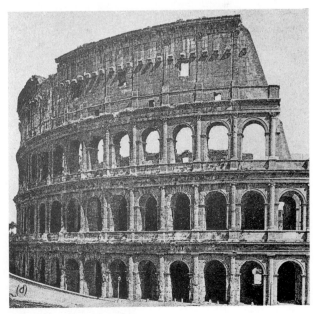

Figure 5.38(a) ROMAN. The Pantheon, Rome (c. A.D. 125). Cast concrete poured over rubble and faced with marble veneer (now lost); dome diameter, 144 feet. A temple dedicated to the principal planetary gods whose great domed ceiling symbolized the vault of the heavens. (Photo: Weltgeschichte der Kunst)

Figure 5.39(b) ROMAN. The Baths of Caracalla, interior view (c. A.D. 210). (Illustration: Denkmaler der Künst)

Figure 5.40(c) ROMAN. The Pont du Gard Aqueduct, Nimes, France (c. first century A.D.). One of many artificial watercourses built by the Romans to bring fresh water into their cities. The aqueduct's gradual slope of only a few feet per mile is enough to draw the water along its path. (Photo: Kunstgeschichte in Bildern I)

Figure 5.41(d) ROMAN. The Colosseum (also called the Flavian Amphitheater), Rome (c. A.D. 80). Constructed of concrete poured over rubble and faced with marble veneer; dimensions: 600' X 500' X 160' high. (Photo: Weltgeschichte der Kunst) The three orders of classical Greek architecture are each represented: first level, Doric; second level, Ionic; third level, Corinthian. Now in ruins, the structure was originally of uniform height. Much of its marble veneer was pillaged by the early Christians for use in other building projects.

Figure 5.42(a) ROMAN. *Arch of Titus* (A.D. 81). *Arches were built to commemorate victorious military campaigns. Reliefs on inside walls depict Spoils from the Temple in Jerusalem and Triumph of Titus. (Charakterbilder aus der Kunstgeschichte)*

Figure 5.43(b) ROMAN. RELIEF. *Sack of the Temple in Jerusalem. Marble, figures life-size. A companion relief (on opposite wall) depicts the emperor Titus in his war chariot returning to Rome in triumph. (Photo: Kunstgeschichte in Bildern I)*

Figure 5.44(c) ROMAN. *The Augustus of Prima Porta (c. 20 B.C.). Marble, over life-size. Cupid astride the dolphin alludes to Augustus's being a descendent of ÆNEAS, a legendary son of Venus and founder of Roman civilization. (Photo: Kunstgeschichte in Bildern I)*

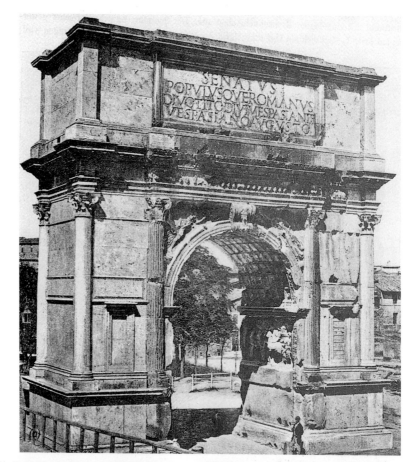

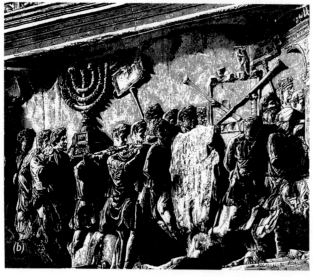

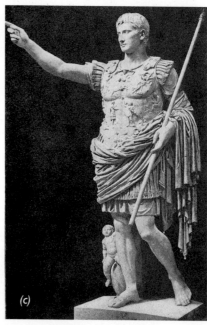

became increasingly popular. Amphitheaters like the COLOSSEUM in Rome and CIRCUS MAXIMUS, a chariot racetrack capable of seating an astonishing 250,000 spectators, were constructed as arenas for armed contests of martial skill. (See Figure 5.41.) During the decadent later years of the empire, the mass execution of Christians or other grotesque contests between persons and wild beasts provided blood-sport diversions for the populace. Catapultlike devices were used to hurl fierce wild animals, such as lions, into the arena for heightened dramatic effect.

TRIUMPHAL ARCHES and other monuments such as the COLUMN OF TRAJAN, built to commemorate the emperor's military conquests, bear relief carvings that recount the high points of the principal campaigns. (See Figures 5.42 and 5.43.) Many monuments bear the inscription S.P.Q.R., an acronym for the Latin phrase *Senatus Populusque Romanus* meaning "The Senate and People of Rome."

Although the Romans admired Greek art (many surviving classical sculptures are actually Roman copies of Greek originals), Roman art also exhibits a distinctive **realism** that in some ways surpasses the bland idealism of the Greeks. Romans worshiped ancestors as household gods, called *lars,* thus **portrait busts** and **encaustic portraits** of widely varying quality are also common. Enterprising Roman sculptors often offered stone figures for sale, sculpted in the Greek style, but with blank or missing faces that were personalized after purchase (reminiscent of the novelty photos of our own era where the subject inserts his or her head through a hole in a painted background). The best **portrait sculptures,** however, are one-of-a-kind works produced for members of the high-ranking **patrician** class. The emperor, called by the title *Caesar,* is frequently portrayed idealized and in military garb as if delivering a proclamation to his troops. The *Augustus of Prima Porta* is a work of this type (Figure 5.44); its **cupid astride a dolphin** suggests Caesar Augustus's link to the line of Æneas (hero of Virgil's *Æneid,* and legendary son of Venus), who was revered as the founder of Roman civilization.

During the late imperial era (after mid-second century), the classical realism of the earlier Republican period gives way to stylized, doll-like figures regarded by many historians as a debased style too strongly influenced by the Eastern barbarian cultures of Asia Minor. This so-called **decadent** figural style became the prototype for most Early Christian art.

A practical people, Romans appreciated exacting

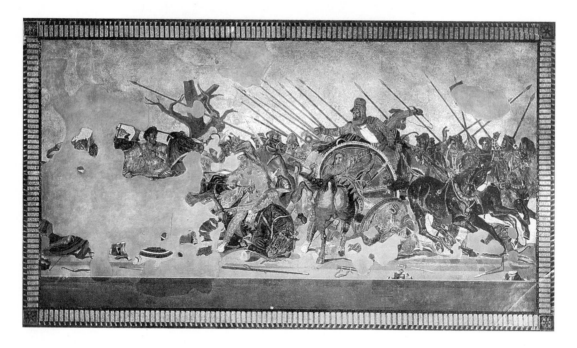

Figure 5.45 ROMAN MOSAIC. (Pompeii.) Battle of Issus *from House of the Fawn, Pompeii (c. 80 B.C.). Mosaic, probably a Roman copy of a Hellenistic work. Darius the Persian (right) is routed by Alexander the Great (on horseback at left). (Photo: Alinari/Art Resource, NY)*

craftsmanship, especially the sort of fussy detail evidenced in the production of **mosaics.** Roman mosaics, made of small, cut stones called *tesserae*, decorate floors and walls with images from common life and likenesses of popular folk heroes. (See Figure 5.45.)

In contrast to the philosophical Greeks, the true genius of the Romans is manifested in their organizational skill. A sense of pragmatism permeated Roman life and is reflected in their culture, which assimilated the best aspects from all its conquered peoples. (For example, Virgil's epic *Æneid* parallels Homer's *Odyssey;* and the Roman gods are essentially transformations of the ancient Greek deities. The Greeks' Zeus corresponds to the Romans' Jupiter, and so forth.)

Among Rome's most impressive cultural achievements is the vast network of roads built to link the far-flung outposts of the empire. Until the advent of railway travel, these roads were the principal means of transportation in Europe. Many of these ancient Roman roadways (such as the Appian Way, which cuts across the "boot" of Italy from Rome southeastward to Brindisi, for example) remain in use today.

The eighteenth-century English historian Edward Gibbon in his monumental work, *The Decline and Fall of the Roman Empire,* identified a cluster of factors which contributed to Rome's downfall including the barbarian incursions, the rise of Christianity, the

various domestic quarrels within the empire whose sheer size and complexity eventually became too unmanageable, not to mention the apathy and inertia of its citizens who, in the end, became too accustomed to free "bread and circuses."

The fall of Rome (A.D. 395) brings an end to the GRECO-ROMAN CLASSICAL ERA, which spanned the centuries from the Golden Age of Greece (c. fourth century B.C.) to the zenith of the Roman Empire (first and second centuries A.D.).

Early Christian Art: During the Silver Age of the Roman Empire, the early Christians were bitterly persecuted on the grounds of suspected ideological sedition. This state of affairs continued until A.D. 313 when the Roman Emperor **Constantine,** himself newly converted to Christianity after a battlefield vision, promulgated the **Edict of Milan** which legalized Christianity. Later, Constantine proclaimed Christianity as the official state religion of the Roman Empire (A.D. 325), thus firmly establishing Christianity's foundation in Western civilization.

The primary emphasis of the Christian ethos is the salvation of one's immortal soul. The world, with all its temptations, was regarded as an arena or spiritual testing ground, beset with snares set by the devil to lure the unwary into sin. Christian art also reflects this perspective. Although Christians turned away from the worldly art and culture of Rome, its old pagan gods were sometimes pressed into service by Christian artists seeking a ready link with the past. (In one remarkable instance Christ was even depicted as Apollo driving the sun chariot across the sky.) Christian art is didactic. Its essential purpose is to teach the way of Christian salvation and

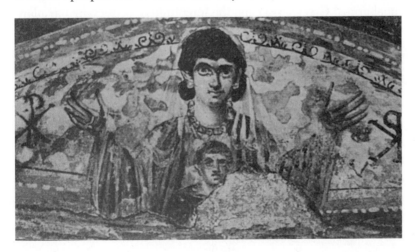

Figure 5.46 *EARLY CHRISTIAN.* Madonna and Child *(c. first-third centuries). Catacomb fresco; figures with arms lifted in prayer are called **orans figures.** Note the chi-rho symbols, a Greek abbreviation for "Christ," at left and right. (Photo: Geschichte der Bildenden Künste)*

Figure 5.47 *The* ROMAN BASILICA, *a civic building with a high central aisle (nave) flanked by lower side aisles, became the model for longitudinal plan churches. Christians regarded the basilica's three-part structure as an allusion to the concept of the Holy Trinity—God the Father, Christ, and the Holy Spirit—three beings in one God. (Illustration: The Complete Encyclopedia of Illustration)*

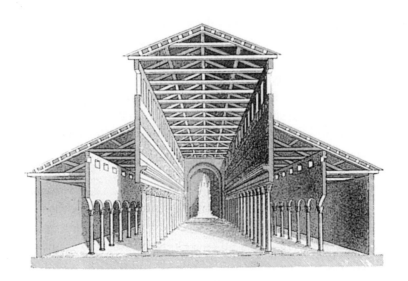

spread the faith. Formal beauty, which is merely another worldly diversion, remains a secondary consideration. (See Figure 5.46.)

Early Christain art is divided into several well-defined subperiods: (1) the ERA OF PERSECUTION (first through third centuries) during which Christianity was practiced as an underground religious movement; (2) the ERA OF RECOGNITION (mid-fourth through fifth centuries) during which Christianity was adopted as the official state religion of the Holy Roman Empire; and (3) the BYZANTINE ERA (fifth through seventh centuries) during which Christian art was orientalized by contact with Eastern artistic styles.

The first churches were modeled after the **Roman basilicas,** [three-aisled civic meeting halls. (See Figure 5.47.) There are two main types of architectural plan: the **central plan** (modeled after an equal-armed Greek cross) and the **longitudinal** or **rectangular plan** (modeled after the familiar Latin cross). Church exteriors tend to be plain, even severe; while interiors are ornate, reflecting the Christian dichotomy between the *outer self* (body) as debased matter and the *inner self* (soul) as transcendent and immortal.

The interiors of Christian churches were adorned with **frescoes** and **mosaics** (made with larger, rough-cut tiles) depicting religious allegories, Biblical stories, or episodes from the life of Christ. Figures were intentionally denaturalized to avoid distracting worshipers with earthly sensualism. During the period of recognition, Christ is frequently depicted as a HEAVENLY KING in robes of regal purple.

VI. The Early Medieval Period
(c. A.D. 500–1000)

Feudalism and the migration period

The **medieval** era (*medius* = middle + *aevum* = age), or Middle Ages, refers to the 1,000-year span from the fall of Rome (A.D. 410) until the rebirth of classical Greco-Roman culture during the Italian Renaissance (c. 1400). Although once referred to by such disparaging titles as the "Dark Ages," the medieval era has since come to be appreciated as a rich historical period in its own right. The medieval era in continental Europe and Britain was dominated intellectually and spiritually by the Catholic Church and by the social-economic institution of *feudalism,* a complex system of status hierarchies and social obligations all revolving around land ownership.

In the feudal system a wealthy landowner or *lord* allowed *vassals* to work his land and keep a portion of the harvest in exchange for a promise of military service in times of crisis (the *oath of fealty*). The lord enjoyed other privileges too, such as first rights to a vassal's wife on their wedding night, but he also owed fealty to someone higher than himself. Thus, a complex network of obligations evolved spanning all levels of the social strata. The Church and the nobility are the two principal patrons of the arts in the Middle Ages.

The conflict-ridden feudal way of life necessitated the construction of fortified castles. The earliest castles consisted of a hill stronghold (or *motte*) overlooking a stockaded yard (or *bailey*), called a **motte-and-bailey castle.** Later innovations included **crenelated** (notched) stone curtain walls, reinforced at invervals with round **drum towers** or **turrets.** A heavily fortified building called the **donjon** or **keep** was usually found within the encircling walls, as well as a great hall for audiences. Entrance to the castle was gained by means of a drawbridge over a water-filled moat. A heavy **portcullis,** (port *cue* lis), a vertical-sliding iron gate, restricted entry to the forecourt or **barbican.** Despite many later additions, the essential features of the motte-and-bailey plan are still plainly evident in most later castles. (See Figures 5.48 and 5.49.)

The denaturalized style of early Christian art continues

Figure 5.48 *A MOTTE-AND-BAILEY CASTLE (c. 1100). Simple earth and timber fortifications such as these were erected by the armies of William the Conquerer following his victory at the Battle of Hastings. The motte, a fortified hill, is surrounded by a walled yard, the bailey. (Illustration: Dover Pictorial Archives)*

While the essential features are the same as those of the primitive motte-and-bailey castle (pages 4 and 5), they are much more sophisticated. The motte tower has become the great keep, and the wooden palisade is now a strong curtain wall with flanking towers. The simple gatehouse has become the barbican. The baileys are here called wards.

Figure 5.49 *A NORMAN CASTLE (c. 1200). The essential features of the earlier motte-and-bailey plan are still visible, but elaborated in stone. (Illustration: Dover Pictorial Archives)*

Figure 5.50 *MEDIEVAL. Detail from the* Bayeux Tapestry *(c. 1070) commemorating the victory of William the Conqueror over the Saxon king Harold at the Battle of Hastings in 1066. Embroidered wool on linen, 20 inches high (full length 231 feet). (Photo: Giraudon Art Resource, NY.)*

throughout the Middle Ages with regional variations. Small-scale relief carvings, tempera paintings on wood or paper, and woven tapestries are common. Popular subjects include religious, mythical, or historical scenes. The *Bayeux Tapestry* depicting the NORMAN CONQUEST (the defeat of Anglo-Saxon king Harold by William the Conqueror at the Battle of Hastings in 1066) is one well-known example, sewn by a group of anonymous nuns. (See Figure 5.50.)

Depictions of religious figures were bound by strict formal rules intended to guard against the possibility of intentional or unintentional defamation. In crucifixion scenes, for example, Mary was always portrayed on Christ's right-hand side, and St. John on Christ's left-hand side. Also, artists were prohibited from mixing sacred and mundane portraits within the same picture. Thus, there arose a system of two-paneled paintings (*diptychs*) and three-paneled paintings (*triptychs*), which enabled portraits of worldly patrons to be physically juxtaposed with sacred images of the Madonna and Christ by means of hinged frames.

The early Middle Ages (especially seventh to ninth centuries) are known as the MIGRATION PERIOD due to the continuing movement of northern Germanic and Norse peoples into southern Europe (i.e., the old Roman Empire) during this era. The term *Viking*, by which the Norsemen are popularly known, is similar to an Old English term meaning "pirate" (*wicing*), although the precise entymology remains uncertain. The characterization of Germanic and Norse cultures as little more than ruthless barbarians, however, is entirely inaccurate.

Northern cultures were highly developed and infused with their own sophisticated cultural ideas. The ferocity of their raids, however, is captured in a phrase from an Old English prayer which begs the Almighty for protection against "the fury of the Northmen."

The artwork of the Norse and Germanic tribes is usually associated with practical ends: finely wrought edged weapons, jewelry such as carrying purses or broaches for fastening capes, and other portable **nomad gear,** like utensils and horse tack. In general, forged and cast implements predominate, with little or no **repoussé** work in evidence. Jewelry was chiefly decorated with **cloisonné,** that is, pieces of colored glass or enamel set between thin strips of soldered metal. *Metal inlay work,* in which a strip of soft metal wire—like copper or gold—was hammered into the grooves of a design chiseled into another metal surface, was often employed to decorate ceremonial weapons.

Figure 5.51 *VIKING. Head of a sea monster from a ship's prow. Carved wood. (Illustration: Dover Pictorial Archives)*

Designs on the artifacts of northern migration cultures typically suggest plaited or woven strips of leather, and exhibit the *horror vacui* prevalent in Eastern and primitive art. Stylized **heraldic animals,** arranged in mirror-image poses, also frequently appear.

The marine architecture of Viking ships is well understood due to the recovery of intact full-size specimens such as the OSEBERG SHIP (used as a burial vessel, c. ninth century). Viking ships are typically shallow draft hulls, extending less than 3 feet below the surface, allowing them to be rowed in close to shore. Carved wooden figureheads of stylized sea dragons often adorned the ship's prow. (See Figure 5.51.) A single sail often embroidered and trimmed with fur was hung from a removable mast slotted into the ship's keel. Interestingly enough, Norse dwellings were typically large communal halls whose roofs resembled overturned ships' hulls (their probable origin). Norse burial sites often feature cairns (stone arrangements) which mimic the shape of sailing vessels alluding to death as a spiritual journey. The OSEBERG SHIP, used as a large funerary casket for a Viking chieftan, was buried with its tether line tied to a nearby boulder.

VII. The Later Medieval Period (Romanesque and Gothic Eras, c. A.D. 1000–1350)

As the year A.D. 1000 approached, devout Christians anticipated the coming of the Apocalypse (*see* Book of Revelations 20:7) and withdrew from the world into self-sufficient monastic communities to devote themselves to prayerful contemplation of the divine mysteries. (See Figure 5.52.) Fear of the Apocalypse was so widespread that large-scale building projects dropped off noticably during the last years of the first millenium. After the year 1000, a renewed interest in cathedral construction, however, soon flowered across continental Europe, especially in France.

Figure 5.52 *A MEDIEVAL ABBEY, c. 1000 (St. Germain-des-Prés). (a) Main gateway to stables, grainery, hospital. (b) Church. (c) Virgin's chapel. (d) Cloister. (e) Monk's dormitory. (f) Clergymen's gateway. (g) Refectory (meals). (h) Moat. (i) Pillory. (k) Inn. (l) Outer fence. (m) Vacant land. (n) Clergymens' road. (o) Moat road. (q) River Seine road. (r) Cultivated fields. (Illustration: Le Treiziéme Siécle Artistique)*

The period from 1000–1350 is dominated by two distinctive styles of cathedral architecture called the **Romanesque** (c. 1000–1250) and the **Gothic** (c. 1250–1350) styles. Widespread cult worship of the Virgin Mary resulted in many cathedrals being dedicated as *Notre Dame* ("Our Lady"), such as Notre Dame de Paris, Notre Dame de Chartres, and so on.

Abbot Suger, architect of St. Denis (Paris), first advocated the use of **stained glass** and precious materials as a means of uplifting the hearts and minds of worshipers (c. mid-1100s), thereby making the inside of a cathedral a place seemingly *in* the world but not *of* the world.

The Romanesque and Gothic styles are preeminently architectural styles and, thus, are best illustrated by their **cathedrals,** immense churches, under the auspices of a bishop, designed to hold the entire population of a city. Medieval cathedrals were often called the "Bibles of the Poor" because the religious-didactic imagery, presented in their stained-glass windows and relief carvings, helped to spread the lore of Christianity among the townsfolk, most of whom were illiterate. (See Figure 5.53.)

Figure 5.53 *ROMANESQUE.* Adoration of the Magi. *Relief by an anonymous German sculptor. (Illustration Kunstgeschichte in Bildern II)*

Most cathedrals share several basic features. Beyond the entrance vestibule or **narthex** is a wide central aisle, called the **nave,** flanked by two or more narrower side **aisles.** The **transept,** an aisle laid perpendicular to the nave (corresponding to the shorter arm of a Latin cross) is often included in the plan. The nave and transept meet at the **crossing** which, in larger structures, is occupied by a secondary altar. A passageway or **ambulatory** was often built around the **choir** (where the main altar is located) to provide a path for pilgrims visiting sacred **relics** housed within the small **apsidal chapels.** The eastern wall (directly behind the altar) may be curved to form an **apse,** and a burial **crypt** may lie below the altar. The ground plan of most Romanesque and Gothic cathedrals are of the **longitudinal plan** type, patterned after the Latin cross. (See Figure 5.54.)

In addition to these basic features, Romanesque and Gothic structures each have their own distinctive characteristics which are summarized in the following list. (See examples in Figures 5.55 through 5.62.)

Figure 5.54 SCHEMATIC OF A TYPICAL LONGITUDINAL PLAN CATHEDRAL. Most cathedrals locate their main entrance at the western end which is, according to tradition, the direction from which the Almighty will appear on the Last Day.

Romanesque Style (1000–1250)

(1) Use of the round or **Roman arch** allows spans of only limited width.

(2) Thick walls reinforced with **buttresses** (wall sections that are thicker at the bottom and thinner at the top).

(3) **Clerestory** (wall space above the aisle roofs) is fenestrated with plain windows. Dark naves.

(4) Structures are low and somewhat squat; low ceilings in the nave.

(5) Structures consist of simple, blocky forms.

Gothic Style (1250–1350)

(1) Use of the pointed or **Gothic arch** allows wider, more stable spans.

(2) Thin "curtain walls" reinforced by **flying buttresses** (bracing arches attached to freestanding exterior piers).

(3) Entire wall is fenestrated with **stained-glass.** Muted light in nave.

(4) Structures are tall and airy; high ceilings in the nave.

(5) Structures consist of complex, structurally explicit forms (e.g., the flying buttresses)

(6) Interior decorations principally mosaics; few exterior sculptures.

(6) Few interior decorations; elaborate exterior sculptures (gargoyles, reliefs, and so on).

The stylistic shift from the Romanesque to Gothic style is gradual. It is not unusual to find a few Romanesque features in some later Gothic structures, or a blend of the two styles during transitional periods. In the Romanesque cathedral LA MADELAINE AT VEZELAY, for example, a Gothic apse is attached to an earlier Romanesque narthex and nave. (See Figure 5.57.) Such hybrid features are partly due to the fact that most cathedrals took several centuries to construct. Even today most remain incomplete; that is to say, their entire architectural program was never fully realized. Interestingly enough, the contours of the Gothic arch and vault are said to have been inspired by the overarching tree branches found along forested lanes, which produce a natural vaultlike effect.

The exteriors of Gothic cathedrals were adorned with relief sculpture (often painted) produced by anonymous itinerant stonemasons who dedicated their works to the greater glory of God rather than to the advancement of their personal ambition. (See Figure 5.58.) Types of relief carvings include: **tympanum reliefs** (semicircular panels above doorways, *tympanum* = drum), **archivolt reliefs** (on mouldings around doorways), **jamb statues** (beside entrances), and **trumeau statues** (on post in the center of a wide doorway). Grotesque **gargoyles** serve as reminders that the devil is afoot in the world, ready to ensnare unwary pilgrims. Decorative stone **tracery** carvings, which resemble the stylized, intertwining plant forms of the Byzantine era, often embellish window openings and passageway screens. Freestanding sculptures are rare due to severe religious prohibitions against idolatry.

Elaborate **stained-glass windows** depict religious as well as genre subjects and often bear a vignette image of the sponsoring patron or guild as a kind of signature emblem. Round **rose windows** and narrow **lancet windows** are used extensively in Gothic cathedrals. In larger stained-glass windows, the ponderous weight of the glass and lead channels is supported, at intervals, by thick iron bars. (See Figures 5.59 through 5.63.)

The great pride which Gothic builders took in the height of their cathedral's nave sometimes led to disasterous consequences. The stone vaults of Beauvais Cathedral, stressed

Figure 5.55 *ROMANESQUE. Speyer Cathedral, Germany (begun 1030). Romanesque cathedrals tend to be low, squat structures whose simple, planar forms mirror the interior organization in a frank, straightforward manner. Note the side aisles, transept, and curved apse. (Photo: Geschichte der Bildenden Künste)*

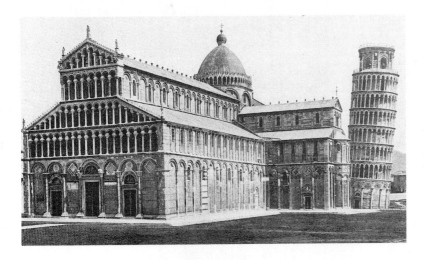

Figure 5.56 *ROMANESQUE. Cathedral of Pisa, Italy (c. 1050–1270). The famous Leaning Tower of Pisa (visible at right) is the cathedral's freestanding bell tower or campanile. Note the dome over the crossing. (Photo: Kunstgeschichte in Bildern II)*

Figure 5.57 *ROMANESQUE. La Madelaine, Vezelay, France (begun 1096). Asymmetric facades are not uncommon in cathedral architecture, considering the fact that most structures took several decades or even centuries to build. The shorter tower, squat doorways, and round arches are typical Romanesque features, while the taller tower and pointed arches (added during the twelfth century) are more characteristic of the later Gothic style. (Photo: L'Art Gothique)*

Figure 5.58 ROMANESQUE. The Ascension of Christ and the Mission of the Apostles (c. 1130). Tympanum relief from La Madelaine at Vezelay, France, depicting Christ sending his apostles to preach to all nations. Images of fantastic dog-headed men (cynocephaloi), probably baboons, appear in the curved panel (left center) as well as other strange beings reported to have been seen by returning Crusaders. (Photo: GiraudonArt Resource, NY)

Figure 5.59 GOTHIC. Cathedral of Notre Dame (south flank), Paris (begun c. 1215). Gothic cathedrals employ a network of spidery flying buttresses which brace the exterior walls, allowing them to be fenestrated with stained glass. A rose window is visible in the transept facade. (Photo: L'Art Gothique)

Figure 5.60 GOTHIC. Cathedral of Notre Dame, Paris. View of the nave from a transept gallery. (Photo: L'Art Gothique)

Figure 5.61 GOTHIC. Sainte Chapelle, Paris (c. 1245). Designed to house sacred relics recovered during the last of the Crusades, the interior wall space of this structure consists mainly of stained glass. (Photo: L'Art Gothique)

Figure 5.62 GOTHIC. Sainte Chapelle, Paris. (Photo: Kunstgeschichte in Bildern II)

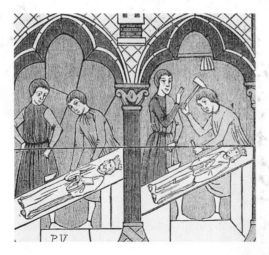

Figure 5.63 *Medieval stonecarvers at work (from a thirteenth-century stained-glass window). Chartres Cathedral, France. (Photo: Le Treiziéme Siécle Artistique)*

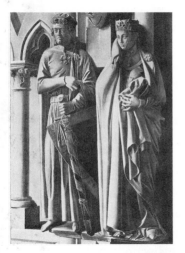

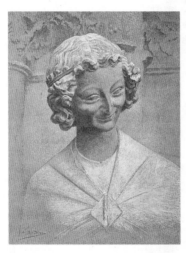

Figure 5.64 GOTHIC. Ekkehard and Uta (c. 1250). Naumberg Cathedral. (Photo: Kunstgeschichte in Bildern II)

Figure 5.65 GOTHIC. Smiling angel (mid-thirteenth century). Autun Cathedral. Figures such as these, whose implike smiles seem to belie their angelic character, signal a reawakening of interest in worldly realism after the long hiatus of the Middle Ages. (Photo: L'Art Gothique)

Figure 5.66 LATE GOTHIC. Lamentation (1305) by Giotto. Fresco (approximately 8' X 8'), Arena Chapel, Padua. (Photo: Kunstgeschichte in Bildern II)

beyond their endurance to 157 feet (nearly 16 *stories* high), collapsed in 1284; they were later rebuilt at a safer height. More typical nave heights are: Laön (80 ft), Notre Dame (107 ft.), Chartres (120 ft.), Amiens (140 ft.).

Beginning in the mid-1200s a new courtly realism in art, evident in the implike smiling angels of Autun cathedral, and the portraits of EKKEHARD AND UTA at Naumberg cathedral, anticipate the Italian Renaissance's reawakened interest in naturalistic representation. (See Figures 5.64 and 5.65.)

In painting, late medieval works such as Giotto's *Lamentation* (1305) depict figures more convincingly as massive three-dimensional bodies in real space, rather than as the denaturalized floating figures characteristic of the Byzantine era. (See Figure 5.66.)

The famous twentieth-century art historian Irwin Panofsky once likened the Gothic cathedral to the *summa* or treatise of the medieval philosopher; the same clarity and explicitness found in the arguments and disputations of Scholastic philosophy also appear in the stonework of the Gothic cathedral. The evident weighing and balancing of each structural part inspires in us the feeling that the inner workings of thought itself are laid bare in the structural fabric of the Gothic cathedral.

Recurrent outbreaks of the "Black Plague" (bubonic plague), beginning in the mid-fourteenth century, decimated the population of Europe (one third of all Europeans died from 1347 to 1350). The macabre "Dance of Death" illustrations, which depict villagers hand in hand with skeletons, are from this period. Ironically, the plague traveled with the same trading ships that brought economic prosperity to Europe.

Medieval art is principally in service of Christian religion, reaching its highest expression in its intimate association with cathedral architecture.

VIII. The Renaissance in Italy and Northern Europe (1400–1600)

The **Renaissance** (*naissance* = birth, hence "rebirth") begins c. 1400 in the Italian city of Florence and spreads rapidly throughout northern Europe. Throughout this period Italy remains the cultural center of the Renaissance because it is the site of the ancient Roman Empire, the home of the papacy, and an international center for commerce, banking, and trade.

The Renaissance is an era of reawakened interest in (1) the art and cultures of classical Greece and Rome, (2) scientific naturalism, and (3) humanism, the idea that "Man is the measure of all things" (from Protagoras, 480–411 B.C.). Artists rediscover the world as a source of artistic inspiration; some masters, like da Vinci and Michelangelo, improved their knowledge of human anatomy by performing cadaver dissections. During this period artists become known as important personalities in their own right. This is in direct contrast to the medieval era during which anonymous artists worked only for the glorification of God. Renaissance artists' signatures often include Latin inscriptions such as *pictor* (painter), *fictor* (sculptor), or *fecit* (he made it).

The principal sources of artistic patronage during this period were the clergy and the nobility. Especially notable as patrons of the arts were Lorenzo de'Medici, (1449–1492) head of the powerful Medici banking family; Pope Julius II, patron of Michelangelo; and the Duke of Milan, Ludovico Sforza (called *Il Moro,* "the Moor," 1451–1508) the principal patron of Leonardo da Vinci. Artistic themes are, consequently, varied exhibiting an unusual mixture of religious subjects, episodes from pagan mythology, portraiture, and intellectual allegories, in roughly that order of popularity. Strangely enough, there is relatively little interest in realistic historical subjects during this historically-conscious era.

The hallmark of the ITALIAN RENAISSANCE style is its emulation of the artistic works of classical Greece and Rome. (An apocryphal legend has it that young Michelangelo even buried one of his own sculptures—a sleeping cupid—in order to pass it off as a "Roman antique," thereby increasing its value.)

The Renaissance era in art traditionally dates from the

sculptural competition to design the bronze doors of the Florentine
Baptistry (1401), won by painter-sculptor-goldsmith Lorenzo
Ghiberti. Another contender, the sculptor Filippo Brunelleschi, was
so disheartened by his loss that he abandoned sculpture and left
Florence for Rome. He later became the most respected architect of
the Renaissance.

 The art of the Italian Renaissance is dominated by many great
personalities. During this period artists came to be recognized as
something more than simple craftsmen and were accorded the same
status as writers and other intellectuals. A selection of the most
representative artists and architects follows, grouped by century to
reflect their historical order and stylistic affinities.

Prominent Renaissance artists of the 1400s (the *Quattrocento*)

Filippo Brunelleschi (1377–1446): Sculpor-turned-architect whose
 works freely incorporate elements from Roman classical
 architecture in his designs. His PAZZI CHAPEL recalls the
 Roman PANTHEON. (See Figure 5.67.) Early in his career
 Brunelleschi lost the sculptural commission for the doors of
 the Florentine Baptistry to Ghiberti (1401), a fortuitous defeat
 which eventually turned him from sculpture to architecture.

Donatello (1386–1466): Sculptor whose rugged figures exhibit a
 naturalistic weight shift or ponderation, recalling the Greek
 sculptor Praxiteles's fluid style. Donatello's highly
 individualistic works exhibit a range of stylistic diversity in a
 correspondingly wide variety of media including wood, metal,
 clay, and stone. See *The Repentent Magdalen,* as shown in
 Figure 5.68.

Masaccio (1401–1428, Tommaso Guidi, "Big Thomas"): Painter
 known primarily for his religious frescoes. While his depictions
 of anatomy are often awkward and uncertain (he died at 27),
 Masaccio used bold *chiaroscuro* effects (light and shadow) to
 emphasize the volume of his figures, making them appear as
 massive objects in realistic space. Although frequently an
 innovator,—he is credited with the invention of **atmospheric
 perspective**—Masaccio also drew upon older medieval
 techniques, such as **simultaneous narrative,** the idea of
 portraying several episodes in the same painting. See *The
 Tribute Money,* as shown in Figure 5.69.

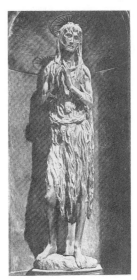

Figure 5.67 ITALIAN RENAISSANCE. Pazzi Chapel (west facade), Santa Croce, Florence (c. 1440) by Filippo Brunelleschi. Compare to Roman PANTHEON. (Alinari/Art Resource, NY)

Figure 5.68 ITALIAN RENAISSANCE. The Repentent Magdalen (c. 1455) by Donatello. Wood (approximately 6 feet). Baptistry, Florence. The flamelike contours of the repentent prostitute's garment suggest the purifying spiritual fires that burn within her. (Photo: Kunstgeschichte in Bildern III)

Figure 5.69 RENAISSANCE. The Tribute Money (1427) by Masaccio. Fresco (approximately 20' X 8'). Brancacci Chapel, Church of Santa Maria del Carmine, Florence. The scene illustrates a New Testament miracle; Christ (center) directs St. Peter to catch a fish from whose mouth he extracts a coin (left) to pay the tax collector (at right). Unlike the highly tentative medieval illustrations, Masaccio's figures appear as massive, solid forms in realistic space. Note the painter's use of one-point perspective in building at right. (Photo: Almari Art Resource, NY.)

Fra Filippo Lippi (c 1406–1469): Known for religious subjects portrayed with a humanized, worldly elegance. A colorful friar, he kidnapped a black-eyed nun who later bore him a child. The painter Botticelli was Fra Filippo Lippi's student. See *Madonna and Child with Angels,* as shown in Figure 5.70.

Andrea Verrocchio (1435–1488): Official painter/sculptor of the Medici family in whose workshop Leonardo da Vinci served his apprenticeship. Verrocchio's figures incorporate the classical **contraposto** stance (weight shift) and always seem to suggest the idea of great strength or power held in restraint. See *David,* p. 23.

Sandro Botticelli (1444–1510): Painter known for his sensuous linear style. An ardent student of Platonic philosophy, Botticelli fell under the influence of the fanatical Dominican reformer Savonarola and, in a fit of religious fervor, burned several of his own "pagan theme" paintings in the so-called bonfires of the vanities. See *Birth of Venus,* as shown in Figure 5.71.

Prominent Renaissance artists of the 1500s (the *Cinquecento*)

Leonardo (da Vinci) (1452–1519): Universal genius and student of Verrocchio known for his subtle evocations of mood, sophisticated foreshortening effects and masterful use of **sfumato** (literally *smoke,* a hazy softening of outlines). He worked for a time under the patronage of Ludovico Sforza, Duke of Milan. See *Last Supper,* (Figure 5.72) *Mona Lisa,* (p. 80), and *Madonna of the Rocks* (p. 108). Da Vinci is admired as much for his scientific insights as his artistic skill; his notebooks contain sketches for the contact lens, parachute, and other modern inventions. (See also comparison with Michelangelo, Chapter 2.)

Michelangelo (Michelagniolo Buonarroti, 1475–1564): Stone sculptor and master of the monumental figure (student of the painter Ghirlandaio) who spent part of his boyhood in the Medici household. At mid-career he was commissioned by Pope Julius II to design an extravagant papal tomb, but was later set to work decorating the SISTINE CHAPEL with frescoes when the papal tomb project met with financial setbacks. Also an accomplished draftsman and architect, Michelangelo

Figure 5.70 *RENAISSANCE.*
Madonna and Child with
Angels (c. 1455) by Fra
Filippo Lippi. Tempera on
wood, (approximately 36" X
24"). (Photo: Kunstgeschichte
in Bildern III)

Figure 5.71 *RENAISSANCE.*
Birth of Venus (c. 1482)
by Sandro Botticelli.
Tempera on canvas,
(approximately 6' X 9').
Ostensibly an allegory on
the naked passions clothed
by reason, this is the first
realistic large-scale female
nude painted since the end
of the classical period.
(Photo: Kunstgeschichte in
Bildern III)

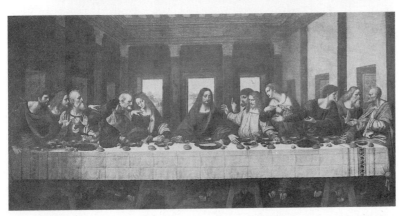

Figure 5.72 *RENAISSANCE.*
Last Supper (c. 1495) by
Leonardo da Vinci. Fresco
(approximately 14' X 28'),
Santa Maria dell Grazie,
Milan. Illustrates the moment
when Christ declares "one of
you will betray me." The
vanishing point is located at
Christ's eye; note how the
background arch subtly acts
as a halo. (Photo:
Kunstgeschichte in Bildern III)

Figure 5.73 *LATE RENAISSANCE. St. Peter's Basilica, Rome (1546–1564) by Michelangelo. Michelangelo's original design, a simplified version of the plan proposed by the architect Bramante, called for a hemispherical rather than a tapered dome. The Sistine Chapel roof is just visible to the right of St. Peter's. Forecourt designed by baroque sculptor Gianlorenzo Bernini. (Photo: Kunstgeschichte in Bildern III)*

Figure 5.74 *LATE RENAISSANCE. Creation of Adam from the Sistine Chapel ceiling (1508–1512) by Michelangelo. Fresco, (detail approximately 7' X 14') (Photo: Kunstgeschichte in Bildern III)*

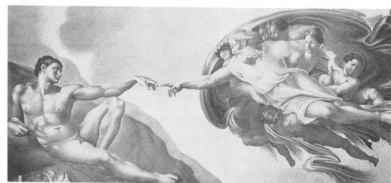

Figure 5.75 *RENAISSANCE. Madonna with the Goldfinch by Raphael Sanzio. The goldfinch, which builds its nest among thorns, is a metaphor for Christ's passion. (Photo: Kunstgeschichte in Bildern III)*

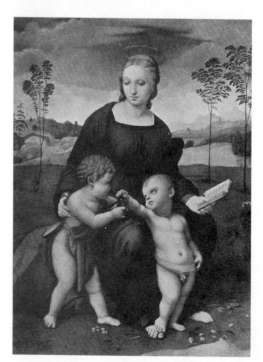

Figure 5.76 *RENAISSANCE. The Tempietto ("little temple"), Rome (1508) by Bramante. (Illustration: Geschichte der Bildenden Künste)*

simplified Bramante's original plan for ST. PETER'S BASILICA. See also *David* (p. 23), and the *Pietá* (p. 108) See here Figures 5.73 and 5.74.

Raphael (Raphael Sanzio, (1483–1520): Portraitist also known for his tenderly beautiful Madonnas and large-scale wall frescoes painted in the papal apartments of the Vatican Palace. See *Madonna with the Goldfinch* (Figure 5.75) and *The School of Athens* (p. 107).

Bramante (Donato d'Angelo, 1444–1514): Famous scholar-architect and associate of Leonardo da Vinci. Bramante's TEMPIETTO ("Little Temple", 1504) in Rome marks the spot where St. Peter is believed to have been crucified. Its well-reasoned simplicity served as an inspiration for all later domed neoclassical structures. His original plans for ST. PETER'S BASILICA (partly inspired by the Pantheon) were later revised by Michelangelo, who consolidated its complex arrangement of interior masses with a few simplifying penstrokes.

Andrea Palladio (1508–1580): One of the most popular architects of the Venetian Renaissance (although his best works are concentrated in and around Vicenza). In particular, Palladio is known for his composite neoclassical churches (Doric and Ionic) and villas modeled after Roman prototypes. Author of *The Four Books of Architecture* (1570). See VILLA ROTUNDA shown in Figure 5.77.

Figure 5.77 LATE RENAISSANCE. *Villa Rotunda (c. 1570) near Vincenza, Italy, by Andrea Palladio. Compare to the Roman* PANTHEON, *p. 145 (Photo: Kunstgeschichte in Bildern III)*

The Northern Renaissance

Miniatures were especially popular in the northern tradition and many painters began their careers as miniaturists, thus the NORTHERN RENAISSANCE style exhibits an extraordinary realism and attention to details which rivals modern scientific illustration. This is a radical departure from earlier medieval styles which shunned the practice of drawing "from life." But something of the medieval period is also preserved in the art of the North, particularly its preoccupation with complex religious symbolism and at times grotesque Gothic imagery.

Quasi-sciences such as alchemy (which sought to convert base metals into gold) created a strange admixture of science and mysticism which inspired the imagery of artists like Hieronymus Bosch (c. 1450–1516). Bosch's *Garden of Earthly Delights* (1505–1510) combines abstruse alchemical symbols, as well as nightmarish scenes reminiscent of the twentieth-century SURREALISTS, in a three-panel painting depicting the creation, sensuality, and destruction of the world. (See Figure 5.78.)

Prominent artists of the Northern Renaissance

Jan Van Eyck (c. 1390–1441): Trained as a miniaturist, Van Eyck is commonly held to be the inventor of oil painting (it was actually developed sometime in the twelfth century). His portrait of *Giovanni Arnolfini and His Bride* is rich in symbolism (Figure 5.79). The dog symbolizes loyalty (*fido* = faithful one), the single lit candle alludes to the Divine Presence, as well as the cast-off shoes (always removed on sacred ground).

Albrecht Dürer (1471–1528): German printmaker and one of the first international European art celebrities known mainly for his precisely detailed woodcuts and engravings. (See Figure 5.80.)

Matthias Grünewald (c. 1480–1528): German painter and contemporary of Dürer known for his complex *Isenheim Altarpiece,* a richly symbolic **polyptych** (many-paneled painting) which, as tradition has it, alludes to the sufferings of the amputees being treated for ergot poisoning at Isenheim's monastic hospital. (The painted panels of the altarpiece, when opened, cause the limbs of Christ to be ablated.) Grünewald is

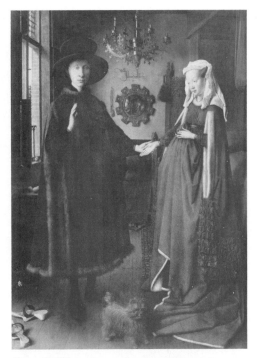

Figure 5.79 *NORTHERN RENAISSANCE.* Giovanni Arnolfini and His Bride (1434) by Jan Van Eyck. Oil and tempera on wood; approximately 32' X 22'. (National Gallery, London) (Photo: Almari Art Resource, NY.)

Figure 5.78 *NORTHERN RENAISSANCE.* The Alchemical Man from right panel of The Garden of Earthly Delights (1505–1510) by Hieronymus Bosch. Oil on wood, (center panel approximately 7' X 7'). (Mueso del Prado, Madrid; Photo: Almari Art Resource, NY)

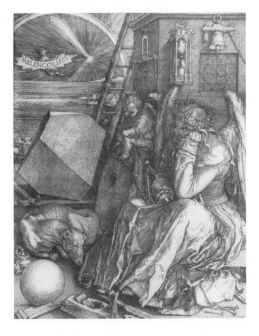

Figure 5.80 *NORTHERN RENAISSANCE.* Melencolia I (Melancholy, 1514), by Albrecht Dürer. Engraving, 9.5" X 7.5". Fogg Art Museum, Harvard University, Cambridge Massachusetts (bequest of Francis Calley Gray).

Figure 5.81 *NORTHERN RENAISSANCE.* Isenheim Altarpiece (1510–1515) by Matthias Grünewald. Oil on wood, center panel approximately 9' X 10'. (Musée Unterlinden, Colmar.) (Photo: Art Resource)

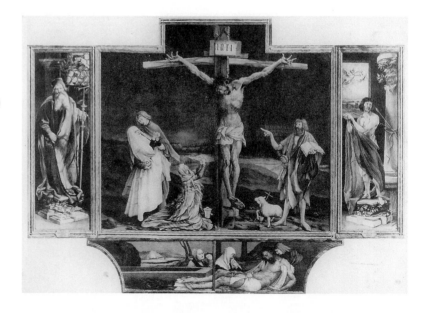

Figure 5.82 *NORTHERN RENAISSANCE.* Hunters in the Snow (1565) by Pieter Bruegel. Oil on wood, approximately 4' X 5'. (Photo: Foto Marburg Art Resource, NY.)

a master realist and depicted Christ's wounds with brutal, clinical precision. (See Figure 5.81.)

Pieter Bruegel the Elder (c. 1525–1569): Painter nicknamed "Pieter the Droll" due to his gift for satiric caricature plainly evident in his group portraits. Also an accomplished landscape painter, his genre images afford us a glimpse into northern life during the mid-sixteenth century. See *Hunters in the Snow* (Figure 5.82).

El Greco (Domenicos Theotocopoulos, "The Greek," c. 1547–1614): Painter (born on Crete, but lived in Spain) known for his highly individual and expressive stylistic elongations of his figures. Although commissioned by Phillip II to design an altarpiece for the chapel at the ESCORIAL PALACE, El Greco's masterpiece is *The Burial of Count Orgaz* depicting the ascent of a man's soul into heaven, which ironically El Greco painted for his own modest parish church. (See Figure 5.83.) El Greco's unusual, expressive compositions anticipate the emerging Baroque style in painting.

Figure 5.83 NORTHERN RENAISSANCE. Burial of Count Orgaz (1586) by El Greco. Oil on canvas, approximately 16' X 12'. (Church of Santo Tomé, Toledo, Spain; Photo: Giraudon Art Resource, NY.)

Mannerism (Sixteenth Century)

During the last decades of the 1500s, artists sought to capture the stylistic essences of the great Renaissance masters by distilling their painting techniques into simple artistic formulas, thus allowing any artist to paint *in the manner* of Leonardo or *in the manner* of Raphael; hence, artists who followed this style were called *Mannerists*. Once regarded as followers of a decadent style, Mannerists like Antonio da Correggio (c. 1489–1534) are now appreciated for their own unique characteristics, rather than for their ability to emulate Leonardo's or Raphael's techniques.

The Renaissance is portrayed as a time of great cultural achievement, but it was also a violent era marked by political and religious conflicts, such as the Protestant Reformation begun by Martin Luther in 1517. This atmosphere of disquietude is portrayed in no uncertain terms in Leonard da Vinci's famous letter of introduction to his prospective patron *Il Moro* (Ludovico Sforza). Here Leonardo presents his credentials, somewhat in the manner of a résumé, by mentioning first his expertise as a designer of fortifications, military bridges, siege mortars, and other instruments of warfare. Only at the very end of the letter does Leonardo mention, almost as an afterthought, that he also dabbles in sculpture and architecture and can paint as well as any man "be he whom he may."[5] Similarly, it is known that the great Renaissance patron of the arts Lorenzo de'Medici seldom appeared in public without an entourage of armed guards who carried their swords drawn, ready for a surprise attack. (Lorenzo's younger brother Giuliano had been stabbed to death, during a celebration of Holy Mass no less, by members of a rival banking family acting in league with the Archbishop of Pisa!) The fact that so much significant art emerged from so brutal a period remains one of the great ironies of history.

The Renaissance biographer Giorgio Vasari (1511–1574) presents many fascinating details of the period in his famous *Lives of the Most Eminent Painters, Sculptors, and Architects* (1550).

[5] *J. P. Richter and I. A. Richter, The Literary Works of Leonardo da Vinci [2 volumes] (London: Oxford University Press, 1939), pp. 325–327 cited in A Documentary History of Art [Volume 1] by ed. Elizabeth G. Holt (New York: Doubleday/Anchor Books, 1957), pp. 273–274.*

IX. The Baroque and Rococo Eras
(1600–1750)

The word *baroque,* derived from a Portuguese word meaning "imperfect pearl," was first applied as a term of derision to artworks that seemed overly ornate or extravagant. And in general usage, *baroque* still carries that same connotation today. In art history, however, **Baroque** refers to the period from 1600 to 1715, during which the neoclassical rationality of Renaissance art gave way to a more emotionally exhuberant and sometimes artificially theatrical style.

The Baroque style originated primarily in Italy and France, but its influence quickly spread across Europe, northward to the Netherlands and westward to Spain. The court of **Louis XIV** of France (called "the Sun King," *Roi Soleil*) stands as the epitome of the grand and opulent aristocratic Baroque style. Louis's grand palace complex at VERSAILLES (a suburb of Paris) was widely imitated by other monarchs of Europe. (See Figures 5.84 and 5.85.)

Following the death of Louis XIV in 1715, the cultural epicenter shifted from Versailles back to Paris (the Louvre was then a royal palace). The opulence of the courtly Baroque style gave way to a more subdued and delicate, almost feminine, style called **Rococo.** This style flourished in the urban *salons,* fashionable gatherings of artists and intellectuals hosted by influential socialites. Smaller easel-size paintings and tabletop-scale ceramic sculptures are typical of the delicate Rococo style.

Baroque art emphasizes emotion and dramatic action.

Figure 5.84(a) BAROQUE. The "Marble Court" of the Royal Palace Versailles, (c. 662–1688), Architects Louis Le Vau and Jules Haroudin-Mansart. (Photo: Versailles)

Figure 5.85(b) BAROQUE. Hall of Mirrors Royal Palace, Versailles. (c. 1680), Jules Haroudin-Mansart and Charles Le Brun. Approximate dimensions: 240 feet long 35 feet wide, 40 feet high. (Photo: Versailles)

Figure 5.86 *BAROQUE.* Ecstasy of St. Theresa (c. 1650) by Gianlorenzo Bernini. Marble and gilded bronze, life-size. The sculpture illustrates an ecstatic vision of the saint in which an angel appeared to pierce her breast with a flaming spear. (Cornaro Chapel, Santa Maria della Vitoria, Rome) (Photo: Alinari Art Resource, NY.)

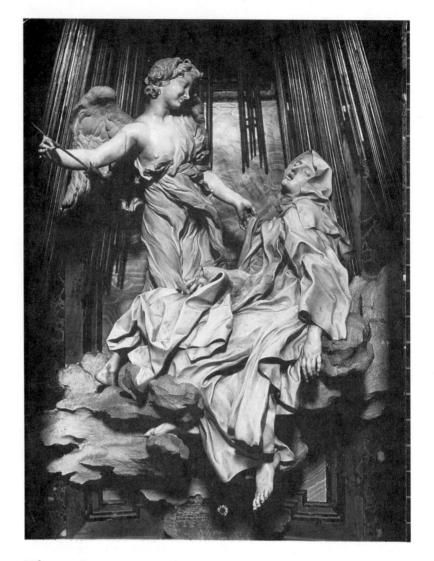

Whereas Renaissance artists organized their compositions around stable geometric figures, such as triangles or squares, Baroque artists chose circles, spirals, or sweeping diagonals as the basis for their compositions (see discussion of Rubens's *Rape of the Daughters of Leucippus,* Chapter 4). Emphasis is upon old themes reworked in new unusual ways, dramatic scenes of great emotional expression, or exotic and sometimes bizarre subject matter. Large wall or ceiling paintings, which seem to sweep the observer into the scene, were popular as well as life-size sculptural groupings in elaborate interior settings. The modern art historian Heinrich Wolfflin characterized the Baroque style generally as a "painterly" style emphasizing light and color in contrast to the

Renaissance "sculptural" style which emphasized solidity of form.[6]

The sculptor-architect Gianlorenzo Bernini (1598–1680) the "Michelangelo of the Baroque" best typifies the Baroque style. Bernini's twisting, writhing marble figures make extensive use of dynamic **contraposto** stances (upper body turned one way, lower body turned another) pioneered by Michelangelo in his Sistine Chapel frescoes. Bernini's carvings depict figures frozen in motion as in *Ecstasy of St. Theresa* (Figure 5.86) and *David* (see p. 23). Bernini's mastery remained unquestioned until Louis XIV rejected Bernini's design for a new facade for the Louvre (then the royal palace) in favor of the French designer Claude Perrault, thus breaking completely with the Italian tradition.

The Baroque style is often subdivided into an *aristocratic* and a *bourgeois* (middle-class) style. Both styles emphasize portraiture. Other principal themes include episodes from classical mythology (aristocratic style) and stories from the Bible and genre scenes (bourgeois style). In the later **Rococo** style, subject matter is devoted almost exclusively to earthy parables on the vicissitudes of amatory love.

The Baroque style in architecture is expressed through curved facades which combine convex and concave forms such that exterior walls resemble undulating curtains. Baroque architecture favors *historical eclecticism*; that is, architects draw their inspiration from various works of the past—the purpose of a structure dictating its design. Thus, a banking house might be modeled after a Renaissance palace, a small chapel after a Greek temple, and so forth.

The aristocratic Baroque style

The showplace of the aristocratic Baroque style is VERSAILLES, Louis XIV's self-contained palace-city (about 12 miles southwest of Paris). Built on the site of an old hunting lodge, Versailles was about half the size of Paris. During Louis XIV's reign, all important nobility lived at the court of Versailles. (See Figures 5.84, 5.85.)

Life at Versailles was extravagant; *60 percent of all taxes levied in France* went to support Versailles and its army of servants. In later years the infamous Marie Antoinette had a full-sized replica of a peasant hamlet, including an elaborate cottage, dairy, and mill, built on the grounds so she could indulge her fantasies of returning

[6] *Heinrich Wolfflin, Principles of Art History (1915), trans. M. D. Hottinger (New York: Dover Publications, Inc., 1950). See especially Chapter 1.*

to a simple peasant's life (probably inspired, in part, by French philosopher Jean Jacques Rousseau's popular "back to nature" movement).

Designed chiefly by Jules Hardouin-Mansart and decorated by Charles LeBrun, the Versailles complex includes in addition to the royal palace a royal chapel, stables, and a large "Palace of Oranges," a greenhouse so grand that a visiting ambassador once mistook it for the royal palace. Perhaps Versailles's most well-known features are its formal gardens, designed by André LeNôtre, which act to mediate between the stark geometry of the buildings and the wild naturalism of the surrounding countryside. The principal streets all radiate from the center of the palace, specifically Louis's bedroom (an allusion to the rays of the rising sun). An artificial canal for evening boating excursions links the main palace with the Trianon, a smaller private residential palace.

Other important artists of this period include:

Gianlorenzo Bernini (1598–1680): Principal sculptor-architect of the Italian baroque style known for his sculptures of figures in motion, fountain designs, and the keyhole-shaped piazza in front of St. Peter's Basilica, Rome. See also *David* (p. 23) and *Ecstasy of St. Theresa.* (Figure 5.86)

Diego (Rodriguez de Silva y) **Velazquez** (1599–1660): Spanish portraitist and court painter to Phillip IV of Spain known for his compositionally sophisticated paintings. See *Las Meninas (Maids of Honor)* Figure 5.87.

Peter Paul Rubens (1577–1640): Flemish portraitist and diplomat who maintained a workshop of assistants in order to satisfy the demand for his works. See *Rape of the Daughters of Leucippus* (p. 104).

The bourgeois Baroque style

The painter Caravaggio (Michelangelo di Merisi) is to Baroque painting what Bernini (his near-contemporary) was to Baroque sculpture. Possessed of a turbulent personality, Caravaggio was often in trouble with the law and spent much of his life consorting with criminals. His extreme realism made Caravaggio a controversial figure. (He once infuriated a clergyman-patron by depicting one of the apostles with soiled feet.) Caravaggio's use of **tenebrism** (the dark manner) and his portrayal of religious subjects in contemporary dress—as outlandish a juxtaposition in

Figure 5.87(a) SPANISH BAROQUE. Las Meninas (Maids of Honor, 1656) by Diego Velasquez. Oil on canvas (approximately 10' X 9'). The subjects being painted on Velazquez's huge canvas are the royal couple, dimly reflected in the central mirror. (Mueso del Prado, Madrid). (Photo: Almaril/Art Resource, NY.)

Figure 5.88(b) NORTHERN BAROQUE. Aristotle Contemplating a Bust of Homer (1653) by Rembrandt van Rijn. Oil on canvas, 56" X 54". (Photo: The Granger Collection.)

his time as showing the disciples of Christ eating at a fast-food restaurant would be in our own—are distinctive stylistic traits.

During this period the rise of the merchant class, the bourgeoisie, in northern Europe made portraiture a profitable enterprise. Painters, such as Rembrandt, were able to support themselves for much of their careers on a free-market basis, that is, without the lifelong sponsorship of a single wealthy patron.

Important painters of this period include:

Caravaggio (Michelangelo de Merisi, 1571–1610): Master of tenebrism and painter most typical of the Baroque style. See *Conversion of St. Paul*, p. 86.

Rembrandt Van Rijn (1606–1669): Dutch printmaker and portraitist known for moody character studies typically done in the "dark manner" of Caravaggio. Rembrandt produced at least 62 self-portraits in addition to numerous biblical paintings and group portraits. (See *Aristotle Contemplating a Bust of Homer*, Figure 5.88.)

Jan Vermeer (van Delft) (1632–1675): Enigmatic painter whose small canvases depict one or two figures in simple interior settings, suggesting a mood of great solemnity. His reputation rests upon only a few dozen finished works (others may have been lost), many painted with the aid of a camera obscura. See *Young Woman with a Water Jug* (Figure 5.89).

Artemisia Gentileschi (1593–1652?): Stylistic follower of Caravaggio

Figure 5.89 NORTHERN BAROQUE. Young Woman with a Water Jug (c. 1665) by Jan Vermeer. Oil on canvas, Approximately 18" X 16". (Johannes Vermeer/ Metropolitan Museum of Art, New York)

and one of the first truly significant female artists. She was well known for her portraits and biblical theme paintings, often featuring female subjects. (See Chapter 3, Figure 3.15.)

The Rococo style

This urban style is associated with the Parisian *salons* and characterized by works of a smaller, intimate scale. The mood and subject matter are often light and frivolous. Amatory love is a dominant theme, usually depicted through mythical episodes and settings. The work of Jean Honoré Fragonard (1732–1806) whose charming, often humorous paintings depict the intrigues of love are typical of this era. See *The Swing* (Figure 5.90).

Figure 5.90 ROCOCO. The Swing (1766) by Jean Honoré Fragonard. Approximately 35" X 32". A young woman playfully kicks off her slipper at the sight of her paramour hidden among the bushes; the kindly old vicar is oblivious to their intrigue. (Wallace Collection, London; Photo: Art Resource)

X. Neoclassicism and Romanticism (1750–1850)

Neoclassicism

The emergence of the **neoclassical style** in France and England (*neo* = new) was fostered by (1) the remarkable archaeological excavations of the cities of **Pompeii** and **Herculaneum** (buried by an eruption of Mt. Vesuvius in A.D. 79), and (2) the prerevolutionary atmosphere of late eighteenth-century France, which sought an alternative to the excessive styles favored by the aristocracy.

The **Neoclassical style** is, as its name imples, a frank emulation of Greco-Roman culture. As an artistic style, it expresses a certain reserved austerity that is ironically based largely upon mistaken interpretation of what classical art looked like. (As pointed out earlier, most Greek sculpture was painted, not left in the pristine whiteness of natural stone, an accident caused by weathering of the marble over the centuries, which later sculptors emulated.)

Not all neoclassical works met with the same degree of success. The premier French neoclassical painter Jacques Louis David won acclaim for his paintings of salient episodes of patriotism drawn from ancient Roman history, but Horatio Greenough's monumental marble sculpture (1832–1841) of George Washington wearing a toga and swearing an oath upon a Roman sword (Smithsonian Museum, Washington, D.C.) now looks simply incongruous.

The Neoclassical style in America finds its best expression in architecture in Thomas Jefferson's designs for his country estate Monticello (1770–1806, Charlottesville, VA) and the Rotunda at the University of Virginia (1819–1826, Charlottesville). Both emulate the Roman PANTHEON but with a distinctly colonial accent. Similarly, French architect Pierre-Alexandre Vignon's Greek templelike LA MADELEINE, a church dedicated by Napoleon to his troops, is unmistakably a reincarnation of the Athenian PARTHENON with three domes added, visible only from the interior.

Other significant neoclassical masters include:

Jacques-Louis David (1748–1825): The preeminent painter of the neoclassical period who served for a time as Napoleon's

personal portraitist. A short biography as well as a detailed discussion of his *Oath of the Horatii* are presented in Chapter 4, page 121.

Jean-Auguste Dominique Ingres (1781–1867): Student of Jacques-Louis David, known primarily for his academic paintings (especially a ceiling mural for the Louvre) depicting episodes drawn from classical myth (see *The Riddle of the Sphinx*, Figure 5.91), as well as portraits, and grouped female nudes in Turkish bath settings. Ingres held great contempt for excessive color in painting, believing it to be merely a crutch used by mediocre artists to disguise flaws in their drawing. These beliefs naturally brought him into conflict with the colorful romantic painter Eugène Delacroix; their lifelong rivalry is discussed in Chapter 1.

Figure 5.91 NEOCLASSICISM. The Riddle of the Sphinx (1808) by Jean Auguste Dominique Ingres. Oil on canvas, approximately 6' X 5'. (Louvre, Paris; Giraudon Photo: Art Resource, NY.)

John Flaxman (1755–1826): Sculptor-draftsman known for his
austere contour drawings of human figures depicted in the
Classical style; his drawings are reminiscent of Roman
monument reliefs and later Greek vase paintings.

Antonio Canova (1757–1822): Sculptor known for his portrait
figures. He depicted Napoleon's sister Pauline Bonaparte
(Borghese) as "Venus Triumphant" reclining partially nude
upon a carved marble couch. His work influenced the early
American sculptor Horatio Greenough (mentioned earlier).

Angelica Kauffman (1741–1807): Neoclassical painter whose
interest in historical subjects was inspired by a trip to Italy
early in her career. (Most women artists of her period favored
less challenging subjects, such as still lifes.) Kauffman later
became a founding member of London's Royal Academy of Art
and also produced a number of portraits and architectural
decorations as a commercial sideline.

Elizabeth Vigée-Lebrun (1755–1842): Eminent French portraitist
whose sitters included many figures of European nobility,
including Marie Antoinette, and the Prince of Wales. After
escaping the French Revolution, she traveled throughout
Europe as an itinerant painter, amassing a considerable
income from her works. Her experiences are recounted in her
journal writings published under the title *Souvenirs*.

Romanticism

The Romantics sought emotionally-charged subject matter and,
thus, represent a reaction against the austere intellectualism of the
Neoclassicists. Evocative even grotesque images were favored over
bland historical-classical subjects and nature was glorified as a force
greater and more enduring than humankind.

The Romantic movement began in England (c. 1820) but
spread quickly to France and Germany where similar trends were
also evident. Romanticism is often regarded as a reaction to the
ultrarationalism of the eighteenth-century Age of Enlightenment and
the social oppressions of the Industrial Revolution (c. 1760 in
England). Romantic writers and artists, in their search for evocative
subject matter, culled images from the past, especially the medieval
period. (Sir Walter Scott's classic tale from the age of chivalry,
Ivanhoe, enjoyed immense popularity among nineteenth-century
readers.) In architecture, Horace Walpole (1717–1797), a wealthy

Figure 5.92 *ROMANTICISM.* Arab Horseman Attacked by a Lion *(1849/50) by Eugéne Delacroix. Oil on panel, approximately 18" X 15". One of many paintings inspired by the artist's journey to Morocco in 1832. (Art Institute of Chicago, Mr. and Mrs. Potter Palmer Collection.)*

Figure 5.93 *ROMANTICISM.* Cloister Graveyard in the Snow *(1810) by Caspar David Friedrich. Approximately 47" X 70". Destroyed during World War II. (National Galerie Staatliche Museen, Berlin. Photo: Foto Marburg Art Resource, NY.)*

eccentric, constructed an entire "fairy-tale" Gothic castle on the grounds of his estate at Strawberry Hill, Twickenham (near London). Sham medieval ruins (as in Bath, England) were widely popular as "set pieces" in English gardens of the period, which exhibited nature in all its feral, unmanicured beauty.

The majesty and grandeur of nature is a popular theme among Romantic painters, particularly images which evoke a sense of the *sublime* (awesome beauty), such as volcanic eruptions, storms at sea, and so on. The Romantics also found the "inner landscape" of the imagination no less appealing and saw deeper human truths reflected in the fleeting images of dreams and nightmares.

The mature works of the French Romantic painter Eugène Delacroix (1798–1863) are regarded as among the foremost examples of the romantic style. Delacroix's paintings combine images of dramatic action (such as lion hunts) set in exotic locales depicted with bold color and a vigorous drawing style. His scenes of Morocco, painted following an expedition there, rival the works of the Neoclassicists in their evocative mystery and visual power. (See Figure 5.92.) Had Delacroix never painted, he would probably still be known for his marvelously detailed journal writings (available in translation). For a comparison of Delacroix's style to that of his Neoclassical rival Ingres, see Chapter 1.

Other significant artists of the Romantic era include:

Henry Fuseli (1741–1825): English painter/illustrator known primarily for his macabre fantasy images and illustrations of scenes from Shakespearean drama.

Francisco Goya (1746–1828): Court painter to King Charles IV of Spain, Goya is known for his unsentimental depictions of events drawn from contemporary history (such as his *Executions of the Third of May, 1808*). Goya was also an accomplished printmaker; his very graphic print series *The Disasters of War* and the more philosophical *Los Caprichios* (i.e., *Caprices*) are among his masterworks.

Caspar David Friedrich (1774–1840): German painter known for his moody, atmospheric landscapes (see *Cloister Graveyard in the Snow*, Figure 5.93).

Joseph Mallord William Turner (1775–1851): English landscape painter whose expansive canvases depict the raw, sublime power of nature. His later works such as *Rain, Steam, and Speed: The Great Western Railway* (1844), a nearly abstract painting of a locomotive crossing a bridge during a driving

rainstorm, anticipate in many respects the development of the impressionist style as well as the expressionistic abstractions of the mid-twentieth century. Turner was notorious for continually retouching his paintings, sometimes even while they hung on museum walls. A newspaper cartoon once depicted him dabbing a few quick finishing touches onto a canvas while a museum guard's back was turned.

Théodore Géricault (1791–1824): Friend and mentor of the painter Delacroix whose startlingly realistic *Raft of the Medusa* (16' x 23') depicts a group of shipwreck survivors who resorted to cannibalism while stranded on a raft in the open sea. Géricault constructed a full-size raft in his studio as a model for the painting and interviewed actual survivors of the wreck. (Delacroix posed as a model for one of the figures.)

The Romantic and Neoclassical styles continue to survive in various transformations in the art of the present, especially in POSTMODERNISM which has a distinctly neoclassical undertone. Romanticism and Neoclassicism are compared in depth as complementary and opposing stylistic attitudes in Chapter 1.

XI. Realism, Impressionism, and Expressionism (Postimpressionism) (1850–1900)

Since the mid-nineteenth century, the history of art has been characterized by a succession of stylistic movements created by small groups of artists united by their philosophical and/or stylistic similarities. The relatively brief life spans of these movements, measured in terms of years or decades rather than centuries, usually coincide with the working careers of their principal representative artists.

In France and Britain the emergence of the **Realist style** in painting (c. 1850) can be traced to several factors including (1) the invention of photography (c. 1840) by Niepce and Daguerre, (2) the reaction against the escapist styles of Neoclassicism and Romanticism, and (3) the rise of modern scientific knowledge and its associated philosophy of *logical positivism*. (Briefly, this is the idea that the universe is physically just as it appears to be and operates much like a machine; the opposite of mysticism).

The Industrial Revolution spread during this period, transforming Great Britain and much of Europe from a rural-agricultural way of life into a modern urban-industrial economy. The associated interest in modern industrial machinery is reflected in monumental works such as engineer Gustave Eiffel's EIFFEL TOWER (built 1889) and even in the Impressionist painters' inclusion of trains and modern bridges in their works.

The **Impressionist painters** (1874–86) were influenced by scientific research on the nature of light and color. Ironically, the Impressionists are often portrayed as opponents of realism when, in fact, they were searching for a new realist style. Their technique of *optical blending of colors* (e.g., adjacent dabs of yellow and blue will fuse into green when viewed from a distance) recalls the psychophysicist Hermann Helmholtz's demonstration that spinning a multicolored disk blends the hues back to white. The Impressionists' use of **chromatic shadows** (a complementary hue or dark blue, rather than black) demonstrates their appreciation and sensitivity to color contrast effects.

Post-Impressionist and Symbolist styles (c. 1880–90s) can be understood as representing both (1) reactions to the

impressionist style and (2) early forays into **abstraction,** prompted by painter Paul Cézanne's famous admonition to reduce all forms in painting to the *cone, cylinder, and sphere.*

Realism (c. 1850)

Realist painters such as Gustav Courbet (1819–1877) employ a documentary approach to their subjects which is neither idealized nor satirized, similar to the scientific technique of natural observation. Brushstroke effects are minimized (surface textures flattened) in order to suggest an almost photographic image. Open compositions are generally favored to avoid the look of staged artificiality; color is realistic, with mood expressed through atmospheric effects.

Important realist painters include:

John Constable (1776–1837): An early exponent of English realist painting who broke with the absurd "academy picture" tradition which held that landscapes should have a warm, umber glow, "... like the finish of an old violin." When criticized for his bold use of greens, a legend tells that Constable once laid a violin down upon the grass for the enlightenment of one of his critics. His principal works include *The Haywain* (1821) and views of Salisbury Cathedral.

Jean François Millet (1814–1875): A transitional genre painter of the late Romantic movement known for his realistic, dignified portrayals of French common folk laboring in their fields.

Honoré Daumier (1808–1879): French painter-printmaker known primarily for his satirical and startlingly realistic drawings (over 4,000), many published in Parisian journals. (One of his typical cartoons shows two gentlemen politicans ostensibly exchanging a friendly embrace while actually rifling through each other's pockets.) The intense emotional expressiveness of Daumier's work simultaneously associates him with the Romantic style.

Gustave Courbet (1819–1877): Courbet's starkly realistic painting style, such as the dismal burial scene portrayed in his *Burial at Ornans* (1849), lends an archetypal "everyman" quality to his subjects. His famous quote, "Show me an angel and I'll paint one," typifies the hard-line Realist's approach to painting.

Édouard Manet (1832–1883): A transitional painter who spans the late Realist and Impressionist eras. Manet's painting style is

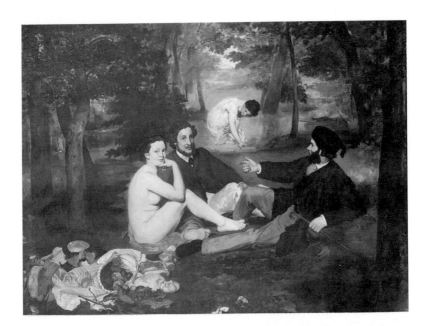

Figure 5.94 REALISM. Le Déjeuner sur l'herbe (Luncheon on the Grass, 1863) by Édouard Manet. Oil on canvas, approximately 7' X 9'. (Galerie du Jeu de Paume, Paris; Photo: Giraudon Art Resource, NY.)

characterized by broad, flat passages of color applied with little or no blending, somewhat reminiscent of the later Impressionist technique. His juxtaposition of classical nudes and contemporary figures in a idyllic Parisian park scene (Le Déjeuner sur L'herbe or Luncheon on the Grass, 1863) caused a livid public outcry over its presumed amoral implications. (See Figure 5.94.)

Augustus Saint-Gaudens (1848–1907): American sculptor (trained in France) whose realistic figures convey a sense of profound human drama. His bronze *Figure of Mourning, Adams Memorial* (Washington, DC) is a simple yet enigmatic seated figure draped, from head to foot, in a mourning shroud.

Joseph Paxton (1801–1865): English greenhouse designer known for his innovative design for the Crystal Palace (1851), an exhibit hall built for a London industrial arts exhibition. Constructed entirely of prefabricated iron frames and glass panels, it was dismantled in the early days of World War II when it was learned that Nazi pilots were using it as a navigational landmark during their raids on London.

Impressionism (c. 1874–1886)

The term *Impressionism* was first applied as a term of critical disapproval to a small harbor scene painting (*Sunrise: An Impression*, 1872) by the principal figure of this movement Claude Monet

(1840–1926). The Impressionists' interest in fleeting effects of light and color and the subtle moods they evoke are best represented by Monet's "series paintings," which included a series of haystacks portrayed during the different seasons. Others include the facade of Rouen Cathedral portraying the subtle, shifting patterns of color and light at different times of day. The Impressionists were a tightly knit group; Auguste Renoir and Monet often accompanied one another on their **plein-aire painting** expeditions into the local countryside. Monet's interest in Oriental artifacts, called *chinoiserie* and Japanese prints was shared by many artists of the period, including Vincent Van Gogh.

The Impressionist style was not well received initially by critics or the general public. Most painters exhibited in the *Salons des Refusés*, a hodgepodge show of works rejected by the official juried exhibitions of the French Academy of Fine Arts.

Significant Impressionist painters include:

Claude Monet (1840–1926): Principal painter of the Impressionist movement, his works provide the purest statement of its aims—to capture the subtle as emotional states embodied in fleeting effects of light and color. (See Figure 5.95.) Cézanne said of him, "He is only an eye, but what an eye!"

Auguste Renoir (1841–1919): Colleague of Monet whose pleasant, endearing works combine impressionist scenes with portrait figures. Renoir was one of the most prolific artists of the late

Figure 5.95 IMPRESSIONISM. Arrival of the Normandy Train, Saint-Lazare Station, Paris *(1877) by Claude Monet. Oil on canvas, approximately 24" X 32". (Art Institute of Chicago, Mr. and Mrs. Martin A. Ryerson Collection)*

nineteenth century. Toward the end of his life paralysis forced
him to strap his paintbrushes to his hands.

Edgar Degas (1834–1917): A Realist painter-turned-Impressionist,
best known for his elegant compositions depicting ballet
dancers in rehearsal and performance in which a sense of
motion is conveyed through his use of rhythmic visual patterns
(spiral staircases, converging floor boards and so on). Degas's
bronze statue *14-year-old ballet dancer* (1881) is clothed in an
actual ballet skirt, a gesture which anticipated twentieth-
century assemblage techniques.

Mary Cassatt (1844–1926): Called the "American Impressionist,"
Cassatt befriended Edgar Degas and traveled to France, where
she exhibited with the Impressionists. Cassatt's principal
works are sensitive portraits of mothers with their children.
She was a friend of BERTHE MORISOT (1841–1895), a lesser-
known female Impressionist painter.

Auguste Rodin (1840–1917): Sculptor associated with the
impressionist style due to his bold, expressive modeling
technique—similar to the Impressionists' bold brushstrokes—
which makes no attempt to disguise handprint and tool
marks. Rodin worked exclusively in bronze (cast from
clay/plaster models). The marble statues attributed to him
were carved by assistants working under his direction. He
is perhaps best known for his intense seated figure, *The
Thinker* (1888).

Post-Impressionism (c. 1880)

Post-Impressionist styles constitute a reaction to the superficial
beauty of Impressionist works by stressing a more expressive,
though not always realistic, approach to color and draftsmanship.
The works of Paul Cézanne (1839–1906) established significant
trends in painterly abstraction that influenced most later twentieth-
century artists. The Cubist painter Pablo Picasso called Cézanne,
"the father of us all." Cézanne's admonition to interpret nature in
terms of the cone, cylinder, and sphere is evident in his many still-
life paintings, although his landscapes of the rugged countryside
around Mt. St. Victoire (near Aix-en-Provence) are perhaps best
representative of his profound ability to abstract color and form
from his natural subjects. Cézanne is regarded as one of the most
influential artists of the modern period, a significant transitional

Figure 5.96 *POST-IMPRESSIONISM.* Basket of Apples *(1890–1894) by Paul Cézanne. Oil on canvas, approximately 26" X 32". (Art Institute of Chicago, Helen Birch Bartlett Memorial Collection)*

Figure 5.97 *POST-IMPRESSIONISM.* A Sunday on La Grande Jatte-*1884 (1884–86) by Georges Seurat. Oil on canvas, approximately 6'10" X 10'. (Art Institute of Chicago, Helen Birch Bartlett Memorial Collection)*

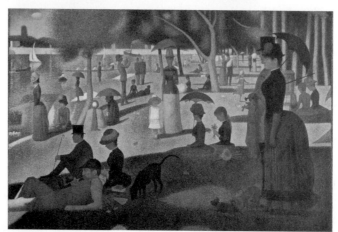

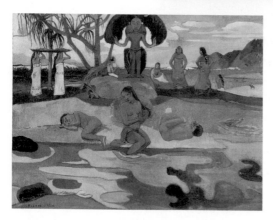
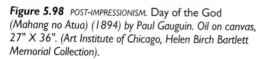

Figure 5.98 *POST-IMPRESSIONISM.* Day of the God (Mahang no Atua) *(1894) by Paul Gauguin. Oil on canvas, 27" X 36". (Art Institute of Chicago, Helen Birch Bartlett Memorial Collection).*

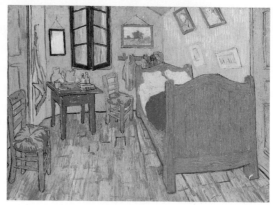

Figure 5.99 *POST-IMPRESSIONISM.* Bedroom *(at Arles) (1888) by Vincent Van Gogh. Oil on canvas, approximately 29" X 36". (Art Institute of Chicago, Helen Birch Bartlett Memorial Collection)*

figure that bridges the gulf between realism and abstraction in painting. (See Figure 5.96.)

Other significant Post-Impressionist painters include:

Georges Seurat (1859–1891): Post-Impressionist painter known for his use of the painstaking, ultracontrolled technique of **pointillism**—that is, creating an image from thousands of small points of pure color set on a white ground. The points of color optically blend, like the dots in a halftone photograph, to produce an image of extraordinary color intensity. (Purists will point out that Seurat's painting technique is actually *divisionism,* in which the white surface of the painting ground is entirely covered. In *pointilism* portions of the primed canvas are left partly visible.) See *A Sunday on La Grande Jatte* (1884), Figure 5.97.

Paul Gauguin (1843–1903): A brokerage agent and amateur painter, Gauguin abandoned his prosperous bank position at age 35 and sailed to Tahiti in order to devote himself entirely to painting. Although he was only moderately successful as a working artist during his lifetime, Gauguin's paintings are now respected for their vividly expressionistic approach to color, often applied in abstract patterns. Gauguin's work combines an Impressionist's sensitivity to color with the painter's own fascination for symbolism which, at times, reaches almost mystical intensity. (This new style Gauguin dubbed *synthetism*). In fact, Gauguin was associated with the symbolist movement early in his career (see *Day of the God,* Figure 5.98). Gauguin's followers, the **Nabis** were influenced by the pungent, earthy vigor of primitive art.

Vincent Van Gogh (1853–1890): Dutch painter (lived in Arles, France) known for his expressive flamelike brushstrokes and bold use of color. (See Figure 5.99.) His stylistic tendency to exaggerate essential features of his subject while leaving the obvious vague, approaches at times a sublime form of caricature. Van Gogh's letters to his brother Theo (now published as a collection) and to his friend the painter Paul Gauguin present a sensitive, deeply moving portrait of the artist. His tragic affliction with an unidentified psychological disorder resulted in the self-mutilation of his left ear (1888) and contributed to his untimely death at age 37.

Henri de Toulouse-Lautrec (1864–1901): French painter, printmaker, and gifted caricaturist who, outcast because of his

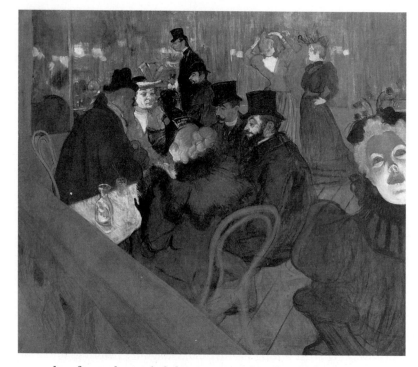

dwarfism, chronicled the seamy underside of life in
Montemarte café society in his pastel drawings and paintings.
His many studies of the nightly patrons at the Club Moulin
Rouge (the Red Mill) include sketches of then unknown
painters, including Vincent Van Gogh. Lautrec's satirical style
is always tempered with a tender compassion for the
prostitutes, lesbians, and various social outcasts who became
his cohorts. See *At the Moulin Rouge* (1892), Figure 5.100.

The emerging trend toward **abstraction,** evident in the last decades
of the nineteenth century, signals the beginning of a new concept in
painting. The idea of paintings as nonrepresentational aesthetic
objects to be experienced and appreciated in their own right, rather
than simply as copies of things in the world, emerges most fully in
Vasily Kandinsky's entirely abstract watercolor paintings of 1910.
Abstraction in all its various degrees and styles, combined with
intensely personal expression, will form the conceptual and stylistic
basis for much of twentieth-century art.

XII. Early European Modernism
(1900–1945)

Small groups of artists, united into stylistic movements, comprise much of twentieth-century art. Most movements of this period, however diverse they may appear, share a common commitment to **abstraction** as the principal route to emotional expression and stylistic originality.

Among these movements **Cubism** (1907–) is perhaps most representative of the early modern period, as its influence extends through most twentieth-century art. Co-developed by Spanish artist Pablo Picasso (1881–1973) and French painter Georges Braque (1882–1963), Cubism drew its initial inspiration from the geometric abstractions of Paul Cézanne.

During their early Cubist years, Braque and Picasso shared a studio in Paris and worked as closely, as Braque once put it, as two mountaineers roped together. Indeed, many of their early cubist

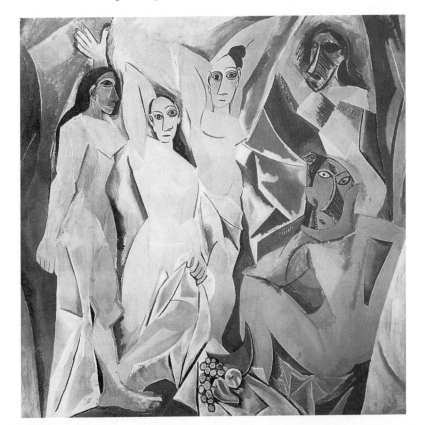

Figure 5.101 CUBISM. Demoiselles d'Avignon (Women of Avignon) (1907) by Pablo Picasso. Oil on canvas, 8' X 7' 8". The influence of African masks is evident in the faces of the women at right. (Museum of Modern Art, New York)

paintings are, apart from their signatures, virtually indistinguishable. Picasso's *Demoiselles d'Avignon* (1907), considered to be the first Cubist painting, was intended as a moralistic statement (it depicts prostitutes posing for a customer; See Figure 5.101). The painting was originally wider—with a sailor at the right, and another man, carrying a skull, emerging from a doorway at left—before it was trimmed by Picasso to strengthen the composition. The women's faces were inspired by African masks which Picasso happened upon by chance one afternoon in the Trocadero Museum. Braque remarked upon first seeing *Les Demoiselles* that it was as if Picasso were asking him to chew rope and swallow gasoline, nevertheless, Braque soon incorporated the strange, prismlike forms (similar to Cézanne's later painting) in his highly stylized landscapes of L'Estaque and La Roche-Guyon. (The name Cubism was coined by a journalist who ridiculed Braque for painting nothing but "little cubes.")

Unlike images made using traditional linear perspective, which depict a scene from the vantage point of a single stationary observer, Cubist paintings portray their subjects from several different vantage points simultaneously. This effect is most evident in Cubist portraits, which often combine profile and frontal views in the same image. Although Cubism is sometimes compared to Einstein's relativistic physics, which involved the paradoxical behavior of wave phenomena observed from different inertial reference frames, Picasso explicitly denied any connection between his work and Einsteinian physics.

The evolution of Cubism is divided into two distinct phases: the earlier *analytic Cubism,* which resembles images seen through a faceted crystal, and later *synthetic Cubism,* which resembles collagelike figures cut from boldly colored sheets of paper. Picasso also invented the technique of **collage** (c. 1912), which he and Braque often used in connection with their cubist images.

The twentieth century witnesses a proliferation of artistic styles which, however diverse, nevertheless have these traits in common: (1) a rejection of the "spent" stylistic traditions from the past, coupled with a search for highly original and personal styles created through abstraction, and (2) a preference for subject matter drawn from contemporary life, or based entirely upon nonrepresentational formalist principles.

The most influential early twentieth-century art movements are listed here, along with their most representative artists.

Cubism (c. 1907-)

This group is most closely associated with the career of its two co-inventors, French painters **Georges Braque** (1882–1963) and

Pablo [Ruiz y] Picasso (1881–1973): Spanish painter, sculptor, printmaker, ceramist; one of the most prolific and successful artists of the modern era. Picasso's long career encompasses a remarkable range of styles, including an early Post-Impressionistic period (before 1903), the so-called "Blue Period" (1903–1905), the "Rose" or "Circus Period" (1905–1906), and Cubism (1907–). Picasso's later work alternates between variations on his earlier Cubist paintings and a highly stylized realism featuring balloonlike figures derived from ancient Iberian statuary. In addition, many of Picasso's later works contain neoclassical allusions to myth and legend. The Minotaur (bull-man of Greek legend, symbolic of humankind's dualistic nature) served as a personal totem image for Picasso and appears frequently in his works. Picasso produced a considerable number of sculptures in addition to his paintings, drawings, and prints; one of his most unusual objects is an assemblage (cast in bronze) called *Bull's Head* (1943) made from a bicycle seat and handlebars.

Robert and Sonia Delaunay (1885–1941, 1885–1979, respectively): French colorists, (husband and wife) each with a distinctive style, known for their cubist interpretations of the *Eiffel Tower* (R.D., 1910) and later nonobjective paintings of prismatic, wheellike forms such as *Electric Prisms* (S.D., 1914).

Fauvism (1905–1907)

This group of French painters, which included **André Derain** (1880–1954) and **Georges Rouault** (1871–1958), were nicknamed the *fauves* ("wild beasts") because of their unrestrained use of color and boldly expressionistic drawing styles. The founder of Fauvism, **Henri Matisse** (1869–1954), is known primarily for his elegant portraits, complex still lifes, and interior scenes often embellished with intricate arabesquelike patterns and large, flat planes of brilliant color (See Figure 5.102.). An advocate of a frankly decorative style, Matisse once said that a painting should feel like a "comfortable armchair" after a long and tiring day. Matisse's reknown as an individual painter all but eclipsed the Fauvist

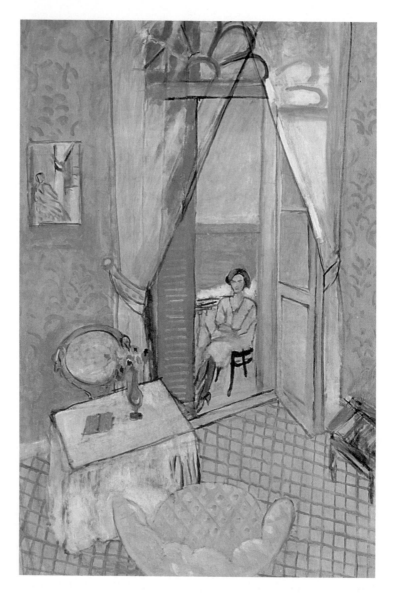

Figure 5.102 *FAUVISM. Interior at Nice (1921) by Henri Matisse. Oil on canvas, 52" X 35". (Art Institute of Chicago, Charles H. and Mary F. S. Worcester Collection)*

movement as a whole. In addition to painting he experimented with sculpture (figural abstractions) and, bedridden in his later years, with cut-paper compositions of brilliant, high-intensity color.

Futurism (1909–1916)

A short-lived movement founded by Italian poet F. T. Marinetti, author of the *Futurist Manifesto* (published in *Le Figaro*, 1909) which proclaimed that a speeding racecar was more beautiful than the *Winged Victory of Samothrace*.

Futurist painting celebrates the aesthetics of speed or *dynamism* (especially that of modern inventions, like the automobile and airplane) and many Futurist paintings explicitly include the term *dynamism* in their titles. Duchamp's painting *Nude Descending a Staircase #2* (1913), though ignored by the Futurists, is more or less typical of their painting style, which often resembled a stylized multiple-exposure photograph.

Principal Futurist painters include:

Umberto Boccioni (1882–1916): Painter-sculptor who, like Duchamp, used Cubist pictorial devices (e.g., dissecting an object into planar shapes) to simultaneously portray and analyze objects in his Futurist paintings. His bronze sculpture *Unique Forms of Continuity in Space* (1913) is a highly abstracted image of a striding human figure. In one of the great ironies of art history, Boccioni was killed in World War I, the same war which he once declared would serve as the "hygiene of society."

Giacomo Balla (1871–1958): Perhaps best known for his witty Futurist painting of a leashed dachshund out for a walk, titled *Dynamism of a Dog on a Leash* (1912), Balla's works use rhythmic repetitions of pattern to achieve a compelling impression of motion.

Gino Severini (1883–1966): Italian Futurist painter who incorporated cubistic collagelike elements (song titles, for example) in his colorful scenes of café life.

Dada (1916–1921)

A short-lived movement of antiartists, founded in Zurich by playwright Hugo Ball (1886–1927) and poet Tristan Tzara (1886–1963) whose goal was the destruction of the decadent culture responsible for World War I. Their meeting place at the Cabaret Voltaire in Zurich was the site of numerous exhibitions, performances, and readings, most of which involved nonsense creations based on the concept of randomness (also called *indeterminacy*). Though ultimately unsuccessful in their goal of stamping out all decadent bourgeois art, Dada experiments laid the foundation for the later Surrealist movement. According to legend the group's name (which means "hobbyhorse") was chosen by plunging a knife blade at random into a French dictionary.

Perhaps the best known Dada member was relative latecomer

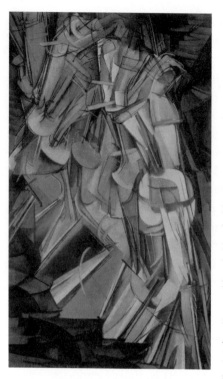

Figure 5.103 *FUTURISM DADA*. Nude Descending a Staircase #2 *(1913) by Marcel Duchamp. Oil on canvas, approximately 3' X 5'. This early work by Duchamp combines a Cubist reduction of form with a Futurist interest in motion. Ironically enough, both movements denied affiliation with Duchamp, whom they considered a young, undisciplined renegade. (Philadelphia Museum of Art, Louise and Walter Arensberg Collection; Photo: Marcel Duchamp)*

to the movement **Marcel Duchamp** (1887–1968) whose early work combined Cubist imagery with Futurist motion-images (see *Nude Descending a Staircase #2,* 1912). (See Figure 5.103.) Duchamp's later works are almost entirely conceptual, consisting largely of **readymades,** common objects which Duchamp purchased, retitled, then exhibited as "antiart." His most famous readymade, titled *Fountain* (1917), is a mens' room urinal signed with the pseudonym *R. Mutt* (after Europe's Mutt Ironworks Co.). Duchamp submitted the urinal to insult the judges of the art exhibition, but they praised it instead for its formal beauty as well as its poetic allusion to the baptismal font (!), and exhibited it in a locked closet. The exhibition program notes state simply "Mr. R. Mutt has submitted a fountain," hence its title. Duchamp eventually gave up art to devote his full attention to playing chess, his last and grandest Dada gesture.

Other Dadaists include:

Jean Arp (1887–1966): Sculptor known primarily for his abstract biomorphic forms.

Francis Picabia (1879–1952): Painter, with a reputation as a showman-opportunist, whose work included some of the first abstract paintings, many of which bear absurd titles.

Surrealism (1924–1940)

The Surrealists set out to combine everyday reality with dreamlike images of irrationality, thus creating a new superrealism or *surrealism,* a term first coined by poet GUILLAUME APOLLINAIRE (1880–1918). Originally a literary movement created by the poet ANDRÉ BRETON (1896–1966), Surrealism experimented with various techniques of drawing upon unconscious imagery, such as the well-

known **exquisite corpse** parlor game in which several persons each contribute a few lines to a folded drawing or poem, never seeing what the others have done until the very end. (The name derives from a nonsense sentence once generated in this way: *The* exquisite corpse *shall devour the young wine*).

Perhaps the most infamous work of the Surrealist movement was the short film *Un Chien Andalou* (*A Spanish Dog*, 1928), produced as a collaborative experiment between painter SALVADOR DALI and film maker LUIS BUÑUEL (1900–1983). Intended as a tongue-in-cheek spoof of abstruse French art films, it assails the viewer with bizarre, disturbing imagery (e.g., a closeup of a straight razor slicing through an eyeball), all revolving around a virtually incomprehensible plot. (*Un Chien Andalou* is available as a rental film and videocassette.)

Although the outbreak of World War II overshadowed the original Surrealist movement, rendering many of its nightmare images tame by comparison, Surrealism has never completely disappeared. Today it survives, though perhaps more as a general attitude than a distinct style, in the work of many contemporary artists and writers, especially those whose works involve dream imagery or elements of bizarre fantasy. Examples are the works of pop fantasist H. R. Giger, designer of the monster in Ridley Scott's film *Alien* (1979), or Irish painter **Francis Bacon** (1910–1992), whose disturbing psychological portraits depict subjects' faces as smeared or grotesquely disarranged. One of Bacon's best known works depicts a screaming figure seated between butchered sides of beef whose contours resemble split human heads (*Head Surrounded by Sides of Beef*, 1954).

Prominent surrealist painters include:

Salvador Dali (1904–1989): Spanish surrealist painter known for his "hand-painted dream photographs." See *Slave Market with a Disappearing Bust of Voltaire*, (p. 110).

Max Ernst (1891–1976): Surrealist painter known for his collagelike images. In his painting/relief *Two Children Threatened by a Nightingale* (1924), Ernst attached three-dimensional objects—a small wooden house, gate, and doorbell—to an oil painting depicting several figures fleeing in panic from a tiny nightingale.

Marc Chagall (1887–1983): Russian painter whose mystical images moved the poet Apollinaire to whisper the word, *"sur-réel,"* thus inventing the term *surrealism*.

Figure 5.104 SURREALISM. Avenue of the Mermaids (1942) by Paul Delvaux. Oil on canvas, 41" X 49". (Art Institute of Chicago, Gift of Mr. and Mrs. Maurice E. Culberg)

Meret Oppenheim (born 1913): German artist best known for his uncanny surrealist objects such as his *Fur-lined Teacup, Saucer, and Spoon* (1936).

Giorgio DeChirico (1888–1978): Although technically a member of the *Pitura Metafisica* school of painting, DeChirico's stark images of deserted plazas seen in exaggerated perspective and populated by featureless mannequins associate him, in spirit, with the surrealist style (See *Mystery and Melancholy of a Street* (1914), p.83).

Paul Delvaux (born 1897): French painter, associated with the later Surrealists, whose dreamlike images depict Victorian men and women wandering (sometimes nude) in a trancelike state through strange twilight landscapes. See *Avenue of the Mermaids* (1942), Figure 5.104.

German Expressionism (c. 1910–1930)

Early twentieth-century expressionist painting is represented by groups of well-organized German and Dutch artists who combined formal aspects of the Fauve and Symbolist movements, always with an intense interest in color and pure design.

The most prominent Expressionist groups included:

Die Brücke (c. 1905, *The Bridge*): A group of German painters
(Dresden) who emulated the expressive qualities of medieval
woodcuts and primitive art. Their revolutionary spirit sought to
create a "bridge" to future art. Principal members included
female graphic artist Käthe Kollwitz (1867–1945) whose
powerful images chronicled the sufferings of the working-class
poor, Emil Nolde (1867–1953) who turned to religious
subjects for inspiration, and Ernst Ludwig Kirchner
(1880–1938) whose fauvelike paintings chronicled the urban
decadence of pre-World War II Germany.

Der Blaue Reiter (c. 1911, *The Blue Rider,* after a painting by
Kandinsky): Munich group which advocated no specific style
other than one's own spiritual vision. Its founder, Russian
painter Wasily Kandinsky (1866–1944), produced the first
entirely abstract modern paintings (c. 1910) by combing his
fauvist interest in color with pure design. An amateur musician
interested in *synaesthesia* (merging of the senses—hearing
colors, tasting sounds, and so on), Kandinsky regarded his
abstractions as analogous to *absolute music,* which has no
representational intent. Many of his compositions have
musical titles (e.g., *Improvisation #28*). Paul Klee
(1879–1940), a Swiss painter known for his theoretical
writings and often charming mythical images, was also
associated with Der Blaue Reiter, as was Lyonel Feininger
(1871–1956), a painter known for his cubistlike landscapes
painted in broad, translucent planes of color.

De Stijl (c. 1917, *The Style*): A group of Dutch artists, mainly
followers of Piet Mondrian (1872–1944) and Theo Van
Doesburg (1883–1931), who followed reductionistic
abstraction to its logical conclusion by producing pure
geometric compositions consisting of a few well-chosen lines
and flat, rectangular areas of pure primary color. At their
best, these austere compositions evoke the stark beauty of
pure mathematics.

The architecture of the early twentieth century is dominated by the
European INTERNATIONAL STYLE whose aesthetic principles
emphasized economy of design, truth to materials, and a module-
based approach to construction. The elegant simplicity of Ludwig
Mies van der Rohe's (1886–1969) glass-walled **steel-cage structures**
are typical of the international style. (Mies's terse and pithy aphorisms
such as "Less is more," and "God is in the details" are nearly as

famous as his building designs.) The Swiss architect Charles Édouard Jeanneret-Gris, called LE CORBUSIER (1887–1965), established a modular canon of proportions for architecture based upon the ergonomics of the human body. He called his buildings "machines for living," and is likewise considered one of the principal exponents of the International Style, which sought to eliminate all extraneous ornamentation in favor of a purely geometric approach to design.

THE BAUHAUS (1906), a famous German architecture and design school founded in Dessau and directed during the early 1920s by architect Walter Gropius (1883–1969), was instrumental in shaping the aesthetic principles of the International Style. The Bauhaus curriculum stressed a modernist approach to design emphasizing extreme economy of form and materials combined with a module-based approach to design. (One of their typical teaching assignments involved having students design and build a chair using a standard sheet of plywood so that not a single scrap of wood was wasted—an important skill to master in war-ravaged Germany.) The school was influential in shaping the spartan aesthetics of painters of the DE STIJL group. At one time Klee, Kandinsky, and Feininger (all members of Der Blaue Reiter) served as faculty at the Bauhaus.

In America, the prominent architects of the early twentieth century were Louis Sullivan ("Form follows function," 1856–1924) and his pupil Frank Lloyd Wright (1867–1959), who likewise rebelled against the overly ornamental Victorian approaches to architecture. Wright developed the PRARIE STYLE of architecture, which emphasized a flowing organic continuity, a fitness among the individual parts of a structure analogous, as Wright once compared it, to the elegant interconnectedness of bone and muscle in a human hand.

American artists and critics received their first glimpse of European Modernist styles at the now-famous **Armory Exhibition of 1913,** held at the Armory in New York City. The initial response to the exhibition was mixed; critics savagely attacked Duchamp's *Nude Descending A Staircase #2* as a mockery of painting (one critic dubbed it "Explosion in a Brick Factory"). The Armory Show, as it came to be called, nevertheless challenged American artists to develop more abstract and expressionistic approaches to painting in response to their European counterparts.

Figure 5.105 REGIONALISM Nighthawks *(1942) by Edward Hopper. Oil on canvas, 30" X 56" (Art Institute of Chicago, Friends of American Art)*

XIII. Late Modernism (1945–1970)

In the years preceding World War II, the most fully developed indigenous stylistic trend in American art was **Regionalism,** identifiable by its realistic genre images. Represented by such artists as Thomas Hart Benton (1889–1975) and Edward Hopper (1882–1967) (see Figure 5.105), the Regionalist style flourished under President F. D. Roosevelt's **Federal Arts Project.** This program of the 1930s helped subsidize out-of-work artists during the Great Depression era by granting commissions for the mural decoration of public buildings, photo documentation projects, and the like.

Regionalism at its best recalls the spirit of early American frontier artists like Thomas Cole (1801–1808) of the **Hudson River school,** and George Caleb Bingham (1811–1879), George Inness (1825–1894), and Albert Bierstadt (1830–1902) who, likewise, sought to foster a new cultural heritage through naturalistic depictions of the grandeur of the American landscape. Later realist painters like Winslow Homer (1826–1910), Grant Wood (1892–1942), Andrew Wyeth (born 1917), and Georgia O'Keefe (1887–1986) continued and expanded upon this essentially realist tradition, reinterpreting it in terms of their own unique visions.

The enduring realist tradition in American art, however, remained mostly in the background throughout much of the post-World War II period, being eclipsed by a succession of avant-garde movements which built upon the stylistic foundations of twentieth-century European artists like Picasso and Kandinsky. Following the end of World War II, New York City came to be recognized as the virtual art capital of the United States, due to (1) the mass exodus

of many important artists from Europe to New York during the war, and (2) the era of postwar prosperity in America, which fostered artistic enterprise.

The Late Modern period in America is dominated by a series of art movements that continued trends established during the first half of the twentieth century. Like their immediate predecessors, Late Modern artists rejected old traditions in favor of original, and highly distinctive individualistic styles achieved mainly through abstraction.

The most significant of the post-World War II movements are listed next along with some of their most representative artists.

Abstract Expressionism (1940s–1950s)

Figure 5.106 *Jackson Pollock at work in his studio (1950). (Photo: Hans Namuth)*

The first American postwar movement to generate wide-scale national attention was **abstract expressionism** (called *Ab-Ex* for short) developed by artists of the so-called New York School, including the influential abstractionist Jackson Pollock (1912–1956, see also discussion in Chapter 1). Abstract Expressionism sought to express ephemeral emotional states through pure abstractions composed of free-form shapes and color. By stripping away all representational subject matter, Ab-Ex artists also hoped to approach more closely the essence of painting, a formalist concern underlying most forms of abstraction.

Critic-author Harold Rosenberg coined the term *action painting* to describe Jackson Pollock's technique of dripping paint onto an unstretched canvas laid flat on the studio floor (see also discussion in Chapter 1 and here Figure 5.106). The Ab-Ex style is often associated, directly or indirectly, with the philosophical movement of Existentialism as represented by the writings of such Nobel Prize laureates as Jean Paul Sartre (1905–1980) and Albert Camus (1913–1960). Denying the existence of an absolute truth, Existentialism held each individual responsible for creating meaning in his or her own existence and focused particular attention upon the significance of communication as a pathway to self-realization. For many commentators, Ab-Ex paintings epitomize both the sublime revelatory aspects and the angst of this process.

Principal artists of the Abstract Expressionist movement include:

Jackson Pollock (1912–1956): Developer of **action painting**, and the most characteristic representative of the Ab-Ex style. A

former student of regionalist painter Thomas Hart Benton, Pollock's career and personal life were turbulent. Inspiration for his later abstract works came from highly symbolic "gesture drawings" done during psychotherapy. Pollock died in a highway mishap at age 44.

Franz Kline (1910–1962): Painter known for his powerful black-and-white gestural paintings, which suggest huge calligraphic symbols. (See Figure 5.107.)

Willem DeKooning (born 1904): Painter who applied the bold, gestural brushstrokes of Ab-Ex abstractions to often harsh figural compositions depicting mainly women.

Ad Reinhardt (1913–1967): Artist-educator known during the 1950s for his all-black paintings with textured impasto surfaces that seemed to bring the reductionist trend in abstract art to its logical (or absurd) conclusion.

The early works of Jasper Johns (born 1930) and Robert Rauschenberg (born 1925) form a conceptual bridge between Abstract Expressionism and Pop art, combining the expressive brushwork of Ab-Ex styles with the banal subject matter typical of Pop art. Jasper Johns's work (discussed pp. 25-26) involved painted transformations of American flags, maps, targets, and other

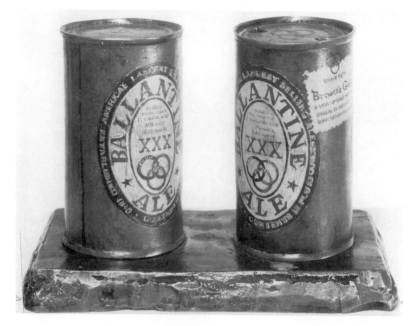

Figure 5.108 POP ART.
Painted Bronze (1960) by
Jasper Johns. Life-size.
(Photo: Jasper Johns)

mundane objects (See Figure 5.108), while Rauschenberg concentrated mainly on the visual poetics of assemblage in his combine paintings (see Figure 2.10, p. 39).

Pop Art (1960s)

British and American **Pop art** (a term derived from *popular*) uses images drawn directly from popular media. Hollywood personalities, magazine advertisements, and common consumer products have all served as grist for the Pop artists' mill. Although Pop art purported to be a radical new direction in art, its actual premise—the presentation of deadpan mass-media images as art—recalls the hoary traditions of still-life and genre painting brought up to date and reframed entirely in terms of mass culture.

The Pop movement originated in London in the mid-1950s and eventually gained wider recognition in America through the works of American East- and West-Coast artists during the early and mid-1960s. The origins of Pop art derive from a variety of sources including the Cubist collage experiments of Picasso and Braque, who sometimes included names of popular songs in their paintings (c. 1915). Other origins are found in artifacts of the **Dada movement,** especially Marcel Duchamp's *readymades,* common objects with no intrinsic aesthetic value which were exhibited by Dadaists as antiart objects (c. 1920).

British artist Richard Hamilton (born 1922) first used the term pop, which appears with a punning double meaning on the wrapper of a candy sucker in his satirical collage *Just What Is It That Makes Today's Homes So Different, So Appealing?* (1956). But American printmaker-film maker Andy Warhol (1928–1987) became perhaps the most famous exponent of the Pop movement. His controversial *Brillo Box* sculptures (silkscreen on wood) and silkscreen prints of Campbell Soup cans and celebrities like Marilyn Monroe, Elizabeth Taylor, and Jacqueline Kennedy (most in multiple-image, high-intensity color) are typical works of his mature style, produced by his "Art Factory."

Other significant Pop artists include:

Claes Oldenburg (born 1929): Sculptor-performance artist whose early interest in **found-object sculpture** became the basis for his outlandishly enlarged objects, many of which suggest humorous or erotic subtexts (e.g., a 50-foot clothespin recalling the ancient *Colossus of Rhodes*; a 25-foot phallic giant lipstick mounted on tractor treads; and so on). Oldenburg's sculptures are often produced in "soft versions," such as *Soft Toilet* (1966). This tongue-in-cheek allusion to Marcel Duchamp's *Fountain* of 1917, is made of limp white vinyl stuffed with kapok, which imparts a surrealistic melting quality to the object. Oldenburg's series of sculptures inspired by Walt Disney's iconic cartoon character Mickey Mouse demonstrates how Mickey's famous ears apparently derived from the circular film cannisters of old-style motion-picture cameras.

In addition to his object-oriented work, Oldenburg experimented in the 1960s with performance art events (heavily laced with social satire) inspired by everyday experiences, such as a night at the movies. Oldenburg once opened a "grocery store" that sold only painted-plaster and paper-mâché food replicas.

Roy Lichtenstein (born 1923): Painter best known for his enlarged comic book-style images (involving mainly war and romance), painted with simulated halftone dots. The droll humor of his paintings satirizes the shallowness of modern society.

George Segal (born 1924): Painter-turned-sculptor known for his ghostly cast-plaster figures hauntingly reminiscent of casts made from the remains of ancient Romans buried at Pompeii by an eruption of Mt. Vesuvius (A.D. 79). Segal juxtaposes his

figures with the mundane remnants of modern life (plastic chairs, Coke machines, and so on) poetically evoking the angst and emptiness of contemporary life and perhaps the threat of thermonuclear war which hovered like a specter over the Cold War years of the 1950s and 1960s.

Minimalism (Late 1960s to 1970s)

A stark and highly formalist style, Minimalism can be interpreted as a reaction to the emotionalism and painterly indulgence of the Ab-Ex style. Minimalism borrows its subject matter from elemental geometric forms (cubes, cylinders, planes, and so on), ostensibly allowing artists to deal with pure material essences untainted by extraneous subject matter or emotionalism—in short, pure aesthetic objects. The clean, precise edges and homogenous color fields which these works present have, at times, something of the austere beauty of mathematical equations, or the serial precision found in Bach's *Brandenburg Concertos.*

Minimalist paintings typically take the form of hard-edge abstractions—stark planar fields of color bounded by precise contours—painted on huge, sometimes shaped canvases. Thus, the painting becomes an aesthetic object in itself, rather than a representational "window onto the world." Minimalist sculptures often appear with their native materials left exposed (as undisguised plastic or stainless steel surfaces) or painted in high-intensity artificial hues like bright orange or "hi-viz" yellow, or alternatively, neutral shades of grey or black, to emphasize their nature as fabricated objects.

David Smith (1906–1965), a direct-metal sculptor whose early works recall the assemblage constructions of synthetic cubism, deserves mention as a transitional figure in American sculpture whose later works anticipate the trend toward minimalist aesthetics. His *Cubi Series* of the 1960s combines stainless steel cubes, rectangles, and drums as if precariously balanced upon a narrow pedestal. The unusual textured finish of his *Cubi* elements was produced by abrading their mirrorlike stainless steel surfaces with a coarse grinding wheel, thus allowing the molested surfaces to reflect the hues of their surroundings.

Minimalism continues the trend toward pure abstraction begun in the pre-World War II era, most notably Cézanne's reductionist abstractions based upon the cube, cylinder, and sphere.

Conceptual artists have frequently found minimalism an interesting sideroad for exploration because of its intellectualized approach to aesthetics. One of the most fully realized Minimalist artifacts to enter the domain of popular culture is the mysterious "black slab" that looms as an enigmatic space-age totemic presence throughout Stanley Kubrick's motion picture *2001: A Space Odyssey* (1968).

The minimalist movement in painting is represented by *Color-Field Painting*, a style that emerged at roughly the same time (the 1950s) as Abstract Expressionism. Highly geometric and more formalist in its orientation than Ab-Ex, Color-Field Painting typically involved large canvases divided into homogenous "fields" of high-intensity color. The works of Barnett Newman (1905–1970), Clifford Still (1904–1980), Mark Rothko (1903–1970), Kenneth Noland (born 1924), and Helen Frankenthaler (born 1928) are all representative of the color-field approach to painting.

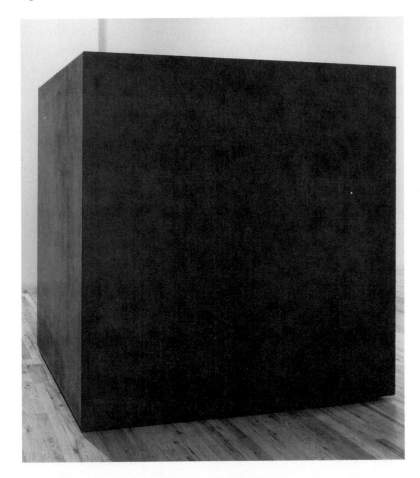

Figure 5.109 *MINIMALISM. Die (1962) Tony Smith. Welded steel, 6-foot cube. (Paula Cooper Gallery, photo © Geoffrey Clements) Reduction of forms to their primary, elemental essences is the hallmark of the minimalist style. (See also* De la Nada Vida a la Nada Muerte *by Frank Stella (p. 27) for an example of the minimalist style in painting.)*

Principal artists of the Minimalist style include:

Donald Judd (born 1928): Sculptor and writer-critic known primarily for his retangular boxlike modules of stainless steel usually arranged as multiples in horizontal or vertical rows, either freestanding or wall mounted.

Tony Smith (1912–1980): Sculptor (not to be confused with David Smith) best known for his work *Die* (1962), an enigmatic steel cube measuring 6 feet on each side. (See Figure 5.109.) His later work consists of large, asymmetric, prismlike structures fabricated in painted steel.

Anthony Caro (born 1924): English sculptor and former studio assistant of sculptor Henry Moore, Caro's works include large-scale welded metal constructions often painted in bright, primary colors. Caro's work stresses the raw physicality of metals and often uses materials in their undisguised industrial forms as rolled cylinders, sheets of steel grating, and so on.

Frank Stella (born 1936): Formalist painter who established his reputation with monochromatic "pin-stripe" compositions on shaped canvas painted using strips of removable masking tape (see *De la Nada Vida a la Nada Muerte*, 1961, Chapter 1). In the 1970s and 1980s, Stella produced a series of compositions based on overlapping protractor curves painted with high-intensity hues, as well as a later series of uncharacteristically expressionistic painted reliefs.

Conceptual Art (peaks 1960s to 1970s)

Conceptual art (also called *concept art*) is a generic term used to identify artists who regard the making of objects as contrary to the true meaning of art, which they regard as the expression of an *aesthetic concept*. Conceptual art is not intended, in most cases, to be bought and sold, but rather to be experienced firsthand, recalling the egalitarian spirit of the nineteenth-century art print. In accordance with this philosophy, conceptualists produce gestures, acts, statements, and events often documented on **film** or **videotape** rather than traditional paintings or sculptures. Some conceptualists become so involved with the process of documentation that film and videotape eventually become their primary media.

During the late 1950s, early conceptual artists like Alan Kaprow (born 1927) experimented with audience-participation

events called **happenings** (derived from futurist and Dada theater experiments of the 1920s). These early happenings gradually matured into **performance art,** which often involves structured theaterlike presentations but without the *willing suspension of disbelief* demanded by traditional theatrical performances (see discussion, in Chapter 2). Acts performed by a single artist, called bodyworks, often place the artist in absurd and/or physically dangerous situations in order to convey a metaphorical message. Chris Burden, whose bodyworks seem at times an acting-out of Franz Kafka's disquieting short stories, once had himself shot with a rifle as a bodywork.

Performance-like events have long been produced by avant-garde theater companies such as THE LIVING THEATER founded in the late 1940s by Julian Beck (1925–1985) and Judith Malina (born 1926). In Beck's production of *Paradise Now* (1968), the cast came down off the stage and confronted audience members, demanding to know why they purchased expensive theater tickets when so many people around them are forced to live in poverty. Those audience members who chose to remain after this initial challenge were invited to strip away all artifice (that is, their clothing) and join the nude cast on stage. After engaging for several hours in open-ended events (some of which resembled the "awareness-enhancing exercises" of humanistic psychology), the cast called upon everyone to take their message, literally, out into the street—where waiting police vans usually arrested everybody for public indecency. Even several decades later, Julian Beck's productions stand as provocative and controversial attempts to transform the theater experience from light entertainment into a direct instrument for social change.

Other trends in sculpture loosely derived from conceptualist aesthetic sensibilities include installations and earthworks. **Installations** are typically room-sized works of temporary duration erected on site, usually in a gallery or museum, and sometimes employing materials found on hand at the site. Given their transitory nature, installations have the character of extended events as well as objects in space. The large-scale wrapping projects of CHRISTO (Christo Javacheff, born 1935) which have involved wrapping objects, entire buildings, or landmarks in fabric, represent one type of on-site installation. **Earthworks** such as the quarter-mile-long *Spiral Jetty* by Robert Smithson (1938–1973) constructed in Great Salt Lake (see discussion in Chapter 2), and *Double*

Negative by Michael Heizer (born 1944), a pair of immense slotlike excavations in the desert near Mormon Mesa, Nevada, are huge environmental on-site works which fuse the artists' conceptualist sensibilities with a sculptor's feeling for the raw physicality of natural materials manipulted on a massive scale.

Conceptual works range across a wide spectrum—from very political works that defy categorization as art objects because they consist entirely of words, gestures, or declarations—to nonart objects intended to convey a concept to the viewer. A sampling of well-known conceptualists includes:

Joseph Kosuth (born 1945): Important Conceptualist who, during the 1970s, juxtaposed common objects (a broom or chair) alongside a life-sized black-and-white photo of that object and its enlarged dictionary definition. Viewers are prompted to set aside their aesthetic expectations and reflect upon the nuances of these three distinct levels of reality.

Joseph Beuys (1921–1986): German performance artist (a former Luftwaffe airman once shot down in Russia) whose installation-performance works often contain overt political messages. In one memorable work *I Like America, America Likes Me* (1974) Beuys had himself locked in a gallery space for several days with a live coyote (a pile of straw in one corner, and a pile of *Wall Street Journals* in another) until the two became friends.

Carl Andre (born 1935): Sculptor whose low, minimalist floor sculptures typically involve the arrangement of flat metal tiles (often steel or copper, 1' X 1') laid end to end or in rectilinear patterns. One of his best-known works *Equivalents I-VIII* (1966) involved eight stacks of 120 bricks, each stack arranged so that it looked uncannily as if it contained more or less bricks than any of the others, thus creating a compelling tension between what is known and what is seen.

Sol LeWitt (born 1928): Sculptor known primarily for his large 8-foot framework cubes fabricated of white, painted aluminum by a commercial firm working according to the artist's specifications. One of his most successful works *Open Modular Cube* (1966) is a large white framework cube divided in its interior by a regular horizontal and vertical array. When viewed close up, the interior framework becomes a complex arrangement of foreshortened lines and angles that shift compellingly along with the viewer's vantage point.

Robert Morris (born 1931): Conceptualist sculptor whose mixed-media works use objects as springboards to conceptualist themes (see discussion of *Box With the Sound of Its Own Making*, Chapter 2).

Photorealism/Superrealism (1970s to 1990s)

During the early 1970s realist styles again reemerged after a long period of benign neglect. **Photorealist** painted images, copied directly from photographs, are so accurate and detailed that they become virtually indistinguishable from the original photographs. (Photorealism is known by a variety of names including Superrealism, Hyperrealism, New Realism, and others.)

Photorealists/Superrealists often use smooth particle board (pegboard without the holes) as a painting ground. This provides an ultrasmooth surface, flatter than the finest grades of canvas. The standard practice is to choose a photograph of a banal subject (like a gas station) which nevertheless seems visually interesting because of its formal features (lines, colors, values, and so on). The photograph is then projected directly onto the prepared painting surface with an opaque or slide projector, where it can be traced and later painted using the original photo as a guide. (Photorealists often work with their paintings turned upside down so as not to be distracted by the subject matter). What emerges from this process is an impersonal aesthetic image which can be appreciated purely on the basis of its formal relationships. Photorealism also places the skilled craftsmanship of the painter—always magical to behold—very much at the forefront though, ironically, all traces of the artist's hand (such as brushstrokes) are usually eliminated.

During the mid-1970s several New Realist painters were active as muralists transforming blank urban walls into large *trompe l'oeil* landscapes so compellingly detailed that they appear to be an extension of the landscape, like Warren Johnson's *Tunnel Vision* (1975) painted on a bank wall in Columbia, SC. (Several apparently apocryphal stories have arisen concerning motorists who have crashed into such ultrarealistic landscape murals, having apparently mistaken them for a continuation of the roadway.)

Well-known photorealist/superrealist painters include:

Richard Estes (born 1936): Cityscape painter known for his stark

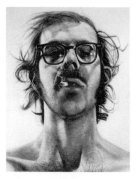

Figure 5.110
PHOTOREALISM. Portrait of John (1972) by Chuck Close. Acrylic on canvas 100" X 90". (Collection of Mrs. Robert B. Mayer, Chicago) This billboard-sized portrait, enlarged to many times life-size, projects the traditional portrait image to a new scale of stark realism.

exterior views painted in compelling one-point perspective. A virtuoso painter who worked after graduation in the graphic design business, Estes remains one of the principal figures of the Photorealist movement. His paintings are derived from his own photos usually taken at random while on Sunday walks in the city.

Philip Pearlstein (born 1924): Figural painter whose work involves academic nude studies (i.e., resembling models from a figure-drawing class) typically shown at rest. Pearlstein's compositions, painted from live models, are set in well-lit interiors whose white walls suggest a gallery space, often including contrasting objects such as patterned rugs, bentwood furniture, parqueted wood floors, or Native American blankets. His cropped compositions—reminiscent of newspaper photos cut to fit the restrictions of the page layout—transform the posed nudes into depersonalized aesthetic objects.

Chuck Close (born 1940): Known for his huge close-up portraits of persons who, while not attractive in the usual sense, are nevertheless striking to behold. Close's portraits, which average a year to produce, are built up in separate layers of primary hues, like a four-color lithograph. The artist works seated on a small platform mounted on a forklift, and often employs unusual tools of his own invention—such as a pencil eraser set into an electric drill. (See Figure 5.110.)

Ralph Goings (born 1928): Photorealist known for his scenes of fast-food restaurants and shop windows, often featuring complex glass reflections and/or mirrorlike chrome surfaces. One of Going's signature devices is his preoccupation with "old workhorse" pickup trucks, which often appear parked in many of his paintings.

Duane Hansen (born 1925): New Realist sculptor whose ultrarealistic figures, cast in polyester resin from live models, are virtual replicas of their subjects (including such fine details as hair on the arms). Hanson's deadpan figures, dressed in real clothing and accessories, attract our attention not because of their physical beauty, but rather because of their rude commonness which seems to make them all the more interesting as specimen images from contemporary life. Among his later works are disturbing multifigure tableaus recreating scenes from the Vietnam war.

XIV. Post-Modernism (1970–)

During the last two decades, the emphasis in art and architecture has shifted away from the accepted Modernist principles which have dominated most of twentieth-century art and toward a new aesthetic attitude which has been dubbed **Post-Modernism** (meaning simply, "that which follows Modernism"). Some commentators regard Post-Modernism as a transitional era as a reaction against Modernist principles. Others see it as a new and self-contained stylistic epoch in its own right. One skeptical critic remarked that Post-Modern art, or *PoMo* as it is sometimes abbreviated, constitutes not so much a movement as a "collective loss of direction." Other less disparaging critics have identified distinctive elements of the Post-Modernist style and have applauded its historical and stylistic eclecticism.

The Modern style in art involved, above all else, a *search for novelty,* expressed through highly individualistic and original artworks. Abstraction—the more reductionistic, the better—became its principal instrument. In contrast, Post-Modernist paintings are primarily realist in style and frequently borrow compositional fragments from older classic works which they present anew in revitalized and updated form, recalling the old maxim that there is "nothing new under the sun," except, perhaps, nuances of presentation. Post-Modernists seem to regard the art of the past as a kind of conceptual stockpile of styles, techniques, and compositional elements, all of which are theirs for the taking.

In sculpture, design, and architecture, Post-Modernism recalls the frankly decorative **Art Deco** styles of the 1920s and 1930s (i.e., geometric-curvilinear forms in bold colors and synthetic materials) but refigured in more contemporary materials and with a greater emphasis upon design for its own sake, rather than in service of utility.

In painting and sculpture, certain substyles of Post-Modernism (there are several) appear to be a retrenchment to the realistic painting styles of the WPA muralists of the 1930s, as if picking up the thread of continuity in representational painting where it had been left off prior to World War II. (Not surprisingly, the works of many Regionalist painters, like Thomas. Hart Benton, are currently being reappraised after a long period of relative neglect.) A secondary form of Post-Modernism appears as

a kind of primitivistic neoexpressionism which combines graffittilike effects coupled with the sort of pungent drawing style reminiscent of artistically untrained persons, providing a refreshing break from the less spontaneous academic styles. A discernible undercurrent of **neoclassicism,** rather freely interpreted, is also present in many works, often taking a vaguely self-satirizing tone. A simultaneous neopop movement is also discernible.

Since its emergence in the 1970s, the Post-Modern style has become firmly established in the minds of most critics and historians as a principal movement in American art having prompted, in the process, a considerable amount of critical dialog and controversy. A representative sampling of principal Post-Modernists include:

Robert Longo: Realist figural sculptor-painter whose droll montages portray well-dressed young executives caught in contorted poses or engaged in exaggerated physical conflict. His monumental relief *Corporate Wars* (1982) depicts a "hostile takeover" (fought barehanded by yuppie executives) portrayed in the manner of an ancient Roman battle relief. (See Figure 5.111.)

Dottie Attie: (born 1938): Artist known primarily for her small-scale pencil drawings on paper, copied from a variety of preexisting sources, arranged in checkerboard montages or combined with brief fragments of narrative text, usually having erotic overtones. By playing upon the projective content of her imagery, Attie investigates the symbolism and politics of sexuality in its various forms.

Stone Roberts: Realist painter known for his allegorical portraits, such as *Janet* (1984), which recall the Baroque genre-images of Vermeer and Rembrandt, but reconfigured with contemporary personalities and details. (See Figure 5.112.)

Milet Andrejevic: Neoclassic realist painter who reinterprets mythological themes with contemporary figures and settings (much like the early Baroque painter Caravaggio did in his own time). In Andrejevic's *Apollo and Daphne* (1982), Apollo is a blond-haired youth strumming a folk guitar while Daphne, a barefoot brunette in T-shirt and red jogging shorts, stands nearby.

Ian Hamilton Finlay: Sculptor whose monumentlike objects (often bearing inscriptions) blend minimalist and conceptualist attitudes. His *Nuclear Sail* (1974) is a rectangular, upright slab

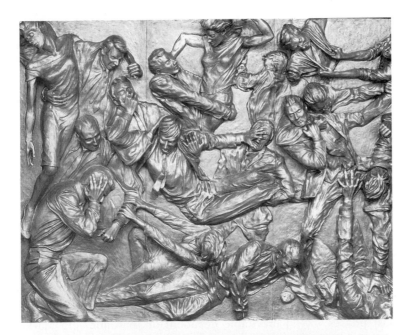

Figure 5.111 POST-MODERNISM. Corporate Wars (Wall of Influence) (1982) by Robert Longo. Relief. (Metro Pictures, New York)

Figure 5.112 POST-MODERNISM. Janet (1984) by Stone Roberts. Oil on canvas, approximately 4.5' X 5'. (Metropolitan Museum of Art, New York). Post-modernist images typically borrow compositional motifs from older, well-known works. Compare this interior, for example, with Vermeer's Young Woman with a Water Jug (Figure 5.89, p. 184). The implicit symbolism, suggested by this painting's many details (such as the broken wine glass), also suggests a certain kinship to Jan Van Eyck's Portrait of Giovanni Arnolfini (Fig. 5.79, p. 171).

Figure 5.113 *Post-Modernism. AT & T Headquarters Building , New York (1978–1982) by Phillip Johnson and John Burgee. (AT&T Archives)*

of smooth grey slate that simultaneously suggests a gravemarker and the sail (conning tower) of a nuclear ballistic-missile submarine.

Charles Moore: Architect of the PIAZZA D'ITALIA, New Orleans (1979), which combines classical design motifs (composite columns, Roman arches, and so on) ornamented with bright synthetic colors and neon lights.

Philip Johnson and John Burgee: Architectural partners who designed one of the most widely publicized Post-Modern structures, the AT&T HEADQUARTERS in New York City (1984), topped by a broken pediment resembling the scrollwork on Chippendale furniture. (See Figure 5.113.)

Historians who take a deterministic view of history have come to regard cultural eras as analogous to the stages in the life span of a civilization, marked by an early period of dynamic growth and vitality, followed by a more settled mature period and, in the last phases, by an inevitable decadent or "baroque" era marking the final phase of cultural decline. The Post-Modernist style has been characterized as baroque in its sensibilities, its self-referential indulgence verging, at times, on self-parody. And this aspect of Post-Modernism may provide us with a clue to its relative importance within the larger context of the history of art, thus enabling us get a better sense of our own historical place within the "big picture."

The English historian Arnold Toynbee (1887–1975) speculated in his monumental *A Study of History* (1947) that Italianate Western-European culture would eventually be replaced as the dominant cultural force in world affairs. A similar idea was put forth by German philosopher-historian Oswald Spengler (1880–1936) in his earlier treatise *The Decline of the West* (c. 1918). Indeed, most contemporary historians agree that the American era of cultural hegemony, beginning around 1945, reached its peak during the early 1960s and is now in its decline. During this same period, the Pacific Rim nations (particularly Japan, Korea, and Taiwan) have reemerged as significant economic and cultural forces, along with the 12-member European Economic Union (founded 1993). Future historians may regard the post-Modernist era in broader terms as a transitional period marking the decline of one cultural hegemony and the simultaneous emergence of another.

Art of Non-European Civilizations

XVII. Native American Art

Native American art is frequently classified by region, although classification by language group is more revealing of origins. The languages of some Southwestern tribes (Navajo, Apache) have more in common with Canadian Atabascan language groups than with their own immediate neighbors, suggesting past migration patterns.

The earliest ethnographic observations of Native American cultures appear in the journals of early sixteenth- and seventeenth-century Spanish explorers, as well as in the paintings and drawings of eighteenth- and nineteenth-century artist-explorers such as Karl Bodmer and George Catlin. These data frequently take the form of field notes made during or after military expeditions. Native settlements along the Pacific Coast have been found dating back to the Stone Age (c. 14,000 B.C.), roughly the same time period as the Paleolithic cave paintings at Lascaux and Altamira.

Features generally characteristic of non-Western cultures appear frequently in Native American art. Navajo culture, for instance, exhibits linguistic and cultural similarities to the Chinese, suggesting a common origin. Generally speaking, pictorial styles rely upon **monocular depth cues** (overlapping edges, size differences) rather than linear perspective. Figures are stylized and rendered in simplified frontal or profile poses in combination with *pictographic symbols* (zigzag lines = water, for example). Images often have a narrative purpose, usually depicting religious themes or significant events in tribal life. Most images emphasize figures rather than ground, which is often simply left as implied (i.e., blank). In contrast, horror vacui is evident to varying degrees especially in NORTHWEST COAST and MAYAN art.

Significant cultural differences affect the interpretation of Native American art. **Animism** (the belief that all things are infused with a vitalizing life force—even rocks, water, the wind, and so on) is a principle underlying much non-Western art and pervades Native American art as well. Also, the idea that dream visions constitute a vaild alternative reality, an important aspect of Native American religious belief, has attracted many Surrealist painters to Native American art.

Aesthetic concepts likewise differ from the usual European

interpretations. Among the Navajo, for instance, the concept of aesthetics is expressed as hozhó—the idea that art is created not so much by the hand of the artist, but by the mind of the perceiver. Thus, aesthetics has more to do with the expression of conceptual relationships, such as humankind's relation to nature, than mere object beauty. Ritual images associated with specific religious/magic ceremonies are often rigidly formulized. Any deviations are believed to destroy their effectiveness. Color symbolism is likewise fixed by tradition and varies somewhat from the standard Western interpretations (e.g., white = mourning).

Material culture is diverse, but tends generally toward portable utilitarian objects (baskets, clothing, and so on) as well as decorated **Nomad gear.** Large-scale sculpture is seldom produced, except among certain MESO-AMERICAN CULTURES, since many tribes are seminomadic. Carvings tend to be highly symmetric (except in certain Eskimo and Woodland masks). Subject matter tends toward religious themes involving spirits or totemic animals intimately connected with the nomadic-hunting existence of these tribal cultures.

There exist approximately 2,000 Native American tribes. Material cultures of the major regional groups are summarized next.

Arctic and Subarctic Cultures

(Eskimo, Kutchin, Chipewyan, Yellowknife, Beaver, Hare, and others) Arctic and subarctic cultures are exclusively nomadic hunting and fishing groups. Material culture is severely limited by practical considerations and consists mainly of garments, tents, and artifacts fashioned from animal bone and hide (especially tundra caribou or sealskin), sinew, bone, and so on. Wood is scarce and used mainly for utilitarian purposes (sled frames, snowshoes, and so on).

Northwest Coast Cultures

(Tlingit, Kwakiutl, Haida, Chinook, and others) Northwest Coast cultures are primarily fishing-seafaring groups. Wood is plentiful and used extensively for building and carving. Highly symmetric wood reliefs and totem poles (typically painted black and white) represent stylized faces of totemic animals. (See Figure 5.114.) Such faces adorn most ritual objects (e.g., shaman masks) as well as artifacts associated with the hunt (canoe prows, paddles, and so on).

Small carvings are made in wood, bone, or tusk ivory. Woven blankets and garments (of mountain goat wool or woven cedar bark) are typical. Wooden lodges feature elaborate painted facades representing faces of totem animals (entrance is through the mouth). Large cedarwood canoes (Haida) are often over 50 feet long. Elk and beaver hide is used to make robes. Bone harpoon tips feature incised eyes believed to guide the weapon to its target.

Figure 5.114 NORTHWEST COAST. *Killer whale (in humanized form), wooden helmet from the* TLINGIT *culture, British Columbia. (Illustration: Dover Pictorial Archives)*

Great plains cultures

(Pawnee, Mandan, Sioux, Crow, Cheyenne, Potawatomi, and others) Plains cultures are primarily nomadic hunter-gather or raiding groups; their riding skills are legendary. (Horses were originally thought to be "magic dogs.") Buffalo was the principal prey animal for these cultures; thus, many hide garments appear decorated with quill or beadwork. Flaked stone weapons, shields, and other battle accoutrements are common. The familiar *eagle-feathered warbonnet*, trimmed with ermine tails, is a famous Plains Culture artifact as are geometric and narrative pictographic designs painted on buffalo hide. (See Figure 5.115.) *Facepainting* is a common form of body adornment used in preparation for battle and ritual (see also *Omaha and Osage Haircuts According to Clan*, p. 17). *Medicine pouches* containing homeopathic-magical artifacts are a common feature of ritual life. Typical dwellings include circular **wattle-and-daub** earth lodges and *tipis*, portable cone-shaped tents made of sewn hides draped over wooden poles.

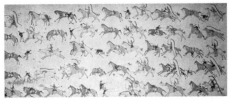

Figure 5.115 GREAT PLAINS. *Buffalo-hide robe bearing pictographic record of the Battle of Little Big Horn. (The Granger Collection)*

Woodland cultures

(Ottawa, Huron, Mohawk, Iroquois, Menomini, Seneca, and others) Material culture is generally similar to that of the Great Plains tribes. False-face masks with grotesque asymmetric faces

representing forest spirits (Iroquois) are used in healing ceremonies. (See Figure 5.116.) Flaked stone implements and clublike weapons (e.g., *tomahawk*) are common as well as reed and stone ceremonial pipes (popularly known as *peace pipes*, but more properly called *calumets*). Shell or bead *wampum* belts were originally regarded as symbols of authority but later came to be used merely as trade articles. Prayer sticks, decorated with simple patterns, are stuck in the ground at holy places to enlist the aid of their associated spirits.

The familiar cone-shaped *tipis* and wooden lodges are common structures, as well as dome-shaped *wigwams* constructed of bent saplings covered with bundled reed or bark. Woodland cultures are primarily forest hunters and fishers (birchbark canoes); consequently, there are many buckskin, porcupine quill, and shell artifacts.

Southeast cultures

(Hopewell people, Adena people, Missippian people, Natchez, Choctaw, Chicasaw, Cherokee, Creek, Seminole, and others) Southeast cultures are primarily farming or raiding groups. Mound building of large artificial hills containing layered funerary remains is a common practice among these groups. (The CAHOKIA MOUNDS near East St. Louis, IL, is the largest stone-age earthwork in North America). *Effigy mounds* in the shape of totemic animals were constructed on a large scale, often with cult burials at the animal's head or heart. Decorated artifacts of copper, obsidian, and carved wood are common as well as body adornment (tattoos) and shell jewelry. Stilt dwellings with open sides and a thatch roof are typical.

Southwest cultures

(Anasazi, Apache, Hopi, Navajo, Zuñi, and others) Sand paintings (formalized images passed on by oral tradition) are used as magical devices in connection with healing and other religious rituals; dry sand is trickled through the fingers onto a spread animal hide "altar." (See Figure 5.117.) Painted wood **kachina masks** and **kachina statues** serve in rituals and for religious instruction of children. Woven baskets, ceramic vessels, and wool blankets exhibit dynamic, visually powerful geometric designs. Fine silverwork (a skill taught by the Spanish) is often combined with turquoise to produce jewelry (belts, armbands) for both males and females.

Figure 5.116 WOODLANDS. False-face society mask (1937) from the IROQUOIS tribe. Red painted wood and horsehair; life-size. (Cranbrook Institute of Science, Bloomfield Hills, Michigan). False-face society masks are used in connection with purification ceremonies designed to rid the tribal community of malicious spirits. More than a simple ceremonial costume, the mask is treated as a religious power object.

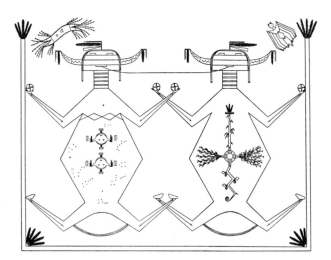

Figure 5.117 SOUTHWEST. Earth and Sky, Navajo sand painting. (Dover Pictorial Archives). Sand paintings are important ritual elements in healing ceremonies and other religious rites. The paintings are "erased" (in reverse order) when their ceremonial purpose has been fulfilled.

The archaeological site at Pueblo Bonito (Chaco Canyon, NM) reveals a well-planned D-shaped complex of interconnected multistoried mudbrick structures, many with interior wall murals. Underground circular chambers (*kivas*) were reserved for ritual use. Structures at the Mesa Verde site (Mesa Verde National Park, CO) are built into the cliff faces and sheltered by overhanging sandstone ledges. Both New Mexico and Colorado sites are essentially large "apartment complexes," all mysteriously abandoned c. 1300.

Basin-plateau and California cultures

(Nez Percé, Ute, Shoshone, Mandan, Shasta, and others) The Basin-Plateau and California cultures are primarily peaceful nomadic gatherers whose food supply is augmented by the hunting of small game.

Woven basketry, decorated with bold geometric patterns, is the principal art form and includes designs intended to be worn like brimless hats. Clothing tends to be simple (loincloths, reed aprons, cloaks of rabbit fur) with feathers and shell beadwork used as adornments. Most artifacts are produced by women.

Dwellings are fashioned from bundled grass or rushes tied to a wooden framework, analogous to the *tipis* and *wigwams* of the Woodland cultures.

Meso-american

(Mexico: Olmec, Mayan and Aztec; Andes Mountains in Peru: Incas, and others) These groups are also generally classified as pre-Columbian (i.e., "before Columbus"). All tribes are generally located around the Gulf of Mexico, Central America, and northern region of South America.

Native Mexican cultures are well documented due to the many histories of "New Spain" compiled by various Franciscan missionary-explorers (c. 1500). Olmec stone carvings such as the monumental, nearly spherical "Olmec Heads" and jade axeheads and statuettes are among the oldest pre-Columbian objects found (c. 1200–500 B.C.).

During the first century A.D., the city of Teotihuacán, meaning "dwelling place of the gods," near Mexico City, was the largest city in the pre-Columbian world (possibly 200,000 inhabitants). Teotihuacán culture enjoyed peaceful commerce with the

Figure 5.118 *TEOTIHUACAN CULTURE.* Rain Priest, *Fragment of a wall fresco (c. 300–600) from the Teotihuacan culture, Mexico. Adobe with lime and red pigment, fragment approximately 36"X24". (Art Institute of Chicago, Primitive Art Purchase Fund). The Teotihuacan culture favored painted murals over the more labor-intensive technique of relief carving for the decoration of their many architectural projects. The influence of the Mayans, a neighboring trade culture, is evident in the treatment of the figure– a fertility god shown sprinkling seeds and life-giving water upon a field of aloe plants.*

rainforest-dwelling **Mayans** and was influenced by Mayan art and culture. (See Figure 5.118.) Mayan stone cities such as CHICHEN ITZA (c. A.D. 300–900) included zigguratlike temples fronted by long stairways. Carved stone reliefs (in the form of *stelae*) and jade statuettes were also common. The Mayans have been credited with advances in observational astronomy and mathematics, especially the invention of the zero.

Following the barbaric Toltec invasions of Mexico (c. A.D. 700–1000), Aztec culture flourished until the 1500s. Worship of the Toltec's benevolent feathered serpent-god *Quetzalcoatl* was gradually replaced by brutal Aztec rites of human sacrifice involving captured enemies. Documents relate that during one four-day period, over 20,000 captives were ritually killed by having their beating hearts cut from their chests. The Aztecs were eventually vanquished (c. 1520) by conquistadors led by Cortez who captured the Aztec king Montezuma II (later killed by his own people). Aztec temple architecture is basically pyramidal and features relief carvings (often grotesque) of composite creatures from their religious pantheon; also common are ritual edged weapons of jade or glasslike volcanic obsidian.

In Peru, principal sites of Inca culture (c. 1440–1530) include the city of MACHU PICHU high in the Andes Mountains, as well as the modern city of CUZCO (South central Peru) whose overall plan generally follows that of the ancient city. Inca builders were masters of mortarless masonry techniques, fitting stones together with such absolute precision that a knife blade cannot be inserted between them.

XVIII. Asia

Among the diverse cultures of the Asian continent, the arts of China are most generally representative of cultural trends in East Asian art. Japanese and Korean art, while stylistically distinct, share many common links to the Chinese traditions.

Generally speaking, portraits and landscapes predominate as the traditional subjects in Chinese art. Even mundane images, such as bamboo stalks, often embody a subtle element of symbolism (the idea of being able to stand firm yet bend without breaking when a harsh wind blows). The ancient philosophical ideas embodied in the Tao ("The Way") and later Buddhist thought, symbolized by the *yin-yang*, the harmonious unification of opposites, inspired the highly abstract symbolism found in most East Asian art.

Ink drawings, done with a stiff horsehair brush on paper (invented c. A.D. 100) or silk, are the traditional media. Representational styles stress a fluid, spontaneous approach to drawing which aims at emotional expression rather than producing an exact copy of the subject. Thus, drawing becomes a sublime form of caricature embracing all the objects and vistas of the natural world. Images rely upon **monocular depth cues** (overlapping planes, size differences, and so on) to indicate spacial relationships.

In sculpture, smaller-scale symmetrical carvings in jade, marble, and wood are common with stylized animals and people as the principal subjects. Vessels of cast bronze, stoneware, or porcelain, usually with elaborate relief or glaze decoration, constitute a time-honored tradition in Chinese art.

Like the elaborate Egyptian tombs of the Old Kingdom, Chinese burial sites often contain artifacts and sometimes the bodies of servants and animals intended to protect and serve the ruler in his next life, similar in intent to Egyptian *ushabti* figures. The tomb of Shih Huang-Ti (Qin Shi Huang), discovered in 1974 in the province of Shensi, contains well over 7,000 life-size ceramic and bronze statues of warriors and horses. Burial suits, fashioned from small jade tiles linked together with gold wire, were believed to impart the precious stone's protective power to the spirit of the deceased.

Chinese architecture employs a distinctive gabled roof design with upswept edges whose basic form was probably inspired by the graceful upward sweep of native pine tree branches. (Tradition

holds that a sloped roof sends falling sky demons hurtling back into the sky.) The typical structure is a low rectangular hall basically of **post-and-lintel** construction. Not intended as load-bearing elements, the walls function merely as hanging screens. The familiar Chinese *pagoda*, an octagonal tower consisting of several roofed stories stacked one atop of another, is derived from traditional Buddist temple architecture.

The art of China is categorized into dynastic periods, the earliest of which, the HSIA DYNASTY (c. 2000–1500 B.C.), may be entirely legendary. The principal dynastic eras are listed here in chronological sequence. (Dates are approximate.)[7]

Shang (or Yin) Dynasty (c. 1500–1000 B.C.): Feudal period of Chinese culture under a succession of priest-kings. Ritual bronze vessels, cast from ceramic piecemolds, represent the most highly developed art form. (See Figure 5.119.)

Chou Dynasty (1000–250 B.C.): Period marking the gradual decline of the priest-kings' power and subsequent rise of their vassals. The moral philosopher Confucius (479–551 B.C.) and the Taoist philosopher Lao-Tze (c. 500 B.C.) were of this period. A mixture of styles is represented, from early works of primitive exuberance to lyrical and subdued ornamental designs in the later era. Animal motifs, often reduced nearly to abstraction, are common design elements of this period.

Ch'in Dynasty (221–206 B.C.): Period of political and cultural unification of the rival states (*Ch'in* > China) under the tyrannical first emperor Shih Huang-Ti (also called Qin Shi Huang, c. 250–200 B.C.) called "First Most Sublime Ruler." The GREAT WALL OF CHINA, a military edifice 1,500 miles long extending across northern China, was erected during this period as a defense against marauding nomads. Grand courtly styles predominate, as evidenced by caches of fine goods buried with their wealthy owners.

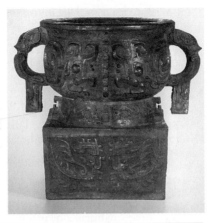

Figure 5.119 LATE SHANG/EARLY CHOU DYNASTY. *Grain vessel, called a* Kuei *(2nd half of eleventh century* B.C.*). Bronze, 10 1/2 inches high. (Art Institute of Chicago, Lucy Maud Buckingham Collection). Note the stylized large-eared bat heads on the handles as well as the highly symmetric relief patterns on the vessel's surface–also inspired by animal forms.*

[7]*Adapted from an historical outline presented in Hermann Kinder and Werner Hilgemann, trans. Ernest A. Menze The Anchor Atlas of World History: Volume I (New York: Anchor Press, Doubleday, 1974); pp. 41, 177, 179, 227, 275.*

Figure 5.120 *T'ANG DYNASTY. Tomb Figure of a Horse (1st half of eighth century). Glazed earthenware, approximately 30 inches high. (Photo: Art Institute of Chicago, A of Russel Tyson). Figures such as this were placed in the tombs of important persons, much like the ancient Egyptian ushabti figures, to serve the deceased in the next life. The glaze colors, predominantly brown, yellow, green, are typical of the T'ang period.*

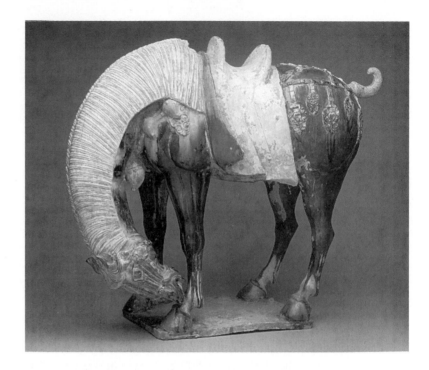

Han Dynasty (206 B.C. to A.D. 250): Era of largest territorial expansion; establishment of transcontinental trade routes along the so-called "silk roads" which extended to the borders of the Roman Empire. Buddhism was introduced from India during this period. Artworks reflect a worldly cosmopolitan air in both style and subject. Afterlife myths and Taoist legends are popular subjects for paintings. Jade burial suits were used to magically preserve the body after death. Flying-horse sculptures reveal an increased realism and knowledge of animal anatomy.

"Six Dynasties" Period (c. 250–600): Era of major political unrest as barbarians and rulers fight for control. During this period ZEN (CH'EN) BUDDHISM was introduced by the semilegendary East Indian holy man BODHIDHARMA (c. 520).

Sui and T'ang Dynasties (c. 600–950): A period of intense cultural interchange between India and China, stimulated by an era of reformation in Chinese Buddhism. Chinese artists adopted many of the iconographic conventions of Indian art, such as the exaggerated side-thrusting hip pose. Ceramic *tomb figures* accompany burials of prominent persons (see Figure 5.120). Intense civil wars raged during the last half-century of T'ang rule (the "five dynasties and ten kingdoms period").

Sung Dynasty (c. 950–1270): Renewed incursions by nomadic Mongols force relocation of capital southward to Hangchow. This southern courtly style exudes a feeling of idyllic idleness, especially in landscape paintings. The Sung dynasty falls to Kublai Khan c. 1270.

Yüan (or Mongol) Dynasty (c. 1270–1350): Dynasty established by the Mongol armies of Genghis Kahn and later Kublai Kahn. An atmosphere of austerity prevails in artistic styles. (See Figure 5.121.)

Ming Dynasty (c. 1350–1650): Overthrow of Mongol invaders. The later years of the Ming dynasty were a period of great artistic vitality and freedom following years of strictly observed traditions. This is the era (c. fifteenth century) of the famous cobalt-blue and white MING VASES.

Ch'ing (or Manchu) Dynasty (c. 1650–1912): Dynasty of the Manchu invaders. Small-scale ivory and jade carvings as well as frankly decorative porcelain sculpture (i.e., china) predominate. The Republican period comprising the first half of the twentieth century is a transitional epoch.

People's Republic of China (1949–): Social realist paintings emphasize the concept of labor for the common good. Abstraction, which promotes individualism and social separation rather than social unity, is shunned in favor of realistic genre images (workers laboring happily in communal factories or cheering political heroes). Ceramic sculpture continues as a prominent artistic form; life-size figural tableaus by anonymous artists illustrate moral and political themes.

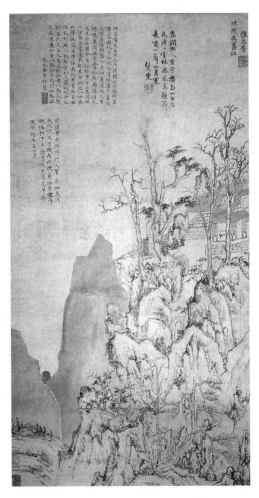

Figure 5.121 YÜAN DYNASTY. A Hermit on His Way to His Hermitage *(c. 1331–1371) by Ch'en Ru-Yan. Brush and ink on paper (hanging scroll), approximately 35" X 20". (Art Institute of Chicago, Kate S. Buckingham Fund). The mist-enshrouded peaks in the background, boldy suggested by a simple grey wash, form a dramatic contrast to the foreground details. The figure of the hermit–barely visible at bottom center–emphasizes with Zenlike simplicity the enduring majesty of nature and the frailty of the human being.*

XIX. Africa

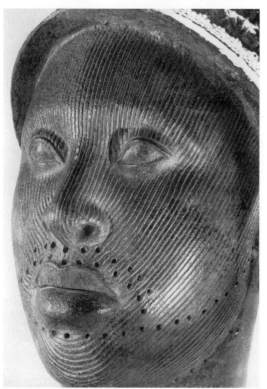

Figure 5.122 WEST CENTRAL REGION. Realistic portrait head (c. 1600) by Ife People, Nigeria. Bronze, life-size. (London, British Museum/Art Resource, NY.). The sensitivity and sophistication of this realistic portrait stands in stark contrast to other more abstract images of gods, ancestors, and totemic spirits. Note in particular the elegant linear patterns adorning the face.

African tribal art is distributed across the entire continent, but most well known are works from the regions of the IVORY COAST (along the underside of Africa's western bulge) and the former GOLD COAST which lies immediately to the east in present-day Ghana.

Organization and description of African peoples by linguistic group is preferred over the more artificial European system of classification by tribe. The YORUBA people, a linguistic group distributed along the coast of West Africa, and the ASHANTI people who populate these regions are regarded as particularly skilled and prolific artisans.

The continent of Africa embraces a large number of clans and families, each of which represents a distinctive microculture ranging from the well-known kingdoms of ancient Egypt to the more obscure groups of southern Africa. Among the largest of these is the BANTU people of central and southern Africa consisting of an estimated 50 million persons whose many dialects all derive from a common language of origin. In spite of this wide cultural diversity, certain general trends are evident:

1. African culture is manifestly rich in nonvisual art forms, especially oral-tradition poetry and myth, as well as rhythmic ritual music and dance. These traditions form the basic substrate for all other art forms.

2. Much of African art is closely associated with the ritual worship of tribal deities and/or the adoration of a *totem animal*—frequently cattle—which acts as the guardian spirit of an individual or group. It is considered taboo to eat or kill the totem animal for obvious reasons.

Generally speaking, sculpture is the dominant form of object art, appearing in all its variations from pure figural sculpture to simple utilitarian objects adorned with incised patterns. Wood carvings are most plentiful. Metal-working skills range from artifacts produced with iron-age charcoal forges to sophisticated bronze

reliefs and brass sculptures in the round, cast using a variation on the lost-wax process.

Nonreligious portraits (mainly of chieftans) are often strikingly naturalistic, rivaling the subtlety and elegance of early classical European sculpture. (See Figure 5.122.) Carved figures used in connection with religious rituals are, befitting their status as ritual/magical objects, highly stylized and often appear in dignified frontal poses. (See Figure 5.123.) Representations of the tribal totem (or principal deities) commonly take the form of highly abstract wooden *ceremonial masks* decorated with paint, metal, or fiber attachments. The wearing of the mask by the *shaman* (holy man) serves as a homeopathic link to the spirit of the totem animal or deity. Thus, the mask itself may be regarded as a power object rather than a simple article of adornment.

Ancestral figures (fashioned of wood or cast metal) function as *spirit traps*, allowing the dead to endure in the midst of their family or tribe. Carved figures are often adorned with shells, copper wire, or beadwork. Nails are sometimes driven into an idol to secure the attention of the associated spirit to one's prayer or supplication.

Rock paintings of the Sahara region resemble those of Mesolithic Europe. These perspectiveless contour drawings depict hunters and prey (usually in profile view), as well as ceremonial scenes. Composite figures with animal features allude to the totem animal or other supernatural beings.

Woven cloth designs incorporating bold geometric patterns, or stylized images of animals and hunters, are common. The ASHANTI people are famous for their colorful woven silk designs.

Most wood, bone, and ivory artifacts take the form of practical utensils (head rests, combs, spoons, and so on). Basketry is a highly developed craft. Some examples are woven so tightly they can be used to carry water. Edged weapons are common; ZULU short spears called

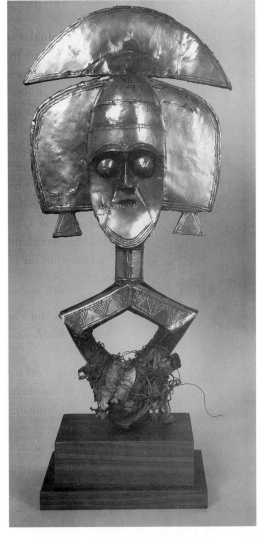

Figure 5.123 *WEST EQUATORIAL REGION. Reliquary figure (late 1800s), Kota People, Gabonese Republic. Thin copper sheet over wood with bone, twine, brass, and hide. Approximately 24" X 12". (Photo: Art Institute of Chicago, Samuel A. Marx Fund). Highly abstracted ceremonial objects, such as this specimen from West Equatorial Africa, inspired the early twentieth-century cubist painters.*

assegais employ an iron speartip whose pointed butt end is driven into a wooden shaft, then wrapped into place with hide strips.

Body adornments take the form of jewelry or decorative wire loops inserted through the (pierced) nose, lips, or ears, or worn in bands around the neck. Among certain tribes decorative patterns of tattoos or raised welts—beauty marks associated with womanhood—are raised on the body by making superficial cuts in the skin which are then rubbed with a spittle mixture. Males undergo similar ceremonial scarring, often in combination with ritual circumcision.

Building styles reflect the diverse regional climates and range from simple nomad tents to wood-framework domes, conical huts, and earth-and-stone constructions. The *kraal* is a typical arrangement of dwellings within a circular fencelike wall. The DOGON people of Mali link the individual parts of a structure symbolically to the parts of the human body (grainery = genitals, and so on).

The various styles represented in African art are as diverse as those of Europe or North America, and as widely ranging in form, quality, and intent. African art has long been recognized as a significant influence in the development of Modern abstract art, especially in the CUBIST (c. 1907) artworks of Pablo Picasso and Georges Braque, who freely borrowed design motifs from African carvings and made virtual replicas of the African masks they admired.

Interestingly enough, the ZULU people of eastern Africa are not deceived by certain optical illusions involving the length of compared lines, such as the Müeller-Lyer illusion. It is believed that because Zulu dwellings are circular rather than rectilinear in shape, their "visual culture" does not impose the same subtle visual cues which act to distort a European's judgment of length when confronted by such illusions.

Postscript: Art and its social situation

We live in a transitional era in which the old maxim *ars gratia artis*—art for art's sake—is no longer taken for granted. Artists, particularly those who work in the volatile domain of "public art," are being called upon to justify their productions in ways that would have seemed unthinkable only a few decades ago. In one notable instance, public opinion (admittedly never the best judge of

anything) turned so antagonistically against a certain piece of minimalist public sculpture—a huge curved ribbon of steel standing on its edge, 12 feet high and ·120 feet long—that the piece was finally removed from its exhibit site in a public plaza. Some commentators chose to interpret this incident as an instance of narrow-minded philistines running amok, while critics on the other side of the fence hailed it as a victory of right-thinking citizens over forces of pretentious buffoonery. One thing appears certain, the artist in this instance seems to have forgotten—or perhaps chose deliberately to ignore—one of the foremost rules of rhetoric: *Know thy audience.*

Artists' indifference to public opinion is, of course, nothing new. And yet it appears as though the traditional visual arts have lost touch with the rest of society in some important ways. Artists today are often perceived as merely visual technicians—one notch above interior decorators—who know very well how to speak that "visual language" of theirs, but sadly enough seem to have very little of any real importance to say with it. We hear proud proclamations that painting is *not* dead, and yet the average visitor to a museum or gallery is likely to find mainly artists, critics, art teachers, and students there, rather than a representative sampling of the general population. Surely there must be more people than these few who are interested in contemporary art—or are there?

Some say the fine arts were never intended to appeal to a mass audience and, therefore, the lack of widespread public interest in art is neither surprising nor unusual. And yet, many artists have felt the need to reverse this condition of self-imposed social insularity by turning to more relevant themes and subject matter. Anthropology, psychology, philosophy, mythology, and literature have all been heavily culled for inspiration by modern artists with mixed degrees of success. Other artists have sought to bring greater meaning to their work by placing their art in service of a just and deserving cause, such as the ongoing concerns over gender issues which characterize much of feminist art and criticism, or the promulgation of religious, political, or counter-cultural values. And for those who embrace them, these issues often take on the character of a personal crusade.

For others, the issue is more simply one of finding the proper "voice" for their ideas and concerns. Of all the many young artists who start out as painters and sculptors, some will eventually switch to a more contemporary medium, like videotape or film making,

which is better suited to their particular style of creative thinking and visualization. A large percentage will simply abandon art in favor of a career offering greater social status and recognition, or switch to fields like psychology, which offer alternative pathways into the inner landscape, or commercial design which provides a relatively more stable income. And while each of these choices represents, in its own way, an individual solution to the problem of art's social insularity, a larger implicit question remains stubbornly before us: *What exactly is the role of the artist in our society?*

Art as it is practiced today has a dual nature as both a poetic avocation and a hard-nosed business enterprise. This duality creates a tension that each artist must confront and somehow resolve to his or her own satisfaction. Artists who choose to follow the path of poetic avocation are the artists of popular legend who, while starving in a garret in the low-rent district of town, sate their hunger with rolls of canvas and tubes of Windsor & Newton Oil Colors. However pure their intentions, these artists rarely find recognition in the ultracompetitive art marketplace because the very personality traits that make them good painters—their introspective, sensitive natures—also tend to make them poor businesspeople.

On the other side of the coin, so to speak, are those for whom art is simply another sort of capital venture. These "culture brokers" learn to anticipate up-and-coming artistic trends by extrapolating from the new styles showcased in the slick "high-art" journals—the official house organs of the corporate art establishment. Such artistic entrepreneurs are often less concerned with personal expression than with cornering the market on some new stylistic direction, as if artistic styles were nothing more than another consumer commodity to be traded like spring wheat, or porkbelly futures. Such individuals may enjoy a brief period of recognition, if their hunch pays off, but often fade from sight when styles unexpectedly change. *Sic transit gloria mundi.* So much for worldly glory.

Between these two somewhat caricatured extremes lies the vast majority of artists who must somehow balance their art interest against some unrelated means of ekeing out a livelihood. Perhaps the most fortunate among them are the tenured university faculty who pursue their art as part of their research obligations. But the smug, ivory tower world of the academic is no artistic utopia. The "publish or perish" mentality promulgated at many large research institutions often leads to a large output of works of disappointingly

mediocre quality. It is, after all, no accident that artworks which appear dreary and uninteresting have come to be labeled perjoratively by the term *academic*. In recent years musicians and composers have rebelled against the overly intellectualized approaches to music fashionable in certain academic circles in favor of a more melodic and spontaneous approach with greater popular appeal. Perhaps a parallel situation can be seen emerging in the visual arts, evidenced by the recent surge of interest among collectors in the artifacts of *brut culture*, such as primitive folk art, comic books, gang graffiti, and the like.

There are, to complicate matters further, indications that the social mission of the fine arts has come to an end or, perhaps, is undergoing a significant transformation. In the eighteenth and nineteenth centuries, art galleries served the purpose that popular motion-picture theaters serve today, a place where society could see its dreams, horrors, and triumphs reflected in the grand mirror of the artist's canvas, which has since come to be replaced by the silvered motion-picture screen. The rules of the game, as one of my graduate instructors used to say, have all changed in the last hundred years.

While most artists continue to work and exhibit for a dwindling and uncertain audience, sources of governmental funding for the arts are being increasingly diverted to more pressing social concerns. In addition to widespread public apathy, there is a growing feeling among many artists that the traditional styles and themes, even the formerly avante-garde styles, have all been "worked out" with nothing new to take their place. I am reminded of a tale concerning an English nineteenth-century surgeon, Sir Astley Cooper, who made a hobby of purchasing battle-wounded cavalry horses and nursing them back to health on his country estate. Early one morning the physician and his staff were delighted to see the riderless horses, now recovered, arrange themselves in their old cavalry attack formations (they had fought with Wellington's army at Waterloo) and spontaneously reenact their military maneuvers against an imaginary enemy.[2] To my mind this haunting little tale neatly describes, in the manner of an allegory, the situation in the fine arts today.

As stated earlier, most serious political theorists believe that the American era of cultural and economic hegemony (from 1945

[2]Max Hastings, ed., *The Oxford Book of Military Anecdotes*, (Oxford: Oxford University Press, 1985), entry 210, p. 245.

to 1965) is rapidly fading into the past, while the nations of the Pacific Rim (Japan, Taiwan, China, and Korea) are all enjoying an unprecedented era of economic and cultural rebirth. Recent developments in Europe, such as the creation of the newly formed European Union, all seem to herald the coming of a new era in which North America will play an important but not necessarily dominant role.

A related trend in education, no doubt partly inspired by these pervasive cultural changes, is the recent emphasis upon *multiculturalism,* which celebrates individualism and cultural diversity rather than conformity and sameness. Multiculturalism is likely to foster a more egalitarian attitude in art by rekindling interest in long neglected and often misunderstood *folk art traditions* of minority cultures. In the same way that the Italian Renaissance brought an end to Gothic culture, the multicultural trends of contemporary society may eventually bring an end to the Greco-Italianate traditions which have dominated Western culture since the Renaissance.

Strangely enough, the most genuine art forms of the future may emerge not from the domain of the fine arts as we know them today, but rather from folk art traditions preserved within our own ethnically diverse microcultures. The recent reawakening of interest in *brut culture,* which has inspired a reappraisal of art forms once thought unworthy of attention much less preservation, can be interpreted as an early indication of widespread change in cultural attitudes and values. Future generations may come to regard art as something to be practiced at intervals throughout everyone's life span as a means of enhancing one's self-knowledge and sense of personal discovery—a talent to be practiced as personal needs and conditions dictate—rather than as an ongoing business enterprise or elitist career path destined for a select and privileged few.

References

Baigell, Matthew, *Thomas Hart Benton.* New York: Harry N. Abrams, 1975.

Bonnefoy, Yves, *Mythologies* (in two volumes). Wendy Doniger, trans. Chicago: The University of Chicago Press, 1991.

Darwin, Charles, *The Origin of Species.* New York: Literary Classics, Inc., (no date given).

Evans, Ivor H., ed., *Brewers Dictionary of Phrase and Fable.* New York: Harper & Row, 1981.

Forman, Harry Buxton, *Shelly's Poetical Works, Volume 1.* London: Reeves and Turner/Ballantyne, Hanson, and Co., 1882.

Glasstone, Samuel, ed., *The Effects of Nuclear Weapons.* Washington, DC: U.S. Dept. of Defense/U.S. Atomic Energy Commission, 1962.

Hardy, Godfrey Harold, "A Mathematician's Apology" from *A Mathematician's Apology.* London: Cambridge University Press, 1967. Also in *The World of Mathematics,* vol. 4. New York: Simon & Schuster, 1956.

Holt, Elizabeth Gilmore, *A Documentary History of Art* (vol. 1). New York: Doubleday/Anchor Books, 1957.

Holt, Elizabeth Gilmore, ed., *Literary Sources of Art History.* Princeton: Princeton University Press, 1947.

Kaisen, Iguchi, *Tea Ceremony.* John Clark, trans. Osaka: Hoikusha Publishing Co., 1976.

Lenz, John W., ed., *Hume: Of the Standard of Taste and Other Essays.* Indianapolis: The Bobbs Merrill Co., Inc., 1965.

Levi-Strauss, Claude, *The Savage Mind.* John Weightman and Doreen Weightman, trans. Chicago: University of Chicago Press, 1966.

Palmer, George Herbert, trans. *The Odyssey* of Homer. New York: Houghton, Mifflin and Company, 1891.

Prideaux, Tom, and the editors of Time-Life Books. *The Time-Life Encyclopedia of Art: The World of Delacroix, 1798–1863.* New York: Time-Life Books, 1966.

Richter, J. P., and I. A. Richter, *The Literary Works of Leonardo da Vinci* (2 volumes). London: Oxford University Press, 1939.

Witherspoon, Gary, *Art and Language in the Navajo Universe.* Ann Arbor: University of Michigan Press, 1977.

Wolfflin, Heinrich, *Principles of Art History.* M. D. Hottinger, trans. New York: Dover Publications, Inc., 1915/1950.

Selected Bibliography

(A listing of selected sources for further reading)

Chapter 1: The Fine Arts in General Terms

Gombrich, E. H., *The Story of Art.* Oxford: Phaidon Press, 1979.

Tolstoy, Leo N., *What is art?* (1896). Almyer Maude, trans. Indianapolis: Bobbs Merrill Educational Publishing Company, 1960.

Chapter 2: Art Forms and Techniques

Blackburn, Graham, *The Illustrated Encyclopedia of Woodworking Handtools, Instruments, and Devices.* New York: Simon & Schuster, 1974.

Clarke, Charles G., A.S.C. *American Cinematographer Manual,* 5th ed. Hollywood: American Society of Cinematographers, 1980.

Crittenden, Roger, *The Thames and Hudson Manual of Film Editing.* London: Thames and Hudson Ltd., 1981.

Lipton, Lenny, *Independent Filmmaking.* New York: Simon and Schuster/Fireside Books, 1972.

Marsh, Ken, *Independent Video: A Complete Guide to the Physics, Operation, and Application of the New Television for the Student, the Artist, and for Community Television.* New York: Simon & Schuster/Fireside Books, 1980.

Meyer, Ralph, *The Artist's Handbook of Materials and Techniques.* New York: Viking Press, 1970.

Ross, John, Clare Romano, and Tim Ross, *The Complete Printmaker.* New York: Free Press/Collier Macmillan, Inc., 1972/1990.

Rostagno, Aldo, with Julian Beck and Judith Malina, *We, The Living Theatre.* New York: Ballantine Books, 1970.

Saff, Donald, and Deli Sacilotto, *Printmaking: History and Process.* New York: Holt, Rinehart and Winston, 1978.

Withers, Robert S., *Introduction to Film.* New York: Harper & Row Publishers, Inc., 1983.

Chapter 3, 4: The Formal Elements of Art and Design and Principles of Composition

Arnheim, Rudolph, *Art and Visual Perception.* Berkeley: University of California Press, 1954/1974.

Gombrich, E. H., *Art and Illusion: A Study in the Psychology of Pictorial Representation.* New York: Princeton University Press, 1960/1972.

Chapter 5: A Brief History of Art in Synopsis Form

(Entries listed by historical era)

Baker, Kenneth, *Minimalism: Art of Circumstance.* New York: Abeville Press, 1988.

Battcock, Gregory, ed. *Idea Art: a Critical Anthology.* New York: E. P. Dutton and Company, 1973.

Brooke, Christopher, *The Monastic World: 1000–1300.* New York: Random House, 1974.

Brown, R. Allen, Michael Prestwich, and Charles Coulson, *Castles: A History and Guide*. Dorset: Blandford Press, 1980.

Budge, E. A. Wallis, *The Gods of the Egyptians (or Studies in Egyptian mythology)* (2 volumes, 1904). New York: Dover Publications, 1969.

Chipp, Herschel B., *Theories of Modern Art*. Berkeley: University of California Press, 1975.

Christophe-Bailly, Jean, *Duchamp*. New York: Universe Books, 1988.

Cohen, George M., *A History of American Art*. New York: Dell Publishing Company Inc., 1971.

Collins, Michael, and Andreas Papadakis, *Post-Modern Design*. New York: Rizzoli, 1989.

Copplestone, Trewin, *Modern Art*. New York: Exeter Books, 1985.

Cotterell, Arthur, ed., *Encyclopedia of Ancient Civilizations*. London: Rainbird Publishing, 1980.

Ferrier, Jean-Louis, and Yann Le Pichon, Walter D. Glanze, trans. *Art of Our Century*. New York: Prentice Hall, 1988.

Freed, Rita E., *Ramses II: The Great Pharaoh and His Time* (exhibition catalog). Denver: Museum of Natural History and Egyptian Antiquities Organization, 1987.

Goldwater, Robert, and Marco Treves, eds., *Artists on Art (from the XIV to the XX Century)*. New York: Random House/Pantheon Books, 1945/1972.

Hadas, Moses, and editors of Time-Life Books, *Imperial Rome*. New York: Time-Life Books, 1965.

Hamilton, George Heard, *Painting and Sculpture in Europe, 1880–1940,* published in *The Pelican History of Art,* Nikolaus Pevsner, ed. New York: Penguin Books, 1967/1975.

Harris, Ann Sutherland, and Linda Nochlin, *Women Artists: 1550–1959*. New York: Alfred A. Knopf, 1976.

Hawkes, Jacquetta, *Prehistory (History of Mankind, Cultural and Scientific Development)* vol. 1, no. 1. New York: New American Library/Mentor Books, 1963.

Holt, Elizabeth Gilmore, *A Documentary History of Art: Michelangelo and the Mannerists, the Baroque and 18th century*. New York: Doubleday/Anchor Books, 1958.

Holt, Elizabeth Gilmore, *A Documentary History of Art: The Middle Ages and the Renaissance*. New York: Doubleday/Anchor Books, 1957.

Hughes, Robert, *The Shock of the New*. New York: Alfred A. Knopf, Inc., 1980.

Huyge, René, ed., *Larousse Encyclopedia of Byzantine and Medieval Art*. New York: Excalibur Books, 1958.

Jencks, Charles, *Post-Modernism: The New Classicism in Art and Literature*. New York: Rizzoli, 1987.

Jencks, Charles, "What Is Post-Modernism?" (Pamphlet reprint of a paper delivered at Northwestern University, Evanston, IL, October 1985.) New York: St. Martin's Press, 1986.

Lippard, Lucy R., *Changing Essays in Art Criticism*. New York: E. P. Dutton, 1971.

Lucie-Smith, Edward, *Art in the Seventies*. Ithaca: Cornell University Press/Phaidon Press, 1980.

Lynton, Norbert, *The Story of Modern Art*. Ithaca: Cornell University Press, 1980.

Marshack, Alexander, *The Roots of Civilization*. New York: McGraw-Hill Book Company, 1972.

Passeron, René, *Phaidon Encyclopedia of Surrealism*. Oxford: Phaidon Press, 1981.

Perrot, Georges and Charles Chipiez, *Art in Primitive Greece,* vol. 2. London: Chapman and Hall, Ltd, 1894.

Pritchard, James B., *The Ancient Near East: An Anthology of Texts and Pictures,* vol. 1. Princeton:

Princeton University Press, 1958/1973.

Richard, Lionel, *Phaidon Encyclopedia of Expressionism*. Oxford: Phaidon Press, 1978.

Roaf, Michael, *Cultural Atlas of Mesopotamia*. Oxford: Equinox (Oxford) Ltd., 1990.

Smagula, Howard, *Currents: Contemporary Directions in the Visual Arts*. Englewood Cliffs, New Jersey: Prentice Hall, 1983.

Wilkinson, J. Gardner, *The Ancient Egyptians: Their Life and Customs*. New York: Crescent Books, 1988.

Wolfe, Tom, *The Painted Word*. New York: Farrar, Strauss and Giroux, 1975.

Non-European Cultures:

Bowie, Henry P., *On the Laws of Japanese Painting*. New York: Dover Publications, Inc., 1911.

Driver, Harold E., *Indians of North America*. Chicago: University of Chicago Press, 1961.

Franklin, Paula A., *Indians of North America*. New York: David McKay Company, Inc., 1979.

Kinder, Hermann, and Werner Hilgemann, *The Anchor Atlas of World History, Volume I*. Ernest A. Menze, trans. Garden City, Anchor Press/Doubleday, 1974.

Roberts, J. M., *The Pelican History of the World*. Middlesex: Penguin, 1986.

Witherspoon, Gary, *Language and Art in the Navajo Universe*. Ann Arbor: University of Michigan Press, 1977.

Miscellaneous Background and General Historical Sources

Christensen, Erwin O., *The History of Western Art*. New York: New American Library, 1959.

Copplestone, Trewin, *Art In Society, A Guide to the Visual Arts*. Englewood Cliffs, NJ: Prentice Hall, 1983.

de la Croix, Horst, and Richard Tansey, *Gardner's Art Through the Ages* (8th ed.) New York: Harcourt Brace Jovanovich, 1986.

Durant, Will, *The Story of Civilization* (11 volumes). New York: Simon & Schuster, 1954.

Evans, Ivor H., ed., *Brewer's Dictionary of Phrase and Fable*. New York: Harper & Row, 1981.

Fleming, William, *Arts and Ideas*. Holt, Rinehart and Winston, Inc., 1991.

Gardner, Helen, *Art Through the Ages: An Introduction to its History and Significance* (2nd ed.) New York: Harcourt Brace Jovanovich, 1936.

Gibbon, Edward, *The Decline and Fall of the Roman Empire* (abridgement by D. M. Low, 1960). New York: Harcourt Brace and Company, 1960.

Lattimore, Richard, trans., *The Iliad of Homer*. Chicago: University of Chicago Press, 1961.

Lattimore, Richard, trans., *The Odyssey of Homer*. Chicago: University of Chicago Press, 1967.

Lautrémont, *Maldoror*. New York: Penguin Books, 1978.

Lind, L. R., trans., *Vergil's Aeneid*. Bloomington: Indiana University Press, 1962.

Maxon, John, *The Art Institute of Chicago*. London: Thames and Hudson Ltd., 1970/1983.

Reinach, M. Salomon, *An Illustrated (Apollo) Manual of The History of Art Throughout the Ages*. New York: Charles Scribner's Sons, 1922.

Spengler, Oswald, (Helmut Werner, ed.) *The Decline of the West* (abridged single-volume edition; English version editor Arthur Helps, from the translation by Charles Francis

Atkinson). Oxford: Oxford University Press, 1991.

Stetler, Susan L., ed., *The Almanac of Famous People* (3 vols.). Detroit: Gale Research Incorporated, 1989.

Sykes, Egerton, *Everyman's Dictionay of Non-Classical Mythology*. New York: E. P. Dutton and Company, 1952.

Toynbee, Arnold, with Jane Caplan, *A Study of History* (abridged one-volume edition). New York: American Heritage Press/Oxford University Press, 1972.

Wells, H. G., *The Outline of History*. New York: Macmillan Company, 1927.

Illustration Sources

Appelbaum, Stanley, *Bizarreries and Fantasies of Grandville*. New York: Dover Publications Inc., 1974.

Becker, A. W., *Charakterbilder aus der Kunstgeschichte*. Leipzig: Verlag von G. M. Seeman, 1862.

Coleridge, Samuel Taylor, *The Rime of the Ancient Mariner* (with illustrations by Gustave Doré). New York: Dover Publications Inc., 1970.

Dehio, G., *Kunstgeschichte in Bildern (Abeteilung 2)*. Leipzig: Verlag von E. A. Seeman, 1902.

De La Marche, A. Lecoy, *Le Treiziéme Siécle Artistique*. Lille: Société de Sainte Augustin/Imprimeurs des Facultés Catholiques de Lille, 1889.

Ehrenberg, Hermann, *Handbuch der Kunstgeschichte*. Leipzig: J. J. Weber, 1906.

Fäh, Adolf, *Geschichte der Dildenden Künste*. Freiburg: Herdersche Verlagshandlung, 1903.

Goodyear, William H., *A History of Art*. New York: A. S. Barnes & Co., 1988/89.

Graul, Richard, *Einsübrung in die Kunstgeschichte*. Leipzig: Alfred Kröner Verlag, 1916.

Hart, Harold H. *Compendium of Illustrations in the Public Domain*. New York: Hart Publishing Company, 1983.

Heck, Johann Georg, *The Complete Encyclopedia of Illustrations*. New York: Park Lane, 1851/1972.

Huber, Richard, *Treasury of Fantastic and Mythological Creatures*. New York: Dover Publications Inc., 1981.

Lehner, Ernst, *Symbols, Signs, and Signets*. New York: Dover Publications, Inc., 1950.

Lethaby, W. R., *Medieval Art*. New York: Charles Scribner's Sons, 1904.

Librairies-Imprimeries Réunies (May and Motteroz, directeurs). *L'Art Gothique*. Paris: Librairies-Imprimeries Réunies, no date.

Lübke, Wilhelm, and Carl von Lützow, *Denkmäler der Kunst*. Stuttgart: Verlag von Paul Neff (before 1892).

Lübke, Wilhelm, (Russel Sturgis, ed.)., *Outlines of the History of Art* (vol. 2). New York: Dodd, Mead & Company, 1904.

Nolhac, Pierre de, *Versailles*. Paris: Libraire Centrale d'Art et L'Architecture, 1912.

Quinn, Gerard, *The Clip Art Book*. New York: Crescent Books, 1990.

Sieglin, Wilhelm, *Schulatlas zur Geschichte des Altertums* (4th ed.). Gotha: Justus Perthes, no date given.

Smith, A. G., *Castles of the World*. New York: Dover Publications Inc., 1986.

von Sybel, Ludwig, *Weltgeschichte der Kunst*. Marburg: N. G. Elwertsche Verlagsbuchhandlung, 1888.

Winter, Franz, *Kunstgeschichte in Bildern (Abeteilung 1)*. Leipzig: Verlag von E. A. Seeman, 1900.

Winter, Franz, *Kunstgeschichte in Bildern (Abeteilung 3)*. Leipzig: Verlag von E. A. Seeman, 1898.

Glossary of Terms and Techniques

Abacus: A thin stone slab at the top of an architectural column which acts as a transitional element between the column's capital and the element it supports.

Abstract, Abstraction: The reduction of a thing to its essential features or characteristics.

Academic: A derisive term applied to any very traditional or stiltedly conservative style of art (such as that taught in the nineteenth-century French Academie) which appeals primarily to narrow, scholarly tastes.

Achromatic: Colorless.

Acropolis: (Greek for "hill city") The temple complex built atop a large mesalike hill within the precincts of the city of Athens. Considered a sacred place, it towered above the marketplace at its base, called the *agora*.

Action Painting: A type of twentieth-century abstract painting characterized by the application of paint in broad, sweeping gestural strokes. Action paintings are not pictures of things in the usual sense, but rather representations of an artist's actions and gestures.

Additive technique: Any sculptural technique which involves building up a form, as with the addition of clay, in direct contrast to a *subtractive technique* such as wood carving.

Aesthetics: A branch of philosophy concerned with the philosophical investigation of the concept of beauty.

Air Brush: A spray-painting technique in which the paint is forced (by compressed air or some other propellant) through a penlike spray gun. Commercial illustrators make extensive use of air-brush techniques.

Aisle: A narrow passageway that runs alongside the *nave* in a cathedral.

Alla Prima: A technique of painting in which the colors are applied all at once, rather than built up gradually in layers.

Ambulatory: In a cathedral, a narrow passageway that winds between the apse and the choir, allowing pilgrims to pay homage at the chapels without disturbing the mass in progress.

Amphitheater: A round or oval structure consisting of rising tiers of seats opening onto a stage *(proscenium)* or an open *arena,* as in a traditional bullring.

Amphora: A two-handled jug of the type used by the ancient Greeks and Romans for storing or transporting wine, water, or oil.

Analogous hues: In color theory, two colors which lie next to one another on a color wheel (because they share a common hue), such as blue/blue-green.

Apparent Color: (also called *optical color*) The changeable appearance of a color as it is effected by shifting lighting conditions, surface reflections, and *simultaneous-contrast effects,* in contrast to its actual or absolute color.

Apprenticeship: A system of instruction used in the medieval guilds in which a young student (the *apprentice*) performed menial duties for a *master* as the first step in learning the master's skills. After years of rigorous study, the apprentice became a *journeyman* fully qualified to practice his

trade in exchange for wages. In later years the journeyman might attain the status of a master and pass along his special skills to his own apprentices. *See also* masterpiece.

Apse: A curved wall usually found at the eastern (altar) end of a church or cathedral, or at either end of a transept

Apsidal Chapels: Chapels arranged around the apse of a cathedral.

Aquatint: An *intaglio* process which produces smooth gradations of value. The printing plate is coated with a finely powdered resin prior to immersion in an acid bath, then the lighter areas are stopped out with an acid resist. The darker areas, given longer exposure to the acid, print as darker than those areas given a shorter exposure time.

Aqueduct: A Roman water conveyance consisting of a long covered trough supported on a continuous series of arches.

Arabesque: Sinuous, intertwining geometric forms, often featuring spirallike patterns, so named because of their origin in Eastern designs.

Arcade: A row of columns joined at the top by arches. When an arcade is used as a decorative wall relief, it is called a *blind arcade.*

Architrave: (*Ark* ih trave) In classical architecture, the lowest portion of an entablature, often consisting of an unadorned band directly above the supporting columns. Also called the *epistyle.*

Archivolt: (*Ark* ih volt) Carved concentric bands (often decorated with relief) that radiate outward from an arch.

Arc Welding: A welding technique in which the heat is generated by the electrical arc created when an electrode is brought into contact with a piece of conductive metal. Compare oxy-acetylene welding.

Armature: In sculpture, a skeletal assembly of wood or pipe which supports the clay during modeling.

ASA Rating (or ISO Number): A standardized measurement used by the photographic industry to indicate a film emulsion's sensitivity to light. The higher a film's ASA number, the more sensitive (faster) the film.

Assemblage: (Ah *sem* blah'zh) A sculpture made from "found objects" put together in new and often unexpected ways. Assemblage is the three-dimensional equivalent of collage.

Atmospheric Perspective: In painting, creating the illusion of great distance by representing distant objects as indistinct and shifting their hues toward blue to simulate the effect of intervening atmospheric haze. *Compare* sfumato.

Atrium: (1) In Roman architecture, a square or rectangular room open to the sky. (2) In medieval church architecture, an open forecourt at the front of a church which alludes to the era of persecution during which Christian worshipers gathered secretly in private Roman homes.

Auteur Criticism: A mode of criticism in which a film maker's body of works is examined for those distinctive features most representative of his or her personal style.

Autographic Replica: In the graphic arts, true art prints are distinguished from commercial reproductions by the fact that the fine art techniques reverse the image (left to right) during the printing process. Such images are called autographic replicas.

Avant-garde: (Literally, "the advance guard") Any new and/or controversial art form. The opposite of *decadent*.

Baldacchino: (Bal da *kee* no) A permanent canopylike structure (usually supported by four columns) built over an altar.

Balloon Frame Construction: In architecture, a structural framework made from prefabricated wooden studs (resting on the sillplate and extending up to the eaves) nailed directly to the floor joists. Ironically enough, it was invented in Chicago, "the Windy City," about 1835.

Barbican: A walled forecourt at the entrance to a castle.

Baroque: (Bah *roke*) The term used to describe the art styles from 1600 to 1715, which were characterized by a certain operatic theatricality with an excess of emotional expression. The term *baroque* is often used derisively by critics to describe any work which appears overdone or "heavy-handed."

Barrel Vault: (also called *tunnel vault*) A passageway formed by extending an arch through space. Two intersecting barrel vaults form a groin vault. Vaults serve as the basic structural units of the medieval cathedrals.

Basilica: A type of Roman public building which consisted of a long rectangular hall flanked on either side by one or more aisles. The early Christian churches are modeled after the three-aisled Roman basilicas.

Bay: In cathedral architecture, a rectangular space enclosed by a single arched vault, usually delineated by its four supporting piers or columns.

Beaux Arts: (pronounced *Bow's arts*) Literally, the "fine arts" of painting, sculpture, drawing, and so on.

Binder: *See* vehicle.

Biomorphic: Any abstract forms inspired by the shapes of living things.

Bisque Firing: (Pronounced *Bisk*-firing) The first firing of a clay vessel in a kiln, which turns the vessel to a stony hardness, thereafter called *stoneware*.

Book of Hours: See breviary.

Breviary: A small book containing prayers to be recited at specific times throughout the day; also called a *Book of Hours*. *Compare* psalter.

Bronze: An metallic alloy of copper and tin preferred for fine art statuary.

Burin: In the graphic arts, a sharp, steel-bladed instrument with a mushroom-shaped handle used to engrave an image into a copper plate. Also called a *graver*.

Burning: In photographic processing, selectively allowing a portion of a photographic image to receive more light (overexposure) during the enlarging process.

Burnisher (Burnishing Tool): In the graphic arts, a tool used to smooth out (and thus lighten) the pitted areas of a printing plate. The blade of a burnishing tool is a flattened half-cylinder, tapered and bent upward slightly at its end.

Bust: A sculptural portrait representing the head, shoulders, and chest (bust) of the subject. Portrait busts were favored by the ancient Romans, who regarded portrait heads alone as too reminiscent of the human remains found after a battle.

Buttress: In cathedral architecture, a structural element which acts to reinforce a wall and brace it against the outward and downward thrusting forces exerted by the mass of the roof. In Romanesque architecture, buttresses are a part of the

wall, while in Gothic architecture they stand away from the wall but are linked to it by a spanning or "flying" element; hence, the term *flying buttress.*

Cache Sites: A cave or sheltered place where Nomads store their nonportable goods.

Calligraphic Line: A line which displays the elegant, flowing quality characteristically found in handwritten script or calligraphy

Calotype: An early photographic print made on paper.

Campanile: (Cam pa *knee* lay) A freestanding bell tower, usually cylindrical or rectangular in shape. The famous Leaning Tower of Pisa is the campanile of the Cathedral and Baptistry of Pisa. (The tower settled unevenly after its construction.)

Canon of Proportions: Any system of proportions devised by an artist to produce an "ideal" human figure. Such canons vary from workshop to workshop and change considerably over time.

Cantilever: In architecture, any structure (made from a high-tensile-strength material) that juts out into space. Cantilevers, supported by the use of steel I-beams, are a common feature of modern architecture.

Capital: The carved upper section of an architectural column consisting of the echinus and a thin slab called the abacus, which acts as a transitional element between the column and the element it supports.

Caricature: A type of portrait in which the distinctive features of a subject are exaggerated, usually for humorous effect.

Cartoon: A type of working drawing usually done full scale on a large piece of paper, then transferred to a wall surface by punching holes along the drawing's outlines and daubing them with powdered charcoal. Cartoons are somewhat rare since they were typically "used up" during the production of the finished artwork.

Cartouche: (Car *toosh*) In Egyptian art, a lozenge-shaped emblem drawn around the name of a pharaoh to indicate his exhalted status. Any scroll-like design used as a decorative embellishment.

Caryatids: (Carry *ay* tids) Sculpted female figures used in architecture as supporting columns. Their male counterparts are called Atlantes.

Casein: (Kay *seen*) A type of paint in which the pigment is mixed with animal or synthetic glue. Most "tempera paints" sold for children's use are actually casein.

Catacombs: A multileveled maze of underground passageways and burial vaults located beneath the city of Rome. Much early Christian art from the persecution period takes the form of catacomb frescoes.

Catalogue Raisonné: (Catalog Ray-zo-*nay*) A published collection of photographs or art prints which documents an artist's lifework, often containing commentary on the principal works, important influences, and so on.

Cathedral: Specifically, the principal church under the direct authority of a bishop. Medieval cathedrals were designed to hold a city's entire population all at once, thus, the term *cathedral* is used generally to denote any unusually large or imposing church.

Cella: (pronounced *sell-uh;* Latin for "cell") In classical architecture, the inner chamber(s) of a temple—usually only accessible to

officiating priests—which contained devotional statues and sometimes a small treasury.

Centering: A semicircular wooden framework used to support the stones of an arch while it is under construction.

Central Plan: An architectural plan (for a church or cathedral) derived from the equal-armed Greek cross.

Ceramics: The branch of sculpture traditionally associated with the fashioning of clay vessels, as well as other utilitarian or purely aesthetic objects, which are then fired to stonelike hardness and decorated with a vitreous glaze.

Chapels: Small rooms built into the wall (or apse) of a church which house the sacred relics of saints.

Chasing: The process of removing all metal seams, gates, and channels from a bronze sculpture after it has been released from the foundry mold.

Chiaroscuro: (*Keer* a *skyoor* oh) In drawing, the modulation of light and dark values to create the illusion of a contoured surface.

Chinoiserie: (Shin *wha* sir ee) A general term used in reference to any decorative Chinese artifacts (such as vases, small statues, and so on) used to lend an exotic flavor to an interior setting.

Choir: In architecture, the space (often demarcated by a raised platform) at the eastern end of a church wherein the main altar is located.

Chroma: *See* intensity.

Chromatic Shadows: The technique of depicting shadows with a complementary color rather than grey or black.

Cire Perdu: (*Sear* pear dew; Literally, "lost wax") A foundry technique in which a mold is produced from a wax model. After

the mold has been constructed, the wax is then heated and allowed to drain out of the mold (i.e., "lost"). Unlike industrial sand-casting techniques, the lost-wax process preserves fine surface detail and, therefore, is favored for casting smaller art objects.

Classical: Specifically, Greco-Roman artworks from the fifth century B.C. to second century A.D., regarded by many as embodying the highest aesthetic ideals, and characterized by a sense of intellectual precision and emotional restraint. The term *classical,* however, is often generally applied to any enduring work of art. *Compare with* romantic.

Clerestory: (*Clear* story) In a cathedral's nave, the free wall space above the aisle roofs.

Cloisonné: (Kl'wah *zhoh* nay) A type of jewelry made from colored enamel set between thin metal strips of varied shape.

Cloister: An enclosed rectangular courtyard surrounded by roofed walkways.

Closed Composition: A type of compositional arrangement in which all pictorial elements appear to be contained within a clearly delineated pictorial space; figures may even appear to be posing for the viewer. *Compare* open composition.

Codices: (*Co*-da-sees) Volumes of scriptural writings arranged in manuscript form (i.e., bound along one edge, like a book).

Coffers: An arrangement of recessed panels found mainly on the interiors of domes (or ceilings) which reduces the overall weight of the structure.

Collage: A technique developed by Pablo Picasso (c. 1913) which involves producing an image from flat objects usually attached to a painted panel. A *papier collé* is a collage made entirely from pieces of paper.

Colonnade: A row of columns, usually supporting a roof.

Complementary Colors: Colors which lie directly across from one another on a color wheel, such as green/red, yellow/violet, or blue/orange. Complementary colors have the highest degree of contrast between their hues and, when mixed together, cancel each other out to produce a neutral grey. *See also* split complementary colors.

Compression Strength: The ability of any structural material to bear weight without being crushed (often contrasted with tensile strength). A stone slab has great compression strength, but little tensile strength.

Composite Order: An ancient Roman variation on the classical Greek architectural orders which combined the acanthus-leaved capitals of the Corinthian order with the scroll-like capitals of the Ionic order. *Compare* Doric order.

Conceptual Art: An attitude toward art making developed in the 1960s revolving around the idea that the essence of art lies in the ideas embodied in a work, rather than in the physical aesthetics of an object.

Contact Sheet: In photography, an 8" X 10" photo made by laying an entire roll of 35-mm film negatives directly upon the photo paper and exposing it to light. Photographers use contact sheets to reveal what is contained on a roll of film before deciding which exposures they will go through the trouble of printing.

Contour Drawing: A simple linear representation, usually restricted to the essential features of a subject.

Contraposto: (Contra *po* stoe) In sculpture, any stance in which a human figure is counterpoised. Examples are a seated figure with legs twisted in one direction and the upper torso twisted in another, or a standing figure which exhibits an S-curve (weight shift) caused by the figure balancing all its weight upon one leg while relaxing the other. Michelangelo's Sistine Chapel frescoes are known for their *contraposto* figures, which suggest a feeling of great power being held in check.

Corbel: Any supporting bracket (of wood, metal, or stone) that projects from a wall and is used to support another structural element from beneath.

Corbeled Arch (or Vault): An arch or vault formed by stepping out successive tiers of bricks until they meet in the middle.

Corinthian Order: One of the three principal orders of classical architecture, readily identified by its slender (often unfluted) columns, and carved stone capitals representing bundled acanthus leaves. *Compare* Doric order, Ionic order, Composite order.

Cornice: In architecture, a narrow strip of moulding which trims the edge of a wall or roof.

Corten Steel: A variety of steel whose surface rust forms a thin protective coating. Corten steel is widely used in architecture and large-scale sculptural projects.

Crenelations: In architecture, the notches along the top of a castle wall. *Compare* Loopholes.

Critique: Any critical analysis of a work of art. At most art schools regularly scheduled critiques are held during which students present their recent works for discussion/analysis/criticism by other students and faculty.

Cross Contour: A drawing technique in

which the surface contours of objects are represented by parallel lines which appear to wrap around the contours of the object's surface.

Crosshatching: A drawing technique in which shading is built up by overlaying hatched lines running in different directions, rather than applying flat areas of shadow. *See also* hatched line.

Crossing: In a cathedral, the square floor area where the nave (central aisle) and transept (crossing aisle) intersect. In churches that follow a square schematism plan, the crossing serves as the basic modular unit from which the cathedral's overall plan is developed.

Crypt: In architecture, a vaulted burial chamber usually located beneath the choir of a cathedral. During Chartres Cathedral's disasterous fire of 1194, three workmen were supposedly saved by locking themselves behind a sturdy iron door in the cathedral's crypt, where the veil of the Virgin Mary was kept as a relic.

Cuneiform: (*Que* knee a form) A type of written language, developed by the Sumerians and used throughout ancient Mesopotamia, which consisted of arrangements of arrowhead-shaped marks impressed into a clay tablet. The earliest cuneiform inscriptions are mainly records of economic transactions and inventory documents.

Daguerreotype: One of the earliest photographic techniques which yielded a single tarnishlike image on a shiny silver plate.

Decadent: Any outmoded style of art, especially those recently displaced by the avant-garde. In this usage, the term *decadent* carries no moral or ethical

connotations, though it is often applied by the artist to his or her rivals.

Dendrochronology: In archaeology, a system for determining the age of a wooden artifact by examining its distinctive pattern of annular rings. Comparison of these patterns against a "time line" comprised of annular ring samples allows the ages of objects to be determined with a high degree of accuracy. *Compare* Radiocarbon-14 dating.

Depth of Field: In photography, the portion of a scene (foreground, midground, background) which appears in crisp focus when viewed through a photographic lens.

Diptych: (*Dip* tick) A two-paneled painting hinged together like the covers of a book. Diptychs were especially popular among medieval northern European painters who often combined a portrait of their patron on one panel with a sacred portrait (especially Mary and the Infant Jesus) on the other. (During medieval times it was not permitted to mix religious and secular subjects in the same painting). *Compare* triptychs, polyptychs.

Direct-metal Sculpture: Any sculptural approach which involves welding, riveting, or some other direct construction technique rather than the traditional bronze castings made from a clay model.

Dodging: In photographic processing, selectively reducing the amount of light a portion of an image receives during the enlargement process.

Dolmen: A large flat tablestone balanced atop one or more supporting stones. Dolmens are believed to be the remains of Neolithic passage graves. *Compare* menhir, henge

Dome: A structural element developed by

the ancient Romans consisting of an arch—the most basic modular unit of Roman architecture—rotated around its vertical axis. Domes which appear pinched at the top are called *ogival* domes.

Donjon: (Dungeon) A heavily fortified inner tower or stronghold of a castle. Also called the *keep*.

Doric Order: One of the three principal orders of classical architecture easily identified by its massive fluted columns and plain, cushionlike capitals. *Compare* Ionic order, Corinthian order, Composite order.

Draftsmanship: An artist's degree of drawing skill, often contrasted with the artist's ability as a colorist.

Drypoint: One of the *intaglio* techniques in which an image is cut directly into the printing plate with a sharp etching needle.

Earthworks: Sculptural manipulations of the landscape, typically done on a very large scale.

Echinus: (Ee *ky* nus) *See* Capital.

Écorché: (Ay core *shay*) A small plaster figure, used in teaching art anatomy, which details the musculature of the human body.

Edition: In the graphic arts, the entire number of prints made from a single plate or block. Prints are numbered to indicate their position in the edition; a print numbered 25/250 is the twenty-fifth print made from a total edition of 250. *Artist's proofs* are sample runs made before the start of the edition. At the close of the edition the plate is canceled (usually with cross-out lines) to prevent unauthorized restriking.

Elevation: In architecture, a face-on view of a building facade undistorted by perspective. *Compare* plan, section.

Embossed Print: An inkless print made by running an uninked metal matrix (or one made of stiff paperboard) through a printing press.

Enamel: A type of paint (usually oil or petroleum based) which dries to a hard, glossy surface. Most commercial spray paints are industrial-grade enamels.

Encaustic: A type of paint in which the pigment is mixed with beeswax. Encaustic paints must be heated prior to their application, but once dry, they are surprisingly durable. Encaustic was widely used throughout the classical period and early Middle Ages.

Engobe: (En *go'* b) In ceramics, a slip of fine clay used by Greek ceramists to achieve a velvety black surface finish.

Engraving: One of the *intaglio* techniques in which an image is cut directly into a metal plate with a sharp tool called a burin.

Entablature: In classical architecture, the massive stone lintel directly above the columns.

Entasis: (En *tay* sis) In classical architecture, the subtle outward bulge of the classical column which both emphasized the mass of the spanning stone lintel, and helped to counter the impression that the roof was sagging—a common illusion produced by an unrelieved row of columns.

Epistyle: *See* architrave.

Etching: An *intaglio* process in which the image is etched into the unprotected surfaces of a printing plate by placing it into a dilute acid bath.

Exedra: (Eck *sed* rah) In classical architecture, an outdoor area with seats (especially concentric rows of curved benches) where performances, discussions, or lectures are held.

Faïence: (*Fay* onz) Technically, a ceramic

vessel decorated with a metallic glaze, although *faïence* has come to mean any glazed vessel.

Fan Vault: A style of vault, characteristic of English Gothic architecture, in which the reinforcing ribs radiate like the splines in a lady's fan.

Fat-over-lean Rule: An old painter's adage which states that when applying paint in layers, thinner layers must always underlay the thicker layers or cracking and peeling will result. The exception is *scumbling,* in which a thin, lightly brushed layer of paint is applied over a thicker layer to tone it, reduce its intensity, or smooth a gradual color transition.

Fenestration: (Latin, *fenestrae* = window) The arrangement of windows in a building. Walls with windows are said to be fenestrated.

Fetish: In the art of primitive peoples, any small artifact believed to endow its possessor with fertility or another similar supernatural benefit (e.g., strength, courage, and so on).

Figure/Ground: In any two-dimensional composition, the positive volumes (usually in the foreground or midground) are considered *figures* and the negative space (usually the background) is considered the *ground.*

Fin de Siécle: (Fan-*da* cycle) (Literally, "the end of the century") When used in art criticism it connotes the idea of a style or movement on the decline.

Finial: Any decorative finishing element attached to a bedpost, cathedral spire, roof peak, and so on.

Fleur-de-lis: (Flure du *lee*) A three-lobed flamelike design (thought to be a stylized iris or lily flower) long associated with the coat of arms of the French monarchy. In cathedral stained-glass designs (especially rose windows), they indicated the window was commissioned by the king.

Fluting: The grooves cut down the length of a classic column which serve to emphasize its surface roundess and visual mass.

Flying Buttress: *See* buttress.

Foreshortening: The apparent distortion in size and/or shape of an object when viewed in linear perspective.

Formal Elements: The lines, colors, shapes, textures, and other relevant physical features that taken together constitute a work of art.

Formalism: The idea that good design alone is sufficient for a work of art. Formalist paintings take their own design elements as their subject matter and, thus, have no implicit subject beyond their own colors, shapes, textures, and so on. Opponents of this position, who assert the importance of subject matter over design, are called nonformalists.

Found-object Sculpture: The use of nonart objects (usually junk found in the street) as the basis for a work of assemblage sculpture. The earliest art objects may have been natural *found objects:* a stick that resembled a bone; a stone that resembled an egg; and so on *Compare* isomorphism.

Freize: In classical architecture, a band of relief decoration which winds around the upper part of a temple's entablature.

Fresco: A type of mural painting in which the paint is applied to wet plaster *(buon fresco),* thus, only a small portion of a wall can be done at a time. In inferior variations, the paint is applied over dry plaster *(fresco secco).*

Frottage: *See rubbing.*

Gallery: In cathedral architecture, a passageway located above an aisle.

Gauffrage: (Gaw *frazh*) *See embossed print.*

Genre Painting: (*Zhon* rah) Paintings which depict commonplace scenes or activities from everyday life.

Gesso: *(Jesso)* A thick white undercoating (usually a watercolor paint heightened with powdered chalk or gypsum) applied as a ground in order to prepare a surface for the application of oil paint. The rationale is twofold: provide an insulating barrier between the raw canvas (or wood panel) and the linseed oil, and provide a uniform, neutral surface for the oil colors.

Gilding: The application of gold leaf (i.e., gold beaten into a very thin foil) to embellish a surface. In medieval art, gilded backgrounds indicate that the depicted scene was a religious episode that stood apart from the mundane world in space and time.

Glaze: (1) A sliplike coating applied to a ceramic vessel which, when fired in a kiln, produces a hard, vitreous coating. (2) A thin transparent layer of paint applied to the surface of a painting.

Gold Leaf: *See gilding.*

Gothic Arch: A type of arch whose peak comes to a point, commonly found in Gothic cathedrals. Also called an ogive.

Gouache: (Goo *osh*) A type of watercolor paint (similar to casein) whose colors have been heightened with white chalk. Gouache colors are brilliant but lack the permanence of oils.

Graffito: (Gra *fee* toe) In painting, scratch lines produced by working the painted surface with the butt end of the paintbrush.

Graphic Arts: A generic term used to refer to any of the various fine art printmaking techniques: relief printing, intaglio, lithography, or serigraphy; not to be confused with the commercial-industrial application of design called *graphic design*.

Graver: *See burin.*

Greek Cross: An equal-armed cross (+). The Greek cross is the basic organizational model for structures built according to a central plan. *Compare* Latin cross.

Greenware: In ceramics, any clay vessel (or other object) which has been dried to a leathery hardness prior to firing in a kiln.

Grisaille: (Gree zye) A painting done exclusively in shades of grey to simulate the look of stone relief sculpture.

Groin Vault: A square or rectangular chamber with an arched roof, formed by the intersection of two barrel vaults crossing at a right angle.

Ground: (1) The surface upon which a painting or drawing is made. (2) The entire background of an image, as distinguished from its *figure(s)*. (3) In the graphic arts, a thin, waxy, acid-proof coating applied to the surface of a metal printing plate into which the image is then cut or scraped.

Hanging Gardens of Babylon: An ancient terraced garden cited by Herodotus as one of the SEVEN WONDERS.

Happenings: Semistructured events, developed by sculptor Alan Kaprow in the 1950s and presented as artworks, often involving multimedia presentations and audience participation. Happenings are regarded as the forerunners of performance art.

Hatched Line: (Also called *hatching*) A drawing technique in which shading is represented by lines *(usually parallel)* of

varying density rather than flat areas of shadow. *See also* crosshatching.

Henge: A circle of upright stone monoliths surrounded by a ditch or low embankment. Stonehenge on the Salisbury Plain in southern Britain is one well-known example of a henge. *Compare* dolmen, menhir.

Herm or Herma: A portrait bust (often of the Roman god HERMES) attached to a square pillar or plinth. In certain parts of Europe, herms were placed along roadsides as signposts or milage markers and it was customary to pat them for luck (some versions included an erect penis protruding from the pillar).

Historiated Lettering: In the illuminated manuscripts of the medieval period, the first letters on a page are often enlarged and drawn in color, their curves and angles converted into a representational image. (The letter "K," for example, might be converted into a striding knight wielding an upraised sword.) Such letters are called *historiated*.

Hologram: A virtual three-dimensional image produced by capturing laser beam interference patterns on a photosensitive film (transmission type) or on a mirrored film (reflection type).

Homeopathic Magic: A ritual magic based upon the idea that an action performed upon a representation of a thing will have its effect upon the thing itself (i.e., throwing stones at an image of a bull will ensure a hunter's later success). Homeopathic magic is believed to be the basis for most Paleolithic cave drawings.

Horror Vacui: (Horror vack-you-we) In the art of primitive cultures, the tendency to completely fill all available space within a design so that no voids are left.

Hue: One of the three principal dimensions of color. Hue is associated with the color's name or, more precisely, its relative position in the visible spectrum (e.g., red, blue, and violet are all hues). *See also* value, intensity.

Hypostyle Hall: In ancient Egyptian architecture, a wide columned hallway featuring the distinctive Egyptian bell-shaped papyrus capitals or budlike lotus-flower capitals. Hypostyle halls are a feature of Egyptian pylon temples.

Iconography: A branch of art historical study in which the development of a single theme or subject is traced across different cultures or eras.

Icon: A miniature portrait of a holy personage.

Illuminated Manuscripts: During the medieval period, books were laboriously copied by hand (*maniform* = handmade, thus *manuscript* = hand written). Books with illustrations were said to be *illuminated*.

Impasto: Paint applied thickly to the surface of a painting, reminding the viewer that what is before him or her is a handmade thing, rather than a strict illusionistic representation. Thus, abstract paintings—which stand as things in themselves, rather than representations—often feature richly textured impasto surfaces.

Impost: In architecture, a pillar or column that supports an arch. An *impost block* is a tapered stone, shaped like an inverted pyramid, at the top of a supporting column.

Intaglio: (In *tah* lee oh) One of the four basic graphic arts, which involves printing from an inked image cut or incised (by the action of acid) into a metal plate.

Intensity: (Also called *chroma*) The purity of

a color, the highest degree of which is represented by the pure hues of the visible spectrum. One of the three principal dimensions of color. *See also* Hue, value.

Investment: A mixture of clay and plaster that is packed around a sculpted figure to produce a foundry mold for bronze casting.

Installation: An impermanent sculptural environment constructed in situ (that is, at the exhibition site). In some respects installations can be regarded as room-sized variations on the technique of assemblage.

Intrados: (In *trah* dos) The underside of an arch. *See also* voussoirs, keystone, springing.

Ionic Order: One of the three orders of classical architecture, identified by its slender, fluted columns and scroll-like capitals. *Compare* Doric order, Corinthian order, composite order.

ISO Number: *See* ASA RATING

Isometric Projection: A method of representing objects so that equal-length edges are shown as equal in length, rather than foreshortened by perspective. Spatial ambiguities often result, such as the familiar Necker Cubes which can interchangeably "flip" their front and rear surfaces.

Isomorphism: A coincidental similarity of shape between two otherwise dissimilar objects or forms (e.g., a violin and a female torso, a bat's wing and an umbrella, and so on). Isomorphs impart a kind of poetic rhyme to visual design elements, and also play an important role in the formation of metaphors ("the road was a *ribbon* of moonlight.")

Jamb Statues: (*Jam*) In cathedral architecture, a statue carved in relief on the jamb (sidepost) of a doorway. Such sculptures were often embellished with paint.

Joists: In architecture, the parallel timbers laid for support beneath a floor or ceiling.

Journeyman: *See* apprenticeship.

Kachina: (Hopi culture) A small wooden figure decorated with paint, bits of cloth, feathers, and so on, representing one of the many tribal deities. Kachinas are mainly used for the religious instruction of children.

Kaolin: (*Kay* o lin) A finely textured white clay used in making porcelain. Its name means "high hill" in Chinese, after the region where it is found. Most sculptural clays are a mixture of kaolin and various grades of silica (sand).

Keep: *See* donjon.

Keystone: The central, uppermost stone in the curved part of an arch. *See also* voussoirs, intrados, springing.

Kiln: The oven in which a clay vessel is baked to a stonelike hardness. The traditional kiln was made of brick and heated with charcoal; most contemporary kilns are metal and fired by gas.

Kinetic Sculpture: Sculptures designed to move with the aid of motors, magnets, electronics, or other kinetic devices. In the best kinetic works movement is not merely a gimmick but an important aspect of the work.

Kitsch: Bad art or art which caters to a debased level of taste.

Koran: The Moslem holy book.

Kore: (*Kor* ray; Greek for "maiden") In early Greek sculpture, a standing female figure usually about life-size and depicted dressed in a gownlike *peplos,* which served as a votive or funerary figure. The male counterpart was called a KOUROS.

Kouros: (*Koor* rhos; Greek for "youth") In early Greek sculpture, a striding male nude, usually

about life-size, which served as a votive or funerary figure. The female counterpart was called a Kore.

Krater: A wide ceramic vessel traditionally used for diluting strong wine with water.

Kylix: (Kye lix) A kind of drinking vessel used by the ancient Greeks resembling a wide, shallow soup dish set on a squat, pedestal base.

Lancet: A long and narrow stained-glass window, so named because of its resemblance to a knife blade. See also rose window.

Lantern: In architecture, a decorative lamplike element placed at the apex of a dome.

Lars: The spirits of deceased ancestors revered by the ancient Romans as household gods.

Latin Cross: A cross of unequal arms. The familiar crucifix is of this type. The Latin cross is the basic organizational model for structures built according to a longitudinal plan. Compare Greek cross.

Lapis Lazuli: (Lap-is Laz- yoo-lee) A semiprecious blue-purple stone often used in inlay work.

Linear Perspective: A technique for creating the illusion of three-dimensional space on a two-dimensional surface through the apparent recession of parallel lines (or edges) to a vanishing point. The basic laws of perspective were first formulated in a systematic and comprehensive manner by the Renaissance sculptor/architect Filippo Brunelleschi. Compare simultaneous perspective.

Lintel: See post-and-lintel architecture.

Lithography: One of the four basic graphic arts, which involves printing from prepared limestone blocks upon which an image has been drawn with a grease crayon.

Lithography was developed in the eighteenth century by the German playwright Aloys Senefelder.

Local Color: The actual or absolute color of an object, in contrast to its apparent or optical color, which is effected by changing light conditions, surface reflection, and simultaneous-contrast effects. Compare apparent color.

Longitudinal Plan: An architectural plan (for a church or cathedral) modeled after a Latin cross which typically involves a long central aisle (nave) transected at one end by a shorter crossing aisle (transept).

Lost-wax Casting Process: See cire perdue.

Maniform: Handmade.

Maquette: (Mah ket) A small statue fashioned as a sculptor's preliminary sketch before the production of the final version, usually done on a much larger scale and in a more permanent material.

Mastaba: In ancient Egyptian architecture, a low rectangular tomb structure with battered (inward sloping) sides. The Egyptian step-pyramids are believed to have developed from stacked mastabas. Compare ziggurat.

Masterpiece: Any artwork or craftwork of grand proportions which established a journeyman's reputation as a master of his trade (see apprenticeship). The term has come to mean any grand or imposing artwork, usually the best an artist has produced.

Matrix: In graphic arts, the actual printing surface (copper plate, wood block, and so on) which bears the incised or relief image.

Medieval Era: The period spanning from the fall of Rome (fifth century) until the reawakening of classical culture during the Italian Renaissance (fifteenth century). Also

called the *Middle Ages,* or formerly the *Dark Ages.*

Medium: (1) The principal material or technique from which a work of art is made (acrylic on canvas, charcoal on paper, and so on). (2) By extension, the specific technical process(es) with which an artist is mainly involved (e.g., *I work in the medium of acrylic painting*). The plural form is *media.*

Megalith: (Literally, "great stones") The tall, massive stones used in the construction of Neolithic era monuments such as Stonehenge. *See also* dolmen, menhirs, henge.

Megaron: In Greek architecture, a rectangular room that opens onto a two-columned porch.

Menhirs: (*Men* heerz) A type of Neolithic monument consisting of large upright monoliths (usually 6 feet to 8 feet tall) found singly or arranged in long parallel rows, sometimes extending nearly to the horizon. *Compare* dolmen, henge.

Metope: (*met* uh pe) In classical architecture, a rectangular slab on the entabulature of a Greek temple. The metope was usually embellished with relief carvings.

Mezzotint: One of the intaglio techniques in which the metal printing plate is uniformly pitted with a tool (called a roulette or rocker), then the light areas smoothed out with a burnishing tool.

Middle Ages: *See* medieval era.

Mimesis: The idea that the essence of art lies in imitation (from Aristotle's *Poetics*).

Minaret: In Islamic architecture, a tall slender prayer tower usually with an encircling balcony and a high, conic roof.

Mixed-media Artworks: Any assemblage-like construction created from cast-off or reworked objects. *Compare* multimedia works.

Mobile: (*Mo* beel) A type of simple kinetic assemblage, invented by Alexander Calder, consisting of solid forms suspended by strings or wires from supporting rods in such a way that the entire assembly turns slowly in the air.

Momento Mori: In painting, any incidental detail that alludes to the ultimate mortality of all things ("Remember you must die"). A human skull or withered flowers sometimes appear as a *momento mori* in still-life paintings.

Monochromatic: An image in black and white only, or in varied shades of a single hue, such as a grisaille. *Compare* polychrome.

Monoprint: In the graphic arts, a one-of-a-kind print which has been made unique through the addition of hand coloring, or some other added feature(s) after it was pulled from a prepared matrix. The basic image remains preserved in the matrix as a simple etching, engraving, and so on. *Compare* monotype.

Monotype: In the graphic arts, a single print made from a "painting" done in ink on a flat metal plate, or from a tracing in ink on a sheet of glass. The image to be printed is not permanently fixed into the printing matrix and, therefore, is transferred completely to the paper during the act of printing, after which no reusable trace remains on the matrix. *Compare* monoprint.

Monumental: Any painting or sculpture of a larger than life-size scale.

Mordant: A dilute acid bath (four parts nitric to six parts water) used to etch the surface of a metal printing plate in certain intaglio processes, such as aquatint and etching.

Mortise and Tenon: In architecture, a way of fitting two pieces of wood together without nails by cutting a notch or square hole (mortise) into one piece which will receive the tapered end (tenon) of another. When floorboards are notched along their edges to fit together, it is called *tongue and groove.*

Mortuary Temple: A temple (popular among the later Egyptian pharaohs) erected to honor the spirit of a deceased personage.

Motte-and-Bailey Castle: An early type of castle consisting of a fortified mound *(motte)* surrounded by a circular walled yard *(bailey).*

Multimedia Artworks: Performancelike events which incorporate film, video, and projected images with recorded or live sound and live actions performed by the artist(s). *Compare* mixed-media artworks.

Mural: A term used to describe any large-scale wall painting, but especially one painted directly upon a wall.

Narthex: An entrance hall or vestibule at the front end of a church (between the entrance and the nave), originally reserved for use by persons not yet baptized into the faith. It is retained in modern churches as a place to gather before and after the ceremony of the Holy Mass.

Nave: The wide central aisle that runs the full length of a church or cathedral.

Necropolis: An ancient Egyptian burial complex (city of the dead) which included pyramids, temples, guardian idols, etc.

Negative Space: The space surrounding a figure; also, the voids in a piece of sculpture, which are treated as integral elements of the composition.

Neo-: A prefix meaning *new,* often applied to art movements which seek to reawaken older fallow syles (as in neoclassicism, and so on).

Neoclassic: (Literally, "new classicism") Any style that emulates the reserved intellectual aesthetics of Greco-Roman classicism. More particularly, artworks of the eighteenth century which exhibit that period's reawakened interest in classicism.

Nib: A detachable metal pen tip resembling a small metal cylinder split lengthwise and flattened and tapered at one end. Metal nibs, available in various width, are made to be inserted into a wooden or plastic handle for use as a drawing instrument. When goose quills were used for drawing and writing, the end of the quill was carved into a nib with a sharp knife blade.

Nimbus: In painting, a halo of light surrounding the head of a religious personage. (The entire body is surrounded in the vesical form). In Christian art the nimbus is often stylized for particular figures—a ring of stars for Mary, three rays or a triangle for Christ, and so on; a square nimbus, according to tradition, indicates the saint was still alive when the portrait was painted.

Nonformalism: *See* formalism.

Oculus: (Literally, "eye") A circular opening in the top of a dome that provides light and ventilation to the interior. The oculus in the Pantheon's dome is about 30 feet in diameter.

Occult Balance: In painting or sculpture, any forms which appear precariously or asymmetrically balanced. (*Occult* here means "hidden" or "mysterious.")

Ogival Dome: (Oh *jye* val) A dome (or arch) which appears pinched at the top, in contrast to the standard hemispherical

dome. Ogival arches and ogival domes are common in Islamic architecture.

Ogive: (*Oh* jive) In Gothic cathedral architecture, the rib (or groin) that runs diagonally across a vault. Also, the pointed or Gothic arch characteristic of Gothic cathedrals.

Open Composition: A casual compositional arrangement with no definite limiting boundaries. Figures appear to wander in and out of the frame, as in a random snapshot, and objects may be represented as partially beyond the viewer's field of view. *Compare* closed composition.

Optical Color: *See* apparent color, local color.

Orans Figures: In Christian art, a figure portrayed with uplifted hands, in the ancient attitude of prayer.

Orthogonal: An imaginary line formed by extending the edge of an object into the background space of a picture. In linear perspective, an object's orthogonals meet at a vanishing point along the horizon.

Oxy-acetylene Welding: A welding technique in which heat is generated by the combustion of oxygen and acetylene gas.

Pagoda: An eight-sided tower with roofed stories commonly found in the architecture of (Chinese) Buddhist temples.

Palazzo: (Pa *lot* zoh) Italian term for a palace or manor house; not to be confused with *piazza* which designates a public square.

Palette: (pah *let*) (1) A flat hand-held tray for mixing paints. (2) The characteristic color combinations used by an artist in his or her paintings (e.g., Rembrandt's palette is rather narrow, consisting mainly of various shades of umber, ochre, white, black, and red).

Panel Painting: The use of stretched canvas as a painting ground is a relatively recent innovation. Wooden panels were used, particularly during the Middle Ages, as the preferred ground for tempera painting. In applications where a textured canvas is undesirable, (e.g., camera-ready commercial illustration and photorealist painting) a piece of commercial compress board, coated with gesso and lightly sanded, provides a pristine glass-smooth painting ground.

Pantograph: A mechanical device for copying pictures which consists of several wooden rods hinged together such that an image traced at one end will be duplicated (larger, smaller, or the same size) at the other end. Analogous devices exist for copying three-dimensional objects and are often used in commercial-\industrial applications.

Pantomimic Gesture: In painting, the use of exaggerated gestures or facial expressions to convey the meaning or emotional impact of a scene (often used by early Christian artists). The idea originated from certain Roman plays in which the actors performed without words, accompanied by a chorus who acted as narrator.

Paper, types of: The most common form of drawing ground, which originated from pressed papyrus leaves found along the banks of the River Nile. Manufactured papers vary widely in quality and permanence, the cheapest and most impermanent being newsprint (made from wood fiber and sizing), and the most costly and permanent being 100-percent rag.

Papier Collé: A COLLAGE made entirely from paper scraps.

Parchment: Lambskin used as a ground for drawing or painting.

Parsimony: In aesthetics, the idea that true beauty lies in simplicity.

Passage Grave: An ancient form of grave in which a circular burial chamber was reached by means of a long, narrow tunnel. Because of the labor involved in ents (e.g., phythalocyanine green), but in earlier times pigments were derived from rare earths like cobalt (blue), and metals like lead oxide (white), as well as other natural substances.

Pilaster: In architecture, a flattened column attached to a wall; also called an *engaged column*. Pilasters usually serve as purely decorative elements in a structure's design.

Pithos: A large, egg-shaped storage jar designed to be buried up to its rim, or held in a framework tripod; thus, it has a rounded bottom.

Plan: In architecture, a drawing looking directly down upon a structure, usually with the roof removed to show the interior structural details (often depicted in simplified, schematized form). *Compare* elevation, section.

Planar Recession: The use of overlapping background planes to create the illusion of receding space in a painting or relief.

Planographic Printing Technique: A generic term for any printing technique in which the print is made from an image drawn upon a flat (i.e., planar) surface. Photolithography is a planographic technique.

Plein-aire Painting: A spontaneous mode of painting done outdoors (usually alla prima), in contrast to the formal, and precisely controlled style of studio painting.

Plinth: A rectangular block used as a display pedestal for a sculpture.

Pointilism: Painting technique of creating an image from tiny dots of pure color applied painstakingly to a canvas.

Polychrome: Many-colored.

Polyptych: (*poly-* = many) A group of painted panels, often commissioned as an altarpiece, which was set into an elaborate hinged frame so that, when opened, the panels presented a succession of scenes or episodes linked by a common religious or moral theme. *Compare* diptychs, triptychs.

Portcullis: (Port-*cue*-liss) A heavy iron grate used to fortify the entrance to a castle. The portcullis can be raised or lowered to provide access to the inner courtyard.

Portico: A shallow porchlike space inspired by the partially enclosed area at the front of a classical temple.

Post-and-Lintel Architecture: One of the most basic structural systems involving two upright posts crowned by a spanning lintel. Most classical Greek temple architecture was based upon a post-and-lintel system of construction.

Postmodern: A style of art (c. 1970–current) which self-consciously borrows various compositional elements from great works of the past and rearranges them in new combinations, often with a distinctive neoclassical flavor.

Proscenium: A theatrical stage.

Primary Hues: (Also called the *primary triad*) The most basic hues from which all others can be derived. The *subtractive primaries* (used with pigments) are cyan, magenta, and yellow; the *additive primaries* (used with spotlights) are red, blue, and green. Combining the primary colors yields white (theoretically at least), but pigment impurities often result in a dull grey. *Compare* secondary hues; tertiary hues.

Prints: A printed image generated by any of the graphic art techniques. Prints are regarded as original works of art, whereas

reproductions are thought of as merely replicas or copies of an original work.

Propylaeum: (Pro pi *lee* uhm) In classical architecture, an entrance portal or gate house that opens onto a larger structure or a group of structures.

Prototype: Any preexisting illustration from which a copy has been made.

Psalter: A book of psalms. *Compare* breviary.

Psychostasis Painting: (Literally, "soul balancing") A category of Egyptian funerary painting which depicts the ritual entry of the deceased's spirit into the afterlife, particularly the weighing of the deceased's heart upon the scales of Ma'at against the feather of truth.

Push-Pull Effect of Colors: A perceptual phenomenon caused by the minute differences in the focal lengths at which the eye resolves certain color wavelengths; warm colors (red, orange, and yellow) appear to come forward, while cool colors (green, blue, violet) appear to recede. Painters often exploit the push-pull effect of colors to heighten the illusion of deep space in their images.

Putto: An infant angel (plural: *putti*).

Pylon Temples: In ancient Egyptian architecture, a temple whose entrance portal was framed by a broad rectangular brick facade with sloping sides. Behind the pylon facade was an open courtyard (atrium), a hypostyle hall, and a series of progressively narrower passageways.

Pyramid: An ancient Egyptian tomb common during the Old Kingdom (before 2100 B.C.)

Quatrefoil: (*Kwa* tra foil) A square or rectangular panel whose sides bulge outward to form a figure much like a four-leaf clover. Quatrefoils are often used as decorative relief elements in architecture, or as background panels for relief sculpture.

Radiocarbon-14 Dating: In archaeology, a method of determining the age of organic remains by measuring the amount of undecayed radioactive carbon-14 present in the sample. Unfortunately, the measurement's margin of error increases with the age of the sample. *Compare* dendrochronology.

Raku: Traditional Japanese fired-earthenware vessels, often embellished with natural glazes. The process of creating raku vessels has been formalized into ceremonial procedures, and the master artisans of this style are often designated "living treasures" by the Japanese government.

Readymade: A type of found-object sculpture, especially favored by members of the antiart Dada group, which involved exhibiting a common object under an unusual or nonsensical title. The term *readymade* derives from the type of man's suit which is purchased "off the rack" rather than individually tailored.

Relic: Fragments of a saint's body (or articles of clothing) which serve to sanctify a place of worship. Relics are often housed in elaborately decorated cases called *reliquaries* whose shapes often suggest the nature of the fragments contained within— an armbone will have an arm-shaped reliquary, for example.

Relief: A type of sculpture consisting of partial figures protruding from a background slab. Reliefs are classified as *bas* (low), *mezzo* (middle), or *alto* (high) depending upon their degree of flattening or roundedness.

Relief Print: One of the four basic graphic

arts, which involves images printed from a raised, inked pattern cut into a wooden or linoleum block.

Reliquaries: *See relic.*

Renaissance: (Literally, "rebirth") A period of reawakened interest in the arts (c. 1400–1600), particularly those styles associated with the classical cultures of Greece and Rome.

Repoussé: A relief image made by hammering the back of a thin sheet of metal.

Reproductions: *See prints.*

Ribbed Vault: In cathedral anatomy, the structural reinforcements added to the edges of a groin vault. In an English fan vault, the ribs are arranged like the splines in a lady's fan.

Rocaille: (Rho *kay*) French term for a pebble or shell (used as a decorative incrustation) from which the term *rococo* is derived.

Rock-cut Tombs: In ancient Egyptian architecture, a style of tomb (popular during the so-called Middle Kingdom) in which the burial chamber was located deep within a rocky hillside and fronted by a simple facade hewn from the living rock.

Roman Arch: The type of arch in which the top portion forms a semicircle. Although the Romans did not invent the round arch (it was used by the Egyptians and Etruscans), it forms the basic modular unit for much of Roman architecture. An arch rotated around its vertical axis forms a dome, an arch projected through space forms a barrel vault, and so on.

Romantic: A nineteenth-century style characterized by the excitement and expression of intense emotions, often through bizarre images of fantasy or the macabre. Romanticism is considered the diametric opposite of the more restrained classical style.

Rose Window: A large, circular stained-glass window usually found above the main entrance to a cathedral. *See also* lancet.

Rotogravure: An early method for printing photographic images using a curved copper cylinder mounted on a rotary press.

Rubbing: A primitive form of relief printing in which a piece of paper is placed over a raised design and a crayon rubbed across its surface to form a shaded impression of the design. Rubbings of various textured surfaces combined to form an image are called *frottage*.

Sarcophagus: A stone coffin. Limestone was preferred since it hastened the deterioration of the remains.

Scraper: In the graphic arts, a metal instrument with a three-sided blade used to remove the curled burrs made when engraving an image onto a metal plate.

Scratchboard: A nineteenth-century drawing technique in which a gesso-coated panel was painted with black India ink, then the image scraped away with a needle or knife blade to reveal the white surface beneath.

Sculpture: One of the most basic art techniques which involves fashioning a three-dimensional object by means of either *additive techniques* (like modeling an image in wax or clay) or *subtractive techniques* (like carving an image in stone), or some combination of these. Sculptures may exist as flattened, partial figures attached to a backslab (a relief) or as full three-dimensional figures said to be *freestanding* or *sculpture in the round*.

Scumbling: *See fat-over-lean rule.*

Secondary Hues: In color theory, the

intermediate colors formed when adjacent primary hues are mixed; the resulting colors are called the secondary triad (orange, green, and violet). *See also* primary hues, tertiary hues.

Section: In architecture, a drawing of a structure as it would appear if one exterior wall were sliced away. *Compare* plan, elevation.

Serigraphy: One of the four basic graphic arts techniques, which involves producing images using a stencil-like process. The commercial-industrial application of serigraphy is called *silkscreen.*

Seven Wonders of the Ancient World: These included The Hanging Gardens of Babylon, The Colossus of Rhodes, Diana's Temple at Ephesus, Phidias's monumental statue of Jupiter, the Lighthouse at Alexandria, the Tomb of Mausolus, and the Great Pyramids of Egypt—the only ancient wonder still in existence.

Sfumato: (S'foo *mah* toe; Italian for "smoke") A painting technique characterized by indistinct contours which lends a hazy or smoky appearance to the image. Sfumato is often used to create an illusion of distance similar to atmospheric perspective.

Shade: Lighter or darker versions of a color, formed by adding a small amount of white or black.

Shaman: In primitive societies, a sorcerer or medicine man who serves as the religious leader of the tribe. The oldest drawings known, found in Paleolithic caves (c. 15,000 B.C.), were probably produced by shamans and used in homeopathic rituals to ensure the success of the hunt.

Silkscreen: *See* serigraphy.

Silverpoint: A drawing technique which utilizes a piece of silver wire inserted into a pencil-like holder.

Simultaneous Contrast: The idea that our perception of a color or apparent value is influenced by the background against which the color or value is seen. For example, a grey glove placed on a black ground looks bright, but the same glove placed on white, snowy ground appears suddenly much darker.

Simultaneous Narrative: A narrative sequence of events portrayed in a painting by showing the same figures at different times.

Simultaneous Perspective: An early attempt at linear perspective which rather haphazardly combines views from several different vantage points.

Simultaneous Profile: A means of representing the human figure (developed in ancient Mesopotamia and Egypt) which typically combines a frontal eye and chest with a profile face and legs.

Slip: Clay thinned with water to a mudlike fluid.

Soffit: In architecture, the undersurface of any structural member.

Soft-ground Etching: An intaglio process in which an image is transferred to the printing plate by laying a drawing on top of the prepared plate, then tracing over the image with a pencil. When the paper is removed, the soft waxy ground adheres to the tracing, exposing the plate, which is then set into an acid bath, inked, and printed.

Spirit Trap: A decorated skull or other cult object believed to contain the spirit of a deceased tribe member.

Split Complementary Colors: On a color wheel, a hue and the two colors on either

side of its complement (such as red/yellow-green, or red/blue-green). Split complement pairs are slightly less contrasting in hue than true complementary color pairs (such as red/green). *See also* complementary colors.

Springing: In an arch, the stone base from which the curved portion of the arch springs.

Square Schematism: *See* crossing.

Squinch: In architecture, a transitional device (resembling a ring of lintels cut and joined at the edges) used to attach a circular dome to a polygon-shaped roof opening.

Stabile: A static free-form sculpture usually made from welded sheet metal.

Stained Glass: A window made from panes of colored glass set into narrow lead channels.

Stele: (*Steel,* or *Stee* lee) An upright stone slab (often covered with relief carvings or inscriptions) used as a monument or boundary marker.

Stereobate: In classical architecture, the lower portion of the steplike base upon which the classical temple rests. *Compare* stylobate.

Stippling: A drawing technique in which shading is represented by tiny dots of varying density.

Stoneware: A clay vessel that has been bisque fired in a kiln to stonelike hardness.

Stylobate: In classical architecture, the uppermost part of the steplike base upon which a classical temple rests. *Compare* stereobate.

Subtractive Technique: Any sculptural technique which involves creating an image primarily by a process of cutting away (as in stone or wood carving) in contrast to the additive techniques such as clay modeling or assemblage.

Sugar-lift etching: An intaglio technique which duplicates the effect of a brush-and-ink drawing. An image is brushed upon the surface of the printing plate with sugar water, then coated with a ground. After immersion in water, which causes the painted areas to lift off, the plate is immersed in an acid bath, inked and printed.

Sumi-e: A Japanese painting style which utilizes black ink and a stiff-bristled brush. *Sumi-e* stresses spontaneity and expressive control, rather than a true photographic likeness.

Surreal, Surrealism: A pre-World War II art movement dedicated to combining the world of conscious reality with the imagery of dreams and nightmares, thus creating a "super-" or *sur*-realism.

Symmetry: The degree of sameness between figures or parts of a figure. Most symmetries are formed from the reflection, rotation, or translation of a figure through space. Mirror-images are said to have bilateral symmetry.

Synaesthesia: (Sin-ah-*stee*-zee-ah) A perceptual phenomenon in which a stimulus experienced by one sense is simultaneously experienced by another sense; a musician, for example, might speak of "yellow notes," or a painter might refer to "out-of-tune" colors.

Tempera: A type of paint in which the pigment is mixed with egg yolk.

Tenebrism: (Italian for "dark manner"). A style of painting adopted principally by the baroque painter Caravaggio, which exaggerated the usual chiaroscuro effects by highlighting the principal subject(s) and immersing the background in deep shadow.

Tensile Strength: The ability of any

structural material to withstand mechanical stress (i.e., vibration, bending, and so on). A steel I-beam has great tensile strength; a stone slab has very little tensile strength, but great compression strength.

Terracotta: A type of clay, usually of a reddish-brown hue, much favored by ceramists (*terra cotta* = baked earth). The familiar red clay flowerpots are made of terracotta.

Tertiary Hues: In color theory, a hue obtained by mixing a primary hue (red, yellow, blue) with its adjacent secondary hue (green, orange, violet). *Compare* Primary hues, secondary hues.

Tesserae: (*Tess* a ray) Small cut and polished stones used to create a mosaic.

Totem: An image (often that of an animal) adopted by a tribe as its representative symbol. It is often considered taboo to hunt, kill, or eat the totem animal.

Tower of Babel: The ancient ZIGGURAT at Babylon. (*See also* SEVEN WONDERS.)

Tracery: In architecture, a type of ornamental stone carving consisting of stylized branchlike forms.

Transept: In a longitudinal plan church, a wide aisle that cuts transversely across the nave, corresponding to the shorter arm of a Latin cross.

Triglyphs: In classical architecture, a decorative element consisting of three vertical bars carved in relief over each column and centered between each pair of columns. The triglyph symbolizes the ends of the roof joists which were visible atop the spanning lintel in preclassical wooden temples.

Triptych: (*Trip* tick) A three-paneled painting hinged together so that the two smaller side or "wing" panels close over a square central panel, like the doors of a cupboard. In some instances the three paintings were arranged to represent a progression from the past (left panel), to the present (central panel), to the future (right panel). Additional paintings often decorated the outer surfaces of the closed panels. *Compare* diptychs, polyptychs.

Trompe L'oeil Painting: (Trawm'p *loy*) A painting so realistic it literally fools the eye into believing it is the actual thing, rather than merely a representation of it.

Trumeau: (True *mow*) In architecture, a post placed in the center of a wide doorway. Trumeau carvings frequently take the form of elegantly elongated figures of Christ, which symbolically greet worshipers as they enter the cathedral.

Truth to Materials: In design, the idea that a form should be suited to its material—plastic should be treated as plastic and not disguised with specious wood grain or passed off as metal. *Truth to materials* is often mentioned in the criticism of formalist sculpture and products of three-dimensional design, particularly those works created from industrial materials.

Tusche: (Toosh) In lithography, a greasy fluid used to paint an image on a litho stone; essentially, a grease crayon in liquid form.

Tympanum: In cathedral architecture a semicircular panel found above a doorway, usually filled with relief carvings.

Ushabti: (ooh *shob* tee) Carved or modeled figures included in the burial cache of an Egyptian pharaoh to ensure he would have abundant servants in the next life. Also called *shawabti*.

Value: The degree of lightness or darkness of a hue or neutral shade. Value is considered one of the three dimensions of color. *See also* hue, intensity.

Vanishing Point: *See* linear perspective.

Vanitas Painting: A still-life painting containing a moral message.

Vault: *See* barrel vault, groin vault.

Vehicle: (also called *binder*) In the chemistry of paint, the inert fluid in which the particles of colored pigment are suspended. The vehicle in oil paint is linseed oil.

Vellum: Vealskin used as a ground for painting or drawing.

Veneer: In architecture, a thin slab of dressed stone (usually marble) attached to a concrete wall in order to make it look like the entire wall is made of marble.

Visual Spectrum: The principal visible hues of the visible spectrum are red, orange, yellow, green, blue, indigo, and violet. Longer wavelengths immediately beyond the visible range are called *ultraviolet,* while the shorter wavelengths just beyond red are called *infrared.*

Volute: A spiral or scroll-like form found in the capitals of Ionic columns.

Votive Figure: In ancient temple rituals, a small sculpted figure which was set before a god as a symbol of devotion.

Voussoirs (Voo s'whaz) The individual stones that make up the curved limbs of an arch. The central stone is called the keystone. *See also* intrados; springing.

"Wallpaper": An insult in the grand manner to be flung in the face of an artistic rival:

"Your paintings, sir/madam, are so much *'wallpaper'!"*

Wash: Paint or ink thinned with water to near transparency.

Wattle-and-Daub Construction: Any primitive structure made from an interwoven framework *(wattle)* of branches, twigs, or thatch covered with wet clay *(daub)* to stop up the holes.

Wedged Clay: Ceramic clay that has had all trapped air pockets eliminated by kneading and repeatedly slamming the clay mass down onto a hard surface. Objects made from unwedged clay can explode during kiln firing.

Weight Shift: *See* contrapposto.

Westwork: In architecture, the west face (main entrance) of a Gothic cathedral, including its spires, entrance portals, and so on.

Wood Engraving: A form of woodcut which uses the endgrain of several glued boards as a matrix, rather than the sidegrain of a single board.

Wonders of the Ancient World: *See* Seven Wonders.

Ziggurat: A mudbrick step-pyramid, crowned by a small temple, found throughout ancient Mesopotamia. Ziggurats are regarded as the forerunners of the Egyptian pyramids. The fabled Tower of Babel was the ziggurat at Babylon.

Pronunciation Guide

ÆNEAS: Ee-*knee* -us.

ÆNEID: Ee-*knee* -id.

AKHENATON: Ock-a-*nah* - ten.

ALTAMIRA: Al-ta-*me* -rah.

AMENHOTEP: Ah-men-*ho* -tep.

AMIENS: Ah-me-*onz*.

ANDREJEVIC, MILET: On-*dray* -zha-vic, Me-lay.

ASHURBANIPAL: Ash-er-*ban* -i-pall.

ASHURNASIRPAL: Ash-er-*nah* -sir-pall.

ASSEGAIS: Az-uh-guys.

ATHENA: A-*thee* -nah.

AVIGNON: *Ah* -vee'n-yo'n.

BAROQUE: Bah-*roke*.

BARYE, ANTONIN: Ba-*rhee* (rhymes with *Paree*), *On* -toe-ahn.

BAUDELAIRE, CHARLES: Bo-due-*lair*, Sharlz.

BAUHAUS: *Bah* -hoss.

BEAUBORG: *Bow* -borg (another name for The Georges Pompidou National Center, Paris).

BEAUVAIS: Bow-*vay*.

BELLINI, GIOVANNI: Bell-*lee* -knee, Jo-*vah* -knee.

BERNINI, GIANLORENZO: Burr-*knee* -knee, *Gee* -on-lo-ren -zoe.

BOCCIONI, UMBERTO: Botch-Ee-*Oh* -knee, Oom-bear-toe.

BORROMINI, FRANCESCO: *Bor* -oh-me -knee, Fran-*chess* -co.

BOSCH, HIERONYMUS: *Bosh* (rhymes with posh), Here-*on* -a-muss (Hieronymus is an archaic form of JEROME).

BOTTICELLI, SANDRO: Bought-tee-*chell* -lee, *Sahn* -dro.

BOUCHER, FRANÇOIS: Boo-*shay*, Fran-*swah*.

BOUGUEREAU, ADOLPHE WILLIAM: *Boo* -zher-oh, Ay-doll'f Vill-yum.

BRAMANTE: Brah-*mon*- tay.

BRANCUSI, CONSTANTIN: Bran-*coo* -zee, *Con* -stahn-teen.

BRAQUE, GEORGES: *Brock,* Zhorzh.

BRONZINO: Brawn-zee -no.

BRUEGEL, PIETER [or JAN]: *Broy* -gull, Peter [or Yon].

BRUGES: (rhymes with *rouge*).

BRUNELLESCHI, FILIPPO: Broo-nuh-*less* -key, Fe-*lee* -po.

BYZANTIUM: Biz-*zan* -tee-um [or Bee-*zan* - tee-um]; the English call it *Buy-zan* -tea-um.

CAILLEBOTTE, GUSTAVE: Kye-*bow* (with a partially sounded t at the end), *Goose*-tah'v.

CALAIS: Kal-*lay*.

CALDER, ALEXANDER: *Call* -der.

CALLICRATES: Cah-*lick* -rah-teez.

CAMPIN, ROBERT: Cam-*pan,* Ro-*bear*.

CARAVAGGIO, MICHELANGELO: Car-ah-*vah* -gee-oh, Mee -kell-*an* -jel-lo.

CARAVAGGISTI: Car-a-vah-*gee* -stee.

CASSATT, MARY: Cah-*sot.*

CASTAGNO, ANDREA DEL: Ka-*stahn* -yo, On-*dray* -uh.

ÇATAL HÜYÜK: Kah-*tal* Hoo-*yook*.

CELLINI, BENVENUTO: Chay-*lee* -knee, Ben-vay-knew -toe.

CÉZANNE, PAUL: Say-*zon*.

CHAGALL, MARC: Shah-*gall*.

CHARLEMAGNE: *Shar*-la-main.

CHARTRES: *Shart.*

CHICHEN ITZA: *Chee*-chen *It*-zuh.

CHINOISERIE: Shin-*whaz*-a-ree.

CIMABUE, CENNI DI PEPO: Chee-*mah*- boo-way, *Chay* -knee da *Pay* -po.

CLAIRVAUX: Clair-*voe*.

CLODION, CLAUDE MICHEL: Clo-*d'yawn*, Clawed Me-*shell*.

CLOISONNÉ: K'*lwah*-zho-*nay.*

CORNEILLE, PIERRE: (playwright) Kor-*nay,*
Pea-*air.*

CYTHERA: *Sith*-uh-rah

DALI, SALVADORE: Dah-*lee, Sol* -vuh-door

DE CHIRICO, GIORGIO: Duh-*keer* -i-ko, Gee-
or -gee-oh.

DEGAS, EDGAR: Dew-*gah.*

DELACROIX, EUGÉNE: Dew-la-*kwa,* You-*zheen.*

DAVID, JACQUE LOUIS: Dah-*veed,*
Zhock Loo- we.

DISCOBLUS: Dis-*cob* -oh-luss.

DORÉ, GUSTAV: Door-*ray, Goos*-tav.

DUCHAMP, MARCEL: Doo-*shawmp,* Mar-*sell.*

DÜERER, ALBRECHT: *Dew* -rer (rhymes with
poorer), Al-*brek't.*

EAKINS, THOMAS: (Rhymes with bacons).

ECHINUS: Ee-*kye* -nuss.

ÉCOLE DES BEAUX-ARTS: Ek-*coal* dew Bows-
artz (French: *School of the Fine Arts).*

ERECTHEUM: E-*rek*-thee-um

EYCK, JAN VAN [or Hubert]: *Eye* -ick, Yon Van
[or *Hoo* -bert].

FARNESE: Far-*nay* -zee.

FRAGONARD, JEAN HONORÉ: Fra-go-*nard,*
Zhan *On* -o-ray.

FREIDRICH, CASPAR DAVID: *Freed* -rick.

FUSELI, HENRY: F'yoo-*sell* -ee.

GAUGUIN, PAUL: Gaw-*gan.*

GÉRICAULT, THÉODORE: Zh'*ere* -ee-ko,
Thay -a-door.

GHIRLANDAIO, DOMENICO: Geer-lan-*die* -
oh, Do-*may* -knee-ko.

HATSHEPSUT: Hat-*shep* -soot.

HONNECOURT, VILLARD DE: due 'On-i-*cor,*
Vee-yar.

HORATII: Ho-*ray* -she-eye.

IMHOTEP: *Im* -ho-tep.

INGRES, JEAN AUGUSTE DOMINIQUE: *Ong* -
ruh; but the British pronounce his name *Ang*
(as in *bang).*

ISIS: Eye-sis.

KATSUSHIKA HOKUSAI: Kat-soo-*she* -ka
Ho-*koo* -sigh (Japanese for "Old Man Mad
about Drawing").

KLEE: *Clay.*

KOKOSCHKA, OSKAR: Ko-*ko'sh* -kah,
Oss -kerr.

KOSUTH, JOSEPH: Coe-*sooth* (rhymes with
forsooth!).

LAOCÖON: Lay-*ah* -ko-on.

LASCAUX: *Lass* -co.

LEBRUN CHARLES: Loo-*broon,* Sharlz.

LE CORBUSIER: (Lay) Core-*boo* -see-*yay.*

LOUVRE: *Loovh* (rhymes with move).

MACHU PICHU: *Ma*-choo *Pea*-choo.

MEDICI: *May* -duh-chee.

METOPE: *Met-* a -pea.

MICHELANGELO [MICHELANGELO
BUONARROTI]: *Me* -kel-*an*- je-lo, *Boo' ah* -
nah-*row* -tee.

MIES VAN DER ROHE, LUDWIG: Meez Van
Der Row, *Lood* -vig.

MILLET, FRANÇOIS: Mill-*ay,* Fran-*swah.*

Miró, Joán: Mee-*row,* Yo-*ahn.*

MOISSAC: M'wah-*sok.*

MONET, CLAUDE: Mo-*nay.*

MOULIN ROUGE: *Moo* -lawn *Roozh* (French
for red mill).

MUNCH, EDVARD: Moonk, Ed-*vard.*

MNESICLES: M'uh-*ness* -i-kleez.

MUYBRIDGE, EADWEARD: *My* -bridge,
Ed -ward.

MYCENAEA: My-*see*-knee.

NABIS: Nah-*bee.*

ODYSSEUS: Oh-*dee* -see-us.

OEDIPUS: *Ee* -dee-poos (widely mispronounced
as Ed -ee-poos).

OOSTERWYCK, MARIA VAN: *OOs* -der-vick.

OSIRIS: Oh-*sigh*-ris.

PALLADIO, ANDREA: Puh-*lah* -dee-yo,
On-*dray* -uh.

PAZZI: *Pot* -zee.

PERICLES: *Pear* -uh-kleez.

PHAETHON: *Fay*-thon

PHIDIAS: *Fid* -e-yus.

PHOCION: *Foe*-see-on.

PIETA: Pea-yay-*tah*.

PLEIAD: *Plee*-ad.

PLEIADES: *Plee*-uh-deez.

PLEIN-AIRE: Plain air.

POLYKLEITOS: Poly-k'*lie*-tuss.

POUSSIN: Pooh-sah'n.

PRAXITELES: Prax-i-*tell* -eez.

PROPYLAEA: Pro-pea-*lay* -yuh.

POUSSIN, NICHOLAS: Poo-*sahn*.

QUETZALCOATL: *Ket* -zull-*kwah* -tull.

RAMESES: *Ram* -zeez.

REMBRANDT VAN RIJN: *Rem*-brant van *Rhine*.

RENI, GUIDO: *Ray* -knee, *Gwee* -do.

RHEIMS: *Romz*.

RIGAUD, HYACINTHE: Rhee-*Go*, Eye-a-syn'th.

ROCOCO: Row-ko-*ko* is preferred, although Rah-*co* -*co* is also fairly common.

RODIN, AUGUSTE: Row-*dan*, Aw-*goost*.

ROUEN: Roo-*awn*.

ROUSSEAU, JEAN JACQUES: Roo-*sew*, Zhon Zhock.

SAN VITALE: Sahn Vee-*tah* -lee.

SETI: *Set* -tee.

SEURAT, GEORGES: Sir-*rah*, Zhorzh.

SUGER, ABBOT: Soo-*zhay*.

SUMER: Soo-*mare* (or more authentically Shoe-*mare*).

TEMPIETTO: *Tem* -pee-et -oh.

TEOTIHUACÁN: Tee-oh-tee-*h'wah*-khan.

THEBES: *Theebz*.

TIEPOLO: GIANBATTISTA: Tee-*ay* -po-*low*, *Zhee* -on-ba-*teez* -tah.

TIRYNS: *Teer*-ins.

TITIAN: *Tee* -t'zee-on (derived from *Tiziano*) is the more proper pronunciation, but most people anglicize his name as *Tish* -un.

TOULOUSE-LAUTREC, HENRI DE: Too-*lose*, La-*trek*, On-ree.

TRUMEAU: True-*mow*.

TUTANKHAMEN: (Pronounced *Two-ton-common*, or more simply, *Tut*).

UCELLO, PAOLO: Ooh-*chello*, Pay-o -low.

VAN EYCK, JAN: Van *Eye* 'ick, Yon.

VAN GOGH, VINCENT: Widely mispronounced as *Van Go*, his name is more properly said *Von Gaw 'h* (he was Dutch, not French).

VASARI, GIORGIO: *Vaz* -a-rhee, Gee-*or* -gee-og.

VELAZQUEZ, DIEGO RODRIGUEZ: Vuh-*las* -kways (the z in Spanish is pronounced as a *th* sound, thus Vuh-*lah'th* -kway'th is actually more authentic), Dee-*yay* -go Rod-*rhee* -gaze. His full proper name is Diego Rodriguez de Silva y Velázquez.

VERMEER, JAN: Ver-*meer*, Yon.

VERONESE, PAOLO: V'air-roh-*nay* -zee, Pay-o -lo.

VERROCCHIO, ANDREA DEL: Ver-*row* -key-oh, Ann-*dray* -uh Del.

VERSAILLES: Vair-*sigh*.

VIGÉE-LEBRUN, ELIZABETH: Vee-*zhay*— Loo-broon, Aye-*lee*- zah-bet (the *th* is sounded as a *t*).

VITALE: *See* SAN VITALE.

WATTEAU, ANTOINE: Wah-*toe*, Ah'n-*twon*.

XERXES: *Zerk*- zeez.

Index